Mountain Hands

Other Books by Sam Venable

An Island Unto Itself
A Handful of Thumbs and Two Left Feet
Two or Three Degrees Off Plumb
One Size Fits All and Other Holiday Myths
From Ridgetops to Riverbottoms: A Celebration
 of the Outdoor Life in Tennessee
I'd Rather Be Ugly than Stuppid

Mountain Hands

A Portrait of Southern Appalachia

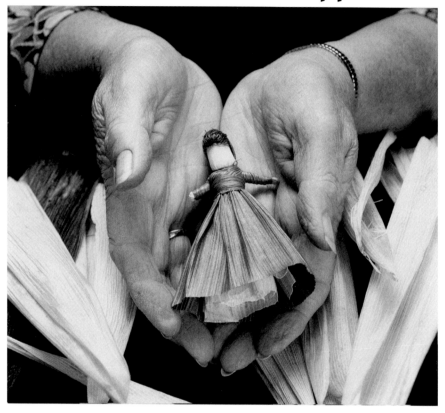

Sam Venable · *Photographs by* **Paul Efird**

THE UNIVERSITY OF TENNESSEE PRESS / KNOXVILLE

The paper used in this book meets the minimum require-
ments of ANSI/NISO Z39.48-1992 (R 1997) (Permanence
of Paper). The binding materials have been chosen for
strength and durability.

Library of Congress Cataloging-in-Publication Data

Venable, Sam.
 Mountain hands : a portrait of Southern Appalachia /
Sam Venable; photographs by Paul Efird.— 1st ed.
 p. cm.
 ISBN 1-57233-089-9 (cl.: alk. paper)
 ISBN 1-57233-090-2 (pbk.: alk. paper)
1. Handicraft—Appalachian Region, Southern.
2. Artisans—Appalachian Region, Southern.
I. Title.
TT23.2.V45 2000
745'.0974—dc21
00-008227

For Maw, whose bony mountain hands pointed the way—SV

For my parents, Paul Sr. and Kathryn Efird, and for Stephanie—PE

Contents

Introduction

I never met the man who served as the inspiration for this book, even though he lived to be ninety-three.

George Cuthbert "Cuge" Branham died in 1989 in a nursing home in Johnson City, Tennessee. He was the father of Lowell Branham, a longtime friend and one of my colleagues at the *Knoxville News-Sentinel*. Born in a log cabin, Cuge was raised, and spent most of his life, in the tiny Wise County town of Pound, Virginia. For his time and place, he received a full, formal, public education by successfully completing the eighth grade.

But like a lot of folks in those days, Cuge didn't need an abundance of "book larnin'" to forge a career for himself. Except nobody called it a career back then. It was merely a case of one's work or calling—"what you done for a livin'"—and Cuge pretty much did it all.

He logged. He mined coal. He did carpentry work. He ran a grocery store. And, like a number of his contemporaries, he was known to make a little whiskey from time to time. Maybe more than a little, actually. One of the brief periods Cuge didn't live in Pound was the six-month stretch he spent in federal prison, the result of his first, and only, arrest for moonshining.

That was then—when Cuge Branham was a stocky, muscular 180 pounds. This was now. By the first time I heard Lowell mention his father's name, Cuge was an old man, withered to 130 pounds, facing death in that nursing home bed.

On several occasions as the end neared, Lowell was summoned to Johnson City for what surely would be the final hour. But Cuge tricked the reaper more than once. Sometimes when Lowell would arrive after a hasty, middle-of-the-night drive from Knoxville, his dad would be sitting upright, as hearty as a frail, terminally ill, ninety-plus-year-old man could be.

Shortly before the end did come, Lowell made a routine visit to check in on his father. He told me about it upon his return a few days later: "When I walked into Dad's room, it looked like he was sleeping. I didn't want to disturb him, so I just said his name real low to see if he was conscious. Dad stirred a little. He never even opened his eyes. But then he stuck out his right hand to shake hands with me."

Lowell held his own right hand aloft, cocked in the handshake position, to underscore the point he was about to make.

"There he was, weak as a baby, but his grip was firm! Even though his body was withered and all wrinkled up, the muscles in his hands were still strong. I reckon that was from all those years of hard work. Dad was always doin' somethin' with his hands."

This was as much an epiphany for me as for Lowell. Unknown to him, I had long been tinkering with the idea of writing a book about the talented people of southern Appalachia. These were the

people who surrounded me as I grew up. The people I had watched—in awe and in envy—as they sawed, cut, drew, threaded, hammered, honed, shaped, sharpened, carved, chopped, whittled, tied, molded, planed, planted, and harvested their way through a myriad of tasks.

I wanted to do *some*thing to chronicle their stories, but precisely what kept eluding me. The concept never seemed to gel in my head. To borrow a term from journalism, the "news peg" was missing. Thus, as Lowell sat in my office that day and relayed the story of his visit, the awakening for me was about as subtle as a two-by-four to the forehead.

Yes! That's it! Their hands!

Immediately the mission came into focus. I not only got the green light from the University of Tennessee Press to begin research, but also had the good fortune to join forces with photographer Paul Efird. Month by month, year by year, this book began to take shape.

To identify likely subjects, I was guided initially by personal contacts and references from friends and other writers. As the project expanded, I sent a mass-mail appeal to political officials, community leaders, agricultural extension agents, handcraft experts, and weekly newspaper editors in eastern Tennessee, southeastern Kentucky, southwestern Virginia, western North Carolina, and northern Georgia. The resulting feedback was exceedingly helpful. The quest proved to be tremendously rewarding, personally and professionally, as I began to log hundreds, then thousands, of miles through the back roads to record the stories of these people.

Hands. What could be more simple—and yet so damnably confounding at the same time?

I've got hands, you've got hands, all God's children got hands. Trouble is, the hands that belong to most of us mere mortals are woefully lacking in the skills department. We are the interminable klutzes, forever banished to digital doom. For us, the pin-

nacle of dexterity is often achieved when we finally master the basics of shoe tying, pencil sharpening, and nail driving. Anything beyond is a gloomy sea of hopelessness.

Not for these folks. I am convinced they were initially blessed with chromosomal gifts that were woven into the fiber of their fingers at the moment of conception.

That was just the beginning, of course. A certain amount of follow-up was necessary to develop these gifts to their fullest potential. These hands had to be trained, refined, and enhanced through diligent study and exercise. But the good stuff, the right stuff, was locked in place from the start.

How else could someone like Hazel Pendley, born as a logger, be able to put down her axe, take up a needle, and learn to create heirloom-quality quilts? How else does someone like Ed Ripley wrap bits of fur, thread, and feathers into trout flies the size of a gnat? How else does someone like Lloyd Carl Owle pick up an ornate piece of stone carving, study it momentarily, think to himself, I can make one of these, and then actually do it?

It's because they've got the hands for the job.

The human hand is a remarkable, yet relatively simple, piece of equipment. It consists of a framework of twenty-seven bones and twenty joints, overlain and operated by a system of thirty-five muscles. Topped off with valuable accessories like fingernails and an opposing thumb, the hand becomes a powerhouse of function for the entire body.

As long as there have been humans, there have been working hands. There will be as long as our species remains on this planet. But much has changed in the last couple of centuries, as more and more pairs of these marvelous instruments have been idled by machines and automation.

Then again, maybe this change is merely part of an ever-evolving cycle. For it takes equally skilled hands to build and operate the machines.

I have always maintained that the hands of southern Appalachia are especially gifted. Unfortunately, they belong to a group of people whose stereotypic image, particularly when viewed through the eyes of Hollywood, amounts to little more than that of quaint simpletons given to fast cars and rebel yells. Forgive the xenophobia, but I find it odd that in this age of alleged respect for ethnic diversity, words like "redneck" and "hillbilly," when used hatefully and disparagingly, are still socially acceptable.

The people of southern Appalachia are anything but the yahoos of stage and screen. True, some of their traditional mannerisms might not parallel those of Emily Post, and their dialect is rarely taught in speech classes, yet even these cultural distinctions are fading from the landscape as more outsiders discover this delightful section of America.

Quite frankly, there is precious little difference between "us" and "them" anymore because the hills and hollows of southern Appalachia are not nearly as isolated, physically or socially, as they were only a generation ago. As you will see in the essays that follow, our craftsmen and workers differ widely in background and longevity in the highlands.

Here, I trust, is a representative swatch of cloth from the rich tapestry of this region. This is not necessarily a book about traditional mountain handcrafts, even though many of the more familiar crafts, and their practitioners, are included. But you're also going to find a few vocations that have never graced the pages of *Foxfire*.

I offer this collection as a celebration of gifted people who understand and appreciate their heritage. In one way or another, each person herein is bonded inseparably with the misty ridges, the fertile valleys, the rushing streams, and towering forests of this land. They share the comfort of belonging to this place, of knowing they're a member of the family. As I was interviewing Von Russell, he said it better than I could ever hope to explain: "It's the sort of thing you don't even think about as you're growin' up. . . . You don't understand it at the time. I'd say most teenagers today wouldn't understand it. But maybe they will—and they'll realize this is somethin' they don't ever want to lose."

Some of the people you are about to meet have lived in southern Appalachia all of their lives; some are relative newcomers. Some are college educated; some are hardly able to read and write. Some of their crafts and services are available on the international marketplace; some are barely distributed outside their county of origin.

Big deal. It is the innate skill of their hands that is so special. Young, old, male, female, black, white—it doesn't matter. What matters is the ability of their hands to perform, to perfection, the job before them.

Southern Appalachians were, and are, an intelligent, independent, innovative, industrious lot. Their work ethic was, and is, exemplary among American wage earners; indeed, it has often been exploited by greedy capitalists whose idea of "low cost of living" equates to "will work for little or nothing."

The people of southern Appalachia are honest and friendly, infused with powerful senses of humor, justice, integrity, and fair play, and I am honored to introduce them to you.

For they are good people.

Proud people.

My people.

Introduction

Sam Venable
Knoxville, Tennessee
June 22, 1999

Mountain Hands

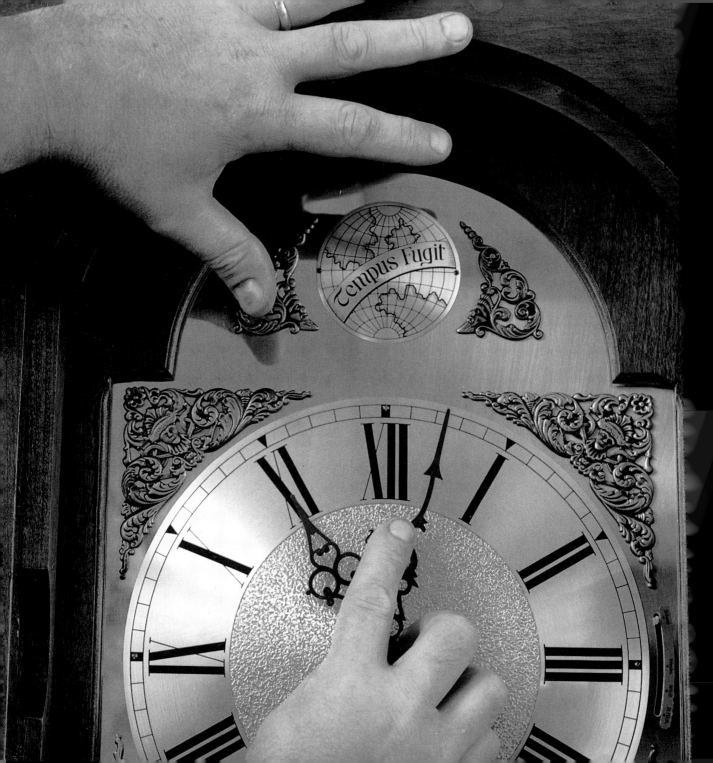

Tempus Fugit—Slowly

Luther Stroup

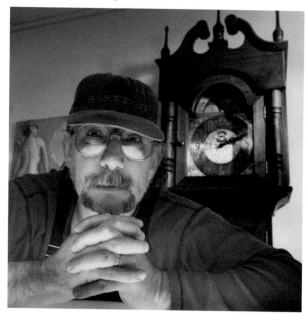

A common thread runs through three generations of Stroup family clockmakers in North Carolina, a continuum that bears faint link to the love of mainsprings, pendulums, bushings, dials, wood cabinets, and other integral components of things that go tick-tock.

Quite the contrary. The key word here is "emergencies."

Had it not been for an incredible series of medical mishaps, broken bones, and surgical procedures, none of the pieces of this intricate puzzle might ever have fallen into place. In fact, this family might never have existed, and lovers of heirloom-quality grandfather clocks would be looking elsewhere to satisfy their craving.

It all began on a spring afternoon in the early 1930s, when a Wake Forest University baseball player named Robert Stroup split his hand open in a freak accident during a game. This happened on a Saturday afternoon; thus, a doctor wasn't immediately available. Stroup's teammates helped him across the street to a drug store for first-aid treatment. A customer in the store that day happened to be a pretty Duke University student named Frances Ragan. She helped apply the bandage, and in so doing caught the athlete's eye. Before anyone could say, "Play ball!" they started courting.

On Christmas Day 1935, Robert and Frances were married. By that time, he was newly graduated from Wake Forest. In addition to a wife, he now had a degree in business and a cigarette sales job with the R. J. Reynolds Tobacco Company in West Virginia.

Yet within three months, he lay at death's door.

Driving the winding, narrow backroads of his route one snowy day in March, Stroup rounded a curve and saw a school bus weaving toward his truck, out of control. The two vehicles collided head-on. The impact crushed Stroup's skull. He was pronounced dead at the scene.

Miraculously, Robert Stroup was not dead. His initial recuperation took months, and as soon as he was discharged from the hospital, he and Frances left West Virginia. They moved to Spruce Pine, North Carolina. This is where Robert had spent his high school years, when his father, the Reverend H. M. Stroup, had ministered to a local Baptist church.

After his health fully returned, Robert worked awhile as an accountant. Then he resumed his sales career, this time with a company that serviced the many feldspar mines in the region. He and Frances began a family—first Betsy, then Robert Jr., then Luther, then another daughter, Ragan.

4

In the meantime, Reverend Stroup retired from the ministry and moved to Spruce Pine himself. As a young man, long before he was called to preaching, H. M. Stroup had been a machinist. These skills, dormant after years in the pulpit, were resurrected in 1949, when he "began piddling" with the notion of making grandfather clocks.

One clock became two. Two clocks became four. Then one hundred. Two hundred. Five hundred.

In his spare time, Robert Stroup started helping his father in the clock shop. They named the enterprise Stroup Hobby Shop because that's exactly what clock making was to them both. Before long, the grandsons, Robert Jr. and Luther, were spending afternoons, weekends, and holidays at the workbench, too.

Five hundred clocks became seven hundred. Then eight hundred.

Luther Stroup enjoyed working with his brother, father, and grandfather, but clock making wasn't going to be his career. He enrolled at Carson-Newman College in Jefferson City, Tennessee, and earned a double-major degree in English and religion.

The morning after he graduated in 1972, however, Luther went to clean out his campus mailbox and found a letter from Uncle Sam.

"Greetings," it began, "You are hereby selected. . . ."

"That was in June," Luther recalls. "In July, I went for my army physical in Charlotte. I passed and was ordered to report for induction on August 27. I got up that morning, said goodbye to Mama and Daddy, and caught the bus for Charlotte."

But that old medical mishap was about to rear its head once more.

When Stroup arrived, a staff sergeant pulled him out of line. Seems the government wanted a second opinion about the scars on the young draftee's knee.

"I'd hurt that knee playing basketball in high school," Stroup says. "I didn't realize how bad it was. The doctors back home had always just told me it was a cartilage injury and they had fixed it. But the orthopedic surgeon the army sent me to didn't agree. He said it was major surgery and I was not qualified for military service. I was back on the bus for home that same day."

Just one problem. Even though he had been rejected by the army, Stroup's draft status officially remained 1-A. Any time he went to a job interview and the subject of military service eligibility was broached, he got the same reply: Don't call us; we'll call you.

"I don't know if it was because of a secretarial error, an oversight, or what, but it was May of the following year before I was reclassified," Stroup said. "By that time, I'd gone back to the clock shop. It was the only work I could get. I just decided to stay. And that's how I wound up making clocks for a living."

That's also a long, complex, convoluted way of explaining why the number of grandfather clocks produced by Stroup Hobby Shop now stands at well over twenty-four hundred. And counting.

"My grandfather worked in the shop nearly every day until he was ninety," says Luther. "He was an excellent, skillful teacher. I learned a lot just by watching him. He wouldn't tell me how to do something. Instead, he'd let me make the mistake, and then he'd laugh and say, 'Well, do you know what

you did wrong?' It was a great way to learn, just like being an apprentice."

After his grandfather's retirement, Luther, his brother, and his father made clocks together. Robert Jr. stayed in the business for ten years before pursuing his own career in construction. Robert Sr. remained active until shortly before his death in 1994 at age eighty-four.

You'll find Luther most days at the Hobby Shop, which is located on the banks of the North Fork of the Toe River, just outside downtown Spruce Pine. That'll be him—over by the pile of seasoned hardwoods or at the lathe or the sander or the table saw or the drill press or the shaper or the planer, patiently crafting from scratch another treasured timepiece.

Aside from a simple black-and-white brochure, Stroup does no advertising at all. His business is strictly word-of-mouth. He delivers every clock himself—he has traveled to every state except Alaska and Hawaii—sets it up, and doesn't leave until the customer is happy. Little wonder, then, that he is constantly backlogged with orders.

"If somebody wants one of my clocks, I'll make it for them as long as they can be patient," he says. "I don't have a niche market. It's not like you have to drive a BMW or a Mercedes and live in a New York penthouse to get one of my clocks. I'm happy to make the clock. It just takes a little time."

Clock lovers aren't the only ones to realize the quality of Stroup's work. In 1996, the CBS television network began airing a Sunday morning program called *Handmade America*. When the film crew came to North Carolina, one of the first artisans they called upon was Luther Stroup.

"They spent four hours interviewing me," he says with a grin. "I figured I'd wind up on the cutting room floor. I watched the show for several weeks and nothing about North Carolina ever came on. Finally, the network called and told me which weekend it would run.

"It opened with a panoramic view of the North Carolina mountains and a narrator talking about the skilled craftspeople of this area. My daughters started yelling, 'It's Daddy! It's Daddy!' I couldn't figure out what they were shouting about because there wasn't anybody on the screen right then.

"Finally, my wife said, 'That's your voice. Don't you recognize it?'

"No, quite frankly I hadn't. Nobody recognizes their own voice. But then they started showing me in the shop and using my voice to narrate most of the program. Later, the people from CBS said they got 136 phone calls before noon that day from people trying to find out who the clockmaker was. It was a flattering experience and gave wonderful exposure to our section of western North Carolina."

Indeed, if there ever was an ambassador of Tarheel crafts, it would be Luther Stroup. In 1978, he opened his own gallery in Spruce Pine to showcase the many talents of his region.

"Whenever I'd be in another part of the country delivering a clock, I always made it a point to visit a local museum or art gallery," he noted. "It dawned on me that a lot of the products I was looking at were made close to my own home. For instance, this area is world famous for its glass artists, but not that many people realize it.

"I kept saying to myself, 'Gee, all this stuff is going on right in my own back door, but nobody knows we're here.' I started looking downtown and found an old building that was literally falling apart. A section of it hadn't even been used since 1954. I bought it and refurbished it and the arts business just took off."

Today, the Twisted Laurel Gallery features the works of more than 150 artisans and crafters from western North Carolina. The inventory includes pottery, glass, woodwork, carvings, jewelry, ironworks, paintings, books. And, of course, a clock or two from the Hobby Shop.

Tempus Fugit—Slowly

Except for the works (imported from Kieninger, a premier German manufacturer), the glass panels, and hardware like hinges and locks, everything in a Stroup clock is made by hand. That's a rather novel concept in a part of the country famous for its bustling furniture factories, where raw lumber goes in one end of a giant machine and the finished product emerges at the other.

But at the Hobby Shop, the pace is definitely slower. Only after the customer has selected the exact design he or she is interested in, chosen walnut, cherry, mahogany, oak, maple, or pine for the cabinet, and made a small down payment, does Stroup begin his labors.

He starts by combing through the many piles of kiln-dried lumber stacked throughout the shop, trying to locate "just the right" boards for the job. You don't have to watch long to realize here is a craftsman who bonds with his raw material as if it were a living entity with a soul of its own.

"Look at this cherry!" he exclaims. "It's absolutely superb. This came off of Grandfather Mountain more than fifteen years ago. There's not a knot in it."

Just as quickly, he sweeps an arm toward a selection of blemish-free walnut, each board a full eighteen inches in width—"This stuff's so beautiful, I hate to even use it. Why, I just want to sit here and look at it!"

Then again, not *all* the wood in Stroup's shop was extracted from the surrounding mountains. Propped against one wall was a rather unique item, crafted from Spanish oak.

"You think it looks like a coffin?" he asks. "That's because it is. A funeral home director I know sent it to me. He wants me to put a clock inside of it."

Stroup begins with a process he calls "facing up" to make certain the grain of each respective board in a given piece will line up with that of the others. "You have to approach this like an artist," he says. "It must please the eye."

Tempus Fugit— Slowly

Once the boards are joined with glue, then planed and sawed to size, he begins cutting a series of tongue-and-groove joints to fit each part of the cabinet together. Then comes the detailed work with lathes and shapers—some using the same bits his grandfather purchased more than thirty years ago—to form the posts, dental molding, swan's neck molding, finial, and other finishing pieces.

Here, a mere second of mental lapse can ruin more than a pretty piece of wood.

"Even at age ninety, my grandfather had all his fingers and toes," Stroup says. "Think about that, after all those years as a machinist and then as a woodworker and clockmaker! It's amazing. Once, I remember this fellow came into the shop and made a remark about it. He said something like, 'Huh! You must not be much of a craftsman. You haven't lost a finger or anything!'

"My grandfather just told him, 'Mister, the only thing that tells me about you is carelessness!'"

H. M. Stroup's constant admonitions about safety still bear fruit. Luther extends both hands and rotates them proudly: eight fingers and two thumbs, all intact and in perfect working order.

Back at the bench, the parts have been sanded smooth and are ready to come together. The tongue-and-groove joints and cross members lock in precision alignment. At any point where a piece must be secured with a metal screw, the screw is hidden and the hole plugged. Again, Stroup stresses, this is the artistry of his craft. It's what separates his creations from mass-produced clocks.

Next the cabinet goes onto a set of sawhorses in the stain room for one to two coats, depending on the shade desired, then two coats of sealer and a low-gloss lacquer finish. The clock will be signed and numbered. After that come the doors, plus the necessary glass, locks, and hinges. The works go in last.

"At one time in this craft, it was necessary to actually 'set the tick' on a clock," he explained. "You

had to listen to it and hear the precise cadence of *tick-tock*. If it loped—*tick-tick, tick-tick*—that meant the pendulum was off balance. It might take a month or so, but the clock would eventually stop running. Around the mid-1980s, though, a process called 'automatic beat' was developed in Europe. Now, the pendulum will find its own center of balance."

How much maintenance does a fine-quality clock need after that?

Stroup laughs aloud at the question.

"It reminds me of the time I was visiting a works factory in Germany. One of the master craftsmen there was talking about the difference between a clock and a car. He said people drive their cars only one hour a day, and yet they change the oil and filters regularly. On the other hand, their clocks run twenty-four hours a day, seven days a week, and they never get serviced at all. Yes, clocks do need a little oil every two or three years. Everything inside is in constant motion. There's continual friction."

Even so, Stroup's clocks all come with lifetime guarantees, meaning that Luther has had to learn a thing or three about refurbishing worn-out movements.

"The holes can get 'egged-out' by friction. Some-times, I have to ream out the hole and install a new bushing. If I have to replace the gears or whatever, I can do it. Sometimes, I have to actually order new parts, too. But after all these years in the business, I have a closet full of old movements that I can rob parts off of, if necessary."

Whatever the need, Stroup is committed to the same ideals of craftsmanship and integrity established by H. M. Stroup half a century ago.

"He had a different philosophy than what they teach in business school," says Stroup, patting the dusty old ledger that chronicles nearly every clock produced by his family. "According to the conventional theory on profit, you're supposed to put the least you can into a product and charge the most you can get for it. My grandfather's philosophy, and the one I certainly hope to continue to follow, is to put the most you can into a clock—use the very best movements, make it far superior to anything from a factory—and then sell it for the least you can.

"I've got to make a living, of course. After all, I've got a wife and three children to feed. But I know a hundred years from now, somebody's going to look at one of my clocks and say, 'This is a great clock. It was made right.'"

Tempus Fugit— Slowly

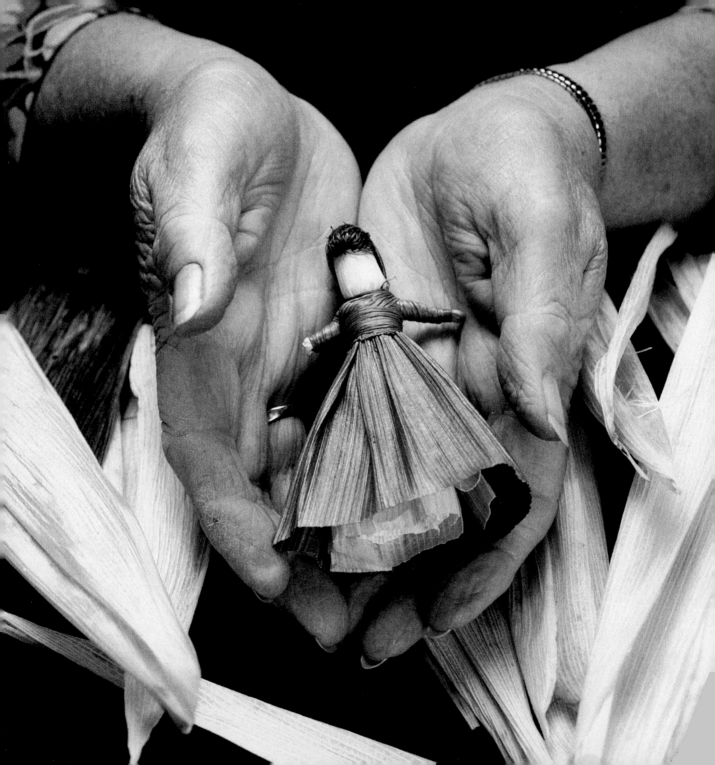

The Doll Maker

Betty Marshall

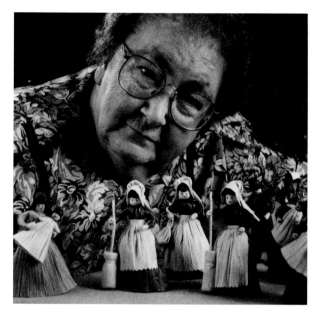

Leon Marshall doesn't need a calendar to know when the tourist season is nigh. All he has to do is open the refrigerator and peek into the meat section.

"When Betty starts makin' corn-shuck dolls, I start eatin' a lot of baloney," he chuckled.

Leon likes bologna sandwiches, which is fortunate because he's had a *lot* of practice eating them during doll-making seasons through the years. His wife of nearly half a century is one of southern Appalachia's most heralded practitioners of this all-American form of art. So is their daughter, Gail Marshall Evans. Yet Leon's association with corn-shuck dolls, not to mention its related bologna dieting, goes back even further. His mother, the late Lila Marshall, was one of the true pioneers of this handcraft, helping to bring it from the backwoods to galleries throughout the Southeast and beyond. If a doll is made by a Marshall, it has to be good.

Long before Ken and Barbie plastics hit the scene in their pricey matched outfits, corn-shuck dolls were cradled by many a young girl in the southern highlands. Betty Marshall remembers her mother-in-law talking about how she'd had them as a child. But corn-shuck dolls have been around for a lot longer than that. According to the Virginia Division of Tourism, native Americans were practicing this unique art form before the founding of Jamestown in 1607. As this was quite a number of years before the arrival of luncheon meat into the New World, one can only marvel how the tribes survived as long as they did.

It was 1959 when Betty tried her hand at twisting corn shucks into a doll-like form. She couldn't have asked for a better instructor.

"Mrs. Marshall used to teach classes on corn-shuck doll making, and I would take her," she said. "This particular time—it may have been in Abingdon or maybe over at East Tennessee State University in Johnson City; I can't remember—I was helping her

set up for a class, and I got to thinkin', I believe I could learn to do this. So she taught me."

Nobody learns a craft overnight, and this is no exception. Lila Marshall lived just down the road from Betty and Leon, and Betty remembers how she "like to wore myself out goin' up and down that road, gettin' her to show me things. I'd get discouraged, but she was real patient. She'd tell me, 'Now you just go back up there and get some rest. Put the dolls aside for a little while, and when you're not tired, pick 'em back up and start workin' on them again. You'll get the hang of it.'"

That's what she did. Even though Leon playfully teases her about how crude her early dolls looked, Betty continued to refine her craft. She sent one of her dolls to another maker and asked her to take it apart, strip by strip, piece by piece, and make recommendations for improvement. The effort paid off in 1961 when Betty made her first submission to the exclusive Southern Highland Craft Guild in Asheville, North Carolina, and was accepted for membership.

In the years since, Betty Marshall has made thousands of corn-shuck dolls. Some she sells out of her home in Nickelsville, Virginia. Others are available through Southern Highlands Craft Guild shops throughout the South. Her wares have been shipped throughout the United States and several foreign countries. Her work has been featured in *The Complete Book of Nature Crafts* from Rodale Press. With the aid of her daughter and mother-in-law, she has filled orders as high as six hundred pieces.

But perhaps one of the most memorable requests she ever received was for a single doll. It came from Washington, D.C., on White House letterhead. That was in the fall of 1993, when Hillary Rodham Clinton asked some three thousand American artisans to create decorations for Christmas trees at the White House.

"The theme that year was for Christmas angels,"

*The
Doll
Maker*

Marshall said. "I thought about it for awhile and started to make one of my regular angels. Then I thought, 'No. Everybody will be doing something like that. I'll do something different.' So I made Mrs. Clinton a Santy Claus. I reckon there's no better angel than that."

The next February, Betty and Leon received a personal note from the First Lady.

"As a child," Mrs. Clinton wrote, "I remember walking around the tree night after night in our family home, looking at each ornament. This year, it took our family weeks to see every ornament magnificently hung on the eighteen-and-one-half-foot tree. . . . Without your help, none of this would have been possible. Thank you for your wonderful ornament. You truly made our first Christmas in the White House a special one."

Enclosed was a photograph of the tree in the center of the Blue Room. Betty studied the picture intently. Her eyes lit up. Right there, on one of the main branches, tucked in among the heavenly host of angels and archangels, was her jolly ol' elf.

"It sure made me feel awful happy," she said.

Whether it's a Santa Claus, a farmer, a bride and groom, an angel, or any of Marshall's many designs, each doll undergoes a long journey from raw material to finished product. It all starts with a sixteen-pound bale of corn shucks imported from Mexico.

"The early crafters raised their own corn, of course," she said, "but most of the corn that's grown in the United States is too rough for the type of work we do today. This is a special breed with real soft husks. Even then, we can only use the first two or three husks away from the cob itself. Same thing with the silks, which I use for hair and beards. I can use some native silks, but a lot of time they've been ruined by bugs. I get most of my good silks along with the Mexican husks."

The first order of business is to open the bundle and stand back—sixteen pounds of compressed corn

husks is a *lot* of material!—and then grade the leaves, just like tobacco. Tougher ones in one pile, softer ones in another. The husks arrive in their natural, uncolored state. Based on the orders she has, Marshall must then decide which ones to dye.

"In the old days, people used natural dyes," she noted. "Walnut shells, white oak bark, maple bark, onion skins, lichens, sage, things like that. I've taken courses in color design with native materials and can do it that way, but it's a lot cheaper and easier to do it with regular fabric dye."

"That's my job," says Leon. "I'm in charge of the manual labor."

He cooks up a kettle full of dye solution and keeps the shucks immersed for six to eight hours. Then they are rinsed several times so the colors won't fade when the shuck is dampened as it is being used. The long leaves drain overnight and then are placed—just like a washer-load of socks and longhandles—on a clothes rack beside the wood stove in the Marshall's den. In thirty-six to forty-eight hours, they'll be dry and brilliant in hues of yellow, red, black, blue, green, and orange.

When Betty sits down to arrange everything into a doll, she places a blanket across her lap. A pan of warm water sits on one side, her thread, knife, and scissors on the other. From this point on, Leon and the bologna get real familiar with one another.

"I can make a dozen five-inch dolls in around three or four hours," Betty said. "I can't work as long at a stretch as I used to. But if you've got the orders, you've got to fill them."

The doll-making process is a series of twists and layers, each bound by several wraps of sewing thread. Because of the way each piece is layered, however, the thread never shows. The process works from the center out and is achieved by rolling the corn shucks alternately across and with the grain to form the head and main torso.

Once the body has been formed, additional shucks are wrapped on to give it shape. The arms can either be made from a single corn shuck, rolled tightly with the grain and inserted through the body, or, in the case of a more elaborate piece, formed with floral wire and bulked up with additional wraps.

If the piece is to have legs, these also are formed with a skeleton of wire that is bound, over and over, by thin strips of shucks. The result is a perfectly balanced doll that will literally stand on its own two feet. Sometimes legs aren't even necessary. If the doll is to be dressed in a long skirt or—in the case of an angel—a long robe, the strength of the corn shuck, when dried, will keep it erect.

"The main thing to remember while you're workin' is to keep the shucks moistened," she said. "When they're wet, they're very pliable. If they dry out, though, they'll start to tear. Sometimes, I'll be into a doll and notice a piece I put on earlier has started to split. There's nothin' to do but take it apart and replace that one and put it back together."

Next comes the detailed work. A tuft of fuzzy dyed silk might become a beard. Then again, she might arrange the individual strands into a bun or other simple hairdo befitting a mountaineer woman. After the doll has completely dried, Marshall uses an artist's pen and India ink to draw in the eyes, nose and other facial features.

To be created with such fragile ingredients, a corn-shuck doll is amazingly strong and durable. With minimal care, it can last for years in pristine condition. In fact, its worst enemy isn't a pair of human hands. It's sunlight, which will eventually fade the colors. For that reason, collectible corn-shuck dolls should be stored in a display case, out of the direct rays of the sun. Then again, for pure display purposes, it's hard to beat the Blue Room of the White House—if you happen to know the right folks.

Marshall doesn't attend as many craft shows as she once did. Production demands keep her busy at

The Doll Maker

home. Plus, the physical strain of meeting hundreds, maybe thousands, of people during the course of a show gets more taxing every year.

"I do love to talk to the people, though," she says. "There's always women and girls who are fascinated with these dolls. Sometimes, they'll be standin' six and eight deep around my booth. I remember once at a show in Gatlinburg, I made dolls for eight straight hours. My mother-in-law was still livin' then. She came by and spelled me for a while so I could walk around and stretch for a minute."

Tiring as the regimen may be, Marshall recognizes an intangible benefit that transcends economics. She knows that somewhere out in those masses is a special little girl who will take home more than a corn-shuck doll. It's a little girl who will spend hours playing with her new toy and then put it on a shelf. A little girl who will take the doll back down some day and realize the cultural heritage represented by those tightly bound strips of corn shucks. A little girl who will study the doll in a totally new light. A little girl who will say to herself, "I believe I could learn to do this."

Let the circle be unbroken.

The
Doll
Maker

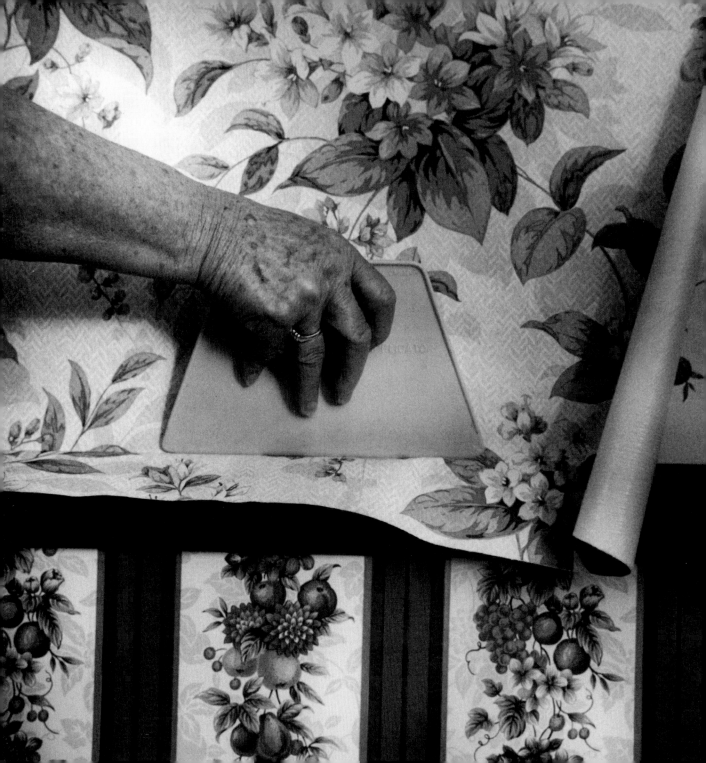

A Job that's Always on the Level

Lois and Dallas Troxell

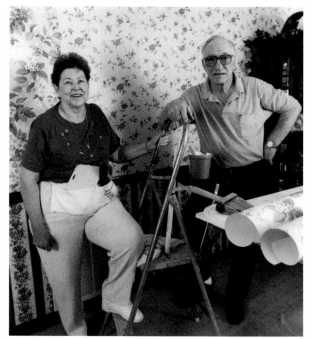

The telephone rang late one night at Dallas and Lois Troxell's house. Lois picked up the receiver. There was a man on the other end, an angry man who made no attempt to hide his wrath and frustration.

"Can you save our marriage?" he wanted to know. "We're on the verge of divorce!" Then he launched into a litany of woeful stories about the escalating angst at his home.

Lois listened patiently. She'd heard it all before. When the fellow stopped to catch his breath, she told him she and Dallas would come over in the morning and help restore peace and tranquillity. Just quit fighting and go on to bed and try to get a good night's sleep.

No, the Troxells are not marriage counselors. Not ministers or social workers, either. Nonetheless, they are responsible for restoring bliss, marital and otherwise, in hundreds of homes and businesses throughout a six-county region of eastern Kentucky.

They hang wallpaper.

"Why, doin' this job with your husband isn't a problem at all," she said, winking toward her mate of thirty-eight years. "All you gotta do is let him *think* he's in charge, even though *you're* the real boss!"

"I'm not in charge of anything!" Dallas teased in response. "I'm just the gofer. I do what I'm told."

Whatever the Troxells' formula, it works. Whether their assignment for the day happens to be a house, restaurant, church, library, office complex, hospital, bank, school, funeral home, or merely a spare bedroom that someone is converting to a den, they pile stepladders, plastic buckets, towels, levels, scissors, knives, and other wallpapering equipment into their pickup truck and head out together.

In truth, Dallas is a relative newcomer to the trade. He's only been hanging wallpaper for the last six years, ever since he retired as a carpenter for the

Stardust Cruiser boat company near their home in Monticello. Prior to then, Lois was a one-woman show.

"You have to learn to improvise when you're on your own," she said. "Like the time I was paperin' the bedroom in this brand-new house. The house was still empty, and the job was pretty easy to do. A couple of weeks later, the owners called me back. They'd decided to put a border around the top. They'd already moved in by that time, and they had this huge waterbed in the room, up against the wall. I couldn't budge it, but I had to get a ladder behind it so I could work."

Lois Troxell does not give up quickly. She wet a strip of the border, climbed a ladder in the corner of the room, thumb-tacked it in place, and climbed down. Feeding off the remainder as she walked across the room, she stepped onto the bed, walked to the head of it, patted the paper more or less in place, and stretched as high as she could reach with a plastic "swiper" to lock it into final position.

No luck.

"I couldn't quite get to the top of the border," she said. "I was standin' there on my tiptoes, wonderin' what to do, when a wave came down that waterbed. Those beds are kinda jiggly anyway, and by me walkin' around on it, the water had started to move. That gave me an idea."

Lois jumped lightly and then waited for the resulting wave to work its way toward her. As the crest rolled under her shoeless feet, it lifted her entire body a couple of inches, just enough to make a swipe or two before descending.

"I got t'jumpin' up and down on that bed and ridin' the water up to the ceiling," she recalls with a laugh. "It worked perfect. I just kept movin' across the bed 'til I got the job done. To tell you the truth, though, I was scared those folks would come home and catch me jumpin' on their waterbed. No tellin' what they might have thought I was doin'!"

Like many people in this trade, Lois started her business after hanging wallpaper in her own home. At that time, she was employed at a shirt factory. Pretty soon, however, her skill with wallpaper caught the attention of relatives and friends. The calls started pouring in. She bade farewell to the shirt factory and started out on her own.

"I've only advertised one time in eighteen years," she said. "That's when I took out an ad in the newspaper. Other than that, it's all been by word of mouth. I intended to just work a couple of days a week, but before long, I was goin' at it eight days a week!"

If the wallpaper business is that lucrative, why don't other folks try it?

"They know better," she deadpanned.

"Sometimes, I wonder why I got into it myself. Maybe the paper isn't hangin' right or we're gettin' flooded with calls, and I just look at Dallas and say, 'Why'd I ever start this?' But then I'll get off my ladder and step back and say, 'Now, that looks good.' It gives you a real feeling of accomplishment to know you've improved the looks of a room for somebody."

When Dallas and Lois were kids, growing up on opposite ends of rural Wayne County, Kentucky, wallpapering was a far cry from the business of today. In the first place, it wasn't a business. Folks pretty much did their own. And they did it from scratch, often with sheets of newspaper and homemade paste.

"Many's the time I watched my mama mix up her own wallpaper paste on the stove," said Dallas. "She'd mix water and flour and stir it to get the lumps out."

Not only was the job labor-intensive, the finished product wasn't nearly as good as today's commercially prepared adhesives.

"Dallas's uncle told me about the time he and his mama papered a room with homemade paste," Lois says. "It took 'em all day. By night, the paper looked great. They went to bed, and the paste dried out and started poppin'. He said it sounded like corn poppin'. Next mornin' everything was cracked."

Quality control may have improved in wallpaper and its components, but installation is just as painstaking as ever. One of the biggest problems, in an old structure or new, is getting the first strip hung perfectly straight.

"A lot of people don't realize this until they try to hang paper, but very, very few walls and corners have exact ninety-degree angles," Lois said. "I don't understand why, because carpenters use levels and plumb-bobs. But that's the way things turn out. So you've got to take your own level and make sure you hang the paper straight. If you mess up the first one, even a little, it's just goin' to get worse."

Even with a the proper tools, the job can still be taxing. There are five major houseboat and yacht companies in the Monticello area, and the Troxells have done custom papering jobs for all of them. Lois chuckled recalling the first one: "It was a great big houseboat, still under construction. They had it up on blocks. I went into one of the rooms and started to work, but I never could level-up the first few sheets. Finally, I went outside and asked the foreman, 'Is this boat sittin' level?' Of course it wasn't. He got the men down off their ladders and I put my level on the floor. They kept jacking up the sides and stickin' shims in, and we finally got it worked out. After that, it wasn't a problem at all."

Another common fault of first-timers, she says, is lapping the edge of sheets rather than butting them squarely against each other. Lapping creates a tiny ridge that's especially noticeable to the discerning eye. As Lois notes, "My sister says the first thing I do when I walk in any room is start feelin' the walls."

In addition, many do-it-yourself hangers try to speed up the job on new walls by not coating the Sheetrocked surface with a thin, paintlike material called sizing. They—or the next homeowner—will pay for this omission later when they try to strip the paper. Instead of peeling off cleanly, the paper will pull chunks of Sheetrock with it.

If the wall is damaged, irregular, paneled, or heavily layered with old paper, Troxell covers it with a commercial liner, then hangs the new paper on top of it. "You run the liner horizontally, then go ahead and hang the paper vertically. That way, you never have to worry about edges appearing in the same line with each other. Once, some folks from an insurance company called. They wanted wallpaper on top of concrete blocks. I put a liner on it first, and the paper turned out real nice."

No matter what the job, though, corners can be a hassle, particularly with paper featuring vertical stripes or large floral patterns.

"Outside corners are harder than inside corners," she said. "You have to learn to work around them, levelin', cuttin', or tuckin' a small piece under to make it come out right. This is one of those jobs where you have to experiment. You're goin' to make a few messes, but that's the only way you can learn."

As with many jobs, the easiest-looking task can often be the hardest. Ever notice how a wallpaper expert has covered an electrical switch plate, blending it perfectly with the pattern behind? Try it some time.

"I was papering a room for this lady, and she saw me cover a switch plate like that," Lois said. "She wanted to try it, so I showed her how. She messed up and tried again. Then she did it again. Finally, she got aggravated and threw everything down and said, 'I'm a school teacher, and I thought I could do anythin' I set my mind to. But I believe I could fly a helicopter before I could learn to do this!'"

Given their lengthy experience in this trade, the Troxells can rattle off milestones with the same patter as a sports statistician. Such as—

Most paper hung in a day: Twenty-one double rolls, start to finish, in a new house, using an electric scaffold.

Most expensive paper ever hung: $120 a *roll!* "I could have worked a lot better if I hadn't known

A Job That's Always on the Level

how expensive that stuff was," she sighed. "Lord, I'd measure and measure and measure before I'd ever make a cut."

Most famous customer: Musician and actor Kenny Rogers. "We did a houseboat for him. They shipped the paper in from California. The strips were five feet wide and weren't prepasted. It was like workin' with upholstery material."

Most hideous request: Black wallpaper in a small bathroom with no windows.

Most unusual request: A full-length mural of a golf course along the wall of a den. "The owner told me he picked out the mural first and then designed the wall to hold it. I wasn't sure how it would look, but it turned out gorgeous. Honestly, it looked like you could step right into that wall and walk up to the tee. It was really unique."

Most beautiful home: There have been quite a few, but perhaps the consensus winner was a million-dollar-plus house on a bluff overlooking Dale Hollow Lake. "It was absolutely gorgeous. I stepped out on one of the balconies one mornin' and was gazin' down at the lake and one of the carpenters joked to me, 'Wouldn't you hate to have to wake up and look at this every day?'"

Most precise job: "In eighteen years, I only had it happen twice. I papered these two rooms, and the walls were exactly straight. I came right back around where I'd started, and the edges butted up perfectly. I didn't have a scrap of paper left over from either job."

Most unusual surroundings: "I've done a lot of funeral homes. Once I was workin' in one of the back parlors of this place. It was a dark, rainy day. I took a break, and when I came back, they'd rolled a casket in there. It had the body of an old man in it. I walked over and looked at him and said, 'I know you ain't gonna hurt me, but I'd just as soon you weren't in here.' It's not fun to work with someone lookin' over your shoulder, whether he's alive or dead."

Most embarrassing situation: Three contenders. All three turned out to be hilarious—after the fact.

The first was the time Lois and Dallas worked all morning installing a detailed border, only to discover near the end of the project that they had put it on upside down.

"You had to look close, but you could see some tiny hot-air balloons in it," she said. "We had 'em goin' the wrong way. Dallas said we oughta leave it, but I said no. The house belonged to a doctor, and I told him anybody smart enough to be a doctor sure would know which way balloons are supposed to go! We were able to peel it off and turn it over. It went back on just fine."

Another time, Lois was backing down a step ladder, slipped on some paste, and missed the last step.

"I landed smack-dab on my hind end—*bang!*— right in front of the woman who owned the house. She was talkin' on the telephone, and it liked t'scared her to death. She hollered out, 'Are you all right?'

"I just jumped up like nothin' ever happened and said, 'Oh, yes. I do this all the time.' I bet she thought I was crazy."

And then there was the day she accidentally set off the burglar alarm of a house.

"I didn't know how to get hold of the fellow to get it turned off. I finally remembered his brother's name and called him. That thing was awful loud, but it was way out in the country where it probably wasn't botherin' anybody, so I just kept on workin'. Finally the front door flew open, and the guy came runnin' in. Sorta startled me. I told him, 'I thought you were the police!'"

Lois's years in the business have afforded her the opportunity to experiment with some of her own designs. For instance, she has taken vertical stripes and papered them at a forty-five-degree angle. It's a slow process that calls for constant checking with the level—and because of the type of cut that needs to be made on both ends of each

sheet, a large amount of paper winds up as waste. Yet the contrasting result is an eye-catcher.

Another one of her design innovations involves very little paper. She merely runs a colorful border at chair-rail height completely around the painted walls of a room, outlining windows, doors and anything else in the path of the strip.

"My son says this is one of those ideas that just popped out of my own head," she commented. "I tried it and liked it, and the next thing I knew, several other people have wanted it."

She gets designing tips from customers, as well.

"I was going to redo our bedroom, but I simply couldn't find a pattern I liked. I had looked for months at a time. Then one day on the job, I saw a paper that was perfect. I got the stock number and went and bought some the very next day."

She pauses. "Of course, it was several months before I found time to hang it.

"That's the real beauty of this job, though. It might take awhile, but I can see something get finished. That used to frustrate me when I was working at the shirt factory. I'd just sew one part of a shirt, over and over and over. I never got to see the finished product. Not only do I get the pleasure of seeing a room take shape, it really makes me feel good when the owner walks in and says, 'Wow! This looks great.'"

When she's not standing on a ladder in someone's home or office, there's a good chance Lois can be found on a golf course. She owes a lot of golf. She has picked up a lot of business contacts through the game. What's more, she has accumulated a fair share of trophies for her play. But there's still one nagging problem.

"I haven't conquered the game yet," she says.

Perhaps she should call Tiger Woods and offer to swap wallpaper installation for golf lessons.

*A Job
That's
Always
on the
Level*

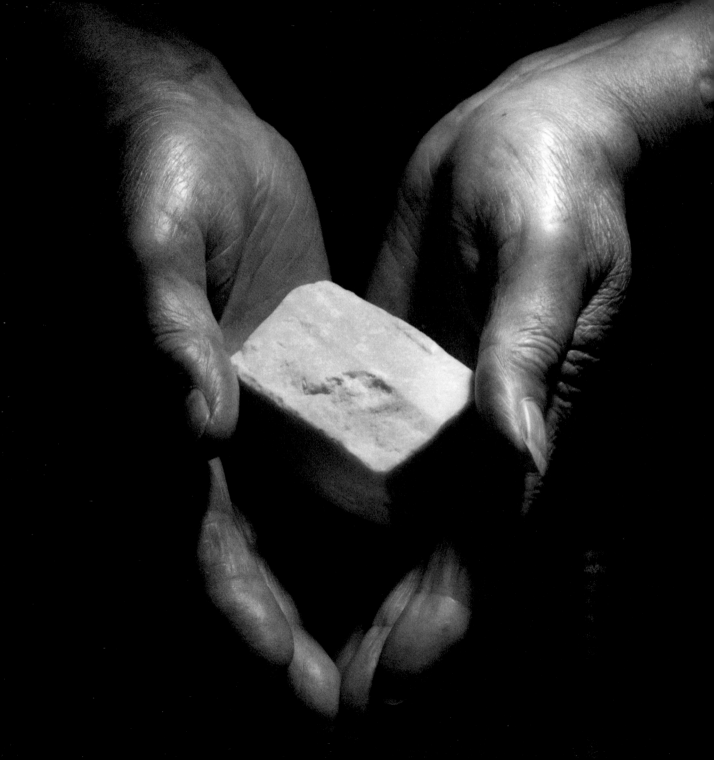

The Long Journey Home
Edna Hartong

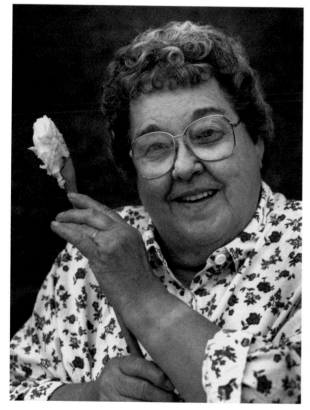

As the crow flies, it is approximately ten miles northwest, directly over mountains and across creeks and valleys, from Edna Hartong's home near Tazewell, Virginia, to the eighty-two-acre farm at the head of Middle Creek where she was raised. Any decent crow, even one that meanders slightly off course, can close this distance in eighteen to twenty minutes. Add a little stimulus to the equation—a red-tailed hawk to chase, for example, or maybe a load of number six lead shot to outmaneuver—and the crow will easily carve two or three minutes off the journey.

As the four-wheel-drive travels, it takes a little longer. Plan on at least sixty minutes for traversing the steep hills and twisting backroads. Plan on substantially more if the driver is either new to mountain navigation or lacks a sense of adventure.

As the foot walks, this is a half-day undertaking, at best. There's no need to approach it that way these days, of course, unless your car has broken down or you have a serious need for exercise. But rest assured it's been done. Many, many times.

"Lord, honey, walkin's all we had back in those days," says Hartong. "That's how everybody got around. Ten miles didn't mean much back then. You just lit out and kept walkin' till you got to wherever it was you were goin'."

Pay attention when Edna Hartong speaks about travel. She's an expert in this department. She has vast experience in matters of time and distance, particularly the amount needed to reach the old homeplace. It took her more than forty years and heaven only knows how many hundreds of thousands of miles to wind up right back where she started.

"I was fourteen when I left home," she says. "I had grandchildren by the time I got back."

Times were hard in the remote pockets of Tazewell County, Virginia, in those days. Then again, times were hard everywhere. The Great Depression held the nation by the throat, and money was as scarce as the proverbial hen's teeth.

But if the truth be known, things were a heck of a lot better out in the country, where farm folks could sink their own teeth into a hen just about any time the notion crossed their mind—or belly, as the case may be.

"I guess we were poor," says Hartong. "We sure didn't have much money, just whatever Poppy made down at the mines. But shoot, honey, who needed it? We raised everything we ate. We always had food. It was a wonderful time to be a kid. We were one big, happy family."

They still are. Twelve children were born to Jeff and Laura Smith. Eight of them are still alive today. They're spread out, for sure—all the way from Virginia, south to Florida, and west to Arizona and California. But they stay in touch, not only with each other but also with that eighty-two-acre plot of land.

"We've still got it," said Hartong. "Up until a couple of years ago, we used to all take turns payin' the taxes. Finally, we put our heads together and realized this couldn't go on forever, so we decided to sell some of the timber. We did it right, too. We got with the forestry people and select cut so it wouldn't hurt the looks. We took the money we got and put it in the bank. That way, the taxes can be paid from now on out, and all the grandchildren can still have a place to call their own."

Taking care of things comes naturally for folks who were brought up that way. Jeff and Laura Smith—"Poppy" and "Mommy," as Hartong still calls them—made sure that every one of their children could fend for his or her self.

"That's the way it was back in those days," she says. "You learned from your folks, the same way they learned from their folks. I remember back to hog-killin' time, when Poppy would cure the meat and Mommy would can the sausage. Years and years later, I was still cannin' sausage for my own family to take on camping trips. Once, we were way out in Idaho, and these people wanted to know where I'd bought sausage in a jar like that.

"'Bought it?' I asked 'em. 'I didn't buy it anywhere. I made it myself.'"

You can make just about anything for yourself if you put your mind to it. You can even make something *in* your mind.

"Poppy worked in the mines at night so he could farm during the day," she said. "That man could get by on just a few hours' sleep. He finally scraped a little money together and bought a Maytag washing machine and this huge Philco radio. They ran off of car batteries. We didn't have any electricity or runnin' water in the house. But once a week, we got to sit in front of that radio and watch *Amos 'n' Andy* and then watch Lowell Thomas give the news."

Wait a minute. "Watch" a radio program?

"Sure, honey," Hartong replies, her brown eyes dancing and her warm, ever-present smile beaming. "You sat right there in front of that radio and *watched* it. You could picture everything in your mind."

On and on Hartong talks about those wonderful days of her youth: the fall threshing parties, when neighbors gathered from miles around to help bring in each other's crops of corn and wheat; the horseback trips to the mill, trading off two sacks of corn and two sacks of wheat for one sack each of cornmeal and flour; the sweet-smelling, delicious-tasting orange that always could be found in the toe of a Christmas stocking; the single toy—a tiny doll for the girls, a small truck for the boys—that was handed out down at the union hall on Christmas Eve; the one-room schoolhouse, two ridges away, where Miss Ratliff taught ten grades "and was sweet on one of

my brothers"; the time two other brothers sneaked a few sips of Poppy's moonshine and covered their tracks by topping off the jug at the spring, leaving the poor 'shiner to get blessed out for selling a watered-down product; Saturday night baths, occasionally two kids at a time, in a metal tub filled with water heated on the wood-burning stove; the heavenly aroma of biscuits and cornbread, straight from the oven, piping hot and baked fresh daily.

"I can still remember the first time I drank a Coca-Cola and ate store-bought bread," she says. "I must have been, oh, maybe ten or twelve. My oldest sister, Reva, had a boyfriend, and he wanted to take her into town for the day. Mommy sent me along as a chaperone. He bought us lunch, and I swear it was the most gosh-awful stuff I ever put in my mouth! The Coke fizzed and went up my nose, and that store-bought bread tasted like dough. I didn't let on that I didn't like it, of course. But up till then, I didn't realize how good we had it on the farm!"

The good times were drawing to a close, however. Barely a teenager, Hartong quit school and went to Marion, Virginia, where Reva had taken a job in a sewing plant that made t-shirts and underwear for the army and navy.

"I lied about my age," she said. "I was only fourteen, but I told 'em I was sixteen. Mommy and Poppy weren't real happy about the situation, but they always knew I was a little bit of a renegade, and they let me go."

Nobody at the plant seemed overly concerned about little details like child labor, either, particularly in light of the fact that there were soldiers to clothe. The newly hired farm girl quickly proved her worth as an inspector. As Hartong remembers with pride, "I knew what was right and wrong about sewing. Mommy had taught me."

By the time World War II ended, Hartong was married and had an infant son, Earl.

"That marriage was a mistake," she said. "It only lasted a year. We separated, and I moved to Florida, where my sister Myrtle and brother Bob lived. I got a divorce down there. Earl's father had never contributed a dime to his upbringin', and I never asked for anythin'. When the judge gave me the divorce, he said I needed to get some money for child support. I told him I didn't need any. He said what if I get sick and couldn't work? I told him that wasn't goin' to happen."

Hartong threw herself into the task of making ends meet. She worked two jobs with needle and thread—one as a seamstress in a dry-cleaning shop, the other sewing liners for caskets. One day in 1954, a long-distance truck driver named Ralph Hartong came into the dry-cleaning shop and asked for his shirts. What he got was a bit more permanent. Within three weeks, he and Edna were married.

Talk about an unlikely couple. She a hillbilly gal from rural Virginia, he a city boy from Ohio. She of mountain drawl, he of Yankee twang. Statisticians would probably fall over themselves trying to estimate how quickly this match-up would crumble.

So much for statistics. Ralph and Edna Hartong are fast approaching their golden anniversary.

"Somethin' told me this was the man for me," Edna says. "I'd had such a bad first marriage, I really had a chip on my shoulder. But I just knew there was somethin' good about Ralph when I saw him. I didn't know it at the time, but he walked out of that shop and called his mama and told her he'd just met the woman he was going to marry. He's the best thing that happened to me. I couldn't ask for a better husband or father for my son. When Earl was sixteen, he went to court and had his last name changed to Hartong."

Edna glances to the nearby sofa where Ralph, now retired from hauling freight coast to coast, sits smiling, his arms folded. "Oh, Lord!" she laughs. "Now look. I've given him the big head for sure!"

For the next four decades, the Hartongs called nearly everywhere *but* Virginia home. They shifted between Florida and Arizona, depending on Ralph's driving schedule. They traveled throughout the Pacific Northwest on vacations and holidays. By the time Earl reached adulthood, he had academic transcripts scattered across the map. Indeed, in one seven-year period, he attended seven different schools. If all that shifting affected him scholastically, it doesn't show. Earl graduated from high school while the family lived in Arizona. After a tour of duty in the navy, he attended night school and now works as a design engineer. Earl and his two children live in Mesa, Arizona.

When Ralph left the roadways in 1988, he and Edna began looking for a place to enjoy retirement. Next thing they knew, they were back in old Virginny, just ten miles and ten thousand memories away from Edna's farm home from long ago.

The old house is gone, of course. The fields have reverted to forests. Mommy and Poppy have long since departed this world. But the lessons they taught their children live on.

Edna still sews many of her own clothes. She still cans fruit, jelly, vegetables, and meat. She still makes her own candy. She still makes the herb medicines that she and Ralph take faithfully every day, including powdered ginseng and goldenseal that she packs into glycerin tablets. She can still take just about any old scrap and turn it into something useful or decorative—like hats from plastic grocery bags, twisted and woven like fabric, or beautiful artificial flowers made from such offbeat materials as plastic spoons and six-pack beverage containers.

And she still makes an item that has all but disappeared from the American scene—lye soap.

This was a standard commodity in every household in the old days, a product with wide applica-

tion. As Mommy always preached to her children, "You may be poor and you might not have much, but you can always keep it clean."

Shaved into a scrub bucket or wash kettle, lye soap would clean floors and clothes alike. A bar or two could always be found next to the wash bowl to render grimy hands fit for the table at mealtime.

"To be honest, I hadn't seen soap made since Mommy would make it at hog-killin' time," says Hartong. "But then one day, a friend of ours got to askin' about it. He and his wife are raisin' their family the old-fashioned way. They grow their own food and pretty much make do all by themselves. I dug out Mommy's old recipes and started makin' it. It's easy, once you get the hang of it."

Despite its strong-sounding name and legendary reputation for removing hide along with the dirt, lye soap is remarkably smooth on the skin. It doesn't produce suds like commercial soap. It is void of perfume. There is a faint scent of fat, of course, since the main ingredient is hog lard, rendered into liquid.

How much lard? Depends on how much soap is needed. Edna Hartong can make a small batch or a large one. Give her a request and let her leaf momentarily through pages of old recipes and hand-printed instructions.

"Small batch is gonna take about six pounds, a large one about sixteen," she calls out. "You've got to go the butcher ahead of time and make sure he saves enough for you. That wasn't a problem at hog-killin' time."

Assuming a large yield is needed, Hartong adds four eight-ounce cans of lye to the lard in her cast-iron kettle, along with eight gallons of water—"rainwater or melted snow"—plus a sprinkle of powdered Borax to knock the foaming mixture down as it heats and help bind the ingredients together.

"You gotta keep it stirred the whole time it's

cooking," she instructed. "Keep stirrin' as it cools. Then pour it into any kind of shallow dish. A cake pan works fine. Let it cool overnight and then cut it into bars with a knife."

Edna picks up a piece of her lye soap, cradles it in the palm of one hand for a moment, and lets her mind wander aloud as she goes back across all those countless thousands of miles of highways to another place and time.

"This right here is a piece of pure country, honey," she remarks softly. "Just as country as it can be."

It just doesn't get any better than that.

The Long Journey Home

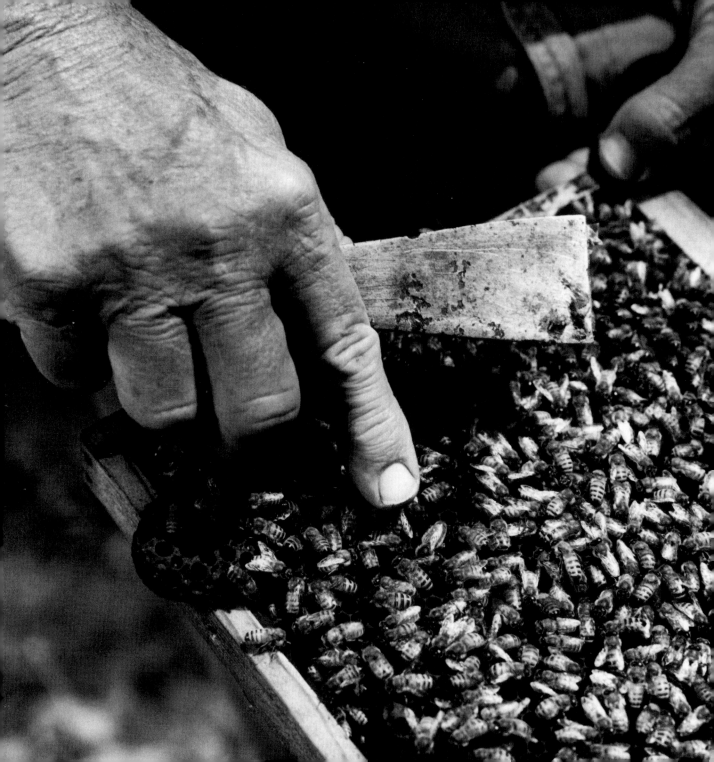

A Business That Really Buzzes

Michael Surles

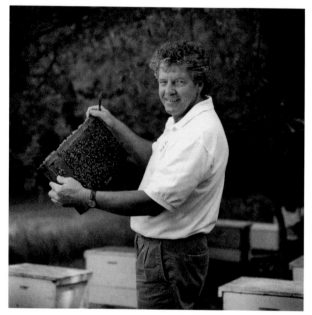

It is the middle of March in the north Georgia mountains, and there's a nip in the wind at dawn. Not the bone-rattling, eye-tearing numbness of February, to be sure. Rather, it's the sort of chill that prompts a brief shiver as you step out the front door—weak in comparison to a month ago, yet sufficient enough to send a message from Old Man Winter that he's still in control of the situation and will need a bit more prodding to relax his frosty grip upon the land.

Ha. Who's he trying to fool? Even the calendar agrees that spring is nigh.

For that matter, one need not even resort to man-made contrivances to tell that a season of change is at hand. Already, the hillsides are fringed with the red lace of maple blooms. Cupped, yellow heads of daffodils dance in the morning breeze. At the edge of the forest, a brilliantly colored male cardinal whistles the boundaries of his territory from the crest of a leafless poplar. Up in the hollow, an unseen ruffed grouse climbs atop a log and thumps his chest to relay the same assertive message.

And far below, way down in the meadow, Michael Surles's bees are starting to buzz.

"They're not in the business of making honey just yet," Surles explains as he gently removes the cover from one hive and inspects its contents. "Right now, they need to be making babies."

Surles estimates there are eight to ten thousand bees in this particular hive. He is making sugar water available to them to jump-start the rearing of new broods. By the peak of production in summer, this hive—and the five hundred or so others he has scattered throughout the Blairsville, Georgia, area—will be crawling with upward of fifty to sixty thousand inhabitants.

"It's an amazing process," he says. "I've been doing this for over twenty-five years, and it's still fascinating. There's truly a mystique to it."

Surles is a native Georgian, but not of the southern Appalachian variety. He was born and raised in Plains, down in the flatlands. There his claim to fame was serving as the teenaged newspaper carrier for the man who later would become the most famous peanut grower the region ever produced.

"Jimmy Carter and his family were farmers, like most everybody else," Surles recalled. "They lived back in the woods in a wood-frame house, built up on brick pillars."

Surles grew up on a small farm himself. His father raised quail for the restaurant industry. Surles graduated from high school in Plains, then headed for Athens and the University of Georgia. He received a degree in business in 1968.

Back then, beekeeping surely was the farthest vocational venture from Surles's mind. He yearned for the sea. To satisfy this craving, he moved to Florida and lived for several years on a thirty-one-foot sailboat in the harbor at West Palm Beach. Surles had the good fortune to make friends with a Danish boat builder, Chris Christianson, who taught him how to work with wood.

"I guess I'm just an old hippie," Surles says with a smile. "It didn't matter if my college studies were in business; I didn't want to plug into the corporate world. I liked working on boats. Boat building is so multidimensional. It's twisted and it's curved and it's beveled. Everything about it is sculpted."

Little did Surles know that the skills he was learning would pay dividends years later, many miles to the north, far removed from salt water. In 1972, he bade farewell to the sea and headed for the Georgia mountains, settling on one hundred acres in Union County. He had a plan for the future, hatched in part by his business training, part by his carefree life-style.

"I was going to grow organic vegetables," he said. "This was at the very beginning of the organic movement in this country. Folks were coming out of the fifties, with their red meat and two-martini diets, and starting to get health-conscious. I'd done some research and realized there was a good market for organically grown food in the Atlanta area. I came up here and planted squash, pumpkins, tomatoes, and corn. I can remember getting dizzy staking all those tomatoes. I'd stand up and the world would just start swirling."

The result of all this labor?

"I almost starved to death."

It took but one growing season for Surles to realize healthy intentions and healthy foods do not necessarily equate to a healthy bank account. Working by hand, he simply could not produce the volume necessary to sustain his fledgling enterprise. As he puts it, "You cut a head of lettuce one day, and it had better be delivered to a store the next. I realized I needed something with a little longer shelf life."

Goodbye, veggies. Hello, bees.

Surles had brought seven colonies of honey bees with him from Florida, but he was a rank novice at handling them.

"The first time out, I put on an old army field jacket and a hat and duct-taped my pants," he said. "I'd never even been around bees before."

He started reading, poring over any book or magazine he could find on the subject. He contacted a beekeeper in Florida "who really took me under his wing. He was an old fellow who was about to get out of the bee business. He really showed me a lot. I realized I needed to focus all my efforts on honey bees. For the first few years, I kept learning and building my hives. I didn't start selling honey until around 1976."

To put food on his table, Surles fell back on those woodworking lessons from the boatyard. He hired out to anyone and everyone who needed a general carpenter/fixer-upper. At the same time, he was building hundreds of beehives, an office, and his work station—"the honey house," in apiary parlance.

"I was real lucky," he said. "A friend of mine had an old chicken house on his property that he wanted torn down. I did it for him and got a lot of lumber to use on my own buildings. About the same time, lightning struck a huge, magnificent white pine that belonged to one of my neighbors, and he let me have it for the wood. I cut it down, carried it to the local sawmill, and had it cut into lumber. There's no telling how many thousands of board feet I got out of that one tree."

These days, the name Michael Surles can be found stamped on beehives throughout the highlands and hollows of north Georgia. In a typical year, he processes and sells around sixty thousand pounds of honey, plus two important by-products, pollen and beeswax. Most of his sales are to bakeries and health-food stores in Atlanta and Asheville, North Carolina. But he also does a substantial retail business at the shop beside his house, located—where else?—on Honey Farm Drive, approximately six miles northwest of Blairsville.

His old college business professors might blanche at the notion, but this is anything but a suit-and-tie, high-tech environment. If Surles happens to be around, visitors are invited in to sit beside the potbellied stove and share a few tales. If not, no problem. He leaves several cases of inventory on the front porch, along with a cash box and a jar full of wooden tasting sticks so customers can sample the goods.

"The honor system works fine," said Surles. "I bet I don't lose 1 percent a year. The prices are marked on every container, and the folks leave their money."

Even though Surles sells honey year-round, fall is his busiest time.

"There's something about the mountain mentality that makes people want to stock up for winter," he noted. "They still do a lot of canning and freezing around here. I'll have folks come in and buy three or four cases of honey at a time. Then I won't see them until the same time next year."

Autumn may be the busiest time for customers in the honey business, but it's during spring and summer that the bees themselves are working at peak efficiency. Surles likens the activity in a bee-hive to the function of a human body: every day, new cells are created to replace the ones that die and slough off. The hive is a bustling, well-organized environment, with each of the tens of thousands of residents carrying out an assigned task.

There's the queen, whose single-mindedness is geared strictly to egg laying. And the workers, all female, who clean the honeycomb or tend larvae inside the cells or haul droplets of water to help cool the interior or fan the chamber to keep the air circulating or guard the entrance to drive away intruders or bring in nectar and pollen from flowers. Plus the drones, all males, whose sole responsibility is fertilization.

"Not a bad life," Surles chuckled. "Then again, they pay for it. As soon as the weather turns cool and the hive starts to contract, the drones get the boot. They're sittin' out there on the front porch cryin', 'Oh, baby, please let me come back in!'"

Surles concentrates on two honey seasons. The first, an opening act for the main attraction, runs between April 20 and May 10, give or take a few days depending on the weather. Poplar and locust trees, as well as clover and blackberries, are in full bloom by then. Surles calls it the wildflower season and so names the honey.

"The bee's part of God's plan is to pollinate," he says. "As the worker bee moves about from flower to flower gathering nectar, pollen collects in the hair on her body. Some of it is transferred to other flowers, which produces a new seed. Some of it stays on the bee and is brought back to the hive.

"Right now is when the beekeeper needs to be a good manager. You want a lot of bees, but you want

them to stay contented. They don't like to be crowded. If you give them plenty of room, they'll produce a surplus of honey. That's the by-product you're after. If they get too crowded in the hive, the biggest part of them will swarm and leave to find a new home. If the beekeeper is present within a few hours of when that happens, he can start a new hive. If not, the bees may leave the area, and their production is lost. They might go to a hollow tree out in the woods, or maybe under the eave of someone's house. Some years are worse than others. I've lost as much as 20 percent production from swarming and as little as 5 percent."

By the first part of June, the early blooming plants will have completed their flower cycle. Surles begins gathering the surplus wildflower honey and preparing his bees for the bigger event in the southern Appalachian honey year. This is the moment apiarists and honey lovers await with great anticipation. It's the granddaddy of them all. The big show. The pinnacle. The best. The one, the only—sourwood season.

"Sourwood nectar makes the gourmet honey of these mountains," he said. "It's a very light, rich, creamy smooth, buttery type of honey that is unique to the Appalachians. You can just about always count on sourwoods to be in full bloom by the Fourth of July. Some years, the woods will simply be white with blooms."

And the workaholic bees take full advantage of the opportunity. They return to the hive with nectar stored in a special gland, the "honey stomach." The nectar is either transferred to house bees or else deposited directly into an empty cell within the honeycomb. Other bees add enzymes to the nectar, and it begins to evaporate into honey. When the moisture content reaches approximately 18 percent, the workers seal the cells with wax. As the days wear on, the process is repeated tens of thousands of times, creating what apiarists accurately describe as the "honey flow."

As quickly as the surplus honey begins to accumulate, Surles adds additional drawerlike trays or "supers" to the hives. For the next four weeks, he'll make continuous visits to his colonies to gather these supers and bring them to his honey house for extraction. Armed with a hand-held canister that emits smoke from smoldering pine needles, he calms the bees by shooting several puffs at the entrance of each hive.

"The smoke does a couple of things that allow you to rob the honey," he says. "Bees are very sensitive to pheromones, or scents. When a hive is invaded, the guard bees put off a warning scent to alert the others. Smoke masks that scent.

"Second, smoke tricks the bees. They don't realize they're in an artificial house. They think they're out in the woods and the woods are on fire. They start eating honey and getting ready to evacuate and don't worry about the invader."

He avoids stings—well, most of the time—by calculated, deliberate movement.

"The secret is to be slow and gentle with them. Sudden movements can scare the bees and cause them to attack. You certainly don't want to crush a bee if you can help it. It'll sting you and put out another type of alarm scent. You can't swat at it. Instead, you just puff a little more smoke to cover everything up."

Yes, he does get zapped from time to time. It's an occupational hazard. This might happen several days in a row, then not at all for weeks. Fate can play as big a role as anything. Says Surles, "Some bees are just badder than others. They're a lot like people. Sometimes you run into a fellow who's just lookin' for a fight."

Human response to bee stings varies widely. For those who are especially allergic, even one sting can prove fatal. In others, the toxicity seems to build up over time; indeed, more than one beekeeper has been forced to abandon the business because of re-

A
Business
That
Really
Buzzes

peated exposure to stings. Surles counts himself lucky that he has yet to suffer any adverse reaction—other than the occasional "ouch!"

Perhaps he should be thankful that he's not living a century ago, when movable-frame hives were perfected and professional beekeeping got its start in the United States. Although the preferred species in America today is the Italian honey bee, most early practitioners raised the German bee, a small, black, extremely aggressive critter.

"From what I've read," said Surles, "it could fly fast and sting faster."

After the bees have done their work, Surles's is just beginning. Back at the honey house, he will employ a vast array of stainless-steel equipment to separate the liquid honey from the honeycomb and prepare it for packaging.

"This is state-of-the-art stuff," Surles says, pointing toward the extraction room. "It's a far cry from the old days, when folks actually squeezed out their honey by hand."

This machinery works just like an assembly line. Saturated with sweet cargo, the honeycomb is placed at one end of the track. It moves between a pair of knives, which slit the cells open, spilling golden droplets of honey and beeswax, the latter sold in bulk to the cosmetics and crafts industries. The comb then moves to a centrifuge, which separates the rest of the honey by gravity force. The honey flows into large vats, where it sits long enough for more wax to rise to the top. Then it is pumped into hundred-gallon tanks from which it is drained into containers of various sizes—everything from five-gallon jugs to half-pint bottles.

The work doesn't end even after the blitz of July diminishes and the bulk of the year's honey production has been processed. This merely signals the start of a new round. Fall flowers like ragweed, goldenrod, and aster are about to bloom. These are not great honey flowers; instead, they yield an abundance of pollen. Surles captures some of the excess with pollen traps, crafted out of hardware cloth. These are positioned just inside the entrance to the hive. As the worker walks by, she comes in contact with the wire, rubbing off granules that fall into a drawer below. A couple of times each week, Surles empties the trays, cleans the pollen, freezes it, and packs it for sale in small boxes.

"Bee pollen is a great high-energy food," he says. "A lot athletes and weightlifters use it."

As the chill winds of November begin to blow, activity in each hive drops dramatically. Egg laying and brood rearing have long since ceased. The unlucky drones have been sent packing. The few thousand bees that will ultimately survive the winter gather in what Surles calls an "energy cluster ball" with their queen in the middle. Touching each other and moving just enough to generate life-sustaining heat, they will remain in this suspended state until the first warm days of spring start this age-old process once more.

"Such a simple, simple business," Surles sighs, shaking his head in awe. "Utterly fascinating, yet so very simple in concept."

So simple, in fact, that disaster can seemingly strike from out of the blue. A disease called foulbrood can turn the entire hive into a gooey, lifeless mass of dead bees. Apiarists have learned to keep it in check with spring and fall applications of antibiotics. A more recent, more serious threat has come in the form of a tiny parasite, the honey bee mite.

"When I started in this business, nobody'd ever heard of a bee mite," said Surles. He snapped his fingers sharply. "Happened just like that. They hit me in 1989. I lost 250 hives in one summer.

"Apparently they came from Africa. There's such a huge business in what's called 'migratory bees'— bees that are taken all over the country to pollinate agricultural crops—that the mites started spreading and went everywhere. About the best you can hope to do is keep them in control with a pest strip

A Business That Really Buzzes

that hangs in each hive. It looks kinda like old-time fly paper, but it's not sticky. It's impregnated with a chemical that kills the mites on the bees' bodies. These strips certainly have helped, but mites have hit everybody in this business. Real hard."

So-called killer bees, the super-aggressive insects from South America, don't cause him much worry, however.

"I understand there are some in Texas and California, but I don't think they'll make it this far north," Surles said. "Even if they do, I think they'll be so interbred, crossbred, and modified by the time they reach us, they won't cause much of a problem."

But what if he's wrong and the fateful day when beekeeping proves more costly and dangerous than it's worth ultimately comes?

Well, there's always boat building and organic farming. Or maybe the Carters can use another paperboy.

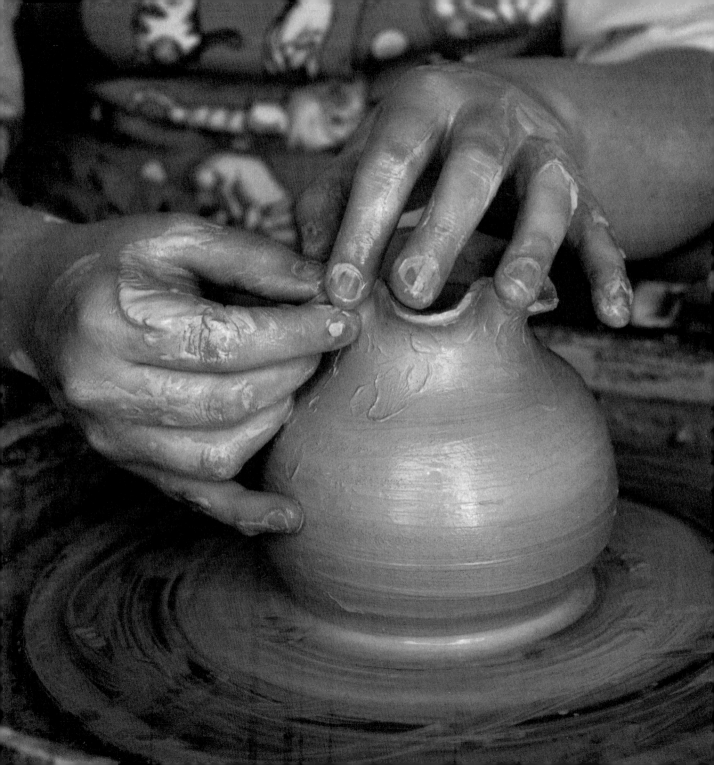

As Seen through a Potter's Hands

Debbie Van Cleave

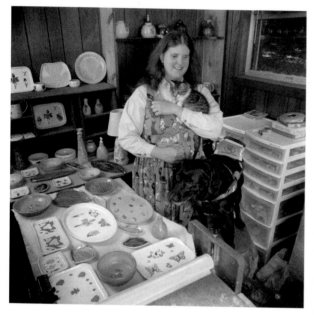

Plantain is a pesky weed that has plagued homeowners since the term "lawn care" became part of Americana. No matter how many times it is assaulted with hoes and herbicides, plantain invariably manages to take root among the manicured fescue. It's hard to find anyone with something remotely civil to say about plantain, let alone complimentary.

Perhaps that's because they don't see it through Debbie Van Cleave's eyes.

"Now, where is that spoon rest with the plantain design?" Van Cleave speaks to herself as her fingers explore stacks of pottery on a display shelf. "I know it's here somewhere."

Van Cleave picks up a piece and runs her fingertips along the delicate imprint inside. Nope, not plantain, she determines. Feels more like a fern. She sets the item aside and resumes her search. Finally, her fingers make the correct selection, and she holds it aloft.

Behold, plantain—like it's never been pictured on a can of weed killer.

This is no garden-variety pest, for sure. Instead, it has been transformed into a thing of beauty. An image of the ribs and veins of the elliptical leaf, darkened by a deep green glaze, stands out in fine detail along the length of the spoon rest. One almost hates to think it someday will be smeared with soup, chili, sauces, and other kitchen concoctions.

(Then again, what the heck. It's plantain. It'll survive.)

"My parents got the idea a few years ago during a dinner party at a friend's house," Van Cleave says, placing the utensil back onto its stack. "There was a magnolia leaf hanging on the wall by a piece of leather cord. They told me about it and I thought, Hmmm, I can do that with pottery."

She points across the room to her slab roller mounted on a table. "It's simple. All you have to do is lay a plantain leaf on a sheet of clay and run it through that roller to make the impression."

Truthfully, it's a little more complicated than that. Between the rolling stage and sale to a customer, the piece will have to be shaped, air-dried, bisque-fired, lightly sanded to remove any burrs or rough edges, washed, waxed along the bottom, immersed in a glazing solution, and then "hot-fired" at upward of 2,100 degrees Fahrenheit. Van Cleave will perform every step of the process by herself, using only her hands—and years of pottery experience—as her guide.

"I've never considered blindness as a handicap," she says. "I never will.

"Pottery is such a tactile art form in the first place. I'd have to feel my way through my work, even if I had twenty-twenty vision. Honestly, I don't need to see a piece to work with it. I just make sure all of my supplies are organized and laid out so I know exactly where everything is. Then I sit down and start working."

Of course, that approach doesn't apply to everyone.

"Once, a story about me ran on the wire service and was picked up by several newspapers around the country," she continued. "A potter from another state called me. He said he had blindfolded himself and tried to throw a pot. All he did was make a mess. I guess it's just what you get used to."

Born in 1973 in Kingsville, Texas, Van Cleave began showing signs of vision difficulties by the time she was two. Tests revealed a cancerous growth that eventually would turn her world black.

"I had some color and shape perception until I was about fourteen," she said. "Then it faded to nothing. But fortunately, I still know colors. I can still think in colors. My mother helps paint some of my pottery. Sometimes she'll ask me, 'What color do you think this piece should be?' I'll answer something like, 'Oh, maybe speckled blue-gray,' and she'll say, 'That's what I was thinking, too!'"

Van Cleave's father was an air traffic controller for the navy back then. The family moved frequently. She was mainstream-schooled in Florida, then later in Tennessee, where her parents moved to pursue graduate studies in psychology.

These days, Drs. Kent and Rebecca Van Cleave teach college-level psychology courses and share their home in Mascot, Tennessee, with Debbie and her six-year-old daughter Elizabeth, not to mention a roomful of computer equipment that includes a voice synthesizer and a Braille printer.

The Van Cleave house also is home to a variety of cats and dogs—two of whom currently, or have in the past, played very important roles in her life. There's Patton, a white-whiskered, ten-year-old German shepherd, and Quincy, a three-year-old black Labrador retriever. Both are highly trained guide dogs from an institute in Morristown, New Jersey, called the Seeing Eye.

"Patton is retired," says Debbie. "His own eyesight was beginning to fail, and I was able to get Quincy. These dogs have two totally different personalities, but they both have been wonderful for me. I couldn't get around so well without them.

"You've got to hear about what happened when I went to get Quincy," she exclaimed. "It's so unreal. For months, I had been talking online with a woman named Susan Meyer. She lives in Pullman, Washington. I logged on one night and happened to mention that she wouldn't hear from me for awhile because I had to make a trip.

"She wrote back and said, 'What a coincidence. I'm also going to be gone.' She asked where I was headed, and I said New Jersey.

"She wrote back, 'New Jersey! That's where I'm going. You're surely not going to Seeing Eye, are you?'

"Can you believe it! Neither of us knew the other was blind! We wound up getting a room next to each other and have been best friends ever since."

As a youngster, Debbie had considered studying English and launching a career in writing. But a chance visit to a pottery shop with her parents changed everything. It happened when the Van Cleaves

As Seen through a Potter's Hands

were at Jane "Buie" Boling's studio in Gatlinburg, Tennessee, to pick out a set of dinnerware. Even years later, Boling still remembers that day.

"Debbie was about eleven at the time. She could still see a little bit. She seemed fascinated by my pottery and the process of making it, so I had her sit down at my wheel and let her touch the clay. I could tell right then she was hooked."

Buie Boling became both friend and teacher. The timing couldn't have been better. Rebecca Van Cleave was working with the Great Smoky Mountains National Park during that period, so she often brought her daughter to Gatlinburg and dropped her off for the day at the pottery shop. The youngster began learning her craft, hands-on.

"Debbie is wonderful," says Boling. "If you treat her like a sighted person, she gets along just fine. I taught her quite a bit and really got her started. She even worked for me several summers. Then the distance got to be too great, and I knew she needed more instruction than I could give her."

With Boling's encouragement, the teenager enrolled in fine arts classes at the University of Tennessee and Pellissippi State Technical Community College to refine her skills. She eventually opened her own business called DebLynne Pottery (after her first and middle names), celebrating the fusion of tactile and visual arts.

"You need someone to show you the basics," says Van Cleave, "but after that, each potter has to develop his or her own style. The only way to keep learning and growing in your craft is to sit down at the wheel and keep practicing."

Which is why you will often find Van Cleave at the wheel in her garage, surrounded by mountains of clay in fifty-pound boxes.

"This is kinda like weightlifting," she noted, removing a block of brownish-gray clay from its plastic wrapper and slicing it into workable pieces with a length of wire. "It keeps you in shape."

Van Cleave selects a chunk of clay from the pile and begins slapping it sharply with open hands. Then she rolls it between her palms, over and over and over, until it is about the size and shape of a softball. She steps several feet to the left and sits down at her potter's wheel.

"The old-timers used a foot-operated treadle," she says. "They rocked it back and forth with one leg. I've tried it, but I can't use it. Electricity is a lot easier."

Van Cleave dampens the surface of the wheel and sets the clay ball in place. Controlling the revolutions with a foot-operated accelerator, she begins spinning the ball in her cupped, moistened hands to center its mass. The clay glistens as it rotates, slowly at first, then faster.

"If it gets off dead-center, I can tell," she says over the hum of the motor. "It starts feeling irregular."

Satisfied with the positioning, Van Cleave presses down with her thumbs. Instantly, a hollow forms in the spinning clay. Moving her fingers up and down forces the sides of the hollow to grow thinner and rise taller.

"Right now, it can be anything I want—a bowl, a mug, a cup, a vase, whatever," she announces.

A vase it will be. With the piece still spinning, she inserts a small stick and tweaks the lower wall. The bottom balloons outward almost immediately. By gentle constriction on the top part, a graceful neck is formed and trimmed.

This is not for people who can't stand getting their hands dirty. Nor for those who demand soft, silky smooth skin. During her busiest times, Van Cleave throws as much as 150 pounds of clay a day. Her hands take a beating from the wet, spinning material.

"Wintertime is the worst," she said. "Sometimes the back of my hands will actually crack and bleed if I don't keep a good quality skin lotion and Vitamin E oil on them."

The wheel continues to rotate as the artist forms

37

As Seen through a Potter's Hands

the vase to her liking. Suddenly, she barks, "Hey, you! Cut that out!"

Then she turns toward her surprised guest to explain: "Oh, I always talk to my pots as I make them. This one was starting to wobble on me. I had to get it back in line."

Properly chastised and satisfactorily shaped, the vase finally comes to a stop. Van Cleave pulls another length of fine wire across the bottom to separate it from the wheel. The clay is still quite soft at this point. The vase will have to be carefully supported as she transfers it to a shelf.

"I dropped one of these things once and thought it was ruined," she said. "It was all mashed in on one side. But as I felt it, I got to thinking what else I might turn it into. The notion of a frog struck me. I just opened the mouth up real wide, added some eyes and legs, and finished it. Ol' Froggy wound up winning a ribbon at the Mountain Makin's craft show at the Rose Center in Morristown, Tennessee."

There are no frogs in this batch, however. As soon as the vase dries long enough to eliminate surface tackiness, Van Cleave will mark it with any of thousands of rubber stamp designs in her inventory—everything from leaping fish to flying birds, trees, horses, airplanes, dogs, cats, seashells, or whatever else strikes her fancy. Then it must air-dry until all traces of moisture are gone. Otherwise, it would break during firing.

Two electric-powered, brick-lined metal kilns sit in the forward part of the garage. The vase Van Cleave has just made, along with other pieces in the same stage of development, will be baked to a rough "bisque" finish. Afterward, they must be sanded and washed and the imprints painted.

"No, I don't do the painting," she said. "My mother does quite a bit of it. Also, I hire art students when I can."

Glazing is next. Then a final firing. The glazing compound comes in a powder form and is mixed with other chemicals to hold it in suspension and allow it to be brushed.

"Basically, it's slime," Debbie laughed.

This will give the finished product its characteristic smooth feel and shiny look and also make it food safe. Some pieces won't require painting at all. Their color will be imparted by the glaze itself.

Not all of Van Cleave's work takes place at the potter's wheel. A number of items—like spoon rests, refrigerator magnets, serving trays, soap dishes, coasters, and other flatware—come from the slab roller.

"It's just like Grandma's old wringer washer," Van Cleave says as she hand-cranks a layer of clay through the rollers. "The pizza industry needs to get something like this."

Buie Boling, her old friend and mentor, sells some of Debbie's products through the shop in Gatlinburg. Van Cleave takes most of her inventory on the road, though, and visits a network of craft shows and festivals throughout the region. She also is developing a web site to promote her wares.

Van Cleave's busy schedule was interrupted in 1996–97 when her old nemesis returned. Cancer was discovered in her bladder and lymph nodes.

"I had to fight it for a year and a half," she recalled. "Chemo, major surgery, all kinds of fun stuff. But I've gotten a clean bill of health ever since. The doctors say I'm fine. So I'm going to keep right on working."

None of which surprises Buie Boling.

"Nothing's ever going to slow Debbie down," she said. "She's a fascinating person."

38

*As
Seen
through
a Potter's
Hands*

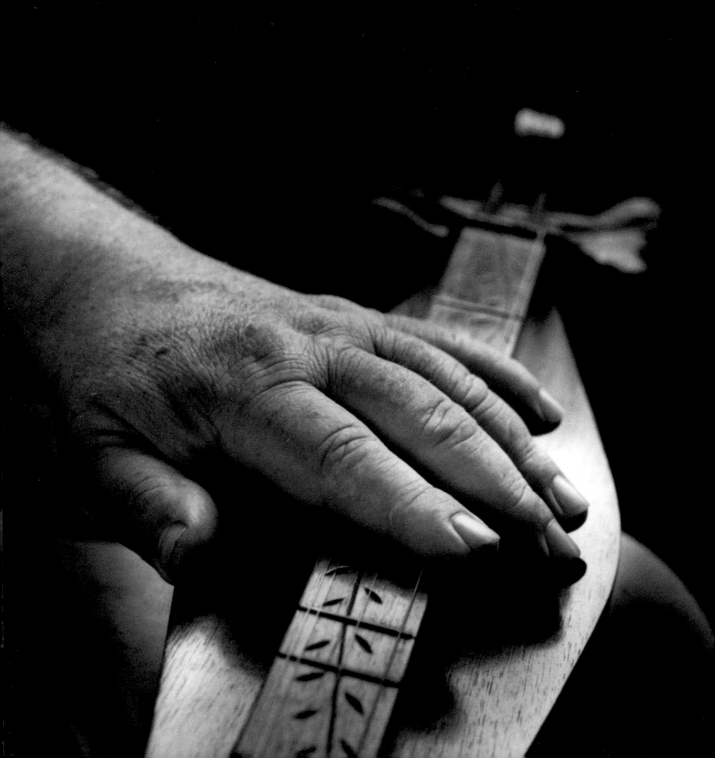

Washington Comes Calling

James Miracle

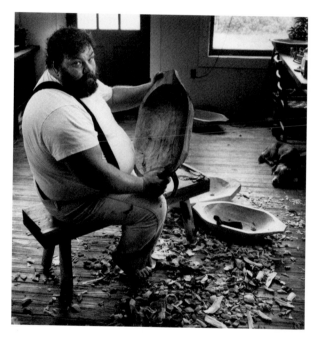

Opportunity doesn't always knock. Sometimes it limps in on a flat tire.

"I was off cuttin' pulpwood the day it happened," James Miracle remembers. "We had a little fruit market and service station back then. This man drove up, pullin' a trailer with a flat and askin' for somebody to fix it. Mom got the fox horn down from the wall and blew it to call me in out of the woods.

"While I was workin' on his tire, the man went inside the store and bought some baloney, cheese, and crackers for his lunch. He got to noticin' some of the things we had made—corn-husk dolls, footstools, wooden bowls, miniature chairs, stuff like that—and asked if it was for sale. We said sure.

"His bill for everything came to eighty-six dollars, and he wanted to write a check. To tell you the truth, we weren't real sure whether we oughta take it. You see, his address was Massachusetts, the check was from a bank in New York, the trailer had California plates, and his car was wearing Virginia tags."

Miracle stops the story long enough to stroke his curly beard and think what might have happened if the stranger had been turned down.

"Dad went ahead and took it. Soon as the fellow left, we figured we'd been had. But you know what? His check cleared the bank just fine."

The Miracles shouldn't have worried. Their visitor just happened to be a buyer for the gift shop at the Smithsonian Institution in Washington, D.C.

"A few nights later, about midnight, someone called from the Smithsonian," Miracle continued. "Dad thought it was a crank call. He hung up. The next day, they called back and finally convinced him it was for real. They were callin' to invite us to Washington for the first American Folklife Festival. That was in 1967. We started makin' some stuff to take up there, and we've been behind ever since."

James Miracle was born in 1947 in the rugged

mountains of Bell County, Kentucky, a make-do part of the country where many folks still scratch a living from the forest or the coal mines. During his formative years, there were no such things as "antiques." Instead, they were called "tools."

"There were eight of us—Mom and Dad, three girls, and three boys—and I reckon everybody grew up makin' things," he says. "We were poor. When we needed somethin', we either did it ourselves or did without. Mom made all our clothes except for underwear and socks.

"Once, my brother wanted a baseball. Mom had saved a bunch of string from flour bags. She wound that string into a ball, cut a piece of leather from one of Dad's old boots, wet it, stitched it over the string, and then painted it with white shoe polish. You couldn't tell it from a baseball off a store shelf.

"I reckon we were the first kids in our school to have homemade potato chips, too," he said with a grin. "Mom took one of Dad's old planes and used it to shave thin strips off some small potatoes. She dropped 'em in hot oil and they cooked up fine. She even took pieces of waxed paper and ironed the edges together to make a bag.

"That's the way things were. You learned from your parents and grandparents. Mom and Dad showed us how to build our own houses, fix our own cars, and do our own electrical and plumbing work. By the time I was seven, I had already made my first hammer handle and woven my first chair seat.

"Necessity is an awfully good teacher, too. So far, I haven't run into anything I can't do. I remember once, I had this '63 Chevy station wagon. A piece in the carburetor called the idle vent valve went bad. There was this little plastic doohickey on the bottom that had broken. I took it down to an auto-parts store for a replacement, but they said they couldn't replace something that small. They said I'd need to buy a whole new carburetor. I came back

home and took the carburetor apart and found that plastic piece. Then I got me a walnut knot and whittled out a replacement. Threaded it, drilled a hole in it and everything. I wound up drivin' that car another twenty thousand miles, thanks to a little piece of wood."

Some things have changed since the early days. Miracle's father, Homer, died in 1980. Except for one sister, Janice, who works as a ranger at nearby Cumberland Gap National Historical Park, the rest of the family has scattered across the map. Yet the same can-do spirit continues in the small wood-frame building alongside U.S. Highway 25-E between Middlesboro and Pineville that serves as both a workshop and home for James and his eighty-two-year-old mother, Hazel.

"Mom's bedroom is in the back," he quipped. "I share a room with the washer and dryer."

Theirs may be a slow pace, compared with the rat race of urban life, but rest assured all hands stay busy. Every morning, after she reads her Bible, Hazel Miracle begins hand-stitching dresses for hickory-nut dolls, or making and dyeing delicate wooden flowers, or whittling bears, hogs, and dogs out of blocks of basswood. Across the room, her son might be weaving strips of hickory bark into a chair bottom, or chopping bread-dough bowls from poplar logs, or fashioning tool handles on his homemade shaving horse, or carving miniature chairs, or making furniture, toys, and dulcimers.

"If it has to do with wood, I can handle it," he says matter-of-factly.

Even if he's never seen a set of plans or received a formal lesson in woodworking.

"My great-grandfather, Dempsey Miracle—they called him 'Uncle Demps'—made dulcimers. He died in 1929, so there wasn't anyone around to teach me. One day, oh, it was around 1970, a woman came by the shop carryin' one of his old dulcimers. I looked it

over real close and stuck my little finger through the sound hole to feel how it was made underneath the fret board. That's how I got started makin' dulcimers."

He never stopped.

Nor can he. At last count, 2,789 dulcimers have come from Miracle's hands. There's a two-year waiting list of back orders.

"I used to keep one in the shop for display," he says. "It belonged to Mom, and it wasn't for sale. One day some Japanese folks were in here, visitin' with a lumberman from this area. One of them wanted to buy that dulcimer. Gosh, I couldn't sell my mom's own dulcimer. The lumberman was a friend of ours, Mister Asher. He had helped us so much in the past. He asked us to sell it to them. So Mom said, 'Sell it!' I usually get $210 for a dulcimer, but he came back in carryin' five hundred-dollar bills. Later, I learned that dulcimer ended up in a museum in Tokyo next to an instrument that's over five thousand years old. That made me feel pretty good."

Truthfully, the number 2,789 is off a wee bit. That's because the very first dulcimer Miracle made turned out to be his fourth.

"I made it to give my brother for Christmas," he recalled. "It was almost done, and I'd hid it out in the woodworkin' shop. My brother walked in one day and slung a two-by-four over on a pile of lumber. Busted that dulcimer all to pieces. So I started over. When I about had the second one finished, I stuck it under the workbench. Dang if he didn't come in a few days later and open a tool chest and drop the lid and bust that one, too!

"He got married a couple of months later, so I figured I was safe. I got the thing completely put together and had hung it out on the front porch so the finish could dry. I was workin' on an old car out in the front yard. Mom happened to walk by just then. She stepped on a piece of the old fuel line, and it flew up and hit her on the leg. She started to throw it in an old hole we were fillin', but when she hauled off to let go, it struck the rail fence, bounced off, and ran through that dulcimer like an arrow.

"On the fourth try, I finally made it. Mom told me that was enough to discourage anybody from ever makin' another dulcimer, but I've never had another accident with one ever since."

Although the hammered dulcimer dates to around 3000 B.C., the plucked, or mountain, dulcimer is an American original. It's as much a part of the authentic southern Appalachian experience as stack cake, barn raisings, bib overalls, and moonshine whiskey. Most musical historians trace its origin back to the 1800s, when Scots-Irish immigrants fashioned a stringed instrument on which to replicate tunes from the ballads of their native lands. Its lilting chords are created when the strings are either plucked or strummed (often with a quill) with one hand, while the pitch is controlled with the other hand (or a small stick) moving up and down the fret board.

Just don't ask Miracle to do it.

"Some people make music, and some people listen to music," he says. "I'm a listener. As many thousand dulcimers as I've made, I can't play a lick on one. It's hard for my hands and my head to keep up with each other. My sister is an expert, though. She puts on dulcimer demonstrations over at the national park."

It doesn't get any more homemade than this. With the exception of the metal frets, the wire strings, the glue, and the gunstock finish he rubs in to accent the grain of the wood, everything in a James Miracle dulcimer is created by his hands.

Repeat: e-v-e-r-y-thing.

He fells the tree. He splits the logs. He dries the wood. He saws the boards. He carves the decorative leaf or wheat pattern. He hollows the fret board. He cuts the cross-bracing. He makes the end block. He

Washington Comes Calling

dovetails the peg head. He whittles the tuning pegs. All these pieces come together on an hourglass frame of Miracle's own design and creation, naturally, and they're all bound together during construction by clamps he made himself.

Somewhere in dulcimer heaven, Uncle Demps is surely smiling.

"I can make a dulcimer out of just about any wood a customer wants," Miracle says. "I've used walnut, Osage orange, cherry, and maple, but I believe the best sound comes from cherry. I cut everything either off the hillside behind my place or over at my neighbor's. He's got eleven hundred acres and has given me permission to get whatever I need."

Then again, providence has been known to supply. An admitted scavenger, Miracle is quick to take advantage of a freebie. The van outside his shop sits on a slab of concrete that fell off a tractor-trailer rig hauling sections of retaining wall. His shaving horse was hewn from a huge timber that drifted downstream one day when he was helping a crew from the U.S. Geological Survey take water samples in a nearby creek.

"I've even got a paddle that I found beside the highway," he chuckled. "I reckon it blew out of somebody's truck. Gonna keep it, too. If I hold out long enough, maybe someday a canoe will blow out."

He can wait, for sure. If patience is a virtue, Miracle is amply blessed. Hanging over the fireplace in his shop, for instance, is an old muzzle-loading rifle. A customer brought it in one day and left it for repairs. Miracle inspected the piece, jotted down an estimate, and sent the man a letter. A reply was never forthcoming, but James isn't overly concerned.

"It's only been thirty years," he pointed out.

Don't look for a James Miracle advertisement in some trendy home-furnishings magazine. Or a crafts catalog. Or, perish the thought, on the Internet. His business is strictly word-of-mouth, sometimes from exceptionally high places.

In 1989, First Lady Barbara Bush delivered the commencement address at a nearby college. For her honorarium, the trustees commissioned Miracle to build a maple rocking chair with a hickory-bark back and seat. He made it start to finish and presented it to Mrs. Bush with photographs documenting the chair's creation from forest to finished product.

The First Lady was ecstatic. Not only did she send a handwritten note—"I can't wait to show George!"—she elected to keep it when her husband left office. You can check Miracle's scrapbook for proof. In a yellowed newspaper clipping describing the president's financial disclosure, one sentence reads, "The Bushes also kept a $210 handmade rocking chair from James Miracle, Middlesboro, Ky."

Still, Miracle would just as soon the limelight shone elsewhere.

"We used to have a sign out front that said 'Miracle's Mountain Crafts,' but we had to take it down. Couldn't hardly get any work done for all the tour buses that would stop. I love to go to craft shows and do demonstrations and meet people, especially the kids, but it keeps me fallin' more and more behind in my work."

Built along the lines of a giant teddy bear, totally devoid of pretense, and gifted with a repertoire of backwoods stories, Miracle is a crowd-pleaser wherever he travels. He usually carries hand tools and several large blocks of poplar. Within fifteen minutes, he can cover the ground with mountains of fragrant chips as a bowl begins to take shape. It doesn't take long for an audience to form and start chuckling at his patter.

"People named 'Miracle' pronounce it different ways," he says. "Up in Bell County, Kentucky, it's

'markle.' Down in Knoxville, it's 'miracle.' But if a Miracle moves way up north and makes it big, he becomes 'mir-*rock*-ley.'"

Then Miracle holds up his right hand. The first two joints are missing from the middle finger.

"Caught this thing in a piece of machinery when I was twenty-two years old," he says, "but when I'm workin' at crafts shows, someone will invariably come up and ask if I did it with an ax.

"I tell 'em, 'Naaaw. My girlfriend bit it off.'

"If they ask me why I didn't get it sewed back on, I say, 'She swallered it.'"

45

Washington Comes Calling

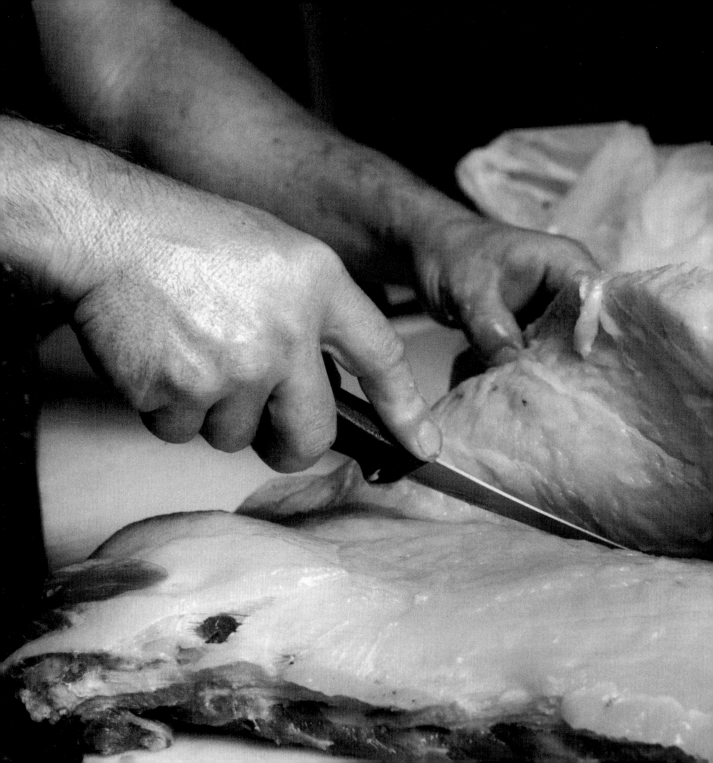

Meat on the Table

Leamon Perkins

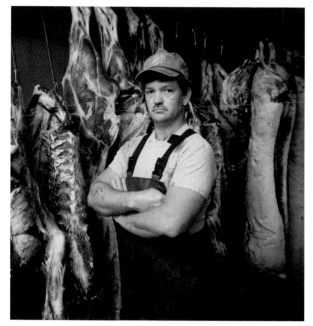

Molly, a 260-pound Vietnamese potbellied pig, leads a blissful existence around the Leamon Perkins place near Pine Knot, Kentucky.

She isn't confined to a pen. She dines daily on an ample ration of high-protein corn. There's always a patch of shade for her to cool off in, as well as a handy mudhole or two for casual wallowing if the mood should strike. The Perkins farm even comes equipped with a resident pair of boys—eleven-year-old Billy and seven-year-old Bruce—to play with this pampered porker and scratch her bulbous belly.

But be not fooled by storybook appearances. Working farms are the epitome of practicality. Molly's life-style notwithstanding, she is, was, and forever shall be a pig. Thus she is always one step—or misstep, as the case may be—from becoming the featured attraction at breakfast.

"If she ever broke a leg," Perkins shrugs matter-of-factly, "we'd eat her."

This is not an idle threat. It is a promise of stark reality with no hint of cruelty, intended or implied. Rather, it is a decision of life and death that Leamon Perkins understands quite well. He's the person who puts meat on the table for hundreds of families in and around McCreary County, Kentucky.

"From the time I was eight years old," he says, "I knew I would run my own slaughter house some day."

Perkins grew up in this business. His father, Willard Perkins, ran a custom slaughtering operation when Leamon was a child. At an age when many boys are still into tricycles, Leamon was tinkering around the tools of the trade. Again, it was a matter of practicality.

"There weren't many baby sitters out here in the country," he said. "When I was a young'in, I'd go to work with Daddy, summer or winter. By the time I was eight years old, I was in charge of splittin' kindling

for the lard-renderin' vat. By the time I was out of high school, I was cuttin' meat for a living."

More than ten years would pass before he took the leap into business for himself, however. Shortly after graduation from McCreary Central High School, Leamon married Lisa Taylor. The notion of a forty-hour-per-week job with benefits appealed to him, so he hired on with a grocery store in nearby Oneida, Tennessee, working his way up from stock clerk to the meat department. All along, he continued to dabble in the meat-packing trade by custom butchering hogs and cattle and processing a few deer for friends and neighbors.

"Then one day, it dawned on me and Lisa that workin' forty hours a week at the store was gettin' nowhere fast," he recalls. "I knew this fellow who had a small meat business set up in an old cold storage semitruck trailer. He offered to sell me everything—his cutting room, tools, grinders, and freezers—for two thousand dollars. I told him I'd be there in five minutes with the money.

"We hauled everything in here the next day. I'll never forget it. It was sleetin' and rainin', and just as the truck that was haulin' it pulled in, the trailer shifted. The whole thing toppled over. I was sick. I'd sunk everythin' I had into that stuff, and I thought it was gone. But I was lucky. It didn't tear up much. We got in there and worked to get it set back up."

That was in 1993. Both Perkins's facility and his list of customers have grown steadily ever since. These days, he runs a full-service slaughtering and meat-cutting business, processing hogs, cattle, sheep, goats, and other farm animals, as well as deer brought in by hunters.

It tends to be a seasonal occupation with frequent stops and starts.

"The slaughterin' business will kill a man two ways," he quipped. "It'll starve you to death in the summer and work you death in the winter."

Before the development of refrigeration and refinement of food-preservation techniques, farm animals raised for human consumption were always slaughtered during cold weather. While "hog-killin' time" is often used in mountain language to describe frosty fall conditions, there remains an element of truth to the phrase. As always, it is a matter of practicality—and, in this case, palatability.

"Raisin' animals for food is just like growin' a garden," Perkins explained. "You can plow up a parking lot and grow 'taters, but they aren't gonna be big, and they're not gonna taste very good. You need some decent soil and fertilizer to grow a good crop. Same thing with meat. You can take a cow right off the pasture in summer and bring her to me. I can kill her and cut her up and you can eat the meat. It just won't taste very good.

"But you take that same cow and let her eat grass all summer. The grass is free, and she'll put on a couple hundred pounds. Once there's no more free feed, you put her in a barn, and feed her corn, and she'll turn into a pretty fair piece of meat. That's why my work really slows down in the summer, then gets to hoppin' in the fall and winter.

"In the summer, I'll process a few head of hogs and cattle, but I also cut hay or do a little carpentry work or whatever else I need to do to pay the bills. Then from September through January, I'm goin' at it eighteen to twenty hours a day, seven days a week. It's the equivalent of two full-time jobs."

Even the type of animals being brought in for processing is subject to change.

"A lot depends on how the livestock market is doin'," he said. "People are gonna eat whatever is cheapest. If pork is cheap, they eat hogs. If beef is cheap, they eat cattle. If nothin's cheap, they eat vegetables. That's when it gets tight on the home front!"

For consumers whose meat selection options are limited to the confines of a grocery store, the term "custom" butchering may seem foreign. Yet that is the very service an independent operator like

48

Meat on the Table

Perkins can provide. Before the process begins, a number of questions must be asked of the owner.

For example, should a hog be skinned or scalded and scraped?

"If they want it cut into pork chops and ham steaks for the freezer, the hog can be skinned," Perkins said. "But if they want to smoke the hams, the skin has to stay on to hold in the moisture. If you tried to salt-cure a ham that'd been skinned, too much salt would absorb into the meat. You couldn't stand to eat it."

Another point Perkins always discusses with the customer is the change an animal's weight as the process evolves. Upon arrival, each animal is led across a set of certified digital scales and its live weight recorded. From there, Perkins can give the customer a close estimate of the carcass weight (after it has been eviscerated and skinned), and a yield weight of actual table meat.

"If you bring in an 800-pound Charlois steer, that doesn't mean you're going to get 800 pounds of beef—unless you eat hair and all," he pointed out. "The average beef will lose about 50 percent from live weight to carcass weight, so that steer now weighs around 400 pounds. Let's say you want it all ground up into hamburger. Does this mean you'll get 400 pounds?

"Nope—not unless you eat bones. The skeleton itself will weigh, oh, around 160 to 175 pounds. That means you're gonna take home about 225 pounds of pure meat. It's a simple matter of mathematics, but unless you take the time to go over it at the beginning, some folks get it in their head that you've shorted 'em. There's nothin' that irritates a custom butcher more than hearin' somebody say that."

On this particular day, a farmer has brought a young steer to be butchered. He has returned, he tells Perkins, "because you done a couple hogs for us, and my wife shore did like how you done 'em." He and Perkins ascertain its weight—585 pounds—

and Perkins checks off his list as the farmer indicates what cuts he'd like for the freezer: round steak, cube steak, sirloin, T-bone, rib steak, chuck steak, pot roast, chuck roast, beef short ribs, sirloin tip roast, liver, and hamburgers, four to a package.

"Oh, and I'd like to have the tongue, too," he says.

No problem, Perkins replies, making the notation in his spiral notebook. Everything will be ready in ten to twelve days. He'll give a holler when to return. And the deal is sealed.

This steer will remain in a holding pen for the moment, for Perkins has already contracted to slaughter three hogs for another customer. The first is brought onto what's referred to in the trade as the "kill floor," a twelve-by-eighteen-foot room with a concrete floor and cinder block walls. Perkins designed and built the enclosure himself, making sure that knives, sinks, hoists, hoses, drains, and vats all were within easy reach of one another.

He dispatches the hog with a .22-caliber rifle round between the eyes and slits its throat as it lays unconscious on the floor.

Quickly and methodically, Perkins practices the time-honed skills of his trade. In less than fifteen minutes, the hog has been skinned, gutted, beheaded, and sawed down the backbone into halves. Dangling from large S-hooks attached to an overhead rail, both pieces are then weighed, tagged, and moved into a walk-in cooler. Here the meat will age for three days at a temperature just above freezing. It will be reduced to the various loin, chop, and shoulder cuts the customer has requested, then wrapped, labeled, and quick-frozen for pickup.

The immediate job is far from over, however. Two more hogs need to be processed. Then the room and all tools must be hosed down and sanitized. The entrails must be removed to a separate cooler, where they are stored until the truck from a by-products company makes its rounds.

Every part of every animal will ultimately be

Meat on the Table

used. Cow hides are salted and sold to a tannery. As the entrails are cooked down at the by-products plant, waxy material will be condensed out of the steam and used in cosmetics production. Meat in the bottom of the cooker winds up as dog food. The bones will be ground into fertilizer.

Occasionally, natural recycling occurs closer to home, just as it did when native Americans roamed the land.

"Fellow came up here once during deer season and asked if he could pull the leaders (tendons) out of some deer's feet," Perkins said. "I told him sure, but I was curious what he wanted 'em for. Turned out he was making a wooden bow to hunt with. He pounded out those leaders and wrapped 'em around the limbs for extra strength. It made a real nice bow."

When November rolls around, Perkins quits accepting farm animals. For that month, he concentrates solely on deer.

"I figure the farmers have eleven months and the hunters have one," is the way he puts it. "I process a lot of deer in any given year, but it always depends on the weather. If it happens to be a cool fall, some hunters will take care of their own deer. If it turns hot, they'll bring 'em to me."

The November hours also are grueling—9:00 A.M. until 9:00 P.M., seven days a week. But before the doors open, and long after they close, Perkins spends several more hours daily doing paperwork, cutting meat, and performing other chores "with no interruptions; I don't even answer the phone before nine in the mornin' or after nine at night."

In a typical season, approximately seven hundred whitetails bagged by hunters in his area will move through the skinning and cutting rooms. This is a time when all hands are called upon. Pearlie Chitwood is a regular employee during Perkins's busiest periods. In deer season, he also hires "anybody who's breathin' and wants to work." Even members of the family get drafted.

"My wife is a mighty good skinner," says Perkins. "Once, Lisa skinned sixty-eight deer in a single day. I stay busy with 'em too, but I've also got to do a little bit of PR work with the hunters. You know how it is; *every* deer that comes through the door is the prettiest and biggest one in the woods. I used to hunt deer myself, but I haven't in years. I reckon if you owned a ski resort, you'd give up skiing."

His strangest butchering job, however, came wrapped in feathers instead of fur.

"A fellow brought me this ostrich one time," he related. "I'll tell you right now, I'd rather skin a whole poke of possums with a dull butter knife as skin another one of those things. There's no meat on the breast. It's just on the legs and thighs, and it's the nastiest stuff I ever saw. It's so brown, it's almost black. I never did eat any ostrich meat, but I reckon it must be like escargot—the nastier it looks, the better it's supposed to taste. I reckon that's why they call it 'gourmet.'"

Come to think of it, there is one other animal he'd just as soon not see the likes of again. Perkins is a stout fellow, with thick biceps that hang off his shoulders like a pair of country hams. But even his strength was no match for a large black steer that broke his nose and bruised his ribs.

"Charlie Sexton brought him in late one night during the winter. I put him in a stall in a small barn I had at the time. He kicked that stall down, busted through a solid oak wall, ran over me, and took off into the pasture. The next day, I drove up there with a high-powered rifle and shot him. That's the only animal I ever really *enjoyed* butchering."

Given his years of experience, Perkins tends to be quite selective with the food that goes on his own family's table. He raises his own livestock and rotates the inventory in his freezer on a regular basis. Even though many consumers believe frozen meat will remain tasty indefinitely, he recommends a maximum storage of three months for pork, six

for beef. Get it to the grill, the oven, or the frying pan by then.

"In all this time, I've only had one return," he said. "It was a beef I had raised myself. I sold it to these two sisters. I butchered it for them, and they split up the meat. One sister said hers was fine. The other'n said hers was tough. I refunded her money, but it got me mighty curious because that meat sure looked good when it left my place. I thawed some of it out, fixed it up, and ate it. Why, there was nothin' wrong with that beef at all. It had excellent flavor. Tender as could be.

"You know what? I don't think that second sister knew how to cook!"

*Meat
on the
Table*

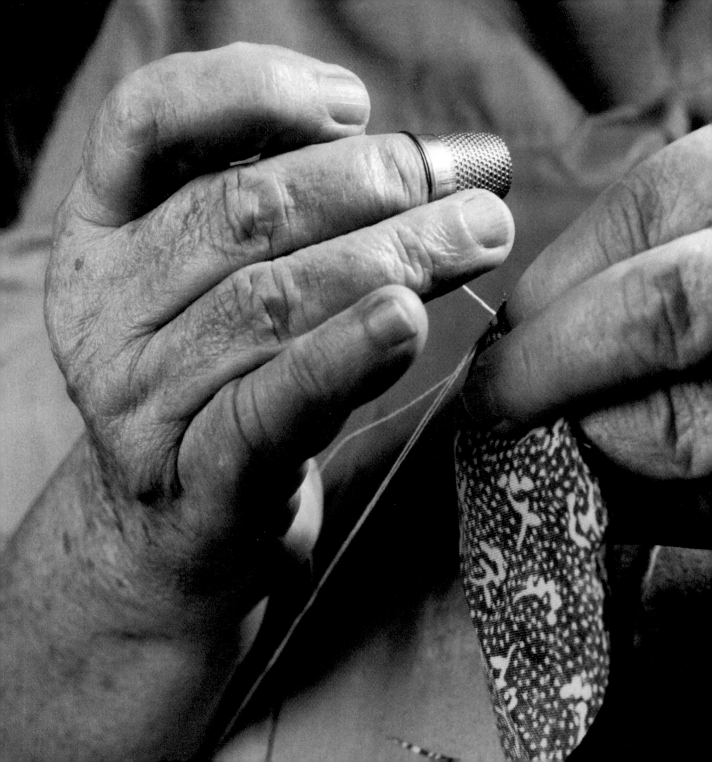

A Stitch in Time

Hazel Pendley

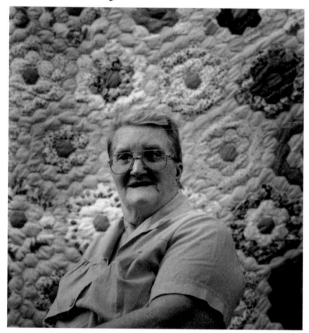

Spectators at the craft show moved to a table of quilts and picked up Hazel Pendley's entry. Carefully, closely, they inspected the all-but-invisible appliqué stitching, the precision running stitches of the piecing, the exact placement of the squares, the decorative quilting stitches on top.

Impressive.

Very impressive.

Too impressive, in fact.

Ought to be disqualified, they sniffed not-so-quietly among themselves. Surely this quilt was machine-made.

Cecelia Erhardt went ballistic at the very mention of such sacrilege about her friend's handiwork.

"Machine-made?" she exclaimed in disbelief. "Absolutely not! There's nothing machine-made about any of Hazel's quilts! She does everything by hand except weave and dye the fabric, and I'm not so sure she couldn't learn to do that!"

Erhardt was determined to set the record straight about Pendley's entry, even if it meant her quilt would beat everything else in competition—Erhardt's included.

Which, of course, it did. Hazel Pendley not only won the blue ribbon that day, she also gathered another set of admirers of her incredible skills with needle and thread. Machine-made, indeed! Hummph!

"I've taught over twenty people to quilt," says Erhardt, "but Hazel is the golden star of them all."

"Taught." What an interesting choice of word. With all due respect to Cecelia Erhardt's instructional bent, one might submit Hazel Pendley was no more "taught" how to quilt than Joe Montana or John Elway were "taught" how to wring the final few seconds out of a football game by engineering a victorious touchdown drive. In either case, the instructor or coach more likely served a facilitator, helping natural talents rise to the surface. Without

a bounty of raw, determined, God-given abilities at his or her disposal, all the teaching in the world would amount to naught.

"Hazel has found her niche," says Erhardt, her dearest friend for nearly twenty years. "She is by far the best quilter around here. She is gifted with a sense of geometry and a natural feel for color and fabric selection. Her eye-hand coordination is excellent. She was a born quilter. It's just that all those years she spent in the woods, she didn't know it."

Astonishing as it may seem, the same hands that now control a number seven quilting needle with pinpoint precision once were assigned to a double-bit ax and a crosscut saw. Fact of the matter is, these hands were fifty-five years old before they ever guided the first strand of thread through a piece of muslin.

"I grew up nothin' but a tomboy," says Pendley. "I could stay right along side the men a'workin' in the woods any day. Why, I had the awfulest set of muscles in my arms there ever was!"

This unusual set of circumstances didn't happen by choice. Instead, it was a matter of necessity. A matter of staying alive.

Pendley was born on the head of Beaver Creek, in Mitchell County, North Carolina, shortly before the onslaught of the Great Depression. Her only other sibling was a brother, Dillard Lee Pendley, who died from whooping cough at the age of nineteen months. She was raised by her mother, Ella Mae Grindstaff, and grandparents, Benjamin and Lizzie Pendley.

"It was hard a'growin' up," she says. "They was the good ol' days, for sure, but it was tough times, too. We didn't have no money. My grandpaw farmed, but just enough for what we needed, never to sell. We never did want for food, but we never did eat fancy. Mainly 'taters and beans, roastin' ears, ramps, some pork and chickens, eggs, milk, and butter.

"We lived in an old board house that didn't have no insulation. No electricity or runnin' water, either. I had to haul water up from the spring. They was big cracks in the front door. Why, many's the time I'd get up of a mornin' and rake snow away so we could build a far and get warm."

Most of the year, Pendley worked barefoot in the woodlands near her home. In winter, she wrapped her feet in paper and burlap bags—"tow sacks"—to ward off frostbite. She never owned a pair of shoes until shortly after she took a Works Project Administration job in Spruce Pine.

The schoolhouse beckoned down a steep, rutted wagon road, three miles in the distance. It might as well have been thirty, for there was too much work to be done around home. Besides, Mae Grindstaff didn't want her only child traveling off that far. As a result, Pendley entered adulthood with virtually no formal education. She can barely write her name even now. She still does not read.

"I've tried to learn it," she says. "They gave some adult classes and I went for awhile, but one thing or another would come up and I'd have to drop out. I believe readin's the hardest thing I ever tried in this world."

As a teenager, Pendley did make regular trips to town. Every Saturday morning, she'd walk into Spruce Pine, carrying bundles of galax leaves to sell. A low-growing evergreen of the *Diapensia* family, galax flourishes in the mountains of southern Appalachia. Then and now, florists use these greenish-bronze leaves in a variety of arrangements, most often as background in funeral sprays.

"I'd pull the leaves in the daytime and then sit up of a'evenin' wrappin' 'em into bunches," she recalled. "You had to grade 'em out by size, sorta like tobacco. You'd put twenty-five in a bunch and tie 'em off. Forty bunches would make a thousand. Some Saturdays, I'd bring seven or eight thousand into town."

For the handsome price of forty cents per thousand.

"Yeah, about three or four dollars was all I'd get for the whole load," she responded to the question of an incredulous interviewer. "But that was a lot of money in them days. You could buy as much groceries with three or four dollars then as you can buy with fifty dollars today."

Best of all, the galax payments were made in cash. Real, honest spending money that could be folded or jingled in the pocket. When Pendley and her family sold timber, they usually were paid in script from a local grocery store.

"They called it 'googaloo money,'" she said. "It was like silver coins, only a lot lighter. You know, like tokens. Hit weren't worth nothin' except at one store. You had to do all your tradin' there if you was gonna get any groceries."

Pendley was exposed to the process of making quilts during this period of her life. But she wanted no part of it.

"My Grandmaw Lizzie made quilts," she said. "Great big heavy things. We needed 'em to stay warm at night in the winter. Otherwise, I reckon we'd a'froze to death. She didn't have no pattern or nothin'. She just sewed 'em together from scraps of cloth—old britches, old coats, old dresses, things like that. She called 'em her 'crazy quilts.'"

Pendley thinks back in time and chuckles aloud: "I can remember, as a little girl, gettin' down below a quilt while she was workin' on it and aggravatin' her. She tried to learn me how to quilt, but I wouldn't listen. I was a lot happier out in the woods."

Cecelia Erhardt breaks into the conversation. "Her grandmother should have spanked her good and made her sit up and learn," she quipped. "Hazel is an artist at heart. I know she could have mastered it quickly."

As the years wore by, Pendley found work wherever it was available. She ran machinery in a mica house, processing local rocks for industry. She raised two sons, Wheeler and Wayne, on factory wages.

Later, she washed dishes for two restaurants in town. But all those years of toil came at a high price. A slipped disc and pinched nerve in her back became more and more debilitating. By the early 1980s, Pendley was forced into full disability.

That's when she discovered quilting and Cecelia Erhardt, in that order.

"When I got disabled, I wanted to learn to do somethin'," she says. "I decided I'd like to quilt. I went to some craft shows and tried to learn myself how to do it. But I couldn't do no good.

"The first'un I made, I pieced it together pretty good, but when I put it on a frame and went t'quiltin', I got into the awfulest mess there ever was. I had to pull ever' bit of it out and redo it. It was all puckered up and everythin'."

Pendley received her initial instruction from quilt artists like Doris Williams. Then she attended a class, taught by Sybil Woody, at the Pine Branch Baptist Church. Once she "qualified" by turning sixty, she began sitting in on the quilting sessions at the senior center at Toe Valley Apartments. That's where she met Erhardt.

A native of Columbus, Georgia, who studied art history at Wesleyan College in Macon, Erhardt had come to western North Carolina in 1981 when her husband, Frank, retired from the military.

"We'd lived everywhere because of Frank's career," she says. "When he got ready to retire, he wanted to play golf. I wanted to find a place where I could enjoy my favorite things, too: bluegrass music and quilting. That's why we came to this part of the country."

Erhardt did more than feed her addiction for mountain folk art. She took a job with Mayland Community College, working for an outreach program to assist economically depressed citizens in the area.

"A lot of the folks were just like Hazel," she says. "Their families had grown up and gone, they didn't have any transportation, and they didn't have the means to supplement their incomes. A group of ladies

A Stitch in Time

down at the senior center said they wanted to quilt, which was fine by me. I'd been sewing since I was three years old. I'd always loved fabric and colors. This was a natural for all of us. We set up some frames and started quilting together."

Another facet of Erhardt's job was teaching English as a second language. It was a task that required physical stamina as well as linguistics expertise.

"There was this Salvadoran woman who lived way out in the boonies, up off the North Toe River," she said with a laugh. "I was teaching her to speak English. We developed this system for every session: I'd drive as close to her house as I could get, then honk the horn on the van. She'd open her front door, and I'd run for my life to get into the house."

Bears? Attack dogs? Copperheads? Onery neighbors? Worse.

"She had a one-legged rooster that terrified me! That mean ol' thing would come hopping up, trying to peck me. A fox finally killed that rooster, and it didn't upset me a bit!"

Must have been part of the local culture as far as Erhardt can figure.

"On another part of my route out in the country," she said, still rolling with laughter, "I swear I saw this sign tacked to a tree—'Watch out for the attack chicken.' And then down below, someone had written 'This is no joke.' Nobody had to tell me twice. I believed it!"

Erhardt realized from the beginning that Hazel Pendley was a special student with extraordinary skills.

"I met with the women at the senior center every Wednesday," she said. "The first time Hazel came, I was showing them how to appliqué. I told each lady to try to have her square done by the next week, and we'd turn them into pillows. The next Wednesday, I walked in that room, and there sat Hazel with twenty squares. Finished! They were ready to be quilted. I was amazed."

A human bond was cemented from that day forward.

"Hazel's mother was still well enough to come to the quilting sessions at that time," Erhardt recalled. "The first time I walked in that room and met them, something clicked. We developed a closeness that transcends everything."

"I told her I'd adopt her as my sister because I didn't have one," says Pendley.

"It's the truth," Erhardt replied. "Mae and Hazel have been like family to me. I was seriously ill four years ago, and they helped me get through it."

Erhardt unfolds her "Toe River Tulip" quilt, a pattern she designed and Pendley created. "I stayed wrapped up in this thing just about the entire time I was sick. I could just feel the love that was in it."

Ever since her initial instructions, Hazel Pendley's fingers have been a blur of motion. She stitches the piecing for her quilts most nights at home. Four days a week, she goes to the senior center to quilt.

"I ain't got no arthritis or nothin'," she says. "The doctor tells me it's because I do all this quiltin'. He says it's the best thing I can do for myself." A diabetic whose vision has been somewhat affected by the disease, she has to wear eyeglasses for closeup work. "But as long as God'll give me my eyesight, I'm gonna keep on doin' this."

Like decoy carving, basket weaving, and dozens of other erstwhile chores, quilt making has long since been transformed from a household necessity into a widely celebrated form of artistic expression. For pioneer families who spent much of the year isolated from their neighbors, quilting bees marked a time of great festive get-togethers. That same spirit lives on in this country today, as untold thousands of practitioners gather in homes, schools, clubhouses, churches, and community centers to swap stories, commit dietary high crime with platters of homemade goodies, and keep their needles moving.

Quilt patterns are almost as numerous as the makers themselves. Guidebooks for the craft reveal

hundreds of commonly recognized designs and names. Some of the more popular ones in the southern highlands are "Trip around the World," "Double Wedding Ring," "Log Cabin," "Grandmother's Flower Garden," "Bear Paw," and "Drunkard's Path."

"There's a legend behind each one," says Erhardt. "That's one of the unique aspects of quilting. The quilts themselves mean something to the people who make them. For instance, even though 'Drunkard's Path' is a popular design, you'd never catch anyone around here tucking their children to bed under a quilt with that name.

"There also are variations in patterns around the country, just like language dialect. Take 'Log Cabin,' for instance. I know of four variations of this one pattern alone. Out in Missouri, they call it 'Courthouse Steps.' Oh, it's a little bit different from 'Log Cabin,' but it's the same basic design.

"A lot of these patterns were named by pioneer women," she continued. "This was a way they could provide an important item for their families and use their creative urges as the same time.

"Think about those women. They usually had *a* quilting needle—as in one. It represented a substantial economic investment. Many of the women in pioneer days carried their needle and thimble in a small holder around their neck, much like a necklace. They certainly didn't want to lose them."

For Hazel Pendley, the carrying case is larger, not to mention a bit more contemporary.

"Have pocketbook," she chuckles, "will quilt."

Even though there is a plethora of gadgetry on the market, Pendley sticks with a number seven needle for almost all her stitching. She knows some quilters employ longer ones, but she'll have none of it. "Them big long things look like a crowbar to me," she said. "I can't keep my stitches close with 'em."

Envious craft show comments notwithstanding, looking over Pendley's shoulder while she works is, indeed, akin to watching a machine. With a metal thimble perched atop her right middle finger, her hands fairly flow across the fabric, lending credence to the term "running stitches." Her placement—ten to twelve stitches to the inch—is crisp, uniform, precise.

How many times has she pricked herself?

"Nary'n," Pendley replied, eyes still riveted her work. "Some of my friends have their fingers jobbed all to pieces. I never do. When I feel that needle a'comin' through, I just turn it up."

From a distance, virtually any quilt can look like a masterpiece. But up close, even a casual inspection quickly separates collectors items from the also-rans.

"It's the little things that count," says Erhardt, pointing to the 'Trip around the World' quilt top Pendley is laboring over at this particular moment. "Some people even shortcut the entire piecing process and start quilting a printed top. Not Hazel. Look at her corners; they're exactly ninety degrees. That's what I mean about her sense of geometry. I had to take a drafting class to learn how to do what she does naturally.

"Look how's she tucked the edges under on each piece of appliqué. You won't find any frayed edges on her work. And you *certainly* aren't going to find any zigzag sewing machine stitches!

"Hazel has a natural talent and ability for color and pattern. That's something you cannot learn. It's either there or it isn't. I just wish Grandmother Lizzie could see Hazel's work. I know she'd be proud."

After all the pieces of the top have been secured in place, the quilt will be transferred to a large wooden frame. It is stretched tightly, along with an interior layer of batting and the exterior backing. All three components are then attached to each other via a series of decorative running stitches—the true "quilting," as it were.

"Back in the old days, folks used heavy insulation material for batting," Erhardt pointed out. "Wool or thick cotton. After all, they were trying to make something to keep themselves warm. These

days, it's usually a light polyester layer. That's the only thing in one of the quilts that isn't 100 percent cotton. It's a matter of practicality. Polyester batting is much smoother than anything else. It won't tend to lump up over time."

Although they are perfectly suitable for the bed, many of Pendley's wares will spend the rest of their years on quilt display stands or as decorative wall hangings. That's fine with her. She's delighted someone appreciates her art.

"This is true about nearly all the people of this area," said Erhardt. "I have discovered a profound love of craft here. They do this type of work because it makes them feel good. The money is secondary. It's not the primary motivation. If someone like Hazel can sell a quilt, that's just frosting on the cake."

And what does the woman who has made hundreds of quilts have in her own bedroom?

"Just a sheet and a bed cover," Pendley answered. "That's all I ever sleep under."

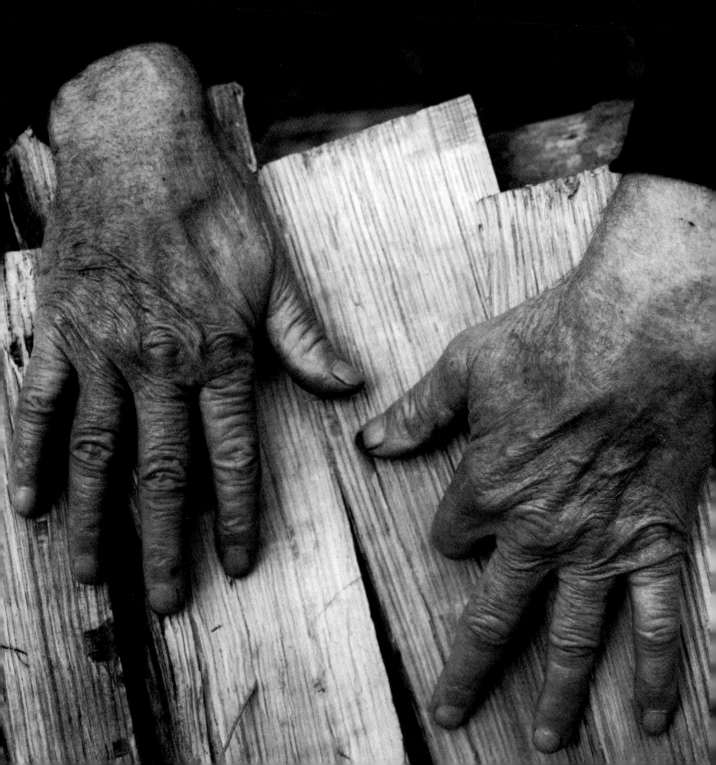

A Good Roof Overhead

Randy and William McClure

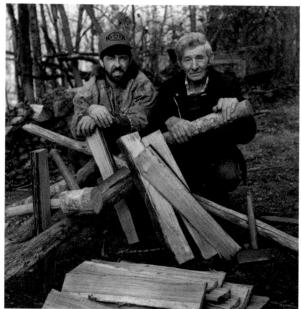

Precipitation is no stranger to southern Appalachia. When windblown clouds stack up against the ridgetops, they empty their cargo in massive amounts. Whether it comes in the form of rain, snow, or foggy mists that shroud the steep slopes and narrow valleys alike, water is a near-constant factor in this rugged terrain. Throughout the region, sixty to ninety inches might fall in any given year.

There is no "wet" season or "dry" season. It just seems that way.

In late January, when the mountains are coated with the latest layer of snow, or in March, when the rain pummels down for days at a stretch, one might wonder if this section of the country is going to pull loose at the roots and slide off the globe. Worry not. By the middle of July, when the corn crop is baking in the field and stunted tomatoes, okra, beans, and cucumbers are withering in the garden under a relentless sun, one starts to think his prayers for a cessation of rain four months earlier might have been answered a bit too fervently. Worry not again. A change is sure to occur, perhaps within the hour, as dark thunderheads begin to form in the west and roll across the far ridge.

Given this abundance of moisture, it is imperative to protect houses, barns, sheds, and other structures from above. The mission is just as necessary today as it was two hundred years ago. It calls for shingles.

Yet there are several strategic differences between now and then. In the old days, there was no such thing as a local hardware store, or asphalt shingles, or a car in which to procure them—let alone the foolish notion that someone else would do the manufacturing. Instead, this was one of dozens of chores that were part and parcel of life in the wilderness.

"Ever'body made ever'thin' for themselves in those days," says William McClure. "If you needed

shangles, you didn't go to the store. You went to the woods and picked out a tree."

William McClure speaks with authority. With the simple tools of metal wedges, a sledge hammer, an ax, froe, and homemade wooden mallets and mauls, he has rived hundreds of thousands of oak shingles ("shangles" or "boards" in the local vernacular) for eager customers throughout southern Appalachia and beyond.

How many are we talking about?

McClure tilts his head back, peers off into the hazy sky of this sweltering summer day, and thinks momentarily.

"Hit's untellin' how many tractor-trailer trucks I could have filled," he finally responds. "They was a period of about twenty years that I hardly ever let up. Many's the time I've made a thousand shangles in one day, sometimes as much as fifteen hundred. 'Course, that hain't no eight-hour day. That's from daylight till dark."

Work is something William McClure knows all about. He lives on 187 acres of mountain land near Skaggs Creek, deep in the heart of Rockcastle County, Kentucky. It's less than one mile from the farm where he, the oldest of ten children, was born on Christmas Day 1921. McClure's formal education ended at the fourth grade. He and his wife Renie raised thirteen children of their own—"and learnt ever'one of 'em to work." Except for military service in the mid-1940s and a brief stint at an Ohio paper mill in the early 1950s, he has lived and worked in Rockcastle County.

McClure is one of those increasingly rare individuals who can do just about anything with his hands. He has raised tobacco, mined coal, cut cordwood, run a blacksmith shop, built cabinets, and carved and whittled everything from kitchen utensils to toys to ornamental birds and other animals out of wood.

"Even whittled me up a set of false teeth once," he says, chuckling with a bubbly, spontaneous laugh reminiscent of the late comedian Ed Wynn. "I figured if they's good enough for George Washington, they's good enough for me."

Then again, maybe not: "I made 'em out of buckeye. They fit okay at first, but then they swole up once they got good and wet."

The wooden teeth now rest in a cabinet at McClure's house, but many of his other works have traveled a bit farther. Five of his wooden pieces—a solid walnut bowl, two miniature chairs, and two pocketknives with movable blades ("Hit's the only knife you ever seed guar'teed not to have no metal!")—are in the Smithsonian Institution. He is a lifetime member of the Kentucky Guild of Arts and Crafts. Governors and foreign diplomats have feasted at his and Renie's dinner table. College classes have studied crafts under his guidance. He sits on the board of a local investment corporation that loans money to small businesses, an endeavor that has created more than five thousand jobs in nine southeastern Kentucky counties.

In fact, McClure's interest in trying to better the lives of his family and friends is what brought him to the forefront as one of Kentucky's most respected craftsmen. It happened when he and some of his neighbors formed a committee to attract industry into the backcountry. One of their meetings was attended by a county judge, who took an immediate interest in one of McClure's carvings.

"I can't even remember now what it was," he says. "Maybe an owl or mushroom or something. Anyhow, I know he paid me five dollars for it. Next thing I knew, some of 'em was askin' me to submit carvin's for the craft guild's standards board."

McClure smiles broadly and laughs again. "I was just foolish enough to try it. I turned in five different pieces, and they passed me. That's what got me into all this trouble!"

For years, McClure carved on behalf of the craft

guild at fairs and shows. One day, the president of the organization approached him with the proposition of riving shingles. All the old folks who knew that trade were dying out, the president explained.

Did William know how to do it? Could he demonstrate the skill to others?

Does a crow say "caw"?

"I'd learned from my dad, Joe McClure," William explains. "He farmed, and he also made chairs and wagons. He could make about anythin', including shangles. Once when I was a boy—I guess I was about twelve at the time—me and Dad and a feller named Harvey Barnes made all the shangles that went on the barns and cabins at Renfro Valley. Made 'em for two cents apiece."

Once he began making shingles for the guild, McClure never stopped. He couldn't. Too many customers were waiting. The front yard of his home, ten miles south of the town of Mount Vernon, became a virtual roof components production yard, as truckload after truckload of oak logs were sawed and split into stack after stack of shingles.

"I just worked out there in the sun," McClure mused. "Some of 'em got to askin' me why I didn't build a shed. I told 'em I couldn't build no shed, 'cause they was too many shangles stacked up. I just worked out there and took the weather as it come."

McClure continued to ply his trade when visitors showed up. He was always willing to give a hands-on demonstration, whether the interested party was a prospective customer, a curious do-it-yourselfer, or a class of college kids studying mountain crafts.

Recalls the mountain man: "One of my son-in-laws told me I shouldn't show ever'body how to do it. Said they'd take my job. I said good for them; they's always somethin' else I could try. I knew it wouldn't happen, though. Makin' shangles is too hard a work for somebody to take my job."

Only one person did—Father Time.

Even for a man with a rock-hard work ethic like William McClure, the years and the labor intensity of the operation began to take their toll. By the mid-1990s, he realized there was no way he could keep up the pace. "I'd like to think I could jump in there and make 'em like I used to, but I know I can't," is the way he puts it.

No more McClure shingles? What were farmers, homeowners, and log cabin reconstructionists to do?

Turns out there was no reason to fret.

McClure shingles still are being rived, hundreds or thousands at a time depending on the need, just up the road from William's house. That's where Randy, his youngest son, lives with his wife Michelle and their two sons, Derrick and Ethan. This is a classic case of the acorn falling close to the tree, both in terms of production and quality as well as humor.

"These days, Dad does all the talkin' and I do all the workin'," Randy says with his trademark McClure smile. "I can't help it. He taught me too well."

When Randy graduated from high school in 1984, jobs were scarcer than ever in the hills of eastern Kentucky. He traveled to Texas, where some of his kinfolk had settled. There he had the offer of a house-painting job.

"Paintin' ain't for me, but at least it was a job," he says. "When I got to Houston, all I had was fifty dollars and a suitcase full of clothes. Within a year, I had me a new house and a new truck. A little later, I got a job workin' on cars for a Ford dealership. Wound up stayin' a couple of years, but then I moved back home. This is good country here. You couldn't drive me outta these mountains with a stick."

Randy's link to the shingle trade began when he was but a seedling himself. By the age of five, he was following his father to craft fairs and shows.

"Actually, I followed him 'bout ever'where he went," says Randy. "I always enjoyed bein' with him. I kept goin' to the shows and helpin' him make shingles. One day about three years ago, he had so

A Good Roof Overhead

much to do, he looked at me and said, 'Son, I believe it's your turn. I'm quittin'.'"

This is not a full-time job for Randy McClure. Not yet, anyway. Four days a week, he drives forty miles north to Berea to work on the assembly line of a forklift manufacturing plant. But on Fridays and weekends, he's liable to be out back of his house with a froe and maul in his hands, taking the weather as it comes. Just like Dad.

The process begins long before shingles start piling up at his feet. First, the right tree has to be selected. Cedar makes an excellent shingle, but very few trees in southern Appalachia are free enough of limbs and knots. As William says, "Hit's untellin' how old a cedar would have to be to be big enough for the job."

Instead, Randy relies on native oaks. Although white, chestnut, and water oak will make very good shingles, the first choice is always red oak. These handsome trees grow in relative abundance in southern Appalachia. They're meaty as beefsteak, strong as a bank safe, yet they have a long, straight grain conducive to splitting. The only problem is finding one without twists, turns, and an overabundance of knots.

"You've got to look at the grain of the bark," says Randy, running his fingers along the trunk of an excellent specimen. "If the bark runs straight up and down the tree, so will the grain inside. If the bark starts to turn, you might as well forget it, because the shingles won't come out good. The wood'll split fine, but the shingles will be twisted."

After the tree is felled and brought to the shingle yard, it is marked off into twenty-four-inch sections and sliced with a chain saw. Now, the work begins in earnest. Positioning the two-foot log upright, larger end at the bottom, Randy sinks two metal splitting wedges into the top, opposite each other at the outer edge of the sapwood, near the bark. A few swift blows with his sledge hammer pops the log open like a ripe watermelon.

"It's pretty much guesswork from here on out," he says. Guesswork, it should be stressed, that has been refined by years of observation and on-the-job training.

Using the distance between the tip of his thumb and tip of his little finger as a guide, Randy marks off a section of the half-log and repositions the metal wedge. Wham! A pie-shaped piece flies off. He marks off another section. Wham! And another—wham!—until both halves of the original log lie in units known as "bolts."

His next strike with wedge and sledge knocks a triangular length of heartwood from the bolt. Except in the largest of logs, this piece is too narrow to produce shingles. It is relegated to the firewood stack. Shingle makers never want for fuel to warm their houses.

Next, the bark must be removed. "You want to cut your trees when the sap's up, if at all possible," Randy advised. "That way, the bark will peel a lot easier. In the winter, when the sap's down, the bark sticks tighter. You gotta hew it off. It's a lot tougher job."

To illustrate the comparative ease of peeling summer wood, Randy drops a bolt to the ground and sharply strikes the bark side of it three or four times with his sledge. The entire length of thick bark disengages in a single layer. At this point, the bolt is ready to be reduced into four shingles, each twenty-four inches long, four to six inches wide, and approximately one-fourth to one-half inch thick.

"You start workin' with these things and you can tell which was the north side of the tree and which was the south," he added. "The north side is wetter. It splits easier. The south side is dry and tough. It's 'lockier.' Takes more time to get it apart."

Randy sets the bolt upright against the inside fork of a leaning, Y-shaped locust pole. The open end of this pole is held off the ground by two additional poles, crisscrossed for strength and support. One is made of hickory, the other of dogwood. A scientist would look at this apparatus and call it a

"crude fulcrum." A shingle maker calls it the "board brake." This is where tools, muscles, hands, and eyes team up to cleave the bolt into two equal pieces and, subsequently, each of these two pieces into a pair of shingles.

He picks up his L-shaped froe, sets the thick, dull blade in the center of the bolt, and raps it with a maul. The wood cracks audibly and begins to split, more or less down the middle. Randy glances at the sapwood edge of the piece to note which side is larger. This is important to determine, for the thicker side must always be on the bottom of the bolt; otherwise, the shingle will "run out" of the grain and wind up tapered at one end. Flipping the thicker side down, Randy twists the froe handle and inserts his free hand into the resulting crevice, thrusting the blade deeper into the split at the same time. *Crrrrrack!* With a sound like cloth being ripped, the board splits completely down its length, filling the yard with the perfume of new wood freshly exposed to the air.

Behold! A perfect pair of shingles.

Elapsed time? A matter of seconds, much longer than it took to read the preceding paragraph.

Be not mislead, however. The job is far more difficult and complicated than it appears. As William tells it: "I was makin' shangles at this craft show once, and a feller stood there and watched me for a few minutes. He said, 'Why, there hain't nothin' to it.' After awhile, I took a break and gave him the froe. He worked and worked and worked and never made airy shangle. Finally, somebody else in the crowd spoke up and said, 'They's a lot more going on there than you know about, Buddy!' We all liked t'died laughin'."

The story reminded William of another tale: "I used to smoke all the time. Rolled my own cigarettes with Prince Albert terbakker. Once at a craft show, I was rollin' one and happened to overhear some kids talkin'. They said, 'Look! That old man's a'smokin' pot!'"

And another: "I lost this finger years ago on a jointer," he said, displaying his left hand with half of the forefinger missing. "They was this feller who used to hang out around craft shows all the time, and he got t'knowin' me. He called me Uncle William. Well, one day, I was a'workin' and this feller was there and some other folks walked up. This feller says to them, 'Uncle William here can stick his fanger up his nose farther than any man I ever saw.' For a second, I didn't know what he was talkin' about. Then I figured it out. I had my back to 'em anyway, so I just run the stub of that fanger to the base of my nose and turned around. Those folks stared at me for a second and then one of 'em hollered out, 'They! Hale far!' Lord, we all laughed!"

Although he has long-since quit smoking, William still chews tobacco. It helps his income. His farm produces six acres of the cash crop every year.

William tore off a chew from the twist in his pocket, nestled it in his jaw, and then picked up Randy's froe and maul. "Here's how you're supposed to make shangles," he laughed aloud, attacking a bolt in the brake to the steady rhythm of a homemade poem: "Chew my 'bakker, spit my juice, make these things when there ain't no use!"

Computers and accountants are not required to keep track of production in this business. Randy does it the same way his father taught him, the same way mountaineers have been doing it down through the ages.

"You make your bolts twenty-five at a time," he explained. "At four shingles apiece, that'll give you one hundred. You stack 'em as you make 'em. Every hundred, lay one aside. At the end of the day, you count those, and it tells you how many you've made."

To determine the amount required for a particular job, Randy relies on another handed-down formula: 250 shingles for every ten-foot-by-ten-foot square of roof area.

They'll need to be overlapped on the sides and

A Good Roof Overhead

ends, of course, starting from the lowest edge of the roof and working upward toward the centerline. Ten inches of exposure is recommended for each shingle. To slow the onset of decay, the McClures say to always keep the sapwood edges from touching each other. Cement-coated or galvanized nails, number six, are large enough to hold the shingles in place, but small enough to deter splitting.

"I never was too far off on my figurin'," says William. "Done it too many times. Once, I was makin' shangles for a feller named Roy Brown. I figured up what I needed, and he said, 'William, that's too many.' I told him, 'Roy, I know I'm right. I'll take back any you don't need.' He said that was fine. When he finished the job, they was one shangle left over. I reckon that's figurin' it pretty close."

How long an oak shingle lasts depends largely upon the pitch of the roof. On steep A-frames, one hundred years is possible. On lesser angles, particularly in a shaded area, decay and moss may end the shingle's life in one-fourth that time.

"The key to a split shingle's longevity is the raised grain of the wood itself," says Randy. "This makes a natural drain for the water to run off. A sawed shingle won't do that. It opens up the pores in the wood. The shingle will rot in no time at all."

Man over machine. Think about it. What a marvelous concept.

66

A
Good
Roof
Overhead

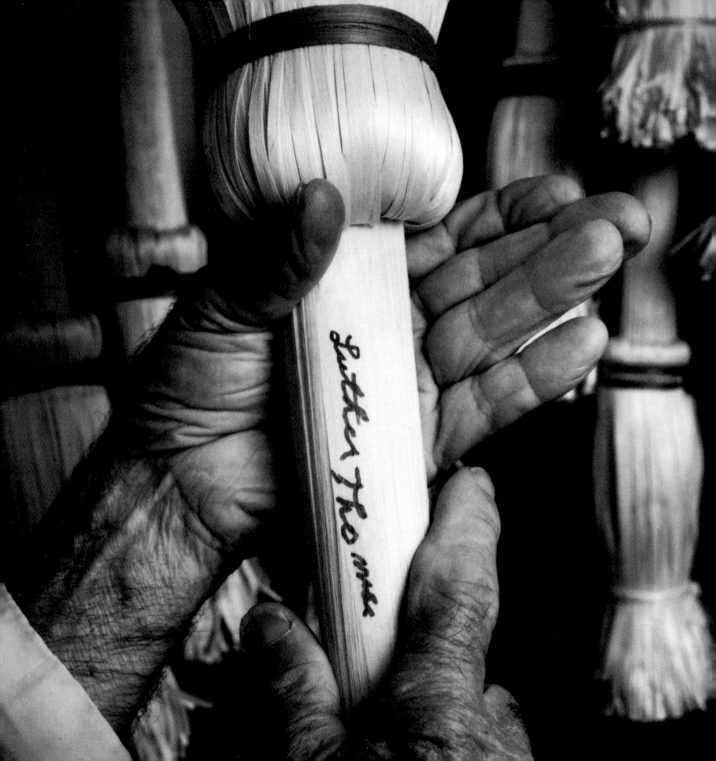

A Clean Sweep

Luther Thomas

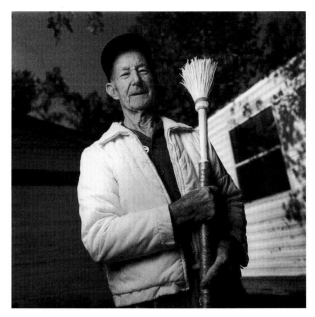

Cane grows again on Cane Branch. You can thank Luther Thomas for that.

Around thirty years ago, he located a canebrake in Marion, North Carolina, pulled up a load of sprouts, and rerooted them along the banks of the creek that flows near his home in Micaville, forty miles northeast of Asheville.

Today, dark, dense stands of cane cover the lower end of the waterway as it gurgles along its course. That's the way it ought to be, Thomas reasons. Helps hold the ground together. Keeps the bank from washing away when floodwaters come raging out of the mountains. Best of all, it's natural. Reminds him of the way Cane Branch looked when he was a boy in the early days of the twentieth century, back before the original vegetation was lost to road construction and other onslaughts of human expansion.

Luther Thomas knows a lot about the natural look of Yancey County, North Carolina, both above and below the ground. He is a walking, talking encyclopedia of the flora, fauna, and minerals of this region. Perhaps his credentials were best summed up in 1988 by the Yancey County Chamber of Commerce, the Toe River Arts Council, and the Yancey History Association, when they named Thomas the recipient of their first annual Heritage Award.

Reads the citation, in part: "When experts from the Smithsonian [Institution] or elsewhere want to know something about North Carolina minerals or traditional mountain crafts or local botany or Indian lore or artifacts, they come calling on Luther Thomas."

Not bad for a fellow who didn't finish the third grade.

Thomas can barely read and write his own name. His storehouse of knowledge didn't come from a book. Rather, it was gleaned from a lifetime of keen observation. He points to his ears and reveals the secret of his success: "It come to my mind when I'us a boy that if I let these things on the side of my

head listen and pay attention to someone who had an education or some sense, I could learn something."

Yes, indeed. Magna cum laude.

One of the first persons he listened to was his father, Bob Thomas, a prospector who combed the steep ridges beneath Mount Mitchell in search of mica deposits.

"When I was big enough to carry a shovel, I'd follow my daddy through miles and miles of these mountains, just to be with him," says Thomas, the third of eight children. "People'd let you prospect on their property because they got an 8 percent royalty on whatever you found. My daddy and I'd go out summer or winter. Didn't matter how hot it was or if there was snow on the ground. Just take a pick and a shovel and a jar of soup beans and some cornbread to eat. Why, some days we'd walk ten miles in, ten miles out, and not have a thing to show for our work."

Father and son actually "looked" for mica outcroppings.

"We'd hunt for a place where the earth was pooched out a little bit, then start diggin'. A lot of times, we wouldn't find anything. But sometimes, we'd hit a pretty good pocket. The deposit might go straight down, or else it might run out in a vein, a hundred or two hundred feet long. It was in all different forms. If we found enough, we'd make us a road and sled it out with a team of horses. There was mica houses all around in this country back then. You'd take in your haul, and they'd pay you for it."

Thus began a lifelong interest in rocks, minerals, gemstones, artifacts, and other objects from down under. The result of these labors can be found in the Old Miner's Shack, a small museum Thomas built next to his home.

Here he conducts tours for school children, scout troops, teachers, rock hounds, and inquisitive tourists. Virtually every square inch of space inside the tiny building is employed to show samples of his find-

ings, including mica, feldspar, aquamarine, schist, emeralds, garnets, quartz, various ores, arrowheads, even a length of sandstone so flexible it can be wiggled like the spine of some prehistoric monster.

"I always tell people they'd be amazed if they knew what they were walkin' over every day," he says. "It's right under their feet. They just can't see it."

Of course, not everybody shares this enthusiasm. Thomas chuckles at the ribbing he regularly receives from his brother, Ed.

"He's always tellin' me, 'Dadburn, Luther! Why don't you sell these old junk rocks and get some money out of 'em?'

"I always tell him, 'Ed, the rocks would be gone, and it wouldn't be long before the money would be gone, too.' I'd rather just keep my rocks and let somebody who's never seen anything like that before have a look. I get a lot more enjoyment out of that."

So much for the present. Way back when, Thomas's interest in rocks could not even remotely have been termed recreational. The most important business at hand was feeding hungry mouths. His included.

"We didn't have much money at all," he recalls. "Nobody did. We always raised a garden and kept a few hogs and chickens and cattle. But it was a tough time. When I'us thirteen, I hired out to my first public job. I started minin' feldspar. Worked in those mines for ten cents an hour, ten hours a day. Did that for nearly eight years. I never got a raise during that whole time, either. But that was still pretty good wages for those days."

In addition to mining, Thomas felled timber, cropping the hills of their wealth of chestnut trees. This was called "acid wood" by the locals, for it was used in the tanning industry.

"We didn't have no chain saws in those days, that's for sure," he said. "It was all done with crosscut and ax.

"Man, the chestnuts that were in this country back then! That was way before the blight. Acres

and acres of 'em. You could find stands of trees that were 75 percent pure chestnut. I've picked up many a bushel of those nuts. All us boys would run barefoot, of course. The bottoms of your feet would get so tough, you could stomp a chestnut burr and it wouldn't hurt."

Another chore assigned to Thomas and other boys in his community was berry picking. Blueberries—"huckleberries" to residents of the hill country—grew in abundance. Much of the virgin timber had been cut around the turn of the century and, as was the "forestry practice" of that era, the slashed land was abandoned. With the original canopy removed, the sun-splashed soil erupted in a carpet of berries of every description.

"They were s'thick, you'd think they'd been set out in orchards," Thomas recalled. "A bunch of us boys would get together and walk five miles back in there to pick 'em."

No sense in carrying an empty metal pail for half of the journey. Instead, Thomas and his friends made do with native materials gathered on the spot. As soon as they reached the berry picking grounds, they'd find a small poplar tree, peel off a two-foot square of bark, score the rough outer side with the point of a knife, fold it together like a large envelope, and lace the sides with strips of fresh hickory bark.

Presto! A berry bucket.

"We'd carry those berries back to our mothers to can for the winter," he said. "Those old berry buckets weren't good for nothin' after that. Why, there's no tellin' how many of 'em Mama threw in the fireplace."

Nobody throws these things into the fire any more.

Shortly after World War II, tourists began funneling into eastern Tennessee and western North Carolina to visit the Great Smoky Mountains National Park and Cherokee and Pisgah National Forests. These visitors brought money. It didn't take the local residents long to realize what had always been considered everyday, utilitarian items were now prized by the outsiders as mountain art.

"That's how I got into the crafts business," he says. "It was just sort of off and on at first. Then eleven of us started the Yancey County Crafts Fair in Burnsville. The tourists kept comin'."

They still do. And Luther Thomas keeps making his wares for them, complete with homespun entertainment.

"One day, these two women came into the shop and bought three berry baskets. One of 'em said, 'Mister, do you know where these baskets is goin'?'

"I said, 'Ladies, don't misunderstand me. I'm not givin' you no short answer or nothin', but I don't care *where* them baskets is goin'. I've made 'em till I'm tard of seein' 'em.'

"She said, 'Well, sir, they's goin' to Siberia, Russia.'

"I laughed and said, 'Well, I reckon that's three I won't see no more!'"

Whether he's preparing for a local crafts festival or the state fair in Raleigh—where he was named Craftsman of the Year in 1988—Thomas spends at least a few hours every day either gathering the raw materials or constructing an item. His business card accurately describes this mission: "Nature's Wonders—Things Collected and Crafted from Nature."

During the summer, he cuts small poplar trees to harvest bark for his baskets. The bark must be gathered when the sap is up. Any other time of year, the bark would cling too tightly to remove. Thanks to the marvels of refrigeration, however, he can have fresh materials for his shop any time he pleases.

"I got to thinkin' how people freeze their meat to eat later and wondered if I couldn't do the same thing for my bark," he said. "The first time I tried it, I just put the bark in the deep freeze. That didn't work. It got freezer-burned and started molding as soon as it thawed.

"Then I tried puttin' it in black plastic trash bags first, with the tops sealed real tight. That way, the

A
Clean
Sweep

air couldn't get in. That did the trick. I can take that bark out of the freezer in the middle of winter, let it thaw, and it'll work up just as pretty as the day it was cut."

Yet Thomas's most unique handcraft, the one that has made him a Yancey County legend, is a one-piece broom, wrought from the trunk of a yellow birch sapling.

Correction. Technically, this broom consists of three parts, if you include the strip of hickory bark wrapped around the bristles and the leather thong threaded through a hole in the top of the handle for easy hanging. But the functioning broom itself—handle and bristles—comes from a single length of wood.

"I bet there ain't one person in a million who makes brooms the way I do," he says. "I learned it from my mother. She taught me how to make 'em and how to use 'em!"

The bristles on a traditional mountain broom are crafted from swatches of broom corn, carefully woven together at the base of the handle. In a Thomas broom, however, the bristles are peeled from the handle itself, one by one.

His chooses yellow birch because the wood remains pliable after harvest and is easy to work with a pocket knife. Even after the broom is finished and the bristles are dry, they resist shattering. In fact, they are so pliable, they can be soaked in water, allowing the broom to be used like a mop.

"I've cleaned many a wood floor with these things when I was a boy," he said with a grin. "First, Mama swept with the broom. Then she'd get a pot of water boilin' and throw some of her homemade lye soap into it. After that, she'd go down to the creek and get some real fine sand and mix it with ashes from the fireplace. She'd throw that on the floor and pour on some of that hot soapy water. Then she'd stick that broom down in the pot to soften the bristles and hand it to me. It was my job to do the moppin'. Mama'd always keep a sharp eye. She could tell if I missed a spot. After I finished moppin', she'd hang the broom up outside and let the bristles dry. It'd be back to a sweepin' broom again, good as new."

Birch brooms are just as functional today. Just as long-lasting, too. Thomas uses his own brooms to sweep up his shop. One of them lasted eleven years before the bristles finally gave out. Still, he acknowledges that most everything he makes these days winds up as decor in someone's country-chic house.

Well, maybe not *every*thing. There's one broom application surely no one ever considered back in that lye-soap-and-wood-ashes era of southern Appalachian cleaning: "A couple from Florida come in one day. They bought one of my brooms to use on their fishin' boats. They come back the next year and bought six more. Said it was the best thing they'd ever used to cut slime and fish juice off the deck."

Thomas starts with a piece of birch, bark removed, that's slightly less than two inches in diameter. The length depends on whether its ultimate use will be a short-handled hearth broom or a traditional floor-sweeper. Holding it across his lap, he nicks one end with the blade of his pocketknife and produces a tiny filament of wood fiber—about the width of a drinking straw, yet barely thicker than a piece of paper. Pinching it between finger and the blade, he peels the strand away from the handle until it is approximately twelve inches long. Then he reaches up for another and pulls it the same distance. Then another. And another. And another, constantly rotating the handle as he goes. In a matter of minutes, the butt of the handle looks like a mass of curling ribbon.

"A lot of people think this wood is shaved off the handle," he says. "That's not right. It's peeled, and the secret is to pull each piece up and away from the wood, not straight back. If you try to take it back, it'll snap off. Every now and then, one's gonna break off anyway. But don't worry none about it.

Just reach up there and grab you another one. If you hit a small knot, don't worry about that, either. It'll just leave a little hole in the bristle. Won't hurt a thing."

After he has peeled the butt end of the stick to nearly half of its original diameter, Thomas cuts off the remaining stub. Then he reverses the process. He turns the stick around, places his knife blade on the shaft, approximately fourteen inches above the point where all the bristles are still permanently attached, and starts peeling back toward them, rotating as he works. This way, a full head of bristles is created. He folds the top layer of strands over the lower ones and wraps them once or twice with a strip of hickory bark to secure everything in place. Then, all that's needed is a hole at the top and the leather thong. Finished product.

"It all depends on what gear I get into, but I can usually make a broom in two to two and a half hours," he said. "Actually, I don't really think much about the time. I just start workin'. Sometimes I'll just make berry baskets all day. Sometimes I'll just make brooms. Sometimes I'll just go out in the woods and gather poplar bark and birch trees.

"I figure I oughter keep on workin'. Workin' never did hurt nobody. It keeps me from gettin' old. I plan to just keep a'workin' till I can't walk.

"Then, I reckon I'll go t'crawlin'."

*A
Clean
Sweep*

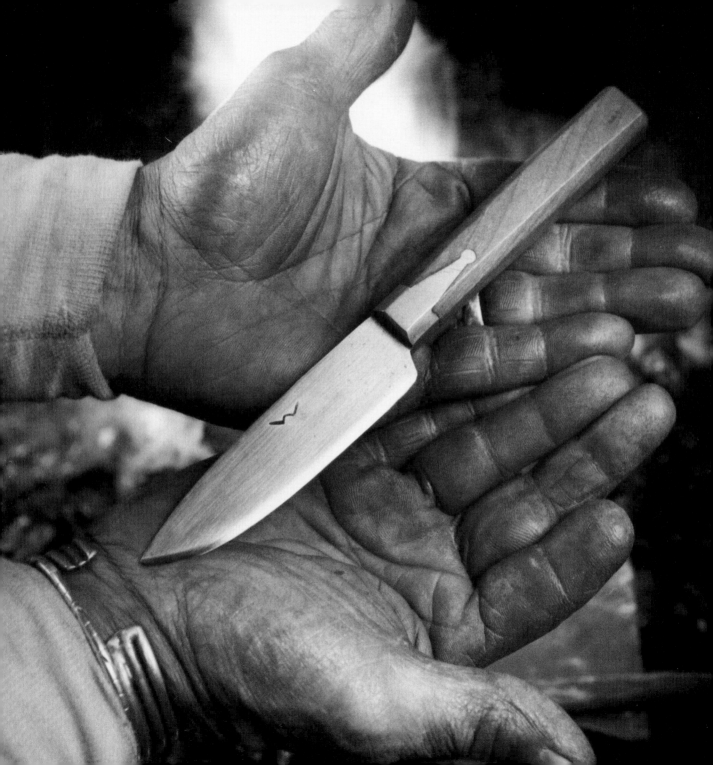

A Steel-Poundin' Man

Richard Williams

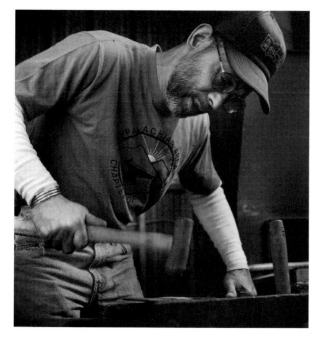

Richard Williams was more than a little perplexed. He couldn't figure out why the crowd kept ignoring him. Here it was, the opening afternoon of a popular folk festival in a large southern city, and yet hardly a soul had wandered by the booth to see demonstrations of his special skills.

Must be the location, Williams told himself. That stood to reason, for he was tucked off to the side of the major exhibits, away from the main flow of traffic.

What's more, he was being swallowed by the noise of street bands and the crowd itself.

Oh, well, he figured; so it goes. Maybe tomorrow would be better.

Then suddenly, as if by magic, people began to gather 'round. And as soon as they started asking questions, Williams realized what the problem had been all along.

"They'd been seein' smoke come out of my place and thought I was cookin' barbecue," he recalls with a laugh. "These folks were hungry. I couldn't feed 'em, but let me tell you, from then on till dark, I was the busiest man at that festival!"

Richard Williams does not need pork shoulder sandwiches to keep an audience spellbound. Just give him a hot bed of coals and a piece of scrap metal, and his hammer and anvil will take it from there, singing the sweet song that once rang through every village, town, and city in America.

Ping! Ping! Ping! Ping!

The music stops momentarily. Using eighteen-inch tongs forged with his own hands, he hoists the glowing metal to eye level, cocks his head to one side, and gives it the once-over with mental-visual measurements calibrated through years of experience. Satisfied all is well, he returns it to the anvil, and the concert begins once more.

Ping! Ping! Ping! Ping!

Less than fifteen minutes earlier, the object of this

attention had been an old metal file, its teeth dulled by years of service on ax heads and lawn-mower blades. In the context of today's throwaway society, it was ready for the junk heap. Guided by the talented hands of Williams, however, its new life was already unfolding. Not anytime soon, of course. There would be more heating in the forge, more trips to the anvil, more pounding and shaping, more filing and fitting. But in the end, this metallic ugly duckling would evolve into a swan of stunning beauty, ultimately finding its way into a knife collector's inventory of prized folk art.

Not bad for a guy from Harlem whose first exposure to cutlery was an army surplus knife he bought for fifty cents.

"I was always fascinated with knives when I was a kid," Williams said. "I was a Boy Scout, about twelve years old, when I bought that one at the surplus store. Before that, I remember trying to make one out of wood. It didn't turn out too well."

Williams recalls his formative years in the Big Apple fondly: "It was a wonderful time. Lots of museums to see, all kinds of great stuff to do. Harlem then wasn't anything like you read about in the paper today. But even with all that, I wondered if I hadn't been born at the wrong time. Daddy used to tease me that I wasn't like the rest of the Williamses. He said I was like the Tuckers, my mother's people from South Carolina. They were hunters and fishermen and farmers. I didn't find out about till later, but my grandfather on Mother's side had been a blacksmith himself."

Williams got the chance to move closer to his rural roots in 1953, when he came to Morristown, Tennessee, to attend Morristown College. He fell deeply in love—not only with the area but also with another student, Celia Stewart.

To say the least, it was a mixture of cultures. Take a man from the midst of one of largest metropolitan areas in the nation and match him with a woman who grew up near the farm where her grandparents had worked their entire lives, and you have the recipe for a quickly dissolved relationship. Not in this case. Richard and Celia have been married since 1955. They have four children and eight grandchildren.

Shortly after marriage, the young couple moved north. Richard worked as a painter at a Sylvania plant in Buffalo, later at a pawn shop back in Harlem. But the lure of the South could not be denied. In 1959, he packed up his young family and returned to Morristown, working wherever he could find a job—mainly factories and service stations. In 1965, he was hired by the U.S. Postal Service. When the agency began downsizing in 1992 and offered him early retirement, Williams jumped at the chance. These days he rotates between two "offices." One is the shop in the basement of his house. The other is the forge, built by his own two hands, that sits inside a small building—"the Den"—in his back yard.

Williams was bitten by the blacksmithing bug in 1976, when he read a story about the craft in *Popular Mechanics* magazine. Always a tinkerer, he was immediately swept up by the process of working with metal. He began collecting books about the subject and attended numerous courses at folk schools, including the Arrowmont School of Arts and Crafts in Gatlinburg, Tennessee, and the John C. Campbell Folk School in Brasstown, North Carolina.

"A friend gave me a small rivet forge, and I built myself an anvil from an old piece of railroad track," he remembers. "That's how I got started."

Like most newcomers, Williams began turning out small wares—flowerpot hooks, hangers, fireplace pokers, chisels, simple tools, and decorative key rings. He still creates these items at craft shows and folk festivals, occasionally to the surprise and delight of hungry visitors searching for the barbecue stand.

But knives, particularly fixed-blade models patterned after designs from the eighteenth and nine-

teenth centuries, are his specialty. They're almost all crafted from pieces of old metal: files, leaf springs, coil springs, metal cable, anything someone else plans to throw away.

To watch this transformation take place, pull up a chair in the Den. It's easy to find in Williamses' back yard. Just look under the spreading tree.

True, this is a red oak instead of a chestnut, but it's only one of two historical details that must be overlooked. The other is the electric blower Williams uses to increase the heat in his forge. No hand- or foot-operated bellows for him, thank you. Other than that, Williams works like the village smithy of long, long ago.

"I like it this way," says Williams, wadding up newspaper to start a fire in a pile of metallurgical-grade coal. "The only machine I use on my knives is a drill press for the handle holes. Everything else is done by hand, just the way they did it in the old days."

As the coal smoldered and smoked, he sprinkled it with water to assist its transformation to high-heat coke. Then he selected a worn-out Nicholson file from a small mound of rusty pieces on a nearby bench.

"Wasn't nothing ever thrown away in the old days," he announced, plunging the bar into the bowels of a 2,300-degree inferno. "Nothing gets throw away here, either. There's a knife in this file. We just have to let the metal show us where it is."

Moments later, Williams removed the file with tongs. Picking up a 3-pound hammer, he turned to his 160-pound anvil that is mounted on an elm stump. Then he unleashed the music.

Ping! Ping! Ping! Ping!

With every stroke, the leathery muscles in Williams's arms flexed. Sweat beaded on his brow, then his face, then dripped down his entire torso. His breathing came in muted jerks as the hammer rose and fell. Indeed, he all but entered time warp and whisked back into another era as he talked—to the fire, to himself, to the metal.

"That's it, fire. You gettin' hot now, al'right. . . .

C'mon, Rich, keep hammerin'. . . . Yeah, now! Let's see what you gonna wind up lookin' like."

The metal cooled during each series of strokes, changing color from blood red to ashen gray. Back into the fire it would be sent, returning to the anvil aglow once more. Just like modeling clay being pounded with a stick, it slowly began to lengthen, broaden, and take on the shape of a blade. During the final stages of this step, Williams laid the piece flat on top of the anvil and struck it smartly with a stamp he had made from a length of coil spring. From that moment on, it would be forever branded with his trademark "flying W."

Yet this was only the first of many steps before the knife would be complete. There is "normalizing," in which the blade is heated and cooled three times. Then annealing overnight in vermiculite to soften the metal so it can be filed by hand. Next, filing to shape. Then polishing, first with wet 120-grit sandpaper, later with finer grits up to 400.

More heat treatment is needed at this point to bring the metal back to its original hardness, followed by a three-hundred-degree session in the oven to draw the temper so the edge won't be brittle. It will be polished once again to remove all unwanted color. A metal guard—or bolsters if a guard is not desired—will be attached. Finally, a handle of staghorn or hardwood will be fitted.

"The very *last* step is to sharpen it," said Williams. "Any knife I make will wind up being sharp enough to shave the hair off your arm. I don't want it in that stage until I'm through handling it."

You better believe it. As a child, Williams lost the first section of his right index finger in a wood-chopping accident. He intends to keep the other nine and one-half digits in perfect working order. He has too many knives to make, too many demonstrations to give.

"I really like putting on shows for kids," he said. "I can look out there in the crowd and see that same

A Steel-Poundin' Man

twelve-year-old boy who paid fifty cents for the army surplus knife. Lot of the kids today have never been exposed to anything like this. Once a boy asked me what coal was; he'd never seen it before. The kids can't get enough of it. Their parents will take them off to see something else, but in a minute I'll look up and they'll be back."

This magnetism affects the man at the anvil, too.

Even though Williams has crafted hundreds of knives through the years, each is an individual. Which is just the way he wants it. No two will ever be exactly alike, a testimony to the unique qualities of both metal and metalsmith.

"You spend all that time making a knife, and you really get to know it," he said. "Sometimes after you've sold it, you wish you had it back."

A
Steel-
Poundin'
Man

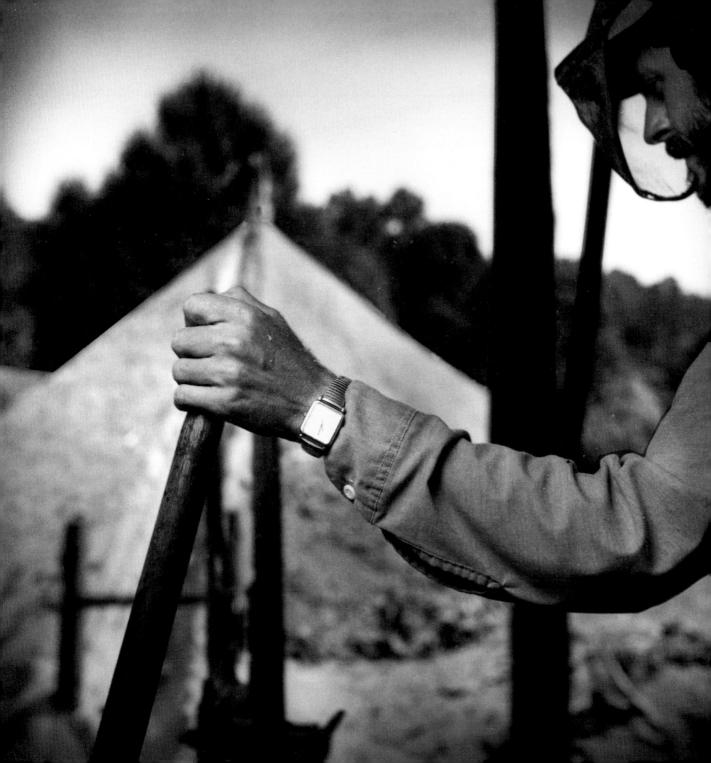

A Place of Their Own

Rick and Barbara Burnette

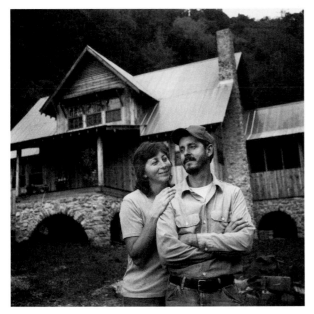

It is seven o'clock on a steamy, humid July morning. Wisps of dust puff from beneath the soles of Rick and Barbara Burnette's boots as they walk the two hundred yards from their trailer home to their sawmill, where a mountain of logs awaits.

Beanpole thin and straight as hickory, Rick surveys the scene momentarily. His eyes, greener than mountain laurel, dance across each log. He recognizes each at a glance: yellow pine, Virginia pine, yellow poplar, white oak, black walnut, red cedar, wild cherry. No curve or blemish escapes him.

Like an airline pilot in preflight, Rick methodically checks the oil level on the Ford engine that powers his mill. Satisfied all is well, he turns the key, touches the starter, and the 108-horsepower diesel motor rumbles to life. He slides a pair of safety glasses across his face, climbs to the control platform, and, with deft use of a peavey, positions the day's first log on the carriage, locking it in place with metal "dogs." He turns, faces the fifty-six-inch blade—its forty-eight whining teeth little more than a metallic blur—and draws the ratchet toward his chest.

The spinning steel orb slides into the log as smoothly as piano wire through cheese. A slab peels off. Burnette withdraws the log and unlocks the dogs, flips it with the peavey, relocks, and sends it back into the blade.

Voilà! A board appears.

Again and again and again the process is repeated. Two-by-fours come forth, along with two-by-sixes, two-by-tens, four-by-fours, shelving boards, flooring—whatever the work order and the logs themselves dictate.

Around a sawmill, there is no such thing as "men's work" and "women's work." Not because of federally mandated, multipage, antidiscrimination

regulations, either. Quite simply, every chore falls under a single category: "work." And Barbara, straight-backed, sun-baked, and strong-armed, knows exactly what it means.

At the other end of the track, she is busy stacking lumber. "Off-bearing," it's called in the sawmill business. She grasps each board as it is filleted from the log, carries it to the appropriate pile, settles it into place, returns for another. In a moment, she might be running the edger. Or stacking bundles of boards with a fork lift. Or performing any of the myriad other jobs that go with turning logs into lumber.

"Anything," she says, "except running the chain saw."

For the next eight hours, this will be Rick and Barbara's home. In an average work day, they will reduce one hundred logs into three to seven thousand board feet of lumber for barns, houses, fences. It is grimy, sweaty work. Hot in summer, cold in winter. The noise level is excruciating. Accidents, even death, are one mistake away. But the Burnettes couldn't be happier.

"Workin' at a sawmill was the first job I ever had," says Rick. "I was thirteen years old. I made a dollar an hour."

His eyes glance upward. He wrinkles his brow in mock thought. A grin opens behind his bushy black beard.

"Hmmmm," he says. "That's about what I wind up makin' these days, too!"

Rick and Barbara Burnette are proof that the American dream is alive and well. With pioneer ingenuity, backwoods grit, and a work ethic stronger than seasoned oak, they are carving their slice of the great American pie. No Wall Street wonders, these. No thick portfolios and slick sales pitches about fast-buck returns from sure-bet investments. Nor are they John Denver wannabes who recently discovered that back-to-nature living is chic.

No. Nothing of the kind. What we have here is a living, breathing, sweating, sawdust-coated mountain man and woman who set their eyes on a goal and bent their backs to turn it into reality.

The Burnettes—along with their children, Adam and Ashley, plus Josie the terrier, Lila the cow, Dan the horse, as well as assorted chickens, ducks, and cats—live on thirty-six acres at the mouth of a deep, north-facing hollow of Copper Ridge near Luttrell, Tennessee. As the crow flies, it's less than sixty miles from Sevier County, in the shadow of the Great Smoky Mountains, where they met as sophomores in high school.

Even then, Rick knew what he wanted out of life. "I always knew I'd be working for myself and gettin' a place like this. I didn't want to spend my life in some factory. Not that I couldn't do it. I've worked for other people to make this happen, and I could still do it again if I had to."

It was tough from the start. When Rick and Barbara graduated from Gatlinburg-Pittman High School in 1976, they faced a dilemma that has haunted young mountaineers since the turn of the century. There was virtually no chance of securing permanent employment. Largely dependant on a lucrative tourist industry, Sevier County is a mecca for workers only during the spring and summer. Long-lasting jobs are scarce.

Two weeks after they were married that summer, Rick left for basic training with the air force. He learned to operate heavy equipment, gaining valuable experience that would pay off after discharge when he began working for construction companies. The money was good. But something was missing, something Rick knew was as much a part of him as his teeth, his eyes, his skin—a four-letter word that had been planted in his psyche years earlier and now was about to take root and flourish.

Wood.

The opportunity came in the mid-1980s when na-

A Place of their Own

tive daughter Dolly Parton returned to Sevier County, took over the old Silver Dollar City theme park, renamed it Dollywood, and launched an immediate facelift. Rick was hired as sawmill operator.

Make that "sawmill refurbisher."

"When I got to Dollywood, the sawmill was in pitiful shape," he says. "It was hardly in workin' condition at all. Parts were layin' around everywhere. I had to tear it down and start back from scratch. Turned out to be pretty good experience for later, when I'd be on my own.

"I learned how to sharpen the blade and swege the teeth. If somethin' broke or got out of alignment, I learned how to fix it. There's books about these things, and I read a lot of 'em. Talked to a lot of the old-timers too. Guys like Belmont Parker, who'd run his own sawmill for fifty-six years.

"Belmont was amazin'. He was eighty years old at the time, and his mind was sharp as a tack. It was impossible for me to go to him with a question that he couldn't answer. The rest of the time, though, I had to learn on my own. You can't be afraid to get in there and tear somethin' apart and see what's wrong."

That was just getting the mill up and running. Once production actually began, Burnette fell into a regimen that makes commuting to the city for an office job seem like vacation.

He was on the road at five o'clock most mornings, piloting a truckload of logs from his home to the amusement park. Arriving long before the first wave of tourists, he had to unload the logs, then refill his truck with the previous day's cutting of lumber. From ten in the morning until six that evening, he ran the sawmill while out-of-towners snapped photographs and asked questions. When the park closed, he drove back home, unloaded the lumber, loaded up the next day's supply of logs, ate a quick meal, and hopped into bed. Before daylight, the cycle started again. And on days when he wasn't running the sawmill, Rick was in the woods, felling trees for raw material.

During those same years, Barbara worked in the deli for a local supermarket. She baked pies, sliced bread, iced cookies, decorated cakes, made sandwiches, dispensed slaw.

"By the time we paid for baby-sitters," she remembers, "it was not much more than breakin' even."

Long hours. Hard work. Low wages. The perfect ingredients were there for discontent. Couples have broken up over much less. When there's no future in sight, when tomorrow is a carbon copy of yesterday, folks tend to wear down. Some give up altogether.

Not Rick and Barbara Burnette. Their dream was still alive. And the dollar-here, dollar-there they had saved along the way was about to make it happen. In October 1988, they both quit their jobs and started work on a sawmill of their own.

"It had to be on a good concrete foundation," said Rick. "You put a sawmill on the ground and it'll start movin', especially after the ground starts to freeze. I poured my footers two feet wide and five feet long and set 'em four feet apart. I'd hate to find out the hard way, but I bet this place could withstand a hurricane."

It didn't take customers long to notice the industrious couple. Even before the mill was operational, folks were piling up logs to be sawed. On February 1, 1989, Rick and Barbara officially fired up the engine and seated the first log on the carriage. They haven't slowed down yet.

But sawmilling isn't the only enterprise at the Burnette farm.

Rick has built his own kiln for drying lumber. It is fueled with slabs and other scraps from the sawmill. He's stockpiling tons of sawdust in the woods, letting it rot into mulch, which he hopes to sell to gardeners. He's just finished a meat curing house and is headlong into the biggest project yet—a home of their own, complete with a root cellar. The Burnettes are building it themselves—would you expect anything else?—with materials grubbed off their own property.

A Place of Their Own

There's more. The Burnettes have also planted an apple orchard and hope to have a cash crop in the near future.

"I picked an old-time variety called the Brushy Mountain limbertwig," he says. "A lot of the agricultural experts recommended against it, but I like it. For one thing, it still tastes like an apple ought to taste. It also has a natural immunity to insects, which is good because I don't like pesticides. I've bought thousands of lady bugs and praying mantises and turned 'em loose in the orchard. I'll let them catch insects instead of using poison spray. When these apples are ready for sale, people will know they're gettin' apples that were never covered with pesticide."

The Burnettes are bringing back the soil with cover crops of winter rye, wheat, red clover, soybeans, and alfalfa. Their one-acre garden is a thing of beauty. It explodes every summer in sweet corn, green beans, potatoes, and okra. What isn't eaten immediately is canned for the winter. They raise and butcher most of their own meat. Indeed, what the Burnettes have is a little bit of pioneer America, nestled less than forty-five minutes away from a bustling city.

"I guess a lot of people wouldn't like our lifestyle," said Barbara. "It's not as relaxing as it seems on the surface. It's hard work. There's always somethin' that needs fixin'. We don't have time for going to movies or long vacations.

"But this is our life. Right here. This is where we want to be."

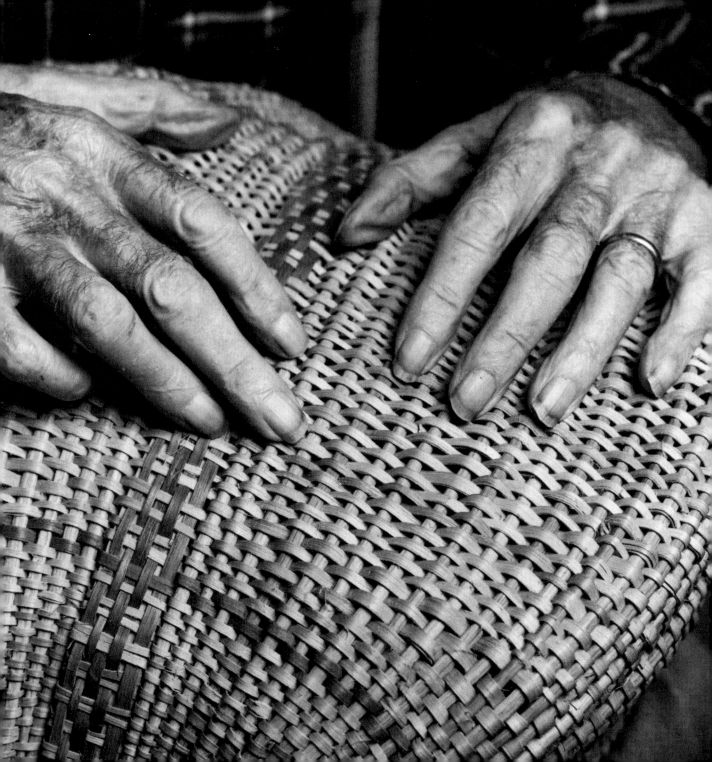

First, You Gotta Find the Right Tree"

Jesse Butcher

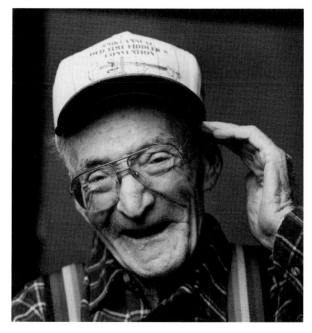

Jesse Butcher nearly lost one of his hands before he discovered what artistry it could perform. In fact, anyone who saw the lanky Tennessean in a hospital emergency room that spring day in 1977 would have considered him lucky just to be alive.

"I was sawin' locust poles for my neighbor, Earl Woods," says Butcher, who lives on a thirty-acre farm near the Knox County–Union County line in eastern Tennessee. "It happened on a hillside. One of the trees hung up in some 'possum grape vines, and I stretched out to cut it a'loose. My feet flew out from under me. When I fell, the saw landed on my right wrist."

What had started that morning as an act of neighborly assistance now became a race against death.

The whirring teeth had ripped through Butcher's arm, leaving his hand dangling from the bloody stub. Butcher had to walk a quarter-mile for help. He was rushed to St. Mary's Medical Center in Knoxville, where he underwent surgery to reattach the hand. Later, he was transferred to a hospital in Louisville, Kentucky, that specializes in nerves and bone structure of the hand. Nerves were stripped from both ankles and transplanted into his right hand. And from that point on, the retired game warden and former car salesman committed himself to full recovery and use of his fingers.

"They had me a'squeezin' dough up there in the hospital," he says. "There ain't much future in doin' that."

White oak baskets had always intrigued Butcher. While patrolling the hills, hollows, and remote farmlands of Union County as an officer for the Tennessee Game and Fish Commission, he had seen many of these baskets, some still in working condition after nearly a century of use. Upon discharge from the Kentucky hospital, he enrolled in the Youngblood School of White Oak Baskets—taught at Tennessee Technological University through the Joe L. Evins

Craft Center near Smithville—and bade farewell to his last lump of dough.

In some respects, "weaving" baskets is a misnomer. Part of the process does require a delicate, tedious, over-under lacing with thin oak splits. That's usually reserved for craft fairs and shows. But as anyone who takes them from log stage to the kitchen shelf will agree, basketry begins long before the product takes shape.

Says Butcher: "First thing you've gotta do is find the right tree. You're lookin' for a white oak. Not a red oak or a water oak or a chestnut oak. Not a hickory or a poplar, either. Some people will tell you the best place to look is on the north side of a mountain. Other people will tell you the south. Hell, they're all wrong. You'll find a white oak wherever it happens to be growin'.

First,
You
Gotta
Find
the
Right
Tree"

"You want one about four inches in diameter. I like my trees to come from a brushy thicket, where they can shoot up fast and put on lots of growth wood. A white oak growin' in the woods usually ain't no good. It doesn't get enough sunlight to grow fast enough.

"Lotta times, I gather wood with Ralph Chesney, from up at Luttrell. He's as good a basket weaver as there is in this country. Him'n me, we argue about trees. I'll find ones he don't like, and he'll find ones I don't like. But after awhile, we'll finally agree."

The tree is felled by chain saw. "I spread my feet a lot farther apart these days," Butcher says with a chuckle. "And I try not to go out alone anymore."

Even then, "accidents" can happen.

"I was high on Combs Ridge one day, nearly three-quarters to the top, and found a perfect tree," he recalled. "Started to cut it down, and that's when I noticed I'd put the dadblamed chain on backwards. Didn't have the first tool on me. There wasn't nothin' to do but leave—I hung my hat on the tree so I could find it—and walk plumb back off that mountain down to the truck."

Butcher's mouth widens into a broad grin. "I want you to know that now, I check my chain ever' time before I go out!"

The truest wood with the straightest grain is the fillet Butcher seeks for basket splits. That's the wood between the limbs. Ideally, it will run upwards of six feet in length—if he's lucky enough to find a deluxe specimen. Forty to forty-four inches is more the norm. Once the sections are brought out of the woods, the next phase of basketry begins.

And what if Mother Nature supplies an overabundance of wood at once? No problem.

"Just store it in a freezer," he recommends. "It won't warp or split on you that way."

Back home, Butcher uses a maul to split the logs lengthwise. This produces "blocks," which are split again with a froe and mallet. Over and over the process is repeated, each time resulting in a smaller section.

In Butcherese, it goes like this: "First, you halve it. Then you quarter it. Then you eighthth it. Then you sixteenth it. And so forth. You wind up with a bunch of lengths that look like little sections of a pie."

The heartwood is removed next. It's fine for splits, or "weavers," but because of its dark color, Butcher uses it sparingly, mainly for contrast. The bulk of the basket will be made from the pearly white growth wood.

Further reducing the sections into pliable weavers can only be described as a labor of love. Or hate, as the case may be. It calls for long sessions with a shaving horse and draw knife. As the pieces become even thinner, less than one-sixteenth of an inch, Butcher puts them across his thigh, which is protected by a tattered piece of horsehide, and scrapes them further.

Southern Appalachian white oak baskets come in a variety of shapes and designs, but the main ones are the egg basket (or aptly named "butt basket" because of its two "cheeks"), bushel, peck, English fan

basket, and small egg gatherer. Whatever the size and shape, each has three integral parts—the hoop (or handle), and a network of lateral ribs, all of which are bound together by row after row of weavers.

"We used t'have t'whittle each rib with a knife, but then Frank Rucker, from over at Rutledge, came up with an idea to shape 'em by pullin' them though a hole in plate metal," says Butcher. "Saves a lot of time and makes a lot more uniform rib, too."

Even then, an odd-shaped rib occasionally shows up. Butcher used to throw them into the fire. Then one day, while weaving at a crafts fair, Butcher's hillbilly humor got the best of him, and a whole new market opened up.

"This fellow walked up and asked what those reject ribs were for. I told him they was poot sticks.

"He says, 'Poot sticks?'

"Yeah," I told him. "You know, for when your wife is cookin' soup beans. Just have her stir 'em with one of these sticks, and it'll take all the poots out of 'em."

Butcher winks. "I even wrote 'poot stick' on that thing and sold it to him for a dollar. I bet I've sold hundreds of 'em ever since."

You don't just pick any ol' day for weaving. Like farming, chores must be matched to the weather. Sunny, windy days are a basket weaver's worst enemy. Butcher does most of his work during damp, overcast periods when moisture in the air helps keep the split pliable. Even then, he must dampen them frequently until they can be threaded into place.

Average elapsed time from log to completed basket? About seventy hours, Butcher estimates. Which translates to a lot of labor for a little bit of money.

"I was at a show one time and this feller said he wanted to buy one of my baskets. He gave me a ten-dollar bill and waited for his change. I told him I needed fifty-five more dollars. He just stood there and blinked. He thought the price tag said five dollars! When it finally hit him, he said there's no way

he was gonna pay sixty-five dollars for a basket. I told him I'd pay him five hundred dollars to make another one just like—and I'd give him a month to do the job. He didn't take me up on it."

One chore Jesse doesn't particularly enjoy is repairing old white oak baskets made by other craftsmen.

"Don't do it very often. Not unless it's for a friend. You see, there's a lot of individual history in a white oak basket. It reflects the person who made it. If I go back over and put my touch on it, it's been changed. I don't like to mess with history."

History is important to Jesse Butcher, with good reason. He is believed to be the last Tennessee son of a Civil War veteran. Son, mind you. Not grandson. His father, William Butcher, died in 1915, three months before Jesse was born. William Butcher's enlistment and discharge papers are part of the impressive collection of Civil War memorabilia at Lincoln Memorial University in Harrogate, Tennessee. The Butcher family contributed them in 1988.

Butcher's baskets have won praise at a number of craft shows in and around the Tennessee Valley. He's particularly proud of two best-of-shows he won during competition in Abingdon, Virginia. He's not the only basket-making Butcher, either. His wife, Roxine, also is an accomplished weaver. One of her egg baskets is on permanent display at the Museum of Appalachia's Hall of Fame in Norris, Tennessee. Jesse regularly demonstrates his craft during festivals at the Museum of Appalachia and at the Foxfire school in Rabun Gap, Georgia.

And speaking of north Georgia, that's where one particularly exquisite Butcher basket is on display. Except most people never get the opportunity to view it. Jimmy and Rosalyn Carter have it in their cabin retreat.

The former president is not the first person in high places Jesse Butcher has rubbed shoulders with. Back during his game warden days, Butcher was asked to serve as personal hunting and fishing

guide for retired army general Mark Clark, a hero from World War II. It didn't take Butcher long to realize the influence a five-star general exerts, even long into retirement.

"The general wanted to go trout fishin' below Norris Dam, but the water was running awful high," he recalled with a laugh. "I made a few calls and finally got the head man at TVA. When he realized who I had with me, he asked, 'What time does the general want the water cut off?'

First,
You
Gotta
Find
the
Right
Tree"

"I didn't know much about trout fishin', but I got hold of Eddy George, who was a sporting goods dealer in Knoxville back then. A real good trout fisherman. Eddy drove up to the river and brought some hip boots for General Clark. Turned out Eddy'd gotten him two right feet! I'll never forget what he said to the general: 'Hell, wear 'em! That's what they used to say to me when I was in the army!' And that's just what General Clark did. Wore 'em all afternoon. Caught a limit of trout too—although I'm still not sure Eddy didn't help him along."

Butcher was among the first group of full-time conservation officers hired by the state after the 1949 model game and fish management act was passed. Prior to that time, game wardens were little more than fee-grabbers whose pay was based on the number of arrests they made.

"I'd worked for TVA before and after the war," he remembered. "Did everything from clear the dam sites to work on a drillin' team to servin' on the security force. But when the game warden job opened, I was glad to take it. I always wanted a job where I could be in the outdoors all the time."

His wish was granted in spades. Over the next seven years, Butcher chased illegal hunters and fishermen through the winding roads, dark hollows, and narrow rivers of Union County. Looking back, he says it was some of the most rewarding work he'd ever done.

"People were all the time catchin' fish in traps. No telling how many of 'em I dynamited out of these rivers. I was always findin' illegal nets, too. It was pretty easy to figure out who was netting. See, in those days, the ol' boys would tar their nets to keep 'em from rottin'. I'd float down the river till I found me a boat with tar streaks across the bow where they'd hauled in the net. That was a good giveaway. If there was leaves in the boat, I had 'em for sure."

Leaves?

"Sure. You dump fish out on the bare floor of an old wooden boat and they'll go to thrashin' all around. You put down a carpet of leaves, though, and they won't hardly make any commotion at all.

"Anyhow, once I found the boat they were using, I'd just look around and find the nearest bend of the river. Fish are just like people going around a curve. They'll take the inside bend. That's where I always found the nets."

Today's conservation officers use sonar and other sophisticated gear to pinpoint the site of illegal underwater operations. But in Butcher's days, it was a matter of dragging for contraband. He hollowed out a baseball bat, filled the center with lead, and attached it to a stout cord. After driving dozens of finishing nails partway into the bat, he had a fine grabbling hook.

"I could take that thing and throw it into the bend of a river and in four or five passes would find the net," Butcher said. "Then I'd pile all the net on the bank beside the boat and burn it.

"All it did was slow 'em down, though," he chuckles. "In those days, a good net maker could weave a new one in twenty-four hours."

Sometimes, the good ol' boys were even quicker than that at outsmarting their nemesis. Butcher loves to tell about the day he was patrolling Norris Lake and happened to spy three bank fishermen standing in the end of a long, narrow cove.

"I suspected none of 'em had a fishin' license, but I knew they'd run from me if I just roared in there

with that state boat," he began. "So I decided to sneak up on 'em. I motored on up the lake, just like I hadn't seen a thing. Went a pretty good distance, too, so I'd be out of hearin'. Then I eased over to the shore, tied my boat to a tree, and started climbin'."

Butcher's plan was to sneak up on the trio from behind. It worked to perfection. Moving from tree to tree, quietly, slowly, cautiously, the lawman finally closed the distance.

"I stepped out behind them and said, 'Boys, I'm the game warden. I need to see your fishin' licenses.' Wel'sir, they looked at me, and then they looked at each other, and then they busted up like a covey of quail. I took off runnin' after the closest one—and don't you know he'd have to be the one with the longest legs! That ol' boy led me right back up the hill I'd just snuck down. I bet we ran a good hundred yards before I caught up with him. I grabbed him by the belt. We were both about to puke 'cause we'd run so hard.

"Finally, he says, 'Hang on a minute.' He reached in his pocket and came out with a license. It was up to date, legal, and everything. I looked at it a second and said, 'Hale far, son! If you had this license all along, how come you ran me up this hill?'

"The ol' boy just grinned real big and said, "Cause my brothers down yonder ain't got nary'un.'

"I looked back where we'd come from, and there wasn't a soul in sight. Those ol' boys had suckered me good. There wasn't nothin' t'do but bust out laughin' myself!"

Butcher did enjoy his share of successes, however. Occasionally he slipped undercover to expose illegal hunting and fishing operations in other areas of the state. One of the biggest busts occurred on Pickwick Lake, where a gang of netters was catching and selling black bass. Using fake identification, Butcher and fellow officer Earl French infiltrated the poachers' camp and earned their trust.

"Stayed with 'em two weeks," he said. "We ate and camped and fished right alongside 'em. When we got all the information we needed, me'n Earl turned it over to the local authorities to make the arrests. We didn't hang around for that. We slipped back here to the hills.

"You know, though, most folks was real easy to get along with. I never bothered their stills and never shot anybody's dog. Usually didn't even carry a pistol, 'cause I figured there wasn't any sense usin' a gun to arrest somebody for huntin' squirrels out of season."

One case he investigated became a landmark court decision. It involved Butcher's arrest of a suspected deer poacher and confiscation of his car, which Butcher suspected contained a dead doe in its locked trunk. The defendant argued that Butcher's actions constituted illegal search and seizure. The case went all the way to the Tennessee Supreme Court, which affirmed the game warden's decision. This marked a historic first for law enforcement, even if it was a money-losing venture.

"It took so long to work through the courts, the state wound up spendin' more money to store the car than we got when we sold it at auction," he laughed.

Butcher's law enforcement career came to a close in the mid-1950s when he took a job selling cars for Reeder Chevrolet in Knoxville. "It wasn't as relaxin' as game warden work" he noted, "but you shore could make a lot more money!"

His quick wit and gift of gab instantly made him a success.

"I sold a lot of cars to a lot of people over that time. The only one I ever regretted was when I sold this young boy a '57 Chevy. It was loaded. Big V-8, stick shift, the works.

"Sold it to him at two o'clock on a Saturday afternoon, and he was killed at eight that night. Drag racin' at a hundred miles per hour. I mean to tell you, that bothered me for a long, long time."

First, You Gotta Find the Right Tree"

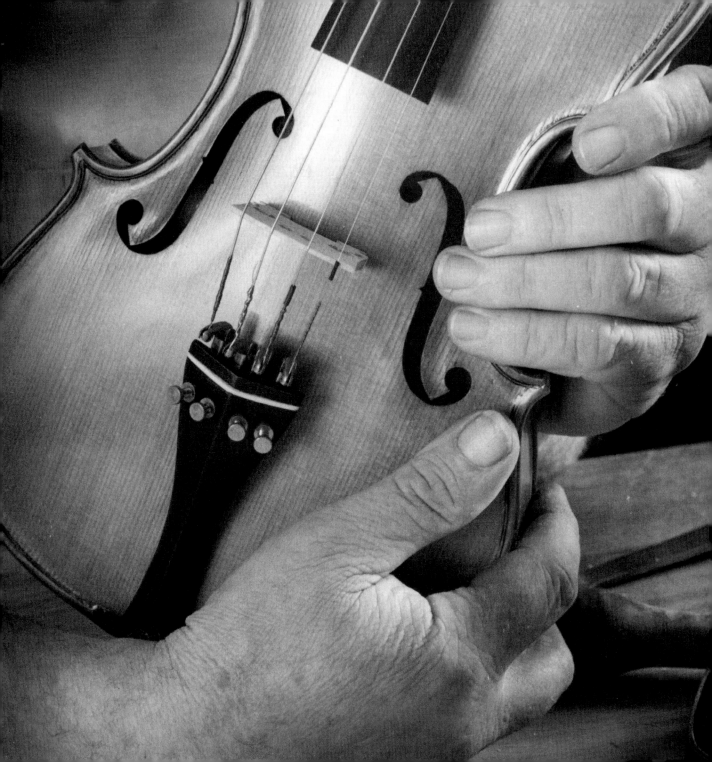

The Music Maker

Gene Horner

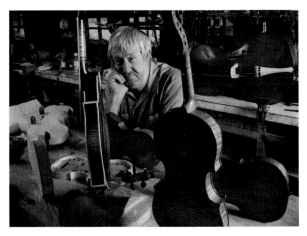

The Fabulous Fifties had arrived, and things couldn't get much better. The Great Depression was ancient history, World War II a fading memory, and Americans were back on their financial feet, striding confidently and blissfully down the road to eternal prosperity.

Most of them, anyway.

Young folks who hailed from the misty ridges and dark hollows of southern Appalachia were not exactly overburdened with homegrown occupational opportunities. For many of them, there still existed only one surefire formula for vocational success, the same one that had presented itself when their parents came of age: Go north, young man.

"That's what almost all my generation did," re-members Gene Horner. "You got out of school and got yourself a job in an automobile plant. There was good money in it."

Perhaps. But it also meant leaving paradise, and that's a step Horner wasn't ready to take.

Oh, he'd been around. Four years in Uncle Sam's navy had given the country boy a glimpse of life outside the confines of Cumberland County, Tennessee. After he was discharged in 1955, Horner even went so far as to visit a buddy near Dayton, Ohio, and flirt with the idea of settling in that foreign land. The notion passed quickly.

"I realized livin' up north just wasn't for me," Horner says with a gentle laugh. "I decided to come back here and starve it out."

Not surprising. "Back here" in the Westel community has been a refuge for Horners for two hundred years. Except the family name was "Harner" then, brought to America from Austria by Gene's great-great-grandfather, Christopher. What's more, the land on which these folks eventually settled was part of Roane County at the time. That didn't change until 1855, when Cumberland County was formed.

Gene Horner knows his family history. He has no choice in the matter, for history is all around him. He was born in 1933 in a one-room poplar log cabin. It's the same cabin in which his father, Charles, was born in 1903. The same cabin his grandfather, William, built around 1896.

"The way it was told to me, my great-grandfather, Adam, was born around 1800 while his family was moving to this area from Pennsylvania," says Horner. "He settled around here and wound up owning a lot of land. About sixty-six hundred acres."

Ownership of huge tracts was not uncommon in those days. If a man needed a mule, he could always trade a hundred acres or so to get one. Or, strapped for cash, he might sell more of the spread for the outlandish price of a dollar an acre. Horner's forefathers did a masterful job of whittling down their holdings. By the time his grandfather died in 1918, only thirty-seven acres remained.

Right there's where Horner lives and works today. His home sits roughly one hundred yards west of the cabin where he was born. Horner built the house himself, largely from wood salvaged from the Waldensia Hotel, about four miles up the road in the coal mining community of Dayesville.

"The mines up there had gone busted, and the heirs started selling everything off," says Horner. "I bought that old hotel for 125 dollars and started tearing it apart. Took me thirty days. I had to throw some of the wood away 'cause the bugs had eaten it up. Sold part of it to get some of my money back, too. I quarried the stone for the foundation and made the windows and doors. By the time I had the walls up and black felt on the roof, I had sixty-five dollars in that house. 'Bout all I had to buy was nails!"

If you're getting the notion that Gene Horner knows something about (1) working with wood and (2) making do, you're on the right track. For nearly fifteen years after he and Anne Lawson got married in 1957, Horner earned his living as a cabinetmaker. For eighteen months during that same period he also tried "public works," hiring out as a forklift operator for the Civil Defense office in Rockwood. He quit just in time to come down with a ruptured appendix.

"My wife was about to have a baby, I had a new car to pay for, we had no money, and I couldn't work

for three months," he sighed. "When you're up to your neck in alligators like that, you better make friends with the alligators! I drew a little unemployment check for awhile. It wasn't much, but it kept us going till I could get back on my feet."

Horner's fortunes were indeed about to change. Not quickly, for sure. In fact, more years of cabinetmaking would pass before he could devote full time to a different type of woodworking. But the change did come. So did the customers.

"I'd always been intrigued by fiddles," he said. "When I was about fourteen years old, I found my grandfather's old fiddle in a trunk. It was busted all to pieces. I stuck it back together as best I could. Made a bow with horsehair—not much more than a stick, really—and went to scrubbing on the thing. I didn't know what I was into. Didn't have the first idea how to start. Matter of fact, I was nearly twenty-five years old before I heard a real, live fiddle player."

As always, it was make do or do without. With little more than a pamphlet and static-filled radio music to guide him, Horner taught himself how to play the fiddle. It was not a classic education.

"I learned a lot of bad habits, like holding my wrist wrong. But there wasn't anybody to show me any different. Teaching string music in school was unheard of in those days. I still can't read music. It's all by ear. It finally dawned on me I wasn't going to be a virtuoso, so I decided if I was going to stay in this, maybe I ought to learn to make the instrument."

On his own, of course. By trial and error.

"The first few I tried were a terrible mess," he said. "No matter what somebody might tell you, this is not the best way to learn. It takes so much longer. You can learn more in four years from a master instrument maker than you can learn on your own in twenty. I make a pretty good fiddle these days, but it could be a lot better if I'd had some training from the start."

The Music Maker

Pretty good?

The professional musicians who use Horner's instruments would surely classify that as understatement. From the Grand Ole Opry to Dollywood to county fairs to bluegrass festivals, Horner's fiddles—as well as his mandolins, guitars, banjos, even a bass or two—send forth the sweet mountain music of America. Singer-songwriter John ("Gentle on My Mind") Hartford uses a Horner fiddle. As does Jim Buchanan of the George Jones band, and Paul Justice, who plays for Mel Tillis. Plus Nashville recording artist Kenny Sears and country comedian-musician Mike Snider. What's more, Horner fiddles have been displayed at the National Folk Arts Festival in Washington, D.C.; the Future Homemakers of America Museum in Reston, Virginia; the Museum of Appalachia Hall of Fame in Norris, Tennessee; the Tennessee State Museum in Nashville; and the Hunter Museum in Chattanooga.

"I was sittin' in the audience at the Grand Ole Opry one night when Kenny Sears opened the show playing 'Old Joe Clark' on one of my fiddles," he recalls. "Man, what a thrill! I may not be a member of the Opry, but my fiddle is!"

All the work, from the first cut of a maple blank to the final coat of varnish, takes place in Horner's twenty-four-by-forty-foot shop that he built himself—with some of that same old Waldensia Hotel wood. The shop sits about sixty yards south of his house, at the end of a row of towering walnut trees his father planted in 1932. Horner gets there early, four-thirty or five o'clock some mornings, and works till he decides to quit.

On this particular day, the doors at either end of the shop are thrown open to allow passage of a cool breeze blowing off of Waldens Ridge. From one door comes the coarse *che-wink* of a towhee, from another the bubbling song of a Carolina wren. Interspersed is the monotone *rum-rum-rum* of a bullfrog in the small pond that sits between the shop and the old log cabin. Horner created the pond in 1970 when he dammed the small spring creek that flows through his property. From where he works, he can look out to the very spot where, as a boy, he used to fetch water for his mother.

Visitors are always welcome in Horner's shop, just as long as they don't mind getting a little dust on their clothes. This place is a woodworker's delight, its floor lined with band saws, drill presses, lathes, shapers, carving machines, planers, jointers, table saws, plus uncountable dozens of hand tools, gouges, knives, and clamps, many of which he made. Not to mention stacks upon stacks of wood, patiently waiting their turn on the workbench.

Horner uses curly maple for the sides and back of his fiddles, and either red or German spruce for the top. For tuning pegs, he selects a variety of woods, including mountain mahogany, ebony, rosewood, and boxwood. He begins each piece by cutting the side, a thin strip approximately one-sixteenth-inch thick, then soaking it in water to make it pliable, shaping it with a heated cast-iron bender, and attaching it to a plywood mold—which, naturally, he made himself.

Using another homemade pattern, Horner saws the top and back from a sheet of maple roughly five-eighths of an inch thick, then shaves them down with small planes and gouges to thicknesses ranging from two and a half millimeters on the edge to three and a half millimeters in the center of the back. The scrollwork on the neck must be carved. Ditto the heart-shaped pegs. The piece might be inlaid with mother of pearl or ebony. And "purfling," a narrow, ribbonlike inlay that flows along the contours of the instrument, is cut with a small, sharp knife. Other parts, like the bridge, neck, fingerboard, and tailpiece, are installed. Everything is glued together, then varnished.

"I can make a fiddle, start to finish, in seven or eight days, maybe even less," said Horner, "but the

The Music Maker

varnishing takes longer because it has to dry between coats. I usually put on anywhere from seven to ten coats."

Is the finished product a fiddle or a violin?

Horner grins at the question: "If I'm sellin' one to you, it's a violin. If I'm buyin' it from you, it's a fiddle. Violins cost more, you see.

"Actually, there's not a bit of difference in this world, and anybody who says otherwise is ignorant. The word 'fiddle' comes from the English language. 'Violin' comes from Italian. Oh, the music you play on them can be different, but there's all kinds of music—classical, jazz, country, whatever. The instruments themselves are the same."

And as far as Gene Horner is concerned, they'll never be improved. He ought to know. He's made more than four hundred.

"The fiddle is a perfect instrument," he says. "You can't change it. It's been that way for three hundred years, and no bright-eyed kid out of college is going to redesign it. It's a simple wooden box, and yet it's complicated. You never know what you're going to get when you make one. The bottom line is when a musician tucks it under his chin, and he likes the sound it makes.

"Nobody has ever made two fiddles exactly alike. It won't ever happen, either. Some are goin' to look and sound better to me than to you and vice versa.

"All you know is that when it's finished, it's goin' to make a sound the world has never heard before."

The Music Maker

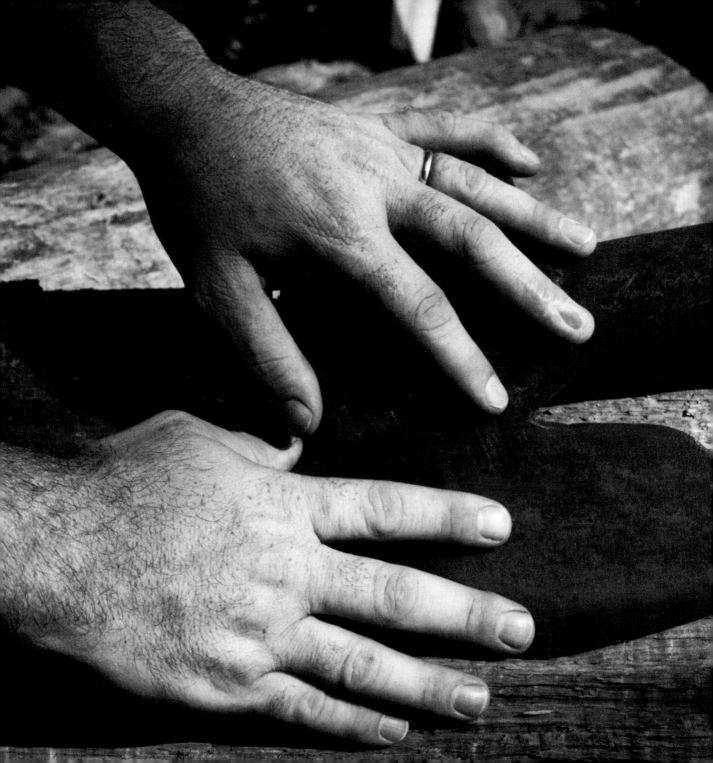

Rebuilding the Past
Rex McCarty

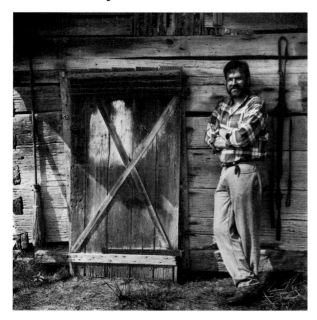

Sometime near the middle of the nineteenth century—around 1840, as best anyone can tell—Nathaniel Smythe began construction on a four-room, two-story log house on the banks of Moccasin Creek in Scott County, Virginia.

In those pioneer days, function took precedent over flair in matters of architecture. Thus it didn't seem to bother anyone that the roof line dropped approximately six inches to the left. Why fret about something as trivial as looks? The walls were sound enough to keep winter's fury at bay, the doors opened and shut without binding, the roof shed water effectively, and the chimney drew admirably.

A century and a half later, Rex McCarty rebuilt that very same house from the ground up. Or the roof down, as the case may be. He pried it apart—beam by beam, log by log—loaded everything onto two flatbed trucks, and drove the entire package four miles southeast to Wadlow Gap. There, on a fourteen-acre tract of land, he reversed the process and carefully put all the pieces back together, log by log, beam by beam. Including the six-inch drop.

For heaven's sake, *especially* the six-inch drop!

"Isn't that just beautiful?" McCarty asks softly, hands on hips, as he stands in the front yard and gazes up at the fruit of his labors. "What character! What a great conversation piece!"

It is gross understatement to suggest that Rex McCarty has "an interest" in the history of southwest Virginia. People with "an interest" in a particular element of the past poke around at their leisure. People with "an interest" might buy a book or subscribe to a magazine to feed their need. People with "an interest" might even go so far as to talk to an old-timer and scribble down some notes.

Hardly the case here.

"Consuming passion" more accurately describes the affliction. McCarty has thrown himself headlong into the mission of re-creating, in fine detail, a

mountain farm community. It's located alongside the historic Daniel Boone Wilderness Trail on the outskirts of Weber City, Virginia. Appropriately enough, he calls it the Homeplace.

This is not some country-chic endeavor spawned of yuppie intrigue. When McCarty talks about his roots, he speaks with vivid recall of his own up-bringing in the steep ridges and dark hollows. He is one of twelve children born to Jack McCarty, a hard-working coal miner, logger, farmer and jack-of-all-trades, and his wife, Alice. As the rural expression goes, the McCartys lived "way out yonder" in the mountains. Rex is the only member of his family with a college education. Six of his siblings did not complete high school.

"The first place we lived was on Sinking Creek, up near the Scott-Russell county line," says McCarty. "It was really out in the country. We had electricity, but no indoor plumbing. All us kids worked around on the farm when Dad was off at the mines."

Bright lights and big city lay just across the ridge. But they were oh so far away, figuratively speaking. It wasn't until the early 1980s that Rex traveled farther than Kingsport, Tennessee. That's when he helped his soon-to-be brother-in-law move from Nebraska to Virginia. He can still remember the exhilaration at reaching the Kentucky border on the trip west: "I thought I'd come to the end of the world."

McCarty may make light about his early back-woods years, but his mood turns serious when he talks about the lessons he learned along the way.

"My dad has always been my hero. Here is a man with a tenth-grade education who worked hard all his life to raise twelve children. He taught me there wasn't anything I couldn't do if I'd just put my mind to it. The first day I went to college, we pulled up to the gate in the battered old Volkswagen he drove back and forth to the mine. He held out his rough hands and said, 'Now son, I've taught you

how to use these.' Then he pointed to his head and said, 'You go in there and learn how to use this.' It about tore me up."

At that point in his life, McCarty assumed he'd follow his father into the mines, albeit in a professional job. He earned a joint degree in mining engineering and education at Mountain Empire Community College. But coal markets were drying up by then, and the mining economy of the region was drastically reduced. A new chapter in his life was about to open.

He married Lisa Watson, a Colorado girl who'd moved east when her father bought a weekly newspaper in Virginia. After graduation from Mountain Empire, Rex continued his studies at the University of Tennessee and then earned a degree in business management at Virginia Intermont. He joined his wife's family's newspaper enterprise, first with the *Powell Valley News* in Lee County, Virginia, then at the *Scott County (Va.) Star,* where he currently is publisher.

Just before he began working with the Lee County newspaper, however, McCarty took a summer teaching job at the Tate School, a small private institution in Knoxville, Tennessee. One day he accompanied the students on a field trip to John Rice Irwin's Museum of Appalachia at nearby Norris. It was an experience he recalls in infinite detail to this day.

"It was incredible. I was amazed by the place. I didn't realize there were this many of the old log buildings left. I just wandered the grounds, absorbed in it all. After the field trip, I went back to the museum and wandered the grounds some more. I still go there a lot.

"When I walk those grounds, I can actually hear voices from my past. I can hear my dad. I can hear my Grandmaw. I can hear my mother's voice singing those old Baptist and Pentecostal songs, never hitting a tune, but in a voice that is so rich and with such pureness of heart, it makes the song what

it is meant to be. I could absolutely *feel* the past come alive in me. Even though I had grown up in this culture, I realized there was so much I was missing. When Lisa and I moved to Lee County, I made a commitment to learn everything I possibly could about mountain people, mountain ways, and mountain trades."

McCarty wasted little time. In October 1984 he was helping with the Tobacco Festival, a folklife celebration sponsored by the newspaper. There he ran into a shingle-river named Howard Ledford, who agreed to teach the youngster the tricks of his trade.

It was not an easy education.

"Howard cussed me from start to finish," McCarty says with a laugh. "I brought some white oak to work with. He didn't like that a bit. He wanted red oak because it splits easier. He gave me a good cussing and said, 'I told you to bring some *good* wood! I ain't gonna waste my time tryin' to learn you how to make shingles with bad wood!' I guess anybody else would have run off and left him, but I was determined to stick it out. I kept coming back, and enduring his cussing, till I learned to make shingles. Out of red oak, of course."

His next lesson was a bit easier. Seventy-eight-year-old Oscar Ely, a chair caner who lived in Etowah, Tennessee, was working at the Tobacco Festival the following year. Slowly, patiently, he tutored McCarty on the how-to's of this particular art. McCarty went back home, completed a chair to the best of his ability, and sent a photograph to Ely.

Close, but no cigar.

"Oscar came busting into the newspaper office the week of Thanksgiving," McCarty recalled. "He set a chair down and said, 'Let's try it again.' We went over it and over it. Finally, I said, 'Oscar, I've got it.' It really pleased him because he had finally found somebody who was truly interested in his craft. I went home and bought two or three old chairs and fixed them up perfectly. I used a beauti-ful basket weave he had taught me. I was so excited about them. I took some more photographs and put them in an envelope and mailed them to him. I'll never forget the date—December 6, 1987."

Unbeknown to McCarty, Oscar Ely had died of a heart attack that same morning.

"By the time I got to the office, his daughter-in-law had called and related the sad news," McCarty said. "Immediately, I drove back to my mailbox to get my letter. I don't cry much, but I'm going to tell you, one of the hardest things I've ever done was reach in there and pull that letter back out. Oscar never knew I had learned the trade."

But the legacy lived on. Late on Christmas Eve that year, Rex, Lisa, and their children were returning from a party at his parents' home. As he pulled into the driveway, the headlights of his vehicle flashed by some chairs stacked in his carport. What in the world were they doing there?

"I walked over to them and found a note from Bill, Oscar's son. It said how happy their family was to know I had learned Oscar's trade. They had rounded up all of his chairs and brought them to me. Gosh, what a Christmas present! Ever since then, whenever I'm doing a chair-caning demonstration at the Homeplace or at a craft show, I think of Oscar. I bet I've given away a hundred chairs. Each one is dedicated to him. He passed on a skill from his hands to mine. I'll never forget him."

As McCarty talked to more old-timers and learned more old-time ways, the fire within his soul continued to flicker. It was about to burst into full flame. The opportunity came in 1995, two years after he and his family had moved to Gate City, Virginia, to take over the Scott County newspaper.

"Ever since that first trip at the Museum of Appalachia, I had thought about doing something like that myself," he said. "One day, I heard that the old house Nathaniel Smythe had built in 1840 was going to be burned down. A church down in Gate City owned

Rebuilding the Past

the property it was on. They wanted to clear the place and build a playground. I asked for a chance to move it. Almost the very same day, I heard that these fourteen acres of land were for sale. It was perfect timing."

True. But the logistics did leave something to be desired, for McCarty was less than prepared for such an undertaking.

"I didn't have the first idea what I was doing," he admits.

But he knew where to turn for help.

"I asked Dad if he'd ever taken a house apart and moved it, and he said no. But he had built a pole shed kind of like it once, and he figured we could work our way through it. That's how we did it. I marked each log, made notes how it sat, and took it apart, just like it was a Lincoln Logs set. That's how the Homeplace got its start."

The move sparked no small amount of good-natured kidding in and around the Weber City area as the locals gathered to watch "that newspaper man" clamor around on logs, hammer in hand. Before long, though, folks realized how serious he was. They stepped forward with news about an old cabin here, a dilapidated barn there.

Would McCarty be interested in them, too?

Does a chicken like cracked corn?

"Before I could hardly turn around, I had more than I could say grace over," McCarty remarked, sweeping his arm around the Homeplace. "All these buildings are in place, plus I've got ten more that are torn apart and in storage, waiting until I can get more land to put them on."

A stroll around the Homeplace offers delightful vignettes into life in the pioneer days of southwest Virginia. With a constant eye on detail and accuracy, McCarty has erected eleven structures. He knows every nook and cranny. When he speaks of these buildings, he's talking about treasured old friends. As he puts it, "There's not a log, there's not a rock, there's not a nail in this place that I haven't touched."

Before McCarty removes the first old shingle or piece of tin at the original site, he makes a careful study of the building's precise location and foundation. He notes which direction it faces and tries to duplicate this at the Homeplace. He marks each piece, no matter how large or small, before it is removed to make certain it goes back in the correct order. The only time he replaces a log or beam is when decay has rendered it useless, or, in the case of chimneys, when modern building codes mandate specific changes on structures open to the public. Otherwise, everything else is as true to history as humanly possible, right down to the window panes.

What's more, McCarty works whenever possible with tools of the period. No electrical or gasoline-operated gadgets, thank you. Part of this insistence is for historical purity. Part is for self-protection.

"I did this on a table saw, trying to make a fret board for a dulcimer," McCarty quipped, displaying a scarred finger. "I realized right away that I need to stay away from electrical tools."

Every building at the Homeplace has a story to tell. There's the leaning-roofed Nathaniel Smythe place, of course, which McCarty has named the Aunt Lyde Cabin, after Smythe's daughter. The downstairs has two distinct areas that its nineteenth-century residents used for relaxation at the end of a hard day's work on the farm—one for men, one for women.

"This house has served many purposes over the years," McCarty says. "In addition to being a home for several different families, it was also a stopover point between Castlewood and Kane's Gap along the Daniel Boone Trail as settlers headed west to Cumberland Gap and beyond."

The William Haynes home, circa 1860, came from Possum Creek in the Yuma community of Scott County. McCarty calls it the Loom House and has made it the headquarters for all spinning, weaving, and quilting activities at the Homeplace. Whereas

most log structures were made from oak and poplar, this one features pine.

"That's probably what was on the site they originally cleared for the place," he noted. "No sense in bringing in logs when you've just cut down a bunch of trees. Oddly enough, these logs still ooze a little rosin. Dad says the house is still alive."

You could say the 1835 Charlie Osborne Cabin, which has been brought back as a broom shop at the Homeplace, literally *was* alive. When McCarty found it in the Big Moccasin section of Scott County, there was a large maple tree growing through the center and a smaller poplar just outside.

The Patrick Franklin Smokehouse is situated as it would have been when it was built in 1870—toward the front, and just off to the side of, the main living quarters. "If the dogs were barking and there was a commotion going on outside, the man of the house would simply have to grab his gun and come out the front door. In all likelihood, something—or somebody—would be trying to get into the smokehouse."

There's another building that always had its own particular location at any mountain farm homestead. The outhouse. As McCarty notes, pointing to the Homeplace's privy, it was set *just* far enough away from the other buildings—but not so far as to make midwinter treks more miserable than they were already. Ideally, this would also put it in the path of prevailing winds that would usher any unpleasant scents elsewhere.

On and on the list continues. There's a blacksmith shop, a sorghum mill, corn crib, springhouse, kitchen, and woodshed, each labeled with interpretive signs that tell of its past. They're all surrounded by a fence that, McCarty will tell you, numbers in excess of forty-two hundred cedar rails. He knows. He split the vast majority of them himself.

Which reminds McCarty of another poignant story about his hero: "We held the grand opening of the Homeplace on December 7, 1996. I had literally worked up to the last minute getting everything ready. My hands were so cold and raw and swollen, I had to put on gloves to shake hands with all the folks that dropped by for the ceremony. It came time to officially cut the ribbon, and I called Mom and Dad up to the front to help. There stood Dad, bare-handed as usual. I just kept focusing on his hands. I kept thinking about all those years he'd worked bare-handed in the mines and in the fields to keep his family fed. It was a special moment for me. He's an amazing man."

Make no mistake. This is a business venture, and Rex McCarty is a businessman. He envisions the Homeplace ultimately as a full-time interpretive educational facility for studies of mountain farming and crafts. He has already started the Clinch Mountain Cultural Center on the property. His craft shop features wares from local artisans. At various times during the year, the Homeplace hosts music shows, Civil War encampments, a fall festival, and a big Christmas celebration. Just like in the movie *Field of Dreams,* he has built it, and the tourists are coming.

But in this venture, capitalism is merely a means to an end. The driving force is not the almighty dollar.

"I feel an enormous responsibility to the people of this region," says McCarty. "I want to make sure they are not forgotten. These are my people. They are my family."

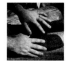

Rebuilding the Past

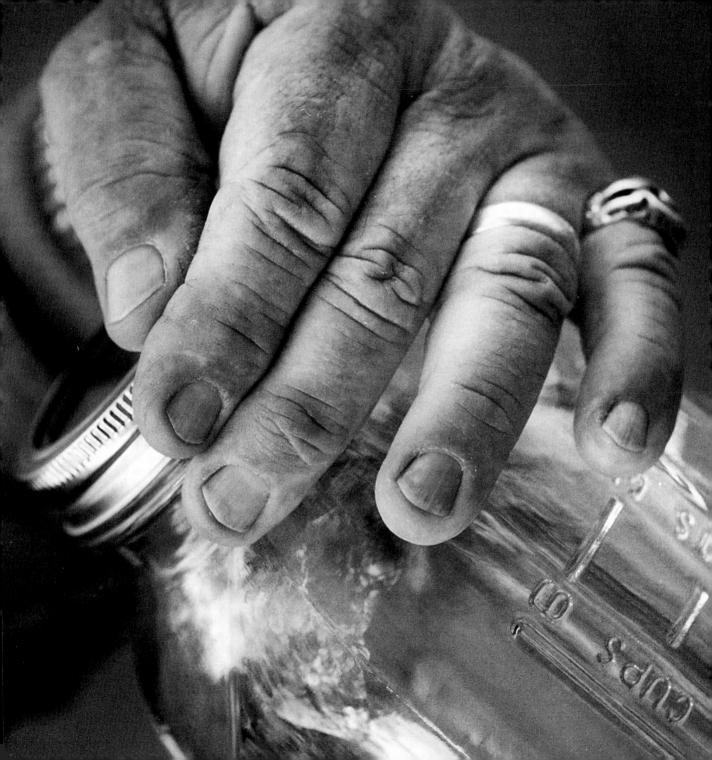

The Second-Oldest Profession

Von Russell

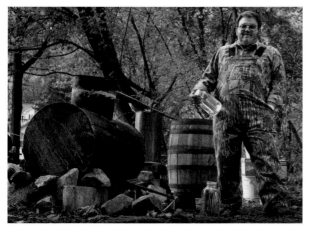

Von Russell is a nondrinker. Hasn't touched a drop in more than twenty years. This was not, he insists, a choice he'd dare presume to make for anyone else. He'd simply had enough. Alcohol was giving him belly aches and starting to exercise more of an influence on his life than he desired. So he put down his cup and never picked it back up.

Yet two times a year, Russell torches the fire under a copper whiskey still and runs off a few jars of nectar from the hills.

This act has nothing whatsoever to do with financial reward. Quite the contrary. It is a matter of pride, tradition, and an incredibly strong link to, and appreciation for, Russell's southern Appalachian roots. And it came about largely because of a revelation he experienced on a squirrel hunt at his grandfather's farm.

Winfield Russell spent all of his ninety-one years scratching out a living on fifty hardscrabble acres overlooking the Powell River in Claiborne County, Tennessee. It's not hard to find on a map of the area—just look for Russell Ridge. Fiercely independent, he never once "hired out to public works," the mountain term for a conventional job. Von remembers hearing the old man talk about how he would cut timber in the Powell watershed, bind the logs into rafts, and float them all the way downriver to Chattanooga. After the sale, he'd ride a train to Knoxville, then light out for home on foot.

"A fellow might wear out two or three pairs of socks doin' that these days," Russell says with a laugh.

So devout were his backwoods convictions, Winfield Russell even refused to change his clock when the federal government switched east Tennessee from central standard to eastern standard time, let alone daylight saving time.

"Sometimes my grandpaw would be two hours off of everybody else," Russell said. "Didn't make a bit of difference to him. Whenever he'd call me on the phone to come huntin', he'd always say, 'Be here on my time.'"

Every hunt followed the same script. Von would bring a pound of fresh country sausage and the fixings for biscuits. He and his grandfather would eat

breakfast, and then the old man—by now too weak to climb the steep ridges—would lay out Von's hunting route for him.

"He'd always tell me to go to a big hickory in such-and-such a holler, or swing by the old beech over yonder, maybe climb up this ridge or that ridge. They were all places he and I both knew. When I'd get back to the farmhouse, he'd always ask where I'd been. The first few times, I didn't go where he told me, and it irritated him. Finally, I'd either go where he said—or at least tell him that's where I went—and show him the squirrels I'd shot. He'd just light up all over.

"That's when it hit me. I realized he was relivin' his life through me."

It was a watershed moment in the young man's life. Everything came into focus. All the formative years he'd spent roaming the rugged hill country around the Tennessee-Virginia-Kentucky border. All the colorful mountain folk he had met. All the experiences he and his boyhood friends had shared. This was his homeland. His people. His heritage. It's an intangible of human existence only a lucky few in these waning days of bustling, high-tech, twentieth-century America are fortunate enough to discover. From that moment on, Von Russell was a man possessed with the old ways.

"It's the sort of thing you don't even think about as you're growin' up," he says, sitting in the den of his comfortable brick rancher on the outskirts of Harrogate, Tennessee. "Oh, every now and then, somebody might call you a hick 'cause you like country music or laugh at the way you talk. You don't understand it at the time. I'd say most teenagers today wouldn't understand it. But maybe they will—and they'll realize this is somethin' they don't ever want to lose. It's like this: You can't go around the next bend in the road without lookin' back at the bends you took to get there. Know what I mean?

"Things I wouldn't have thought twice about as a kid started gettin' more important. Like the sayin's people have around here. Just the other day, this old feller was tellin' me about losin' one of his cows. Said he'd looked for her for a week. Then he said, 'All of a sudden, I found her all at once.' I knew exactly what he meant. Tickles me to death to hear stuff like that."

Every facet of his upbringing recrystallized in Russell's mind. Now he understood why he salt-cured his own hams even though he could buy pork at the grocery store, why he scoured the river bluffs for ginseng, yellow root, star root, and other herbs, why he maintained hives of bees in his back yard.

"It's not for the money, that's for sure. I never made much off my honey. The most I ever got for my ginseng was maybe five or six hundred dollars. You do it because it's who you are. It's part of you. It lets you be outdoors, where you know you ought to be.

"Actually, I had to quit the bees a few years ago," he said. "The mites were gettin' bad and killin' off some of my hives. And besides, I reckon I got stung a few too many times. The stings never did bother me for long—about like a 'skeeter bite, really—but they got to buildin' up in my system. I started swelling. The doctor told me I'd better give 'em up before I really got hurt. I hated to do it. I really had a passion to keep bees, almost as much as my passion to make whiskey."

Ah, yes. That good ol' mountain dew.

Despite its colorful hillbilly legend, moonshining is not purely a southern Appalachian phenomenon. In fact, the history of making alcoholic concoctions from fermented fruits and grains is virtually as old as humankind itself. Doing it on the sly began in the mid-1600s when distillers in England, Scotland, and Ireland suddenly found themselves under the watchful eye—and, more important, the taxing arm—of the government.

When these same people and their descendants immigrated to North America, they brought with them both a love for bottled spirits and a hatred of official intervention. Thus was born a cottage industry that, though long since past its peak, is occasionally practiced in this country today, particularly in the more remote, mountainous areas. Almost any old-timer in rural southern Appalachia—once he has established the credentials of the inquirer, of course—will casually admit to "a'knowin' a few fellers who used to make whiskey."

Some still do.

Let us state for the record that Von Russell's distilling operations are carried out in broad daylight, under the watchful eye of the local constabulary. Assisted by his cousin, Dale Russell, he practices the art as a tourist attraction during spring and fall folk festivals in the tiny hamlet of Cumberland Gap, Tennessee. When the show's over, the stuff goes back to city officials for disposition down the drain.

"At one time, we used to give out little sips to folks, just to let 'em see what it tastes like," he said. "But we've even quit doing that. You see, some folks wanted a little more than a sip.

"I remember one time, this little old lady came up and asked for a sample to take home for 'cough syrup.' I told her to go buy a Coke and wash out the bottle and I'd pour her a shot or two. Wel'sir, she bought a Coke, all right. It was just a little bit bigger than I recommended. She come back up there with a one-gallon Coca-Cola syrup jug. You know, the kind with a ring for a handle. I had to turn her down. I said, 'Lady, that's a little more than they'll let me get away with!'

"It's people like that who make this so much fun. You won't believe the number of times somebody who's, oh, sixty or seventy years old, will walk up to me and say, 'My Daddy used to do this' or 'My Granddaddy made some of the best you ever tasted'

or 'When I was a kid, I remember runnin' into a still up yonder in the woods above my house.' I bet half the people I see come out with something like that. It's part of their family history."

Part of Von Russell's, too. He didn't learn to make moonshine at his grandpaw's place. Nor from his father, either. Even though he's confident many of his long-lost relatives and ancestors distilled whiskey for personal consumption and resale, the only one he knows for certain was his father's cousin, Roosevelt Russell.

"Dad told me the story many times," he said. "It was back in the twenties, before TVA [Tennessee Valley Authority] built Norris Dam. People still used the rivers for travel back then. Roosevelt would fire up his still above the Powell, and then he'd get to drinkin'. Somebody'd be floatin' down the river, and Roosevelt would holler out at them to come get a drink, too. Naturally, it wasn't long before the word would spread, and the law would come arrest him. Way I heard it, they threw him in jail two or three times. The old sayin' was 'You don't start drinkin' when you're makin'.' Poor ol' Roosevelt, he never understood that."

Russell's native tri-state region was a hotbed of whiskey traffic before and after Prohibition. It was one of those known-about-but-not-talked-about occupations.

"The first still I ever saw was out past my grandpaw's farm," Russell recalled. "I was just a kid at the time. The still wasn't in use. It had been taken apart and stuck in a fence row, I reckon just to store 'til it was needed again."

The next encounter wasn't as passive: "I was about fifteen or sixteen that time. It was off Highway 92, down in what they called the Buckeye community. I was huntin' squirrels and came around this bluff. Right there in front of me, in a little ol' laurel thicket, was a still—and it was runnin'.

"It terrified me. I didn't know what to do except turn around and hightail it back the way I'd come. Just as I spun around, I heard this voice say, 'Where you headed?'

"I said, 'I'm gettin' the hell outta here.' I told him I knew this wasn't none of my business and that I wasn't gonna bother anything.

"He said, 'I knowed you wasn't, 'cause I been watchin' you the whole time.'

"I never did even get a good look at that feller. He stayed back in the bushes. It didn't matter to me, though. I was outta there."

The third time was the charm: "A buddy and I were huntin' down on Tackett Creek when we found this one. It was runnin', too, and we left there with a half-gallon of whiskey.

"That was a close call. We got stopped by the game wardens. We had several bags of garbage in the back of the car, and they figured we were going to dump it. We told 'em we weren't, but they started poking through it anyway. We had that whiskey hid in a bag. Buddy, we were on pins and needles. But they never found it, and we got out okay."

Yet it wasn't until years later, long after he'd been discharged from the army and returned to the mountains, that Russell became attracted to the whiskey-making process itself. He was attending a fall festival at Hensley Settlement in the nearby Cumberland Gap National Historical Park and saw a distilling demonstration by a man named Grover Smith. He ran into Smith the following year at a similar show in Middlesboro, Kentucky.

Not long after, Russell was at his job at a propane distributorship in Middlesboro when Smith came in to buy fuel. He and the craftsman struck up a conversation that ended with Russell helping Smith design a new burner for his still. They bonded immediately and worked together at festivals until Smith's death.

"Havin' that hundred-thousand-BTU propane burner made all the difference in the world," said Russell. "It tickled Grover to pieces. This way, he could control the temperature a lot closer. It made the job a whole lot easier."

Russell is quick to point out there was no such thing as occupational ease in the old days. Despite the stereotypic Hollywood depiction of moonshining and its shiftless practitioners—particularly in the 1950s hit song and movie *Thunder Road*—this was tough, demanding work.

"As far as the general public is concerned, the biggest misconception about moonshining is that this was a lazy man's job," says Russell. "Nothing could be farther from the truth. The local moonshiner might not have been a pillar in the community, but he had to be a hard worker. He had to know what he was doing, too. If he got the fire too hot too quickly, it would scorch his product. He had to know when to add fire and when to take it off. He had to know how to mix the proper ingredients. He had to know how to shake a jar of his whiskey and watch it bead to proof-test it. He'd go through all that work and take all that risk for maybe a dollar for a half-pint. That's a tough way to make a living.

"The old moonshiners were true craftsmen. A lot of the time, they were making it for their own use. They used good, clean, copper stills, and they often aged their whiskey in charred white oak barrels to mellow it out and give it that dark bourbon color.

"A lot of the fellows who got into the game after Prohibition just wanted to make a buck. That's when the stories about using old car radiators for stills started popping up. Their whiskey was usually sold before they ran it. They'd bring it off one day, and the jars would be shipped to somewhere like Chicago the next. They never knew anything about the quality of their whiskey. They didn't care, either."

The copper still Russell uses at Cumberland Gap was designed and built by Grover Smith's cousin. Each piece is rolled and bolted together, then sealed on the

outside with solder. "It's a work of art," says Russell. "A good tinsmith could make one like it, but these days, I doubt there's anybody around who knows how."

The distilling process begins long before the fruit jars start to fill with white lightning. What's more, the mixtures, methodologies, and types of stills vary as much as the hundreds of regional recipes for biscuits, breads, cakes, and pies, not to mention all the different types of ovens used to bake them.

There is, for example, a definite line between pure corn liquor and the more common "sugar whiskey" made from corn.

"Pure corn liquor is made of sprouted corn and water, naturally fermented with yeast that's in the air," says Russell. "It takes a lot of time to convert the starch in the corn to sugar that way. Those ol' boys in the hills didn't have that much time, especially when someone with a badge was always lookin' for them. They mixed their corn with sugar to speed up the process."

Russell starts his operation by depositing thirty pounds of white corn meal ("it makes prettier mash than yellow") in a fifty-gallon barrel, adding enough water to mix the two completely. Sugar goes in next, approximately ten pounds for each gallon of liquor he expects to make. Russell uses bread yeast to kick off the process, the exact amount dictated by the weather. If it's summer, only a few pinches are required. In the fall, he might need an entire packet. Over the next three to five days, again depending

on the weather, the sugar will be consumed as the aromatic slurry bubbles and gurgles.

"You can actually hear it runnin'," Russell says in a deep, baritone voice that is accented by his arms, waving in perpetual motion. "*Gluuullluuubbb!* It's just like it was boiling."

When the mixture quits working, the milky looking "still beer" must be separated—by siphoning, pouring, and straining—from mash residue that has collected at the bottom of the barrel. The alcohol, suspended in this liquid, is now ready to be separated via distillation.

Russell carefully pours it into the still. He brings the heat up slowly, just enough to boil off the alcohol at 173 degrees Fahrenheit.

The rich vapor then is piped through a "thump keg," which gets its name from the hollow, rolling sound that emanates as the heat builds. The thump keg contains either fresh still beer or "backin's" from a previous run and provides a second distillation.

From there, the vapor travels through a long spiral or "worm" of tubular copper that is immersed in water, cooling it to the point of condensation. And way down at the end of the worm, dripping steadily into a Mason jar, comes grain alcohol—Ol' Stumpblower.

Russell gazes at the tiny stream, almost transfixed, as it splashes into the glass.

"Hard to imagine you can start with those rough ingredients and wind up with liquor," he says. "It fascinates me every time."

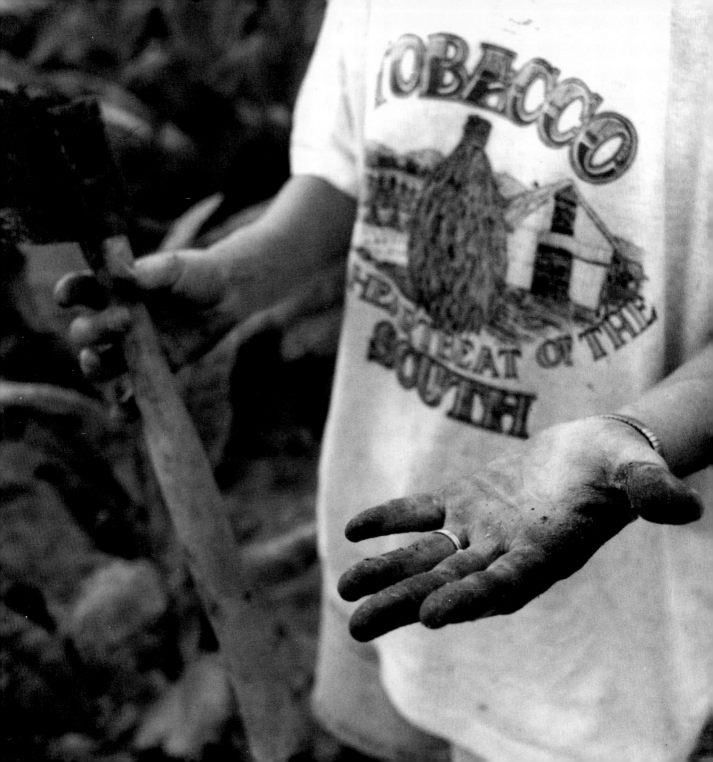

'Bakker Is in Her Blood

Becky Edds

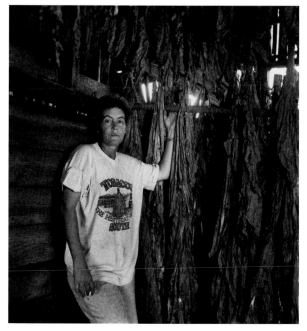

As she as done every morning for more than two decades, Becky Edds starts each day by injecting herself with thirty-five units of insulin to control her diabetic condition. If you want to catch her, you'd better do it then, for that's about the only time her perpetual motion machine isn't running at full tilt. Depending on the time of year, she'll either be planting tobacco, chopping tobacco, topping tobacco, cutting tobacco, hanging tobacco, or selling tobacco—

assuming, of course, she's not hauling feed to her beef cattle, running to the hardware store for supplies, or plowing a field.

Such a frenzied pace comes honestly: "My parents had a dairy farm. The morning I was born, Mama milked twenty cows before she left for the hospital."

Yet the bundle of joy that arrived several hours later wasn't exactly what J. F. and Jo Ann Ellison had in mind.

"Daddy'd told her, 'If it's a girl, send it back,'" Edds laughed. "He didn't get a boy, but he tried every way in the world to make me one. I didn't get dolls and dresses for presents when I was growin' up. I got guns and knives. Heck, I was sixteen before I ever went to a picture show!"

An unconventional childhood, perhaps, but it made Edds self-reliant as she grew up in the rural east Tennessee community of Sharps Chapel.

"I hate to be told I can't do something," she says. "It only makes me more determined to do it. I want to show 'em I can."

Like the time in 1985 when she heard that a heavy equipment contractor needed a bulldozer operator. "I told him there wasn't nothin' I couldn't learn how to drive," said Edds. "I wound up workin' for him for two years."

These days, Edds's heavy equipment deployment is pretty much limited to tractors. It's a full-time job. With only the help of her teenaged son, Brad,

and occasional seasonal laborers, Edds tends more than thirteen acres of tobacco scattered in patches across her 128-acre Union County farm, growing a yearly average of thirty thousand pounds of burley.

Find the word "tobacco" in any dictionary, and you will see it described in three syllables: ta-BACK-o. This pronunciation is acceptable for grammarians.

But for the hill people of Tennessee who know this plant and tend it from seed to final sale, two syllables—said quickly, almost as one—will suffice. When Becky Edds talks 'bakker, you're hearing it from an expert.

Hers is no gentlewomanly operation from the pages of a preppy magazine. It's a dawn-to-dark, nose-to-the-grindstone undertaking that keeps Edds up to her ears in tobacco twelve months a year. When she's not growing it, she's helping sell it. She's a "weighperson" ("I made 'em change the title from 'weighman,'" she quips) at a warehouse in Tazewell.

"I've worked there every winter since 1983," said Edds. "I love the pace of it. There's never a dull moment. The sales start the Monday before Thanksgiving and run till late January. Sometimes, I've worked fourteen hours a day, seven days a week. The sales aren't held on Thanksgiving Day, Christmas Day, or New Year's, but we have to be at the warehouse to help get all the 'bakker weighed in. I've worked as high as forty-eight hours straight and never come home."

If that wasn't enough, she also raises nearly one hundred head of Angus–Santa Gretudis beef cattle. And she pitches in whenever her neighbors need a hand, whether inoculating their livestock or helping with their crops. In the summer of 1995, for example, Carroll McCarty, just up the road, died of a heart attack. Edds and her son worked shoulder-to-shoulder with the McCartys to get their tobacco in. No big deal, she insists. That's what friends are for.

Edds can hardly remember a time when she wasn't working with tobacco. Even though her parents were officially in the dairy business they, like many rural families, grew burley to help pay the bills. She still jokes about her introduction to the plant, painful as it was: "I was only four or five years old. Everybody was grading 'bakker in what we called the 'lower shed,' and they sent me to the upper shed to pick up scrap leaves. I found an old buggy seat up there that had still had the springs on the bottom of it. I was gone and gone and gone, and Daddy got to hunting me. When he found me, there I was, sittin' in that old buggy seat, bouncin' up and down. I hadn't picked up the first leaf. I mean to tell you, he blistered me!"

This is a career she learned from the ground up.

"When I was little, I had to get down on my hands and knees and crawl along the ground and pull off suckers (unwanted stems and shoots at the base of the leaf) on the bottom of each plant while Mama and Daddy worked the tops," Edds recalled. "It was dirty—but at least it was shaded out of the hot sun."

At any age, though, raising tobacco is hard, back-breaking work. Burley brings in more money per unit of land than any crop in Tennessee, yet farmers agree it's the toughest money they earn. One big enticement is that lump-sum, end-of-season income. But there's also an intangible that only the people who work the soil and coax tobacco from seed bed to warehouse can fully comprehend and appreciate.

"Bakker just gets in your blood," says Edds. "That's the only way to put it. You either love it or you hate it."

Preparations for a new crop begin almost as soon as the auctioneer's voice fades into silence. Edds winds up her chores at the warehouse just in time to start working her beds for the next batch.

In February, she plows the one-hundred-foot-by-nine-foot beds and disks them smooth. The soil is then purged of weeds with a gaseous pesticide that is sealed for seventy-two hours under a canopy of

'Bakker
Is in
Her
Blood

plastic sheeting. When that treatment ends, the plastic is removed and the beds airs for at least twenty-four hours. Then it's time to plant the seeds. Edds uses the Ricker 2110 variety, mixing the seeds with lime, bonemeal, and a fine fertilizer, and covers the bed with canvas.

Another kind of plant also goes into the bed. Says Edds, "This is also the best time to plant tomato seeds. Shucks, yeah! Just mix 'em right in there with the 'bakker. You can separate 'em out when it comes time to set out the plants."

This is the "dry" method that is stock-in-trade with Tennessee burley farmers. Since the early nineties, however, Edds has joined a group of tobacco growers who have broken tradition by starting with "wet" beds.

"It's just what the name implies. The plants come from a nursery in Florida. I get 'em at the co-op. They're about two inches tall. You just float them on a bed of water. It's a pretty new idea, and a lot of people won't try it. But I like it. Water plants don't wilt when you set 'em out in the patch. They grow off faster."

Regardless of the method used to initiate the growing process, the transfer of seven- to nine-inch plants from nursery bed to field begins in May, when honest-to-gosh spring spreads its warmth across southern Appalachia. Already, the patches will have been plowed, disked, and fertilized. Using a tobacco-setter attachment on their tractor, Edds and her son can usually plant all thirteen acres in five days.

After that, Mother Nature takes over, assisted in no small part by the farmer.

"You're in each patch two or three times a week," says Edds. "You've got to keep the weeds chopped out and inspect for aphids, budworms, and other insects and spray 'em as needed."

Around the first of July, it's time to start topping. In this stage, the budding flower is removed, allowing the plant to concentrate all of its growth capabilities on the leaves. Suckering also is performed during this time.

"We still do some suckering manually," Edds says, "but most of the unwanted growth is controlled by sprayin' these days. Kids don't have to crawl around on the ground like they did when I was a little girl."

Summer fires its blast furnaces with a vengeance in August, signaling the start of cutting operations. With sweat flowing down their backs and faces, Edds and her hired help work along each row, swinging their tobacco knives like so many metronomes. The cut stalks are left in the field three or four days to wilt, then impaled on a long wooden stick, hauled to the barn, and hung for five or six weeks of curing or drying.

Actually, tobacco "knife" is a bit of a misnomer, for this lethal-looking device is part hatchet, part hammer. Its sharp cutting edge is used to shear the stalk at ground level. Flipped around, it becomes a hammer to drive the sticks into the ground. A four-inch-long metal spear tip is then placed at the top of the stick, making it easier to impale each stalk.

In addition to the labor intensity of the cutting job, Edds relies on a lifetime of experience in knowing what to do, and not do, at this stage.

"If the sun blisters your leaves while they're still in the field, you have to leave 'em out for at least three dews to get the blisters out. Otherwise, when you get 'em to the barn, they'll cure up green. You never haul your 'bakker to the barn when the east wind is blowin', either. It'll cure green. That ain't no old wives' tale. An east wind is all-around bad for 'bakker. If you set it on an east wind, it'll die, and if you haul it to the barn on an east wind, it'll cure up green. I guarantee it. Don't ask me why. I just know that's the truth."

The sight of row after row of tobacco stalks curing in barns is a common one throughout southern Appalachia in late summer. For some casual, albeit

'Bakker Is in Her Blood

uneducated, observers, this marks the end of the tobacco season. Hardly. It's merely the next step. On damp, cloudy days in autumn, all that tobacco comes down from the rafters. It's time for stripping the leaves and grading them for the market.

"You need a damp sorta day to get the 'bakker to a stage we call 'in case,'" said Edds. "That means it'll pliable enough to work. If it's not in case, it'll crumble all to pieces when you handle it, just like an old dried leaf off a tree."

An average stalk of burley tobacco measures five to five and one-half feet in length and contains nineteen to twenty-five leaves that fall into three grades.

The six or seven leaves nearest the ground are commonly referred to as "number one" or "trash." They sell for the lowest price and usually wind up as filler. Conversely, the six or seven dark red tips near the top are the "filet." The majority of leaves on each stalk fall between these two poles. This is the "number two" tobacco—the light, long red that eventually makes its way into cigarettes, cigars, and pipes, as well as chewing tobacco.

Leaves from each grade are compressed into hundred-pound bales and trucked to the warehouse.

The auctioneer's chant and payday are getting closer, but a lot of other bills must be paid first.

"You pay a dollar and fifty cents per hundred pounds, plus a 4 percent commission, to the warehouse," said Edds. "You also have to pay for the government graders through a program called no-net-cost. It's funded half by the farmer, half by the company that buys the 'bakker. It's not money from the government."

Ah, yes. The government. Like many farmers, Edds bristles when there's mention of funding health programs out of tobacco revenues.

"I'm not bashful about talkin' about it," she says. "It makes me mad. 'Bakker gets it from everybody these days. They've taken the ads off TV and people still smoke. How comes they don't do the same for alcohol? How many people smoking have run off the road and killed somebody?"

Of course Edds is a smoker. Whether she's on the tractor, working in the warehouse, or cooking in her kitchen, a pack of Salems always lies within reach.

"I've often wondered if 'bakker off my own farm ever wound up in a pack of my cigarettes," she commented, exhaling a plume of blue smoke. "Over the years, I reckon it's happened."

114

'Bakker Is in Her Blood

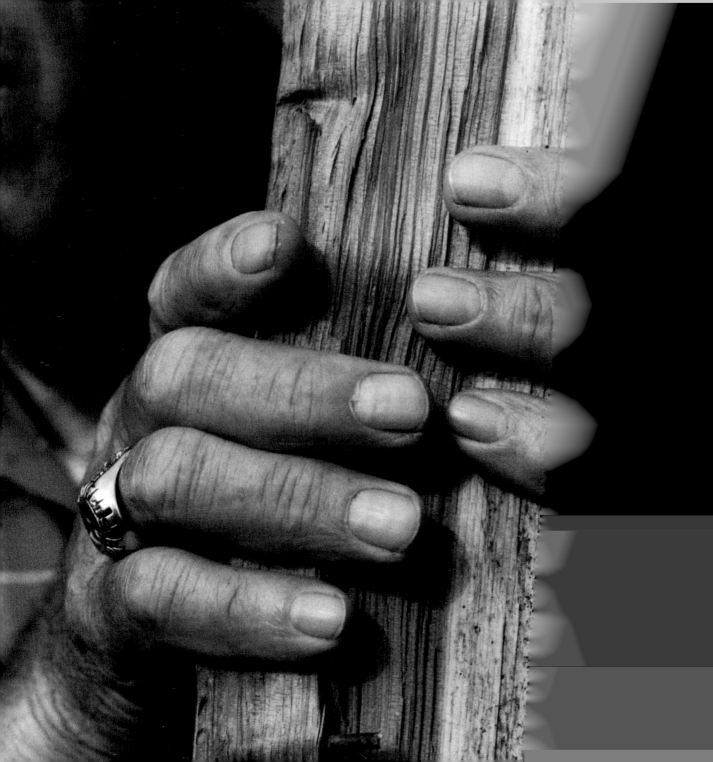

Maul in the Family
Charles and Earl Sherwood

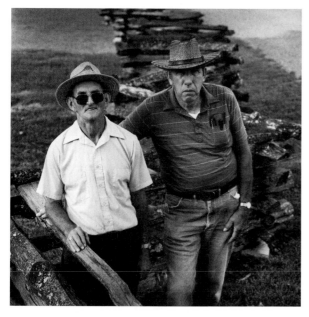

If it is true, as Robert Frost observed, that good fences make good neighbors, it's safe to assume Charles and Earl Sherwood will remain on the best of terms for a long, long time.

In the first place, the border of their adjacent properties in rural Anderson County, Tennessee, is clearly defined by a fence—six taut strands of barbed wire, secured to cedar posts that Earl cut, split, and sunk in the ground himself.

Second, they're family. Tight family. Earl and Charles are so closely related, they might as well be brothers. "Double first cousins," is the way these men describe their unique relationship. This is what happens when brothers marry sisters—of other families, one hastens to point out.

Earl's father was Ed Sherwood, who married June Gilmore. Charles's father was Harvey Sherwood, Ed Sherwood's brother. He—Harvey Sherwood, that is—married Myrtle Gilmore, who was June Gilmore's sister. Suffice to say that at any family gathering, "Howdy, Cuz!" will cover a multitude of greetings.

But the third, and by far most significant, reason that the Sherwoods—we're back to Earl and Charles now, in case you're keeping score—understand the importance of fences is because they are the last of a dying breed of southern Appalachian craftsmen who know how to produce, in quantity, an integral part of the fence itself.

Fact is, their expertise goes beyond the realm of merely "knowing" how to perform this task. They still practice it regularly, with wedges and mauls and axes and copious amounts of rawhide muscle power.

Earl and Charles Sherwood are rail-splitters. There is nothing easy about their job. It is the epitome of labor, borne of cascading sweat and callused hands. In the simplest of terms, rail splitting is a matter of controlled destruction. The mission is to take a tree whose cellular structure has been locked rigidly in place for decades, and cleave it asunder lengthwise.

"Back in the old days," Earl says, stopping the arc of his maul long enough to sweep a towel across his brow, "a feller might do this from dawn till dark for fifty cents. Maybe not even that much. I've hee'rd of folks who worked for as little as twenty-five cents a day."

He repositions his hands on the shaft of an eleven-pound hickory maul and raises it again. "Whew!" he sighs, "what a way to make a livin'. I reckon a feller'd have to be mighty hungry to work for that."

Maul in the Family

The target of Earl's next swing is a foot-long wedge of dogwood—a "glut," in rail-splitting parlance—which Charles has just repositioned, perpendicularly, in a widening crack running down a ten-foot-long bole of red cedar.

The maul comes down thunderously. Again. Three times. On the fourth blow, the tree yields. Cracking and popping, the open seam jags further along the trunk.

Charles reaches for yet another glut and drops it in place. He's got the easy part of the job for the moment, but he knows his respite won't last for long. As soon as Earl splits this piece neatly in two, he'll take a well-deserved break. Then it'll be Charles's turn to swing the maul. Good rail fences, it seems, also make good partners.

On this sun-splashed October afternoon, the Sherwoods are demonstrating their skills during the Fall Homecoming celebration at the Museum of Appalachia in Norris, Tennessee. A crowd of curious spectators, most of them school children, has gathered. Some crane their necks and squint their eyes to follow the action. Then they turn to a teacher and ask, "Why're they doing that?"

Two hundred years ago, when rail splitting was just another domestic chore, the answer would have been obvious. Thanks to an abundance of trees and strong arms in those days, rail fences zigzagged their way around nearly every family farm in the East. They've been replaced by barbed wire—"bobwar," as the locals call it—which defines a boundary more precisely, takes up less room, requires fewer materials, and goes up substantially faster. People who build split-rail fences these days do it strictly for aesthetic reasons.

Not that the fences couldn't handle the job. Properly set and supported, split-rail fences could contain livestock in the 1990s just as effectively as the 1790s. Unless, as Charles notes, "you've got a rogue bull; then, *nothin's* gonna keep him in!" These fences are architectural beauties. What's more, they'll stand up to the elements. Wind, rain, snow, and gnawing insects have little effect on them.

Traditionally, they were hewn out of American chestnut, a wood so impervious to rot that occasional rails still survive on mountain farms today. But the only way to procure them back then was by the same maul-swinging, muscle-flexing method the Sherwoods use now.

They start by sinking a single-bit ax into the butt end of a log. Two or three blows with a maul on the back of the ax will usually send a crack down the middle of the trunk. As the crack grows, gluts are dropped into the widening seam and pounded until they do their job.

Most of the time, the crack will find its own path. Occasionally, though, it will have to be guided with ax strokes to keep it from ricocheting off a knot and "running out" of the wood.

Things go by eyeball estimation from here on. No need for precise measurements. Once the trunk has been halved, it will then be split repeatedly into as many four- to six-inch-diameter rails as the maul-handler deems appropriate.

It's a process of wood on wood. The only metal involved is in the ax blade. One practical reason dates back to the pioneer days, when it was much easier, not to mention less expensive, to make tools out of wood rather than pay a blacksmith. Earl and Charles make their mauls the same way their ancestors did. In the same place, too: the forest.

They find a straight-trunked dogwood or hickory approximately six to eight inches in diameter, and saw it off chest-high. Then, using an ax and drawing knife, they hew the handle into shape, leaving the heavy head of the implement intact at the base. After that, it's a simple job to saw it off at the ground and carry it home for sanding and final touch-up.

"There ain't no sense bringin' in a piece of wood and tryin' to make a maul on a shavin' horse," says Earl. "A maul is so long, it's hard to get it locked down in a shavin' horse. The best way is to let the ground be your vise until you've got it made."

Another reason for wooden implements is safety. Metal-on-metal is a dangerous combination in this line of work. After tens of thousands of strokes, even the best-maintained sledge hammers and metal wedges are bound to start chipping. Far better to have the air filled with the scent of freshly split wood instead of shrapnel.

There's also a matter of comfort. Gluts and mauls made from seasoned hardwood are nearly as tough as metal, yet they will absorb much of the shock on impact. This spares the worker's muscles and joints from unnecessary jarring.

The school children visiting the museum move on to another demonstration. In their place comes a cluster of midwestern tourists. One of the men wants to try his hand with the maul. The Sherwoods are more than happy to oblige.

"Let the maul do most of the work," Charles instructs. "Don't jerk at it. And don't try to swing too hard. Just go smooth."

The man strikes ten or eleven licks, more or less on target, then takes a bow amid cheers from his friends. He returns the maul to its owners, noting that selling insurance isn't a bad way to make a living now that he's had a chance to think about it.

"I believe you two can finish the rest of this job," he deadpans.

Indeed, they can. These cousins—Earl is older by two years—have been working side-by-side nearly all of their lives. At one point, they even lived in the same house.

The original family farm was at the lower end of Freels Bend. It is now covered by the backwaters of Melton Hill Lake. But they had to move out years before Melton Hill was impounded. In fact, when they were mere boys, the federal government took over the farm—and many others in the Clinch River bottoms—for the top-secret Manhattan Project that ultimately brought swift closure to World War II.

That was long before electrification changed almost every aspect of farm life. It may have been hot in summer and cold in winter, yet the Sherwoods remember that era fondly.

"Nobody had a lot of money and nothin' was fancy," says Charles, "but it was a good time to be raised. Nobody ever worried about lockin' their doors or shuttin' their windows. We lit with coal-oil lamps, and all the bathrooms were outside. Didn't seem like any kind of inconvenience at all back then. That's just the way it was."

Work was a constant factor.

"You either worked with wood, or else they took the wood to yore britches," Earl grinned. "I was about twelve years old when my dad taught me how to make rails. The first fence I ever built with 'em was for our garden."

The cousins continue their stroll down memory lane. "You remember the rollin' store, don't you?" Earl asks.

"Oh, sure," Charles replies.

"Now, that was somethin'," says Earl. "Folks couldn't get out to a grocery store as easy as they can today, so the store would come to them. We lived seven miles outside of town, and it was always an excitin' time to see that ol' truck a'rollin' down the road. It come ever' Wednesday. It had sugar, coffee, bakin' powder, some clothes, just about anything you couldn't raise or make on the farm."

*Maul
in the
Family*

Some money always changed hands, but barter was the order of the day.

"We usually traded chicken or eggs for what we needed," Earl continues. "The truck had these big coops on top to carry ever'body's chickens. Mama'd send me down to meet the rollin' store with a list. She'd always tell me to get just what was on that list, too. No candy!"

Forced off the farm by the atomic-bomb project, both families moved to Jefferson County. They stayed eleven months, then their fathers moved everyone back to a dairy farm in Anderson County. That was home until 1947. Ed Sherwood went to work at a sawmill, then later to Bush Brothers. Harvey Sherwood took a job with the Tennessee Valley Authority.

The boys grew up, served hitches in the military, then returned to Anderson County to settle down and raise their own families. Earl wound up working for TVA, Charles for a plastics company. Both are now retired—if by some twisted form of logic and linguistics you can use the words "retirement" and "rail splitting" in the same sentence.

The fungus that robbed America of its vast chestnut forests was accidentally introduced from Europe around 1900. It spread quickly. Within forty years, the species was all but exterminated. Today, the only reminders of this beautiful, valuable tree are infrequent sprouts that spring from old root stock, only to be withered within a few years by blight spores still present in the atmosphere. In chestnut's place, locust and eastern red cedar have become the favored media for rail fanciers. Both woods are relatively easy to split and stand up well to the weather, but cedar is more commonly used because of its abundance.

Actually, the word "cedar" is a misnomer. According to Dr. Wayne Clatterbuck of the University of Tennessee's Department of Forestry, Wildlife and Fisheries, these trees really are junipers.

"The Latin name is *Juniperus virginia,*" he says. "Our 'cedars' aren't even related to the real cedars, which are mainly found on the West Coast."

Taxonomical technicalities notwithstanding, eastern red cedar is found throughout southern Appalachia. Because it thrives in a wide variety of soils, cedar will grow just about anytime, anywhere.

This species was the mainstay of the southern pencil industry around the turn of the twentieth century. It still has commercial application today, whether milled into lumber for cedar chests and closet liners or ground into chips as a highly valued bedding material for dogs, horses, and other animals. And even though few are actually sold for this purpose anymore, red cedar is still the hands-down favorite for a fragrant, homegrown Christmas tree. Rare is the hillbilly family that doesn't cherish memories of frosty December outings when "the perfect" cedar tree was chopped down amid great fanfare, transported home on a mule-drawn wagon, and decorated with handmade ornaments.

Through the years, the Sherwoods have found quite a number of surprises in the cedars they've split—but certainly not of the Santa Claus variety.

"I can sure understand why a lot of sawmills won't take cedar logs," says Earl. "It's too dangerous. Any cedar that was growin' around a house or a barn is bound to have nails or fence staples in it."

That's not all. Horseshoes, spikes, even rocks, can find their way inside. Some folks have a habit of sticking these items into fissures or the crotch of small trees. Over time, the foreign object gets covered with growth wood. Earl even recalls attempting to split a cedar that been bound with barbed wire in its youth.

"That thing was wired together from the inside," he chuckled. "We never could get it apart."

The best trees to work are the freshly cut ones. That's particularly true with more knotty specimens. The longer a log ages, the more it will resist

Maul in the Family

being split. Throw in a row or two of limb knots, and you've got the makings of an afternoon's work.

"To be honest, I don't reckon there's ever been an unknotty cedar," says Charles. "Just a very few, anyway. In all the years me and Earl have been makin' rails, I can only remember two logs that were clear. They split slick as a whistle. The sad thing is, a log like that would have made some mighty pretty lumber."

A cedar rail will last from thirty-five to fifty years, depending on how much oily, pinkish-red heartwood it contains. The white sapwood rots quickly. Thus, as the Sherwood split, they keep a constant eye on each rail. Even if a particular piece happens to be eight or nine inches in diameter and could easily be cleaved into two rails, it goes on the finished pile if there's not enough red wood inside.

Constructing a rail fence is as simple as stacking logs. The bottom rail should be placed on a flat rock to keep it off the ground. The ends are crisscrossed at ninety-degree angles. The height can be adjusted to the task at hand: higher for livestock, lower for mere decorative purposes.

Back at the museum, it is late afternoon. The sun is beginning its slide into the western hills. The tourists wander back to their motel rooms and motor coaches. Earl and Charles gather their tools and head for home. Tomorrow, they'll do it all over again. By the end of this five-day festival, they will have made nearly five hundred rails, which will wind up as fencing on the museum grounds. No one need ask how tired they are.

In the spring of 1993, Charles suffered a heart attack and underwent triple bypass surgery. Since his recuperation, he has faithfully exercised three times a week.

Except during the Homecoming. For just this one brief week, the treadmill and stairclimber can gather dust. He's had all the workout a fellow can stand.

121

Maul in the Family

Syrup Season
Olin Hughes

L abor Day was established by Congress in 1894 as the United States' official celebration of work. It is observed on the first Monday in September.

How strange. In the most bizarre of paradoxes, this tribute to toil brings the industrial output of the entire nation to a grinding halt.

Factories, stores, schools, and banks close. Offices darken. The mail doesn't run. Even the stock market, its lifeblood drained by the sudden cessation of sweat from coast to coast, is idled.

Labor Day is a time for barbecues, political speeches, family reunions, outings to the lake, and, particularly in the South, large-scale dove shoots over freshly harvested silage fields, followed by a sumptuous dinner on the grounds. As Scarlett O'Hara might have put it, "Fiddle-dee-dee! Why worry about work on Labor Day? I'll worry about work tomorrow."

Yet there is one major exception to this rule. For folks who make molasses, Labor Day means just what the name implies: a time for work. Hard, hot work.

Not that it's been any picnic up to this point. Way back in April and May, the fields that grow sorghum cane had to be plowed, fertilized, and seeded. As the young shoots emerged, the soil needed cultivating, perhaps as many as three times, to keep it loose and free of weeds.

Yet all of these tasks can be accomplished with machinery, at least in the world of twentieth-century agriculture. By Labor Day, it's time for human hands to get good and dirty. Not to mention sticky.

"I think this is what they call one of them 'labor-intensive' operations," says Olin Hughes.

Hughes should know. He's been growing sorghum cane and making molasses for most of his seventy-five years.

Early on, this was merely another chore on the family farm. If you wanted thick, sweet molasses

for your morning biscuits—biscuits, it should be pointed out, that were made from scratch, not "whoomped" out of a fancy package from the grocery store—you made them yourself.

(Another point of order. In the vernacular of southern Appalachia, the word "molasses" is not singular. It is plural. One does not make "it." One makes "them." Only a city slicker would sample a dab of the season's first run and announce, "This is good molasses." The correct pronunciation, as anyone who ever wore a sweat-stained John Deere hat knows, is, "These are good molasses." Unless, of course, these molasses haven't been cooked long enough and are runny, which the city slicker probably wouldn't detect in the first place.)

In 1954, Hughes decided to broaden his horizons somewhat. He figured since there was such a big demand for molasses in and around his hometown of Young Harris, Georgia, he'd boil off a little extra for public consumption.

Say, around twelve thousand gallons.

"Yeah, that's how much of 'em we used to make," he says. "We shore did. Did that much for years. But ain't as many people that eats molasses any more. Shucks, there ain't as many people that even eats breakfast anymore! At least not at home. They drive to a fast-food place, and you can't hardly find molasses at one of them. So our production has dropped off right smart in the last few years."

To a mere sixty-five hundred gallons, including what he makes for friends and neighbors who raise their own cane.

Anyway you slice it, though, this represents more than enough industry to keep everybody in the Hughes family from thinking thoughts of leisure around Labor Day. Or anytime thereafter until Thanksgiving.

Olin Hughes's molasses mill is easy to find. It's right off of Highway 76, about seven miles east of town, on Olin Hughes Road. In Towns County,

Georgia—and in much of rural southern Appalachia—death is not a prerequisite to having a road named after you. Instead, you just need to be living in the right place when the road comes through.

Families of Hughes descent populate this region. Olin and his wife, Lois, reside on thirty-five acres at the mill site, most of which is devoted to pasture for their cattle. He leases another sixty acres for hay. Their children—sons Cecil and Terry and daughter Eloise Chastain, along with their respective spouses and children—have homes nearby. Farther east of Olin's farm, in a valley below Brasstown Bald, the highest point in Georgia, the family leases another forty acres for growing sorghum cane.

"We raise several different varieties," said Hughes. "There's Late Orange, and Williams, and Honey Drip, plus a couple of newer ones called Topper 76 and M-81E. They're all good syrup canes.

"I don't know what it is about the soil in this area, but it shore makes good syrup. This whole county's good for it. Our soil makes a light, amber syrup. There are some areas where the soil's got a lotta clay. It'll give you a syrup that's almost cherry red. But it's all got a good taste."

Here in early September, it'll be awhile before anyone gets a taste. With the cane growing season drawing to a close, there's much work to be done before thousands of glass jars are filled with delicious liquid.

First, the leaves must be stripped from the stalks, standing tall in dense rows in the field. This is a job that has not been mastered by mechanization. It calls for an army of arms that can reach and bend, plus hands that can swing knives accurately—which is why children and grandchildren were invented. Then the stalks are cut down and the seed head lopped off.

"I like to strip the leaves one day and then come back and start cuttin' the next," said Hughes. "You don't want your cane standin' bare too long, or else

it'll start losin' its sweetness. We cut it and pile it up, about two armfuls to the pile, and load it on wagons to haul it to the mill."

Cutting cane is not a one-time job. It goes on throughout September and October. Hughes plans it that way by staggering his planting schedule in the spring.

"You don't want the whole crop comin' in all at once," he noted. "Why, it'd work you to death! There's no way you could handle the whole load at one time."

Small cane mills, like the one Hughes used as he was growing up, typically are powered by one horsepower—as in ol' Dobbin. Harnessed to a long wooden boom or "sweep" that is attached to the drive shaft of the mill, the horse walks around and around and around, turning the rollers.

Hughes thought back to those years and laughed, "A feller shore can get tired of duckin' that sweep ever' time it comes around!"

These days, he does his squeezing with a three-roller Golden mill that is powered by a belt connected to the drive train on one of his tractors. Hughes isn't sure how old this mill is. "I do know it was built by a foundry down in Thomasville," he said, "and that outfit went out of business way back in the forties."

Mountains of cane are unloaded at the mill. The stalks are run through the press, butt-first. They emerge at the other end very flat, very fibrous, and very light, for over half their original weight has been extracted as moisture. These spent stalks will wind up as livestock feed and mulch.

In most smaller molasses operations, the greenish cane juice is captured in a large pan or bucket as it flows from the mill. Not here. Several years ago, Hughes buried piping underground to carry the juice into four holding tanks, each with a 280-gallon capacity. It'll be stored there until the actual cooking begins. Before it flows into these tanks, however, the juice runs through the first of four straining processes, each progressively finer, to remove any foreign matter.

"You gotta squeeze nine gallons of juice to get one gallon of molasses," he said. "That's how much they boil down."

Now for the main event. Inside a thirty-five-by-thirty-five-foot block and wood-frame building are two open-top, baffled, copper evaporators, built on stone foundations. Each evaporator is approximately nineteen feet long, three feet wide, and six inches deep. This is action central, the place where the juice will be piped in and "cooked off" to create molasses.

In the old days, Hughes heated his evaporators with wood fires. Most small-time 'lasses makers still do. But in an operation of this size, heat control must be more precise. That's why he switched to liquid propane. Throughout the molasses season, some ten thousand gallons of fuel will be burned.

On virtually any autumn day, the Hughes farm is abuzz with activity from first light until dark. Cane is being cut, hauled, and pressed. Juice is flowing. Burners are on. Every morning, the evaporators are filled with about sixty gallons of juice to kick off the cooking process. The rest of the day, this building will turn into a sticky, sweet-smelling sauna.

"You can shore sweat off a little weight this time of year," Hughes chuckles.

As the heated juice begins it transformation into syrup, a frothy substance containing chlorophyll and fine, suspended particles rises to the surface. This is known as "the skimmin's." In small evaporators, it must be continuously and carefully raked to the side and sieved out. In these large, slightly inclined evaporators, however, the process takes care of itself. The skimmings flow off to either side and fall into a trough, where they are washed away and discarded.

"It's the same basic process we used when I was a boy," Hughes said. "We've just gotten a little fancier with it. This here is a first-class outfit. We've even got county water!"

Syrup Season

But the same care as before must be exercised. Particularly in the final few minutes of cooking, the heat must be *juuust* right to prevent scorching.

"Oh, it happens sometimes," he said. "When it does, you've got to bleed that scorched stuff off and throw it away. It's got a bad, burnt taste to it."

Nineteen feet from where it started as juice, the smooth, thick syrup undergoes one final filtering, this time through cheesecloth, before it is decanted into pint and quart jars. Hughes tried to go ultra-modern one year and pack his molasses in plastic containers. But the experiment ended quickly.

"Molasses're so hot when they come out, they were stretchin' the plastic," he noted. "We never could find plastic that would stand up. So we've stuck with glass."

Even though molasses consumption has dimin-ished somewhat in the hill country, Hughes manages to sell most of each year's run on site. He delivers several cases every fall to grocery stores in the Young Harris area and actually ships a few jars—packed carefully to prevent breakage—to out-of-state customers.

"Folks come here from all over to buy our molasses," he said. "We get 'em from South Carolina, North Carolina, Tennessee, Alabama, even Florida."

He hopes they'll keep coming for many years.

"This is a dyin' art, no doubt about it," says Hughes. "At one time, they was over thirty molasses mills in Union and Towns counties. Ours is the only one left in this county now. But my boys will keep it goin'. Especially Terry. He really likes makin' that syrup."

Even if he does have to work on Labor Day.

Syrup Season

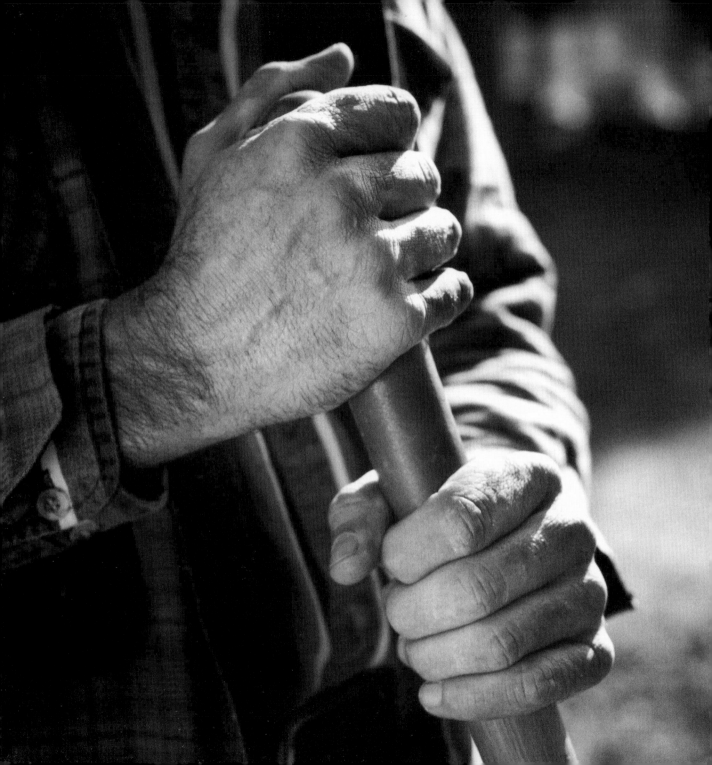

Tombstone Territory

Johnny King

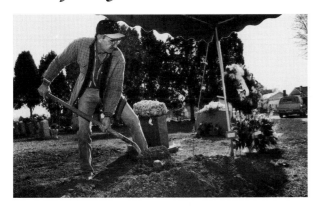

Despite what you might have learned to the contrary from Western movies, graves are not six feet deep. At least not the ones Johnny King digs.

"I guess they had to be that deep back in the old days, before good embalming and vaults," says King. "But all you need now is four and a half."

Specifically, four and one-half feet down, three feet across and seven feet, ten inches in length. King knows the dimensions by heart. With shovel and with backhoe, he has excavated holes to those precise measurements hundreds upon hundreds of times.

"As the old saying goes," he acknowledges with a wink, "I'm the last man to ever let you down."

In pioneer America, grave digging was a community effort. The town bell would toll on the occasion of a death, and all able backs bent to the task of preparing the final resting place. Not so today. This is a job for specialists, and it would be hard to imagine King engaged in any other craft. He learned from the master. His father, John, was caretaker of Bookwalter Cemetery in Knoxville, Tennessee, for fifty-four years, and Johnny literally grew up in the business.

"Our house was right in the middle of the cemetery," said King, whose skin seems permanently tanned from years of toil in the sunshine. "Yeah, my brother and sister took a little kiddin' about that when we were growin' up. You'd be surprised how many people were afraid to come see us."

Especially at Halloween.

"I remember once my brother put a sheet over his head and hid behind some tombstones and waited until some kids walked by," King said. "He ran out at 'em, and they slung candy in every direction.

"Another time, oh, I guess I was about fifteen or sixteen years old, me and a couple of friends were gonna camp out in the cemetery. Another guy came along. I knew where there was an open grave, so we cooked up a plan to 'walk' him through the cemetery. That boy stepped off into the grave, and he never slowed down. He ran plumb down to our house and hid under my sister's bed. Liked t'scared him to death."

More often, there was not a lot of time for play. Plenty of work needed to be done.

"Best I can remember, I was about nine years old

when I started helping my daddy out," King said. "We did everything with a shovel and a spade back then. By the time I was eighteen, I had beaten his record. I dug a grave in one hour and five minutes. The best he'd ever done was an hour and forty-five minutes."

King became caretaker at Bookwalter when his father died in 1988. But if you have any aspirations of applying for the job, think again. King's own son, John Jr., has already made this a third-generation family of gravediggers. When there's burying to be done at Bookwalter—or any of dozens of cemeteries throughout eastern Tennessee—you can bet someone named King will have a hand in the process.

"Johnny King is the best. He will go anywhere, anytime, day or night," said Art Pickle of Mann Heritage Chapel, one of three Knoxville mortuaries for whom King digs graves on a regular basis. "We don't have to worry about him. We know that everything will be ready."

Skilled as he may be, however, King still defers to the memory of his father: "The cemetery at Bookwalter is eight and three-quarter acres, and he knew every square foot of it. Why, when I was a boy, I remember people comin' up to him and asking about where so-and-so was buried. Even if it was back in the thirties or forties, he would know. He'd walk 'em right to it. Never had to look it up in the books. I can't keep up with records like that.

"I've still got his old spade. It started out about ten inches long, but over the years, he wore it down to about four or five inches. I finally retired it."

Although King went high-tech and began using a backhoe nearly twenty years ago ("takes about twenty minutes that way"), he still digs a number of graves by hand each year. This is particularly true in older cemeteries, where the space between tombstones and markers is too small for heavy equipment.

The grave-digging formula is simple: stake off the site, spade out the sod, and start digging. One glance at King's sinewy, callused hands tells you this man and a shovel handle have known one another through the years.

"But y'know, I still get blisters when I dig," he said.

As for the job itself: "The top thirty-nine inches, you gotta haul off. I either save it to fill low spots and graves that have settled too much, or else just haul it off. Afterwards, I mound the dirt up about six or eight inches. Give it two or three goods rains, and it should settle down just right."

One unique situation several years ago presented King the rare opportunity to get by with a minimum of soil relocation. He had opened a grave site, and the funeral had been conducted. By coincidence, he then received notice to dig an adjacent hole.

"I just pitched the dirt out of the second one onto the first," King recalled.

Normally it's not so easy, for the soils of southern Appalachia aren't the most forgiving medium in which to work.

"I like to dig a day ahead of the funeral 'cause you never know what you're going to get into," says King. "Sometimes, you hit real hard red clay. Up in Union County, there's a lot of it. Slate's not too bad, though. It's layered. Once you get it busted it comes up easy. But sometimes you hit rock. When that happens, there's nothing to do but go get an air compressor and start drillin'."

This truly can be back-breaking labor. King had suffered three ruptured discs in the line of duty: "I like t'wore out one chiropractor in nine weeks."

In summer, he works under the broiling sun. In winter, the topsoil can be frozen so solid it must be saturated with diesel fuel and ignited before it can be extracted. Loose, wet soil is especially irksome when the job's being done by hand. It can suddenly give way, negating more than an hour's worth of labor.

But King remains philosophic: "Only thing you can do then is start digging around your feet and bail yourself out."

Nor is grave digging a nine-to-five work affair. Although there ultimately is never a shortage of clients, they are not prone to follow a schedule. In slow periods, King might go a week before his services are needed. Other times, he might dig seven graves in as many days. He once dug five graves in a single day and recalls a small country church cemetery that required eighteen openings in one month.

"I'll never forget that," he said. "It was April. There was more burials in one month in that one little cemetery than they usually have all year."

That was particularly odd because winter is normally a gravedigger's busiest season of the year. Says King, "It's not just old people, either. You'd be surprised the number of young people that die then. Sickness, accidents, lots of suicides too. Around Christmas, that just starts working on some people."

Like any craftsman, King has a keen eye for the handwork of others in his field. He remembers a small country cemetery in Tazewell, Tennessee, where volunteers had dug a grave for one of their fellow worshippers.

"Prettiest grave you ever saw," he remarked.

"They had gone deep—all the way down to five and a half feet—and I'll bet the sides didn't vary half an inch. Even the sides themselves were slicked down. Looked like they'd troweled 'em. Those ol' boys really knew what they were doin'."

The strangest request he's ever gotten in the line of duty?

That's easy. It's the time he was summoned by a mortuary to dig a grave for, gulp, John King.

"What's so weird is that this wasn't long after my own daddy was buried," he said. "That can kinda shake you up when you're diggin' for somebody with your name. I got startled again a few years after that. I was just flippin' through the newspaper one day and saw the name 'John King' in the obituaries. The fellow was about the same age as me, too."

When his time on earth *is* through, however, King knows exactly where he'll be laid to rest—in Bookwalter Cemetery, of course. The ol' homeplace has been an important part of his life. But moreso, it holds a special place in this master gravedigger's heart.

"Bookwalter's got real good dirt," says King. "Not a lot of clay. The dirt's black clear to the bottom. It's easy to dig."

131

Tombstone Territory

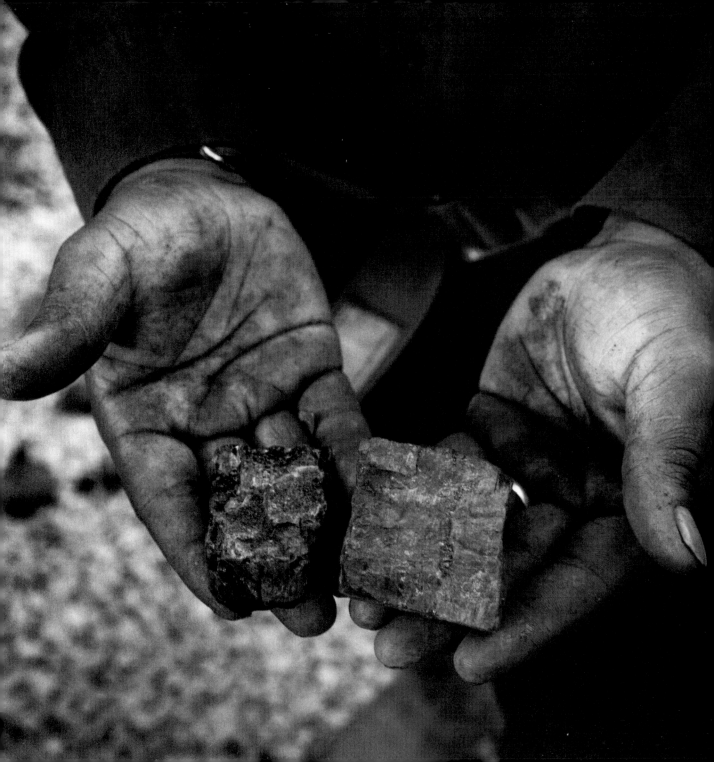

Way Down Deep
Michael Zachery

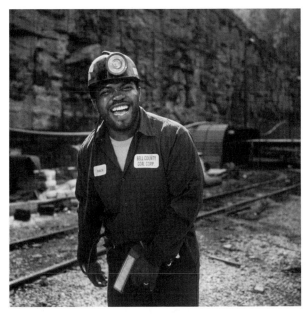

There was a time when Michael Zachery's muscular legs covered a lot of territory on top of the ground in southeastern Kentucky. A star running back at Pineville High School in the mid-1980s, Zachery dashed, rushed, jumped, juked, cut, sprinted, crunched, and pounded his way up and down many a Friday night football field, helping lead the Mountain Lions to a district championship and earning honorable mention All-State honors for himself.

These days, his legs—still muscular from regular workouts in the weight room—continue to traverse an abundance of real estate in Bell County. They just do it significantly deeper, and farther off the beaten path, than before.

Like, say, forty-two hundred feet inside of the mountains overlooking historic Middlesboro, Kentucky.

"I'm the shortest man on my crew," laughs the five-foot, five-inch coal miner. "All my buddies get mad at me 'cause there are places underground where I can almost stand straight up. If not, I just start duck-walking. That's a pretty easy thing for me to do."

Coal. The very word is synonymous with southern Appalachia. Throughout the twentieth century, the coalfields of this region, particularly in Kentucky and West Virginia, fueled the homes, power plants, and factories of the eastern United States. The story of coal is one of boom and bust, of good times and heartaches, of fat paychecks and welfare lines, of labor harmony and violent strikes. One might consider coal like a favorite, if somewhat eccentric, old uncle: beloved in one breath, cussed in the other; a venerable character given to unpredictable whims of anger and joy, yet a stalwart member of the family who's always there through thick and thin. Coal has paid for homes, cars, clothes, and food for the

thousands who wrestle it from the ground. It has made millionaires out of lucky owners and smart investors, and paupers out of those who risked their money at the wrong time. It has kept the heart of entire mountain communities beating with financial fire and then blighted these same areas with black lung, environmental degradation, and occasional disasters of unspeakable proportions.

Thus, for some natives of southern Appalachia, the coal mines were a place to grow up near and move away from, preferably at the first opportunity. For others, the mines proved to be just the opposite. For folks like Michael Zachery, the coal mines are home. Here is where they need to be. Here is where they want to be.

Zachery—or "Zack," as he's been known since football days—works second shift of an around-the-clock operation. At three o'clock every weekday afternoon, he and the other members of his work crew climb aboard a rail runner at the entrance of Bell County Coal Company's drift mouth Coal Creek Mine and head for "the office."

As the train slowly descends into the bowels of the mountain, darkness swallows them completely. Instinctively, he and his crewmates flip switches to activate the lights on top of their hard hats. Fifteen minutes later, they arrive at the face of a thirty-inch-thick seam of coal and break out for their assigned stations and duties. For the next eight hours, this will be their world.

Forget the weather outside. It doesn't matter if Zachery and his partners have driven to the mine through a January snow squall or the rainforest haze of a sweltering August afternoon. Way down deep where they work, the climate remains constant. The temperature rarely drops below fifty-eight degrees or rises above sixty.

Except for the fact that all this activity is taking place underground, this could just as well be any

other heavy equipment operation, albeit one that moves with military precision. In the narrow confines of a coal mine, there is no room—literally or figuratively—for error.

Two of the men sit at the controls of continuous mining machines, guiding rows of whirring metallic teeth into the rich, black seam. Four others, including Zachery, operate electric shuttle cars, ferrying coal back to a central dumping point, where it will be fed onto the seemingly endless miles of conveyor belt snaking back to the surface. There it will be trucked to a processing plant one mile away, washed to remove mud and other impurities, and then loaded onto rail cars for delivery to steam plants throughout the region.

"What I operate is basically a souped-up, four-wheel-drive car that just happens to be twenty-eight feet long," Zachery says. "Even though the area I work in is normally only around forty-two inches tall, I can sit at the wheel of this thing. It's just like driving a car."

As the mining machine operators and shuttle car drivers extract and haul coal from the seam, four more crewmen are drilling the rock-faced roof of the mine, securing it in place with long, thick bolts. All the while, other workers might be running a scoop to clean up the section, or maintaining the mining and safety equipment, or checking the production run.

"Down here, everybody's family," says Zachery. "You've got to work together. You can't work against each other. If you've got any differences with somebody, you better get 'em settled pretty quickly. We've all got to take care of each other."

Mining runs in this man's blood. His great-grandfather, Charles Cooper Zachery, and his grandfather, Charles Zachery, dug Kentucky coal long before automation made its way to the hills.

"That was back in the old pick and shovel days,"

he says. "I never knew my grandfather. He died before I was born. But I'd say one of our crews can produce more coal in a single day than he could in a year."

The lure of the mines then skipped a generation—Zachery's father, Charles Zachery Jr., spent his career with Kentucky Utilities—and might have skipped another one had it not been for an untimely injury.

Zachery originally hoped to make his living in athletics. For many years, sports was an all-encompassing part of his life. In addition to football, he also played center field on Pineville's baseball team. Sallie Greene, the high school sweetheart who later became his wife, was a standout guard on the women's basketball team. Their son, Michael Shawn'ta, is an elementary school quarterback.

"I suppose everybody who plays football dreams of maybe goin' to the pros some day," says Zachery. "That sure was a dream of mine."

But the dream ended, abruptly and painfully, during the fifth game of his senior season when Zachery went down with a knee injury. Several colleges had been flirting with him throughout high school, but their interests waned as Zachery recuperated from reconstructive surgery. After graduation from Pineville High in 1987, Zachery walked on at Eastern Kentucky University and played on the football team for two years. But the old injury proved too debilitating for him to continue.

"I came home and starting working odds jobs," he said. "I really didn't know what I wanted to do. I wound up as a security guard at the coal company.

"One day, one of the inspectors asked me if I'd be interested in workin' underground. I told him I didn't think I could handle it down there. But I went on and signed up for the company's mining school and got what they call my 'greenhorn papers.' That's where they teach you how to prepare yourself for working underground, all the safety procedures, how to set up the belt lines, and how to do your job."

Zachery will never forget his first shift down below.

"It was the day after Labor Day in 1994," he said. "I was absolutely petrified. I mean scared to death. I'd look up and see those roof bolts and think to myself, 'You mean those things are gonna keep this mountain off me?'

"But you know what? In about two hours, I settled down. The fear just passed away completely. Now, I just think of a coal mine as a nice place to work. It's calm and relaxed, as far as I'm concerned. I love it. Oh, you still hear the mountain groanin' every now and then, or the seam of coal goes to poppin'. But you get used to it. You don't really think much about it."

Underground coal mining is a potentially dangerous occupation, any time, any place. Before child labor laws were enacted, mining accidents claimed the lives of many boys. But young and old alike were vulnerable to sudden cave-ins and methane gas explosions in those days. One of the most plaintive chapters in the history of southern Appalachian mining disasters involves the 184 men and boys who perished on May 19, 1902, at the Fraterville Mine in Anderson County, Tennessee, near the present town of Lake City.

"Some were killed instantly," reads a yellowed-with-age United Mine Workers memorial pamphlet about the tragic event. "Some were shut up in passages and small rooms and probably lived but a short time, while a good number were able to escape to the headings and entries in parts of the mine away from the explosion, and there exist for several hours until death came from suffocation and afterdamp."

Some of those who did survive for a few hours wrote heartrending letters to their families. Such

as this one to his wife, Ellen, from Jacob Vowell, whose twelve-year-old son, Elbert, died at his side: "Dear Ellen, I have to leave you in a bad condition. But dear wife set your trust in the Lord to help you raise my little children. Ellen, take care of my little darling, Lily. Ellen, little Elbert said he had trusted in the Lord. . . . Do the best you can with the children. We are all praying for air to support us, but it is getting so bad without any air. Horace, Elbert said for you to wear his clothing. . . . Oh! how I wish to be with you. Goodbye all of you, goodbye. Bury me and little Elbert in the same grave by little Eddy. Goodbye Ellen, goodbye Lilly, goodbye Jemmie, goodbye Horace. We are together. Is twenty-five minutes after two. There is a few of us alive yet. . . . Oh God for one more breath. Ellen, remember me as long as you live. Goodbye darling."

Fortunately, the picture is decidedly healthier today. Thanks to advances in mining technology, improved working conditions, and strict safety regulations, the rates of injury and death dropped steadily and markedly throughout the second half of the twentieth century.

"I'd say back in my grandfather's days, there wasn't near the ventilation that we have today," Zachery noted. "I'm sure there was actually some smoking that went on back in the mines, too. That'd be unheard of today. Our airways are constantly monitored. We have rescue packs with us at all times. Every day, we go over checklists to make sure all the equipment is working properly. It's just a much safer environment than it ever used to be."

Nonetheless, many of Zachery's above-ground friends shake their heads in wonder at his choice of vocation.

"They ask me, 'How can you go back in a hole like that and work? Aren't you scared of getting killed?' I tell 'em, 'You can get killed out on the street

just as easy as back in there.' They look at me like I'm crazy, but I know I'm tellin' them the truth."

Zachery is believed to be the only African American still active in coal mining in Bell County. Yet he says he has never detected any hint of racial strife.

"Not in the mines, not when I was growin' up, either," he replied. "It just never happened. I've spent my whole life in these mountains. Almost all my friends are white. I figure if you don't go lookin' for trouble, trouble's not apt to find you."

A broad smile flashes across his face. "You know what? We might start down in that mine as white men or black men. But when we come out at the end of the shift, we're *all* black! Between the oil and grease and dust and mud, everybody's pretty dirty when we come up."

Meaning, of course, that a nice hot shower is one of the first orders of business on top. And what brand of soap does this veteran recommend?

"Liquid dishwashing detergent," he replied. "The same stuff you'd use in the kitchen sink. It cuts the grease right off of you. My wife buys it in great big jugs. They last about two weeks each."

His playing days are over, but Zachery stays in contact with sports through his children. "I coach my son in football during the fall," he said, "and I ride my little girl [Caitlin] piggyback all the time. That's my recreation these days."

The boy may follow his old man in football, but probably not into the mines. Zachery has seen coal mining go through peaks and valleys. He has been laid off during production cutbacks but always has been able to pick up other shifts at neighboring operations. Still, he wonders just how long his unique craft will hold out.

"I'd like to stay in the mines until I retire," he says. "It's good money, and I really do enjoy the work. But you just don't know what the future holds in this business. We've got the coal reserves

in these mountains to keep mining for a lot of years. But you never know if and when another form of energy might be developed.

"On the other hand, you don't know if there might be some new advances in mining technology that would allow us to reach coal we can't get to easily today. We could be here for a long, long time. There are mines around this part of the country that have been producin' coal for sixty years, and they've still got a lot of reserves left."

Coal. Forever changing.

Coal. Forever constant.

Coal. Forever an integral part of life in southern Appalachia.

Way Down Deep

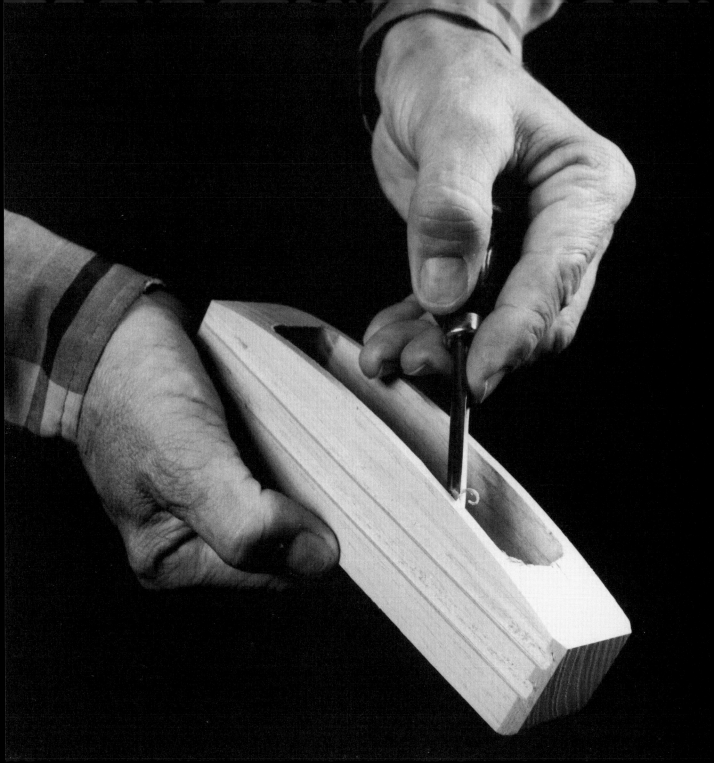

Singing the Siren's Song

Tommy Hepler

Tommy Hepler's degree from Lincoln Memorial University is in sociology and psychology, ideal college training for someone who wound up working for the Tennessee Department of Human Services.

But the psychology specialization also plays a role in Hepler's off-hours passion—turkey hunting.

"I reckon it does take a psychologist to understand turkey hunters," he says, fine-tuning one of a half-dozen wooden turkey calls at his bench. "Nobody else can. It makes no sense at all for a sane person to get out of bed at four o'clock in the morning and climb way up into the mountains and make sounds like an owl or a crow and sit there and let mosquitoes chew on him while he calls to a turkey that probably won't come in anyway.

"Yes'ir, you've just got to be weird. That's all there is to it."

If so, Hepler suffers a lifelong addiction. Born in Allegheny County, Virginia, he was raised in a family of hunters. His three brothers hunted. His sister hunted. His father hunted. So did an assortment of uncles and cousins.

"Mama never did care much for it, though," he noted. "I guess she was too busy cookin' what we brought in."

In that pre-television, pre–shopping mall, pre–swim league era, Hepler never lacked for entertainment. After the chores were done, of course. When you grow up on a 129-acre farm, there's always a wood pile or milk pail standing between you and fun. After that, however, it was off to the wilds.

"I honestly cannot remember a time when I wasn't runnin' in the woods," he said. "You didn't

have to have a reason to go. You just went. If there wasn't anything goin' on at home, we'd roam out there in the hills till dark. Hey, in those days, that's all there was!"

Hepler killed his first wild turkey at age eleven. For the young man who would grow up to become a call maker of regional renown, he brought Number One to bag the old-fashioned way. With his mouth.

"That's all I knew how to do," he admitted. "I'd been in the woods enough to know what sort of sounds turkeys made to each other. This particular day happened to be in the fall, and I scattered a flock of birds. They all went flyin' off in ever-which direction. I plunked down right there and sat real still. After awhile, I could hear 'em start calling to regroup, so I mimicked the sound with my mouth. It worked.

"But shucks, lot of people up around where I grew up are still usin' their mouths to call turkeys. My Uncle Dan'l—that's Dad's brother—he never used a wooden call in his life till I made him one. Now, he's tickled to death with it."

To the uninitiated ear, the raspy *yelp-yelp-yelp-yelp* of a wild turkey hen sounds vaguely like a cross between a rusty hinge and the squeak of chalk on a blackboard. Turkey hunters use a variety of instruments to create the sound, including blades of green grass, hollow wing bones, mouth-held diaphragms, circular pieces of slate, plus an assortment of tubular calls with latex reeds. But the mainstay in any hunter's vest, the ol' reliable to bring forth when all else fails, is the box call.

It is, quite simply, a thin-walled wooden box approximately seven inches long and two inches wide. A piece of wood, descriptively named the "paddle," is attached to the top by one screw. A spring on the screw shaft provides tension. When the paddle is scraped across the edges of the walls, the eerie sound of a "yelp" or a "cutt" or a "purr"—and more than a dozen others—issues forth.

For those who are experienced with box calls,

that is. Mastering a box call is like learning to play a fiddle or pick a banjo. This is a musical instrument in every sense of the word, each call with its own distinct sound.

"I migrated into turkey-call making," Hepler said. "I always liked to carve. That sorta came with the territory, too, because where I grew up, all the boys had a knife. We were always whittlin' on things.

"When I was in college, I started carvin' out small statues and relief figures on wood slabs. I was always tryin' something else. One day, I decided to make my own turkey call. I wanted somethin' that would give me volume and resonance. I'd never been 100 percent satisfied with anything that was on the market back then."

The first call led to a second, to a third, to a fourth. Now, nearly one thousand calls later, a microbusiness known as Hepler's Turkey Calls of Rogersville, Tennessee, is recognized by hunters throughout the nation. And beyond.

"I've got one customer who's stationed with the marines in Okinawa," said Hepler. "Over the years he's bought five calls from me. He only gets back to the states every other spring, but he spends the entire time hunting turkeys."

Another customer, who happens to own a large manufacturing plant, purchased in bulk. He ordered one hundred calls as sales incentives for his employees.

Give Hepler a block of almost any native wood, and he can turn it into a serviceable work of art.

"Black walnut is the most popular with hunters, I guess because it looks so pretty," he said. "But I also work in cherry, sassafras, mulberry, cedar, and poplar. I've even got some poplar that's three hundred years old. I got the wood from an old house that was being torn down. It was hand-hewn, the hardest stuff you ever saw. In the old days, cedar was the standard for calls, but I'd rather have mulberry or sassafras over any of 'em. They've got a good raspy tone."

Like many mountain artisans, Hepler gathers his own materials, usually off the old homeplace in Virginia. He then contracts with a local sawmill to custom-cut each log into sections approximately five feet long, two and a quarter inches wide, and one and five-eighths inches thick.

These boards are stored in a barn for a minimum of four to five years. Only then is the wood dry enough to work well. Hepler reduces these to seven-and-one-half-inch blanks at his shop. And then the real work begins.

Early call makers hollowed out the chamber with a pocketknife. Hepler has done it that way himself, but the process is too slow for his production demand. These days, he uses a one-and-one-eighth-inch diameter drill bit to excavate the bulk of material. Then he completes the job with a chisel, grinder, and knife. Toward the end, it gets critical.

"I sorta have to work by feel from there on out," he says. "Each call is different. I work the side walls down to around one-sixteenth-inch thick at the top, and maybe one-eighth at the bottom. If they're not right, you won't have good tone."

He roughs out paddle blanks on a band saw, then uses a belt sander to bevel the bottom side. Again, that's for the basic shape. The fine tuning and detail work have to be done—by feel—with a knife blade and sandpaper. That same expertise is called upon when the lid is attached to the box itself.

Says Hepler: "They've gotta be lined up perfectly. 'Bout the only way I know how to do it is hold it right in front of my face and line it with my eyes."

If the alignment is precise, which usually doesn't happen right off the bat, the call will play sweetly from the start. Usually, though, last-minute adjustments are needed—a sliver of wood removed here, a touch of sandpaper there. Hepler polishes with lemon oil to restore the natural grain of the wood. Then, all that's left is chalking the edges for friction.

"No two calls I make are gonna be exactly the same," he said. "But that's the nature of doing things by hand. No two humans talk the same way, either. And no two turkeys make the same exact sounds. Get out in the woods and listen for yourself. Sometimes in the fall, I'll hear an old hen that's downright awful! Just when I've convinced myself it's another hunter and start to move, here she comes walkin' along."

For a dedicated turkey hunter, the distinction between fall and spring is markedly significant. Fall season is kindergarten; spring season is graduate school.

"I love all kinds of hunting—deer, squirrel, fall turkey, you name it. But spring turkey hunting is the ultimate," Hepler said. "It's a beautiful time of year to be alive. You get to the woods before daylight, and pretty soon an ol' redbird starts singin'. The sun pops up. The wildflowers are in bloom. It's warm. There can't be a better time."

As for those owl and crow sounds?

"That's how you locate a gobbler in the spring," he replied. "Owls and crows are natural enemies of turkeys. In the spring, they seem to aggravate 'em even more."

Hepler threw his head back, opened his mouth, and unleashed the haunting call of a barred owl—*Aa-ooo-ooo-ooo-ooo! Ooo-ooo-ooo-oooaa!* Then he followed up with a raspy crow call from deep inside his throat—*Kaaaaa! Kaa! Kaa! Kaa!*

"You hit a gobbler with somethin' like that in the morning, and he can't stand it. He'll gobble back, and that gives you an idea of where he's roosted. You try to slip up near him—oh, say, a hundred yards or so—and then sit down and call him toward you making sounds like a lovesick hen."

So much for how-to on paper. In the woods, it's a different ball game. Gifted with superb eyesight, excellent hearing, and a sixth-sense suspicion about anything that moves, the wild turkey is a hunter's greatest challenge. Complete camouflage,

Singing the Siren's Song

including face and hands, is a must. So is the ability to sit absolutely motionless for hours at a time, if necessary.

The fact that outdoor enthusiasts like Hepler can still enjoy turkey hunting is a testimony to modern wildlife management practices. Turkeys were common throughout colonial America, but like many forest animals, they eventually became victims of the ax, plow, and gun.

Singing the Siren's Song

Relentless plundering of natural resources in this country, particularly in the late nineteenth and early twentieth centuries, eliminated wild turkeys in all but a few isolated pockets of the Deep South and southern Appalachia. Had there been a threatened-and-endangered species list in the 1930s, the wild turkey certainly would have been included. In addition to widespread habitat destruction and unregulated hunting, the chestnut blight, leading to the subsequent loss of a rich supply of food, is cited by many authorities as a crucial factor that nearly wiped this grand bird off the map forever.

Help, such as it was, came in the late 1940s when various state game and fish agencies tried raising turkeys in captivity and stocking them into the wild. Although hundreds of thousands of dollars were invested in this approach, it was genetically doomed from the start. The semi-tame fowl it yielded lacked natural wariness. They also were susceptible to disease. Most died within weeks or months after liberation. Indeed, the chief beneficiaries of this huge effort were foxes, owls, and other woodland predators that feasted on these feathered imbeciles.

Finally, in the early 1950s, biologists began live-trapping individual birds from the few remaining wild flocks and releasing them into unoccupied habitats. The turkeys flourished in their new homes. Encouraged by this success, wildlife departments throughout the East embraced turkey restoration with a passion in the 1970s, 1980s, and 1990s. Today the wild turkey is found in all states except Alaska. In the Southeast, the population is higher than ever before in this century.

Nonetheless, a vast chasm exists between a turkey in the woods and a turkey on the table. Just ask the people who pursue them.

"Sometimes, an ol' gobbler'll fly down and strut right into you," Hepler said. "Sometimes, he'll walk a circle around you. Sometimes, he'll stand there and gobble and not budge an inch, tryin' to get the hen to come to him. Sometimes, he won't say nothin' at all. Sometimes, he walks off in the other direction. I swear, they make you want to pull your hair out! There's no sure thing about turkeys—ever."

There is one sure thing about Tommy Hepler, however. When turkey season rolls around, he'll be out in the woods with one of his calls. Some things never change.

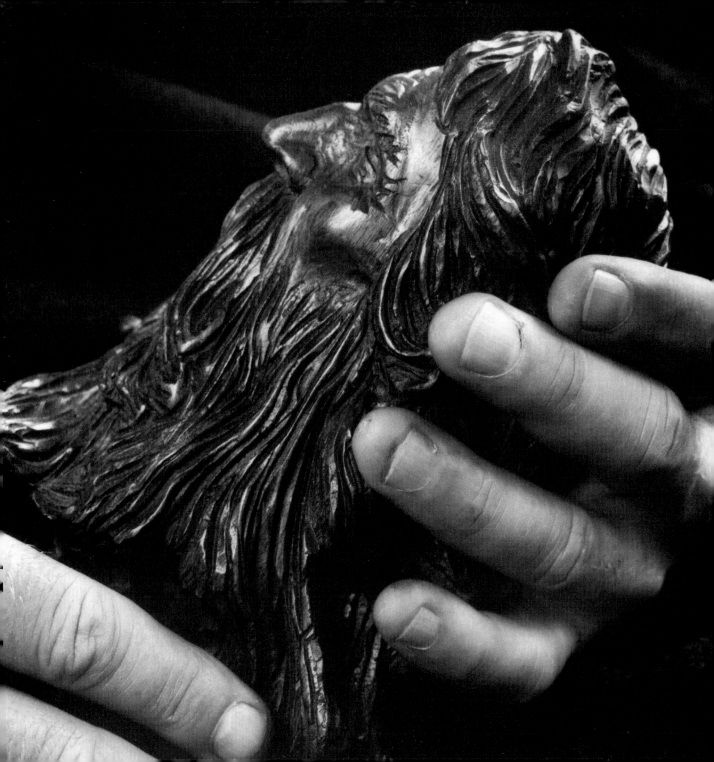

Removing the Stuff that Doesn't Belong

Barry Simpson and Mike Copas

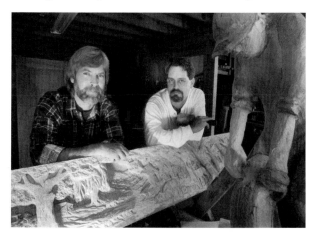

More than twenty years have elapsed since Barry Simpson and Mike Copas so much as touched a math book, let alone opened one.

"Fact is," Simpson states flatly, "I may still hold the all-time record for academic probation at Memphis State University."

But when it comes to matters of subtraction, they can sit on the front row of any class in the land, thank you—just as long as the matter to be subtracted consists of wood, not numbers.

It's a bit inaccurate to say Copas and Simpson are "wood-carvers." That's rather like describing Mozart's line of work as "piano player." But understatement lies at the heart of the artwork these two Smoky Mountains craftsmen bring to life. As Copas puts it nonchalantly, "All we do is remove the stuff that doesn't belong."

Simple theory. Yet knowing *what* to remove is a difficult-enough assignment, requiring the eye of an artist and the soul of a poet. Knowing *how* to remove it is even tougher. Depending on the particular task at hand, it might call for the fingertips of a surgeon or the forearms of an ironworker. No problem for these two. From finely detailed smoking pipes, to relief carvings in mantles, doors, and coffee tables, to cigar-store Indians, to caricatures, to life-sized busts and statues, they have done it all.

Copas and Simpson work in a shop behind Simpson's home in rural Sevier County, Tennessee, some three miles northeast of the bustling tourist city of Gatlinburg. This area is known locally as "Boogertown." The name dates back to the early days of Sevier County, when the region was supposedly frequented by wildcats, haints, and other "boogers" that pierce the night with screams. Despite its dubious heritage, Boogertown today is a quiet community of grassy valleys, framed by the steep ridges of Smoky Mountain foothills. About the loudest noise you'll hear is the nervous clatter of guinea hens across the road—except, of course, when Copas and Simpson are flailing away at wood.

"A lot of carvers work together," Copas observed. "It helps break some of the monotony. It also gives you an instant critic and a source of advice."

"It keeps you from slowing down, too," Simpson added. "It's kinda hard to sit on your butt and do nothing when you hear the other guy over there, tapping away."

Copas and Simpson work almost exclusively on commissions these days, commanding thousands of dollars for detailed mantles, statues, and wildlife carvings. They deserve to, for each has paid his dues, artistic and otherwise.

"I came to the mountains to carve for a living," said Copas, "but I had to haul a lot of hay and pick a lot of beans to keep from starving to death in the process."

Copas grew up in the small community of Madison, Tennessee, just outside of Nashville. He came by his artistic skills honestly. His mother, Edith, is an accomplished quilter; his father, Nordean, a blues harmonica player. So it was no surprise when Mike's talents showed up at an early age.

"When the teachers caught me drawing in class they never made me stop," he says. "In fact, my fourth-grade teacher's mother was my first private tutor."

At the urging of Copas's teachers, his parents got permission to enroll their son in Nashville's Watkins Institute at the tender age of ten. Along with students nearly twice his age, the youngster was instructed in different disciplines of art, including pastels, oils, clay modeling, charcoal, and watercolors. The latter proved to be the most difficult for him.

"I never could get the hang of watercolor," he recalls. "But looking back on it now, watercolor is like sculpture. Sculpture is a discipline of pure subtraction. As long as it stays pure subtraction, then it's being true to its art form. When you add things to it, it's not really sculpture. It's modeling, which is like oil painting—you put on and take off. In watercolor you subtract light with pigment. You can't put the light back on that paper once it's gone, just like working with wood. Once it's off, it's off. You stop when you get to the image."

Removing the Stuff that Doesn't Belong

Copas continued his art instruction through high school. He graduated in 1971. Shortly thereafter, the Opryland theme park opened nearby, and he took a job as a caricature artist. One day he watched in amazement as a friend, Bridges Dillehey, carved the image of the Grand Ole Opry House into a piece of wood.

"The idea of carving a picture instead of drawing it really impressed me," said Copas. "I thought it was the neatest thing I'd ever seen. I had a feeling I could do it."

The teenaged Copas convinced Dillehey to take him on as an apprentice. For six months, he worked at his side, learning everything from the elements of carving to the basics of tool maintenance.

"You've got to have sharp tools," Copas said. "That's the first thing any prospective carver must learn. Bridges kept his tools so sharp, the shadow could cut you."

Thus he also had to learn First Aid 101. "You're gonna cut yourself from time to time. It's just gonna happen. But if you'll stick your finger into some kerosene, it'll stop the bleeding almost instantly and cleanse the wound at the same time."

Copas began carving in earnest, refining his skills and building inventory. He also continued to draw, specializing in murals for store fronts and interiors and selling individual oil paintings. In 1973, he says fate intervened.

"I happened to sell almost everything I had at once. I had that money in my pockets, moved out of town, and headed for the mountains. I had some great dreams, but it was a hard row to hoe when I got up here. I wound up living with two other artists in a farmhouse in Wears Valley. Our rent was fifteen dollars a month—total!"

Copas began to specialize in faces carved in relief. It's an art form whose roots can be traced back into almost any human culture. Guided by his imagination and using simple tools, Copas rendered

the faces into lengths of sassafras logs, which he then sold to tourists. But the wood carvings didn't bring in much money at first. Wears Valley, now bristling with second-home development, was still an agricultural area in the early 1970s, so Copas and his buddies hired out as farmhands.

"That first summer, we put up something like twenty-five thousand bales of hay for folks," he recalled. "I was skinny as a rail back then. When I first started, it was all I could do to lift a bale into the wagon. By the end of that summer, I'd gained twenty-five pounds and could toss a bale of hay seven or eight feet in the air."

Copas also made a few dollars with another of his artistic talents: music. He plays the piano, accordion, banjo, guitar, mandolin, fiddle, saxophone, and clarinet. Bluegrass music was the rage in those days, and Copas and friends had little trouble finding nightly gigs at bars and restaurants in Gatlinburg.

"We had a corny group called the Fish Market Quintet," Copas said with a chuckle. "We always told audiences we just played for the halibut."

Fate was about to intervene again, though. Another young wood-carver wannabe, Barry Simpson, from Memphis, was about to move into town. He also played bluegrass. Copas and Simpson met through a mutual friend and fellow wood-carver–musician, Kerry Brown. They started working the bars together with guitars and banjos.

"Those were good years," said Simpson. "We never made much money—I remember when we'd play all night just to eat the leftover shrimp—but we sure had a fun time."

Like Copas, Simpson had been the beneficiary of early art training. His entire family is also artistically inclined.

"My mother writes for a newspaper, and she and her two sisters are published poets," he said. "My sister is an artist, and my brother is a church youth minister with a master's degree in music. Obviously, the encouragement to follow art was always there. A lot of times, you find families who say, 'You'll just wind up being a starving artist.' Mine was different. We all loved to sing and play the piano and guitar. I also studied art all through high school."

Fresh out of high school and newly married to Patricia Hughes, a budding watercolor artist, Simpson took a job with a construction company. Along came fate once more.

"The Lord works in mysterious ways," he says. "One day on the job, I cut my leg pretty bad with a power saw. It's a wonder I didn't bleed to death. It took two hundred stitches to close the wound.

"The folks I worked for knew I could draw, so as I was healing they brought me inside to do models for the architect. They ended up paying for my schooling in construction technology and architectural design at State Tech and Memphis State."

Simpson eventually took a job in facilities planning with Federal Express and moved to a rural community just outside Memphis. He also began carving with a passion. He and Patricia would occasionally drive to the mountains of east Tennessee on vacation. Each time, the lure of carving for a living became stronger.

Says Simpson, "One day, not long after our son Neal was born, I said, 'If we're ever gonna leave, now's the time.' We sold out, gave away what we couldn't sell, loaded up, and headed for the mountains. I worked part-time for an architect, Ted Prince, and the rest of the time at Dale Gillespie's gallery doing wood carvings. Dale was a tremendous artist. He worked with me and gave me pointers, little tricks and techniques to make me better."

Between the two jobs, Simpson was putting in sixteen- to eighteen-hour days. The money was good, but this was hardly the idyllic life-style he'd been seeking.

"I was never home. It really hit me shortly after

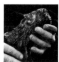

Removing the Stuff that Doesn't Belong

we'd moved into a new house. Neal was about two. One day, he asked Tricia, 'Did Daddy move with us?' It nearly broke my heart. I knew then it was time to quit everything and start carving wood at home."

At the same time, Copas was still doing odd jobs in the farm community and carving every spare minute. He also worked in a leather shop, a dulcimer shop, a restaurant, and gave private music lessons. He built up an inventory of goods—mostly relief faces carved in sections of sassafras logs—and peddled them from a sidewalk booth. One day, Ron Conn from Gatlinburg's Mountain Woodcarver Shop happened by. He was so impressed by Copas's work, he bought his entire inventory and hired him on the spot.

"Ron and his partner, Pete Engler, were great to both me and Barry," said Copas. "They had some of the best wood-carvers in the country working for them. They taught us a lot about the craft. We also got to buy really excellent tools and pay 'em off as we sold carvings. Up till that time, I'd been working with carpenter's chisels, old filed-down screwdrivers, and anything else that could cut wood."

Over the years, both Copas and Simpson have either carved for, or sold their wares through, the Mountain Woodcarver, Little River Woodcarvers, Morning Mist, G. Webb Galleries, Dollywood, and other locations in the Gatlinburg–Pigeon Forge area.

In 1983, Copas's skills took him to an even newer level when the ABC television network came to east Tennessee to film a three-hour movie, *The Dollmaker*. The film, which won an Emmy Award for actress Jane Fonda, was based on Harriet Arnow's novel about Gertie Nevels, a southern Appalachian woman uprooted from her mountain home and forced by circumstance to raise her family in a Detroit slum. A central element in the film was a large image of Christ that Gertie was carving. Copas was hired to produce several large props for the movie and also to teach Fonda the fine points of the craft.

"The first couple of weeks, my main job was to teach her how to not cut herself," Copas said with a laugh. "But Jane was eager to learn. She watched me carve the main piece for the movie, start to finish. Then I taught her how to carve hickory sprout dolls.

"She wanted to carve one thing, start to finish, in the film. There was a scene where Gertie was peeling potatoes, so I taught her how to carve a face in a potato in about fifteen or twenty seconds. We must have gone through fifty or sixty pounds of potatoes before that scene. But she got it right. Since there was some other food on the table in the scene, I told her to get a couple of peas and put 'em in the eyes for contrast. She really got good at it. She could pick up a potato and—boom! boom! boom!— knock out a face in no time.

"Funny thing, though. Every face she carved looked like Jason Robards."

These days, you'll find Copas and Simpson busy in the shop, a place Copas describes as "a constant state of chaos with little pockets of order." Although they have turned out virtually every type of item that can be carved, time and customer constraints have forced them to specialize. Copas works mainly in statues, Simpson in mantles. Each has his own philosophy about starting a piece.

Says Simpson, "I tend to fall back on my early art training. If I can draw something, I can carve it."

Copas eliminates that first step: "If I can see it, I don't have to draw it. I go ahead and carve it."

For a standard mantle, Simpson begins with a piece of kiln-dried basswood measuring six feet long, four inches thick, and eight inches wide. He then selects a scene from one of the many patterns he has drawn. Most of these scenes are outdoor in design—a rustic cabin beside a flowing stream, deer browsing in the forest, ducks landing on a lake. Or he can tailor it to whatever the customer wishes.

Once the basic design has been selected, he

Removing the Stuff that Doesn't Belong

transfers the drawing, via carbon graphite paper, to the face of the mantle and begins gouging and chiseling. He'll need to repeat the drawing step as many as eight or ten times as the work progresses.

"Since I carve the foreground first and work backward, deeper into the wood, I eliminate my original drawing marks as I go along," he explained.

Although wood carving is a process of "refined destruction," it does bear a parallel to building. Simpson likens it back to his old days on the construction crew: "The first few steps are the most dramatic, like raising the walls of a house. You see a lot of instant progress. Then, as the work grows more detailed, it seems like things really slow down."

Simpson uses a router to remove the bulk wood from a scene. From then on, he is relegated to a slow, patient process of chipping and tapping with various gouges and chisels—some as wide as a tablespoon, some as dainty as the tip of a toothpick. If a crack does develop as he works, Simpson mends it by inserting tiny wedges of wood and driving them in soundly. A few strokes of the chisel later—*voila!*—no more crack. When the carving is complete, he highlights the scene with either a color wash or stain to bring out the details.

Even when the creative juices are flowing, though, this is not an assembly-line operation. Instead, it's a never-ending process of hurry up and wait until the wood is ready to be worked.

On a life-sized statue, for example, Copas starts with a full log. It, too, must be dried to prevent it from cracking, but the drying must proceed slowly, from the inside out. Copas encloses the log in black plastic and leaves it in the sun for months at a time. This way, the log literally sweats itself out, a little each day, until it is dry.

Like Simpson, Copas uses a power tool to excavate unwanted wood early in the process of his statue carving. A very powerful tool, indeed.

"It's not much different than the same chain saw you'd use around a home or farm," he said, pointing to the sixteen-inch, eight-horsepower Sachs-Dolmar unit resting in the corner of the shop. "You've gotta be real careful with it, or else it'll kick back when you get the tip in a bind. Once I get the bigger chunks removed, I can do some more refined cutting with a Poulan Pro 150. This is a modified tree-trimming chain saw. It has a twelve-inch bar that rounds off to a tip the size of a dime. It's specifically designed for this type of work. It won't kick back."

Then begins the tedious task of defining the subject with hand tools. Copas swings mallets made of a dense tropical wood called "lignum vitae." These mallets weigh anywhere from twelve to a beefy thirty-two ounces. Sometimes Copas strikes fiercely with them. Other times his strokes are little more than light, soft taps. Through countless hundreds of thousands of repetitions over the decades, Copas has developed an hand-eye relationship that works with machinelike precision.

"This isn't like driving a nail with a hammer," he said. "You don't keep your eye on the mallet. Instead, you have to follow the tip of your chisel. You can't worry about the mallet. You just know it's going to strike true every time you swing it."

Each log or block of wood Copas launches into has a piece of art locked inside. It might be a life-sized human, an animal, a wildlife scene. Although Copas does extensive research into body shapes, feather formations, and other details about a particular species, he's never quite sure how the finished product is going to look until he gets down to the details. Painstaking hours and hours later, it's ready for light sanding and a finish with refined linseed oil.

"There's no such thing as a bad piece of wood, unless it's rotten," he said. "You just have to work with it to bring your creativity to life."

Again, the importance of sharp tools arises. "I teach wood-carving classes, and that's the first

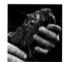

Removing the Stuff that Doesn't Belong

thing I tell the students," said Simpson. "You've gotta spend a lot of time with an oil stone, a grinder, and an Arkansas stone. A dull chisel won't cut the wood well. Even worse, you're more likely to cut yourself with a dull tool than a sharp one because you're putting more pressure on it."

Still, accidents happen. Any wood-carver worthy of the name is a living, breathing collection of scars, and Copas and Simpson are no exception.

"They say you've got to give a little blood to everything you create," Simpson quipped.

Some of their creations have taken a different turn in recent years. Copas and Simpson began experimenting with marble dust/resin casting to duplicate their carvings and now turn out limited-edition offerings.

"It's the same concept as an artist producing prints of an original piece," Simpson explained. "It lets more people share the artwork at a lower price."

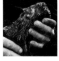

Removing the Stuff that Doesn't Belong

No matter what the final product happens to be, though, the entire process must start in the mind of the craftsman.

"By design or by necessity, wood-carvers were the first artists," said Copas. "Somewhere along the line, a caveman scraped a piece of wood with a stone to make it sharp so he could fling it at an animal. We've been thinking up new ideas ever since."

"No doubt about it," said Simpson. "Wood-carvers are dreamers. The only thing that limits someone in this line of work is a lack of imagination."

Will these gifts be passed to another generation? Hard to say. Simpson's son Neal is a talented artist in his own right but seems more inclined to write or study the sciences. Copas's son is still a toddler, yet the love of wood flows through his veins and will follow him throughout his life, no matter what vocation he chooses.

The poor lad can't help it. His first name is Carver.

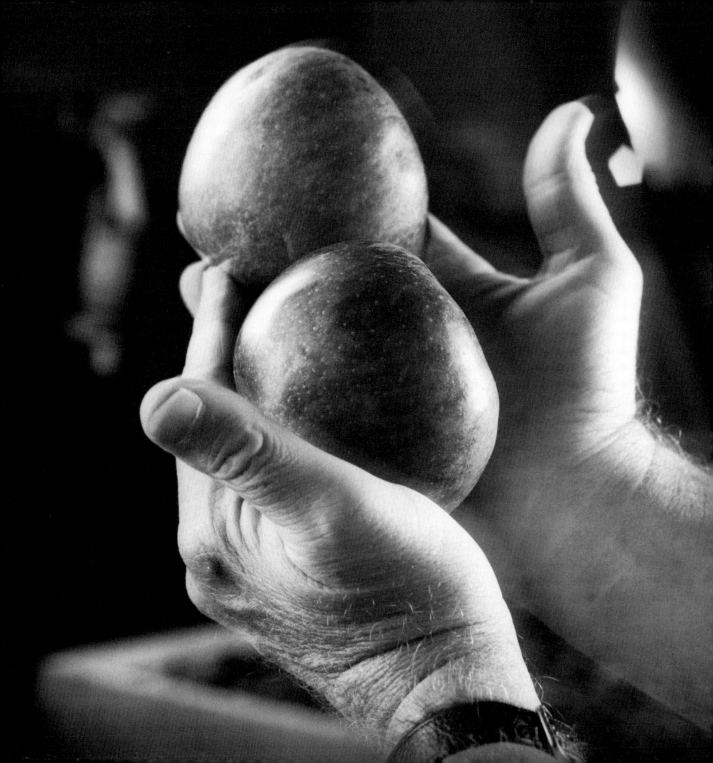

The Fruits of Their Labor

Bill and Judy Carson

Contrary to conventional and theological wisdom, a house divided will not always crumble and fall to pieces. Sometimes it can remain standing. Even prosper.

There is vivid proof of this anomaly in the Blue Ridge Mountains of western North Carolina—smack dab along the crest of the Blue Ridge, to be exact, in a picturesque village appropriately named Little Switzerland. The house belongs to Bill and Judy Carson. It surely represents one of the most tangled cobwebs of registration, taxation, documentation, and representation in the history of bureaucracy.

The Mitchell County–McDowell County line runs right down the middle of the place. That's confusing enough on the local level. But incredibly, the dividing line between two congressional districts, the tenth and eleventh, also zigzags its way below their feet.

"I vote in one county," says Bill. "Judy votes in another."

And just who is attached to where inside the Household of Carson?

"I'm not telling," he replied with a laugh. "This way, *all* the politicians pay attention when one of us has something to say."

Not your standard house, for certain. Not your standard couple, either. For Bill and Judy Carson, nothing has been standard since they unconventionally "settled down" to North Carolina.

In 1993, Bill wrapped up a thirty-two-year career with IBM. Judy had had her own successful graphics arts and design business. It was time for them to coast a bit. They chose the mountains of North Carolina for a couple of reasons.

For one thing, Bill's ancestral roots run deeply into southern Appalachian soil. Both his mother and father, and their parents, grew up in east Tennessee and southwest Virginia. Also, his aunt had owned a home—the divided house—in North Carolina, which they bought after her death.

"We'd always liked this area and had visited it from time to time," he said. "Plus, we thought it would be a shame to let my aunt's house pass out of the family. We made some additions and moved in and were happily retired for about a year and a half."

"Oh, we certainly intended to stay active," Judy added. "Neither one of us is what you'd call a chair-rocker. Before he left IBM, Bill bought a loom and learned to weave. I had always been involved in community activities and kept that going."

Indeed, it was community activity that ultimately changed the Carson's world and forever altered their concept of the term "retirement."

Little Switzerland is located near the Blue Ridge Parkway, a two-lane, scenic road that winds 469 miles from the Shenandoah National Park in central Virginia to the Great Smoky Mountains National Park in western North Carolina. Built in the mid-1930s as a New Deal project, the parkway actually got its start in 1906.

That's when Joseph Pratt, the North Carolina state geologist, proposed a toll road from Marion, Virginia, to Tallulah, Georgia. Quite the visionary, Pratt correctly anticipated the impact motor vehicles would have on America some day. He hoped to lure visitors to the mountains. He started the Appalachian Highway Company and in 1912 began construction of the "Crest of the Blue Ridge Highway." Pratt managed to cut eight miles through the rugged terrain before the United States' involvement in World War I shelved his project. It wasn't until 1933, when the National Park Service began construction of the Blue Ridge Parkway, that Pratt's dream became a reality.

The "new" parkway cut directly through a 350-acre orchard near Little Switzerland that had been established in 1908 by the Clinchfield Railroad.

"It's just speculation on my part, but I figure the railroad developed the orchard thinking to sell it one day," says Bill. "They probably wanted to pro-

mote a business that would increase their shipping tonnage. They put up a siding in the Altapass community, just over the hill, and hauled out apples for years. They paid big for the land—thirty to one hundred dollars per acre. That was great money back then. I'd say the people who got a hundred dollars were quite proud."

From day one, the orchard proved to be a survivor. Not even a devastating series of storms in July 1916 could wash it away.

"A lot of trees were damaged, for sure," Bill continued, "but it's amazing the orchard escaped at all. Two hurricanes came through, back to back, inside of one week. One came out of the Gulf of Mexico, the other out of the Atlantic. There was record rainfall all along the eastern slope of the Blue Ridge. Rain gauges were small and not checked very often, but a documented 22.22 inches fell in twenty-four hours right here at the orchard.

"It nearly washed the entire valley out. A lot of people were killed. I still hear stories about children who were swept away by the floodwaters.

"These storms changed the economic landscape of this region. This was big tobacco country back then. The flood destroyed most of the tobacco crops and the tobacco warehouses and effectively shifted the capital of tobacco production from Asheville over to Winston-Salem.

"The railroad was wiped out, and that isolated all these little mountain communities. The way I hear it, nearly everybody in town quit what they were doing and went to work on the railroad to bring it back quicker. It only took five weeks before the tracks and bridges were repaired and the first train arrived."

Though battered and beaten, the orchard was salvageable. Whoever had chosen this site in the first place had an excellent grasp of agricultural knowledge. This grove was carved and terraced into a steep, south-facing slope near McKinney Gap,

154

The Fruits of Their Labor

looking straight down into North Cove. Warm updrafts kept it protected from all but the worst of unseasonable frosts. They still do.

Like a shady town square or a popular general store, the orchard became the focal point of community activity. It also served as a major employer, using abundant local labor to prune the trees, pick the harvest, and pack and ship the apples to market.

But situations changed, and the orchard ultimately fell upon hard times.

In 1925, the railroad sold its venture to a private investor. The apple crop continued to flourish. But then the parkway came through, cleaving some seventy acres right out of the middle. From that point on, the land above the highway received no management at all; today this tract has been reclaimed by forest.

The succeeding owner died, and his heirs and partners' heirs ran the orchard until the early fifties. Then it passed through a series of purchasers, resulting in an alternating pattern of boom and bust. By the early 1990s, it was held by an absentee landowner who merely leased the apple sales to someone else.

"They weren't even growing apples for market by then," Bill noted. "The apples were being shipped in from outside the area and sold at the orchard."

This was about the time the Carsons moved to North Carolina and began taking part in community activities. Bill soon found himself head of a local association that worked with the National Park Service for the betterment of the region. During the course of discussions, someone mentioned that the Altapass orchard had been offered for sale to the federal government. Fat chance that would happen, for belts were being tightened from Washington on down.

"No way the park service could ever have bought it," he said. "It literally would have taken an act of Congress, and that wasn't going to happen. We'd been hearing that there were plans to turn the or-

chard into a housing development, so I asked one of the ladies in the association to start searching around to see if she might find somebody who'd be willing to take a look at it. You know, a conservation trust or a private fund—someone to keep it from being lost."

Little did he know who that someone would be.

On a Wednesday evening in October 1994—Bill remembers it was a Wednesday because that's when the local weekly newspaper is published—the Carsons had company. His sister, Kit Trubey, a real estate agent from Raleigh, was visiting. Perusing the classified ads before supper, she looked up and said, "I see an apple orchard is for sale. Is that the one I think it is?"

"Yep," Bill replied. "Same one."

Kit was no stranger to the place. She had visited the orchard several times during her frequent trips to Little Switzerland. In the back of her mind, she'd always entertained the notion of investing in some mountain property for her own family.

"But we'd never really discussed it," says Bill. "It never occurred to us that Kit would be interested."

She was.

The three sat down to supper. They talked. Is this really something they'd want to take on? What about a partnership, with Kit in Raleigh and Bill and Judy in Little Switzerland? And in not much more time than it would take to peel a bushel of winesaps, Kit was plunking down earnest money. On January 5, 1995, she officially became owner of 276 acres of apple trees at Milepost 328.3 on the Blue Ridge Parkway.

Oooookay. Now what?

Judy fairly explodes in laughter at the memory: "You've got to understand how *completely* in the dark we were! Here Bill and I were going to run an apple orchard, and we'd never even raised a garden! For years, we had lived in Washington, D.C., where we were lucky to have a patio! And then he

The Fruits of Their Labor

and I walk into this dusty old warehouse and see this rusty equipment and think, 'Well, here we are.' We'd never even been around a tractor before."

That soon changed. Fueled by ancestral mountain grit and an engineer's curiosity and bent for learning, Bill threw himself into the task. He attended seminars on apple growing. He and Judy wore out the telephone talking to agricultural extension agents. Even other apple growers offered advice and tips.

"They were very nice," Judy recalled. "Actually, I think they felt sorry for us. But we're not in competition with them. We're located way up on the parkway. We don't take their market. In fact, we don't even ship to markets at all. Our apple sales are all done right here, on site."

Even with all the help, the Carsons kept asking themselves what in tarnation they'd been thinking when they launched this foolish plan. Weren't they supposed to be retired? What in the world were they doing in the middle of thousands of apple trees that had been neglected for years?

Yet those doubts began to vanish like morning mist any time local folks, many of them the descendants of the original orchard workers, happened to drop by.

"This wonderful gray-haired man came in one day when we were just getting started," said Judy. "I'll never forget when he told me he was so glad to see the orchard wasn't going to be destroyed."

That was Olin Hefner, retired pastor of the First Baptist Church in Spruce Pine. He was born and raised at the orchard. His parents, Deward and Blanche Hefner, had managed the place for nearly thirty years. From the first day he met the Carsons, Hefner has continued to serve as a source of knowledge and inspiration.

Bill and Judy opened the doors on Memorial Day 1995. It was a less-than-auspicious beginning.

Says Judy, "We were so ignorant about what was growing in the orchard, we had to take varieties of apples we couldn't recognize and put up signs that said, 'Do you know what these are?' That helped, but it was also confusing because there are many local names for the same type of apple. What was even more confusing was the fact that people would come in and ask for a certain type of apple, one we knew didn't grow at the orchard. It took awhile for us to realize they'd been shopping here back in the days when apples were being brought in from other areas."

In no time the orchard again became a focal point for the community. Customers, friends, and neighbors began telling stories and retracing histories—not only of their own families but also of the courageous Over Mountain Men, who marched through this land to defeat the British in the Revolutionary War's pivotal Battle of King's Mountain.

"The next thing we knew, they were bringing in jams, jellies, handcrafts, pottery, and walking sticks," said Judy. "We decided to open a shop, which was pretty funny because neither Bill nor I had the foggiest notion about running a store, either! Then all these local musicians started showing up and playing wonderful 'front porch' music. The whole thing has just evolved."

Evolution is an apt description, for the orchard at Altapass has moved beyond the realm of simply producing apples.

"What we did was take over a living museum," said Judy. "We have become a tourist attraction, an entertainment center, and a place for preserving an important part of the history of the Blue Ridge."

Any modern commercial apple grower could glance at the Altapass orchard and realize how outdated it is. The trees are rather tall and planted far apart, translating into additional labor costs for pruning and harvesting.

So be it.

"This is agricultural history," says Judy. "If we relied strictly on apple production, we'd go broke."

Twelve varieties of apple trees grow here, some dating back to the 1916 flood. Among the more popular are the transparent, McIntosh, Grimes golden, Rome beauty, Virginia beauty, king luscious, Stayman winesap, golden delicious, and York. Depending on species, the trees bear fruit from early July until late fall.

With canvas baskets strapped to their bodies, a crew of seasonal workers, local and migrant, slowly make their way through the orchard, climbing up and down ladders, hand-picking each apple. Fallen fruit is not retrieved from the ground. The canvas baskets are gently emptied into large bins. Then they are hauled to a large red warehouse, one end of which has been converted into the gift shop, to be sorted, sized and displayed for sale. In here, the sweet scent of apples is so thick it's almost visible, even long into the winter, months after the harvest is over.

As visitors browse through the rows, inspecting this apple and that, 95 percent will ask the same question: Which one is best for eating; which one is best for cooking?

"It all depends on what you like," Judy answers. "You can cook with any apple. You can eat any apple. If you like a tart apple, for instance, you may wind up liking to eat one that someone else would prefer cooked."

But there's one important point about old-time apples that mountain folks relish and newcomers happily discover: These things don't have a taste and consistency like cardboard.

"To be honest, I never cared much for apples until we came here," Judy confesses. "You know why? It's because all I'd ever eaten were those wax-coated apples you buy in stores. I had no idea what a *real* apple was supposed to taste like."

Few would win awards for looks. On some species, the skin is rough and blotched. But looks are for paintings that hang on the wall. Apples belong in the mouth.

"Think about an apple like the York," Judy said with a laugh. "It's lopsided and ugly as sin. But it is an excellent tasting apple that is extremely long-lasting. In fact, the taste improves with age."

Another of her personal favorites is the king luscious, which matures in mid-October.

"Some of them will weigh almost a pound apiece," she said. "I tell people they're the perfect apple to take on a hike because they're so full of moisture, it's like carrying a canteen of water."

For the first time since the Carsons arrived, production is increasing at the orchard, thanks to the pruning techniques Bill learned at the seminars.

"The limbs want to grow straight up," he explained. "That's what had happened during all those years of neglect. For optimum apple production, the tree needs to be pruned to look like an open, inverted umbrella. This gives room between the branches for sunlight and water to get in."

Easier said than done. When the Carsons took over, some of the trees had not received attention in more than twenty years. Bill and his crew attacked them with limb-loppers and chain saws. At this writing, they have pruned some three thousand of the estimated five thousand trees in inventory.

These trees are treated with federally approved pesticides, but not in a blank-check fashion. Rather, it's on an as-needed basis. "Integrated pest management," it's called. Insect traps are located throughout the orchard and checked regularly to note what species and numbers are present. Only when the situation warrants are the trees sprayed.

"We've learned that Mother Nature is the boss here," Judy added. "We just have to do the best we can to get along with her. We can't irrigate; the orchard is too spread out. If we have a spotty crop of one variety or another, well, we have a spotty crop! There's still a lot of guesswork going on here—it's just more educated guesswork than ever before."

Even if occasional pesticide treatment is necessary,

this orchard is a bug's best friend. When the blooms are out, Edd Buchanan brings in several colonies of bees from his apiary in Black Mountain.

"Ol' Edd's got it made," Judy laughed. "We pay him to rent his bees to pollinate our trees, and then we pay him again for the honey the bees produce."

There's an abundance of butterflies here, too, particularly the orange-and-brown monarch. The Carsons have developed a wildflower garden to attract these insects. In addition, they bring monarch egg cases indoors and let the caterpillars develop in a terrarium, free from predators. Upon emerging from the cocoon, the butterflies are released.

What started merely as a venture in growing apples has branched into a full-fledged tourist attraction featuring guided nature hikes, hayrides, storytelling sessions, buffet meals, mountain music festivals, and displays by renown artisans and crafters from the region. In the fall, thousands of visitors mill around the orchard and gift shop. They soak in the warm sunshine. They feast their eyes on seemingly endless mountains of colorful autumn foliage. They treat their tastebuds to apples, fried apple pies, and fresh apple cider. They listen to the mournful wail of the railroad far below as it carries Kentucky coal to the North Carolina Piedmont.

Throughout its long history, the orchard at Altapass has enjoyed peaks of prosperity and suffered through valleys of neglect. It has stood up to blizzards in winter as well as blistering heat and crushing hail in summer. For now, the good times are here again. Yet the Carsons can't be sure what will happen in the future.

"Frankly, if it weren't for Kit's involvement and our retirement income, we couldn't afford to do this," Judy said. "Bill and I aren't spring chickens. We'd like to think maybe someone in the family would want to run the orchard after we're gone. But it's got to be something they can afford to do. It's got to be a labor of love.

"People often say to me, 'Don't you all work too hard?' I answer, 'Sure, we do.' This is certainly not what we envisioned for retirement. But every single day, something happens that makes us think, 'We wouldn't have missed this for the world!' That's what keeps us looking forward to the next morning."

The Fruits of Their Labor

158

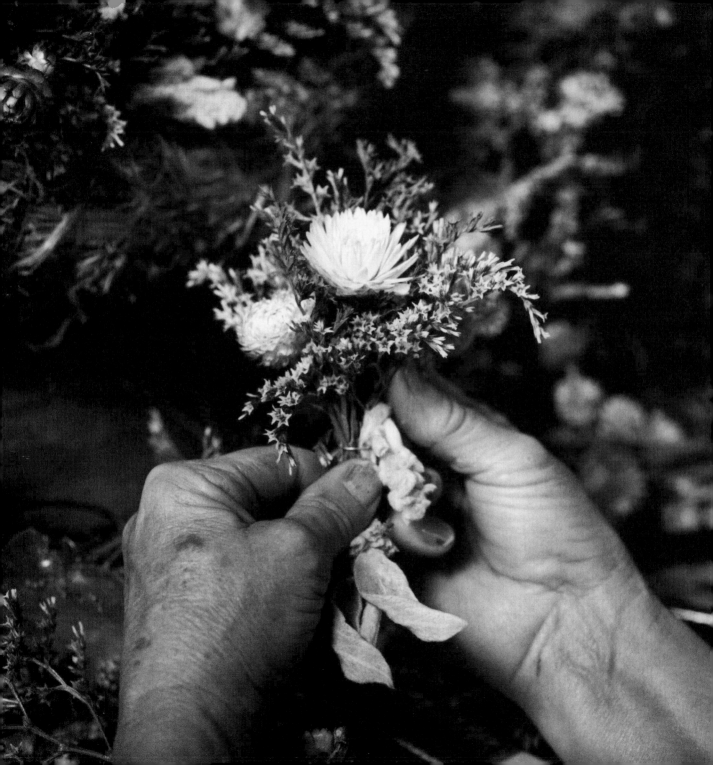

Burpee's Favorite Customer
Leah Branham

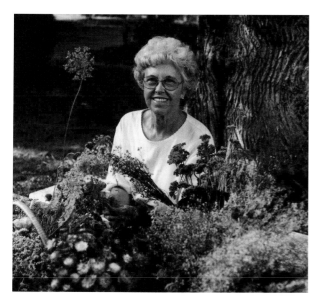

There are no stuffed, moth-eaten moose heads in the attic of Leah Branham's farmhouse home. No dressmaking mannequins, outgrown children's clothes, old lampshades, or busted furniture, either.

Instead, there are dried flowers. By the thousands.

Dried flowers in shipping crates. Dried flowers in shoe boxes. Dried flowers in coffee cans. Dried flowers in paper and plastic bags. Dried flowers on an old towel rack. Dried flowers dangling upside down in bunches from the ancient chestnut beams, reminiscent of country hams hanging in a smokehouse.

Branham stoops as she weaves her way through this botanical maze, her slender hands waving to and fro like a traffic cop during rush hour.

"Lamb's ear, blazing star, lavender, Russian sage, larkspur, tanzy, starflower, broom corn, Queen Anne's lace, wild grass, goldenrod," she says, pointing in one direction. She turns and sweeps an arm toward another section of the room. "Southern wood artemisia, sweet Annie, silver king artemisia, globe amaranth, yarrow, nigella, salvia, Joe Pye weed, German statice. Lord, I've got so much to work with right now, I reckon I'll never get it all done. And here it is time to get ready for another growing season!"

Something's always growing with Leah Branham, either in her creative mind or in her bountiful beds of perennial and annual flowers. But it will be many months, long after the flowers have been harvested and preserved, before they come back to life in beautiful wreaths, vase arrangements, and decorative swags.

"The only thing I use that I don't raise is eucalyptus, which comes from California, and a certain type of cedar foliage that I buy out of Ohio," she says. "Everything else, I either grow myself or pick wild, out in the fields. Sometimes, I might not even know the name of it right off the bat. But if it looks pretty, I can usually find a way to work it into an arrangement."

Leah Branham has spent her entire life surrounded by flowers in the hills and hollows of southern Appalachia. Born in Jenkins, Kentucky, raised

in Pound, Virginia, she and her husband Curtis, a retired coal mine operator, make their home on ten acres of bottomland along the banks of the South Fork of the Powell River in Big Stone Gap, Virginia. This fertile soil, enriched by sediment deposited over the millennia, explodes in a profusion of colors and scents from early spring until late fall each year.

"You can't keep her out of these flowers," Curtis says with a laugh. "There's an old feller down in Pennington Gap who says he's gonna bring her a miner's light so she can keep workin' after dark."

Burpee's Favorite Customer

Little wonder. This is a gardener's paradise. In addition to the flower beds, Leah and Curtis tend several Grimes golden apple trees, an arbor of Concord grapes, plus row upon row of strawberries and blueberries. Curtis annually grows a crop of cane, which he grinds into juice for making molasses in October. In the warm sunshine of this late-winter day, bluebirds flit about ceaselessly, inspecting potential homesites in the nesting boxes nailed on top of fence posts. Across the way, under the gnarled arms of a corkscrew willow, honeybees are beginning to stir inside of two hives.

Although she had gardened all her life, it wasn't until the early 1990s that Leah began making arrangements with dried herbs and flowers. She had just retired from the human resources office of a hospital in Big Stone Gap and began searching for a hobby.

She found one, all right. This hobby has taken on a life of its own.

"Mother always had cut flowers around home when I was growing up," she noted. "Oh, maybe a few dried things, like cock's comb. But mainly, her interest, and mine, was fresh flowers. I hadn't given dried flowers much of a thought until I attended a extension service seminar. The 'country look' was getting big then, and lots of folks were buying dried wreaths and swags for their homes. I visited a farm in northern Virginia where a lot of these flowers were being grown and then attended several work-

shops on how to make arrangements. After that, it was just a matter of getting my hands dirty and going through a lot of trial and error."

If there's a slack time in this operation, it would be just after the Christmas holidays, when Branham can take a breather from craft shows and check her inventory of working materials. The respite is short-lived, however. Long before official spring arrives, she will have ordered seeds for her annuals—"I've got to be Burpee's favorite customer"—and started plants in the greenhouse that Curtis built on the south-facing side of their garage. By the time these are transferred to the garden, early perennials will already be producing. Pretty soon, she will be harvesting gorgeous blossoms every other day.

The flowers are preserved by one of two methods. Most species can simply be cut, bound in bunches with rubber bands, and hung from the rafters and beams in the dark, hot, airy attic. There's surely not a custom-made, commercial drying house anywhere in America as fancy as this.

"I couldn't ask for a better place," says Branham. "It keeps the flowers sheltered from the sun, which would fade their natural colors. It's plenty warm enough to remove all the moisture. All I have to do is open a couple of windows to keep a cross wind blowing through. In two to three weeks after they go in, they're dried. They'll stay beautiful for years. Curt teases me and says when I die he's going to just hang me upside down in the attic and let me dry."

Specimens that tend to be fleshy and prone to wrinkling—pansies, lilies, and roses, for example—need more attention. Branham places each flower into a container and carefully covers it with silica gel. These moisture-absorbing crystals work their magic in twenty-four hours.

"I learned this the hard way," she said, taking the top off an old metal cookie box. "You can't leave them in any longer than that or they just dry up to nothing. After twenty-four hours, I remove the

flower from the silica gel and just leave the stem stuck down in it."

Inside the box rested half a dozen red rose blossoms, virtually as delicate and fresh as they day they were picked, six months earlier. "I'm amazed how well this stuff works on flowers you'd never thought could be dried," she said. "I plan to experiment with some others. Iris, for instance. I bet they'd turn out fine."

Branham does use a commercially made dehydrator for raw materials that veritably drip with moisture. Plump, brilliantly colored oranges, along with McIntosh apples, resplendent in their red skin and white flesh, are perfect candidates for this application. She slices the fruits in layers approximately one-quarter-inch thick. The orange slices need no further treatment prior to drying. Apple slices, however, must be coated with salt and then dipped in lemon juice to prevent browning. After a session in the dehydrator they emerge feather-light, thin, crisp, and holiday colorful.

But growing and drying flowers are only part of the process. Once all these basic ingredients are assembled, the next stage begins. Blending all the varied hues, textures, sizes, and shapes into an attractive floral piece calls for the eye of an artist and the hands of a sculptor.

Ideally, all the elements in the arrangement should complement one another. For height, she might choose stems of southern wood artemisia. For volume, a few carefully placed sprigs of broom corn or baby's breath might suffice.

Now for color—and where on earth to begin? Will it be the purple of blazing star or larkspur? The yellow of santilena? Brown from seed heads off Curtis's cane crop? Blue from salvia? Red from globe amaranth? The varieties and combinations are all but limitless.

"By going to craft shows, I've learned that colors for dried arrangements can be just as trendy as for anything else," said Branham. "Right now, green and

burgundy are strong. Pink and mauve seem to be out. Then again, you're always going to have certain seasonal colors, like pink, green, and pale blue for spring; red and bright blue in summer; orange, brown, and yellow for fall; and Christmas colors in winter."

Although she can create any type of dried floral piece, Branham says wreaths are her favorite. She begins with a circular blank made of straw, purchased from a craft supply house, or woven grapevines, fashioned by a friend of hers from nearby Dickenson County, Virginia.

"He collects the vines and soaks the pieces in water, just like oak splits for making a basket. Then he weaves everything into a wreath," she said.

Once again, the final product depends solely on Branham's imagination or a customer's specific request. With deft use of pins and a hot-glue gun, she starts from the inside and works outward, attaching grasses, flowers, nuts, and berries, creating a home decoration that, if treated with minimum care, will be just as beautiful in ten years as the day it comes from her work bench.

Nothing is wasted around the Branham home. Any metal can or cardboard box that comes into the house on grocery shopping day will ultimately find itself recycled into a storage container. Scraps of cloth and ribbon will eventually come back to life in a wreath or swag. Even castoff remnants of flowers and herbs that didn't quite make the grade in an arrangement are saved for potpourri. Is it any wonder, then, that Leah Branham is still using the offspring of dragon flowers originally grown by her grandmother, Leah Boggs, more than half a century ago?

"Anybody who gets into this to make money has the wrong idea," she says. "It has to be a labor of love. You can't think about the hours you put into it. The beauty of this is the longevity of the flowers. To be able to sit in your kitchen on a cold, snowy day and look at an arrangement of beautiful summer flowers, that's mighty nice."

Burpee's Favorite Customer

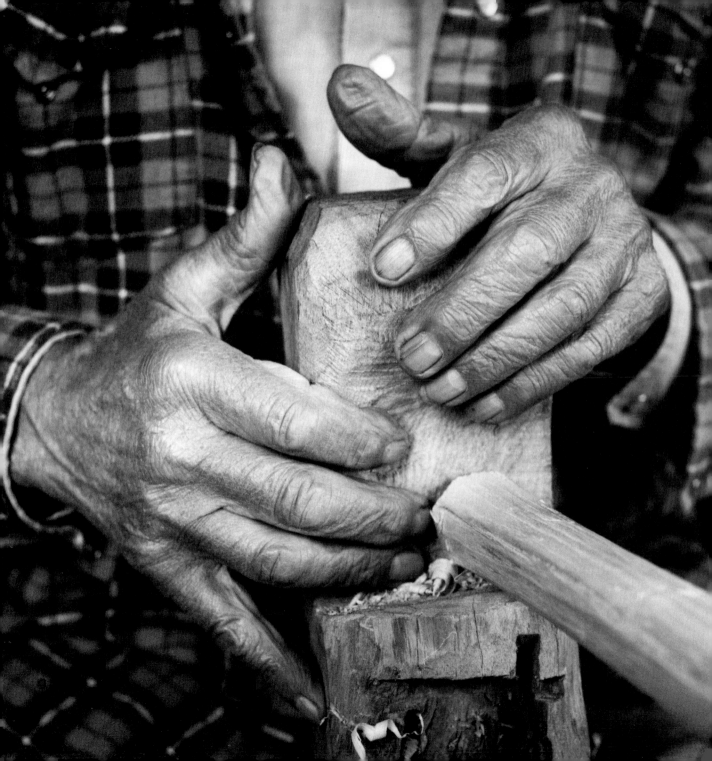

A Little Bit of Heaven in Hell for Certain

Sherman Wooton

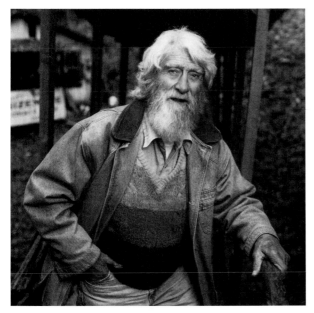

If actor Paul Newman or baseball star Cal Ripken Jr. ever grow curious about how their trademark blue eyes might look in later life, they can always drive into the hollows of Leslie County, Kentucky, and hunt up Sherman Wooton.

Then they can rest easy.

Wooton's drop-dead blues are just as clear, just as piercing, just as twinkling as they've been for the last eighty-eight years. Also just as reliable. He doesn't need glasses for long-distance vision, nor for reading, writing, driving, or any other type of up-close work. He wouldn't even need them for watching television—if he owned a TV in the first place.

"I listen to the radio all the time," says Wooton. "I get up every mornin' at five or six o'clock and fix my coffee and get started on the day. That's when I turn on my radio and start listenin' to a country music outfit up in Whitesburg. I keep it goin' all day long.

"But I ain't got no use for a TV. I can't afford to sit down and start watchin' it. I've got work to do."

That's putting it mildly.

At an age when other men might consider pinochle an aerobic exercise, Sherman Wooton still walks his 225-acre forest, ax and chain saw in hand, sizing up walnut, cherry, oak, and other hardwoods he will turn into some of the finest hand-crafted furniture in all of southern Appalachia. Wooton's chairs have been owned by the rich and famous, including former President Richard Nixon and the late author Alex Haley, but they are available for anyone who appreciates the very best in native craftsmanship.

"Masterpieces," is the word southern Appalachian historian John Rice Irwin uses to describe Wooton's creations. "He makes every chair as if it was going to be entered in the county fair. The price is not cheap, but neither are his chairs."

Nor are any two alike. When Wooton sits down at his homemade shaving horse and begins the slow process of forming chair parts with his ancient drawing knife, he doesn't fret about details of the final product.

"There's no uniformity to my chairs at all," he says. "I just do whatever the wood tells me. However it splits out, that's the way it's gonna shape up. If it's got crooks in it, they stay there."

The very core of Wooton's being rests on this roll-with-the-flow attitude. It's been an important ingredient of his long and healthy life. If one door shuts, he listens for the next to open, whether the sound happens to resonate from the hills of eastern Kentucky or the coasts of California. As the craftsman puts it, "You just never know what you're goin' to wind up doin'."

This recipe for resiliency must run in his family, too. Only three of Wooton's seven siblings have died—one at age eighty-eight, one at ninety-one, the other at ninety-two.

Wooton was raised in a tiny region near Hyden, Kentucky, known officially, if somewhat ignominiously, as Hell for Certain. According to local lore, the name came from early settlers who had experienced more than a small amount of hardships and toil as they explored the land. They'd already named one creek "Cut Shin" in honor of a leg laceration one member of the crew had received. Deeper into the torturous backcountry a few days later, one of the men lamented that if Cut Shin was bad enough, "this is hell for certain."

It was.

Wooton's mother died when he was ten, and his father made the decision to pack off all the youngsters to boarding schools. Wooton and one brother wound up at the Pine Mountain Settlement School, near Harlan, to learn building trades. He was there five years, 1922 to 1927.

"That's where I learned how to work with wood," he said. "They didn't teach us, like in a classroom. They taught us by example. You watched someone else work, and then you were supposed to pick up on it."

However successful the process might have been, Wooton acknowledges that the "book learnin'" part of his education took a bit longer. "I went to five high schools before I got my diploma," he said. "I was always gettin' kicked out for one reason or another. Usually fightin'."

Not long after graduation, Wooton joined the Civilian Conservation Corps, a New Deal program of the Roosevelt administration that jump-started economic life for countless thousands of Depression-era youth. He was plucked from the mountains of southern Appalachia and shipped to another type of hill country clear across the United States. Except for brief visits back to his homeland, this was the start of a forty-two-year exodus.

"I wound up at the Silverado Camp in Orange County, California," he said. "Spent most of my time cuttin' firebreaks from the creek bottoms up to the top of the mountains. I also helped build some of the telephone lines in the mountains back of Los Angeles. Then I got to likin' the looks of that sea as we'd go up and down the road, and the next thing I knew, I'd joined the navy. Came out in 1939 and went crazy and got married."

Wooton obtained his general contractor's license and spent the next eleven years doing construction work in the bay area. The money was good, and there was plenty of work. Children started to appear like stairsteps, eight in all. The family moved into a home in an upscale development, complete with a swimming pool.

Then the course of Wooton's life took another abrupt turn. Downward, this time.

"The nuclear business was getting' started up,"

he says. "There was this old fellow who had a uranium claim down in the Mohave Desert, and we met up with him. The thing got incorporated. Money was pourin' in from everywhere. We were gonna process the ore into what they call 'yellow cake.' I built the chemical lab down there for 'em. Me and my wife, Pearl, sunk eighty-one thousand dollars in that thing in two years. Ever'body was gonna make all kinds of money."

Not quite. Before the first load of ore was ever processed, the project went bust. Wooton and his partners lost their entire investment. The crisis took an even greater toll on his family life. By 1962, Pearl and Sherman Wooton were divorced.

"I never have gotten remarried, and I never intend to," he says emphatically.

Wooton moved to Redding and resumed his carpentry business. That's when another mineral beckoned.

"I got me a gold-mining claim and started prospectin'," he continued. "But to be truthful, I didn't prospect that much. I mainly looked on while some of the other fellows were doin' it! We'd pan around in the creeks, and every now and then we'd find a small nugget. One of my boys has still got an aspirin bottle full of nuggets, and one of my buddies did wind up findin' a nugget that was nearly an inch in diameter."

The memory makes Wooton roll with laughter: "He'd walk into a joint and plunk that nugget down on the bar and say, 'Give the nugget here a drink!' Then he'd stick it back in his pocket.

"I don't reckon he ever sold it because gold wasn't worth much back then. Only about thirty-five dollars an ounce. That's the reason I didn't fool much with it. I could make a lot more money doin' construction work than tryin' to find gold. I finally sold out my claim and all my stuff—and that's when the price of gold started goin' up."

Wooton moved back to Kentucky just in time to miss out on yet another opportunity to reap riches from gold. Except this time, it was black gold.

"I started foolin' around with coal and finally bought me a little mine. I wasn't hardly makin' any money at all. Fact is, I was losin' money. I was only gettin' three dollars and sixty cents a ton for it, delivered into Manchester, thirty-five miles away. I finally leased out my coal, and within three months, the price jumped to twelve and thirteen dollars a ton."

Lessons learned.

"I'd lost with the uranium, lost at gold, and lost at coal," he says. "I knew I oughta be workin' with wood."

He began making furniture the old-fashioned way, the way he'd learned a lifetime earlier at the settlement school. Everything by hand.

There are no nails or screws in a Sherman Wooton chair. No part—not a single spoke or leg or back or arm—has been turned on a lathe. He gathers his own hickory bark for seat material. He splits his own logs with a froe and mallet or an ax. And he patiently works each piece into shape, one stroke at a time, with a drawing knife.

This simple lifestyle may be a far cry from the bright lights of California, but Wooton wouldn't have it any other way. He has long since found peace.

"The last fellow that cut my hair has been dead seventeen years," he says, running a finger through the white mane that flows off his head. "I take some clippers and trim it off myself every now and then."

The same technique applies to his full beard: "Actually, I started growin' this when I was doin' that uranium work out West. I hadn't shaved in a few days, and the main man come around one day. He said, 'Wooton, how long you gonna grow them whiskers?'

"I told him, 'Soon as we make yellow cake, I'll cut 'em off.' We never did make yellow cake, and I never shaved. Why, just think of the thousands of

A Little Bit of Heaven in Hell for Certain

dollars I've saved in razors and shavin' mugs all these years!"

Unless he's off visiting family and friends, or demonstrating his skills at one of the half-dozen craft shows he attends annually, Wooton can be found at his rustic house in Citation Hollow, near Wendover, Kentucky. He tries to spend at least part of every day making chairs. The only interruption comes at noon, when he drives to a nearby senior citizens center for lunch, then to the post office to pick up his mail. After that, it's back to the shaving horse. Or "pin horse" in Wootonese.

"I call it that because I made my first one when my dad and I were buildin' a raft of logs to float down the river to a sawmill. We needed some wooden pins to hold the logs together. I was tryin' to shape 'em with a drawing knife, and my dad kept tellin' me to watch out or I'd cut myself. That's exactly what I wound up doin', too. I ended up makin' me a shavin' horse that was adjustable, depending on the length of wood I need to work. It's the same design I use today."

Wooton straddles the wooden bench. He picks up a piece of red oak, approximately twenty inches long and two inches in diameter, and secures it in the horse by pushing a locking pedal with his feet. This particular item will wind up as a spoke beneath a black walnut chair, hidden by layers of hickory bark strips. He reaches forward with the double-handled drawing knife and brings it back toward his belly. A curl of fragrant wood peels away.

"You can't do this kind of work with a new knife," he says. "The new ones have straight blades. The old ones are rounded. This one I'm workin' with is about seventy-five years old. I bought it at an antique shop near Berea. It'll really hold an edge. It's been over a month since I sharpened this one, and I've been workin' with it every day."

A Little Bit of Heaven in Hell for Certain

Over and over the process continues. Wooton stops only to rotate the oak, then locks it down once more and continues peeling. By the time it has been properly rounded, its diameter will be nearly halved.

Eyesight and experience are the guiding principles here. When a piece "looks right," it comes off the horse and another takes its place. The same goes for every part of a chair—the four-foot-long backs, the two-foot-long fronts, the rockers, the arms, whatever. The only precision measurements in the entire process are made when Wooton lines the various pieces up to drill the holes that will lock them together. The fit will be so tight, Wooton has to notch the male ends of each piece to permit an even flow of glue.

The job is far from completion. Hickory strips still must be soaked in water to make them pliable, then tightly woven across the bottom. Next, all the wooden pieces are lightly sanded, treated with a sealer, and covered with two coats of satin varnish.

This is not mass production. Each chair requires approximately two weeks of work, and Wooton stays constantly backlogged with orders.

"I never do take no money with my orders," he said. "Why, I may drop dead before I ever get the next one finished! All I do is write down their name and address. Then I call 'em when the job's done and say the chair is on its way."

Assuming he hasn't forgotten.

"Yeah, that happens sometimes," Wooton said with a hearty chuckle. "Somebody'll call and say, 'You got my chair finished yet?' and I'll have to think on it a minute. Then it'll come to my mind and I'll have to tell 'em, 'Yeah, but I've done sold it. I'll have to make you another one.'"

Wooton always enjoys a good laugh and rarely misses the opportunity to tell a tale on himself. Like the time he was demonstrating chair making

during the 1982 World's Fair. After work one day, he strolled into a local watering hole and approached the bar.

"I had a coal royalty check for around six hundred-some-odd dollars," he said. "I asked the fellow at the bar if he'd cash it. He took one look and said, 'Man, we ain't seen that kind of money in these parts for awhile!' Well, there was a couple of other fellows sittin' at the bar, and they heard him. I bought them a drink, and ever' time I walked in that place after that, they was all jumpin' up and buyin' drinks for the coal tycoon."

A Little Bit of Heaven in Hell for Certain

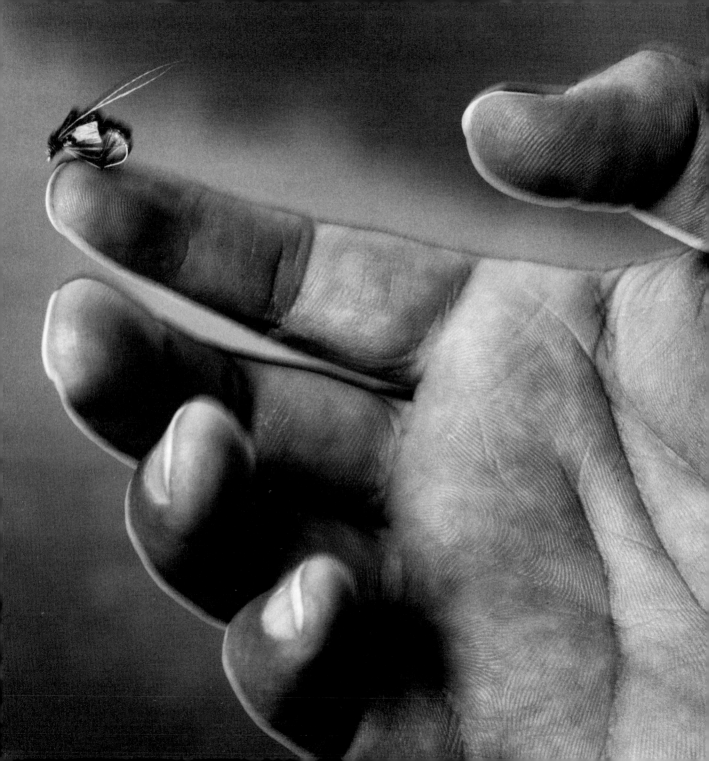

Feathered Treasures

Ed Ripley

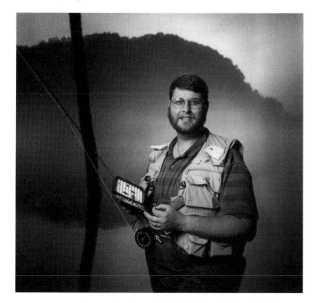

Ed Ripley looks back on his high school days in Staunton, Virginia, with mixed feelings. Or perhaps "no feelings" is more accurate, considering his right index finger—slimmer and decidedly more tapered than his other digits—is permanently numb from middle joint to the tip.

Ripley didn't avail himself to shop class in high school and thus missed important lessons about machine nomenclature and safety procedures. He learned, hastily, several years later when he tried to force a board through a jointer planer and wound up peeling his finger—skin, flesh, nerves, tendons, blood vessels, the works—clean to the bone.

"The name 'jointer planer' is a very descriptive one," says Ripley, displaying the trim finger that got in the way of his woodworking project. "It means this machine will plane anything, right down to the joint."

But as painful as the initial accident was, not to mention subsequent skin grafts with tissue from his right arm, the experience taught Ripley something about himself: "I was born right-handed. But thanks to the stupidity of youth and the efficiency of a machine, I learned to be ambidextrous. This accident happened when I was a sophomore in college. I had to learn to take notes with my left hand while the other one healed. I realized either hand could do anything."

These days, the two hands work in concert with each other at Ripley's fly-tying vise, turning bits of feathers, fur, synthetic fibers, and thread into tiny insect look-alikes that are eagerly sought by trout fishermen throughout the mountain regions of Tennessee and Virginia. Whether they're whipping out a brown, inch-long stone fly nymph or a minuscule Clinch River midge that looks like a black BB on a hook, Ripley's deft fingers perform tasks no machine could ever match.

Yet the persona of Ed Ripley has far more facets than trout flies. To discover them, it's best to tour the orange, shag-carpeted room in the Knoxville,

Tennessee, home he shares with his wife, Becky, and their toddler son, Will. Ed calls this man-place the Bear's Lair.

"It's off-limits to women and children," he laughed. "Women hate the decor. As for kids, there are lots of things in here that are too dangerous or fragile for little hands."

He's an incurable collector—of autographed baseballs, mostly from the old Negro League; of ancient Roman coins; of political campaign buttons; of vintage cameras; of recorded music from the 1940s and 1950s. He plays classical guitar "with the best pick ever created by a jointer planer." He builds incredibly small, lightweight (one gram or less) indoor airplanes, powered by rubber bands and capable of flights lasting as long as fifteen minutes. Matted and framed on the wall are evidence of his skills as an artist (watercolors and acrylics) and photographer (he interned at the Smithsonian's National Portrait Gallery). All this from a man who also earned one B.S. in biology, another in art, both from Emory and Henry, plus a master's in nuclear engineering from the University of Tennessee, and holds down a full-time position as nuclear engineer in nearby Oak Ridge.

Absolutely none of which led him into fly tying.

"I got into flies when I quit the jewelry business," Ripley says matter-of-factly.

Wait a minute. How does jewelry fit into this intricate puzzle?

"I had to learn it to keep my family supported between college and graduate school. A friend of my father's up in Virginia taught me. I learned to set diamonds, repair broken jewelry, and make new pieces. It's a fascinating business, and I enjoyed the years I worked in it. When I started at Lockheed Martin in 1990, I didn't want to lose the dexterity in my fingertips."

Enter Becky's uncle, Bill Parker, a retired advertising salesman and lifelong fisherman.

"I was in his shop one day and he was showing me how to tie hair jigs for crappies," Ed recalled. "He said with my skills as a jeweler, this ought to be easy for me. I tried a few and liked it. Uncle Bill gave me all his equipment—vises, hair, threads, plus several pounds of leadheaded jig hooks—with the agreement that I'd supply him with jigs for the rest of his life."

The evolution from clunky leadheaded lures to delicate trout flies didn't take long. Ripley devoured books on fly tying. He talked to some of the masters like Eddy George, a retired sporting goods dealer and arguably Tennessee's most heralded fly fisherman—his "George nymph" is recognized throughout the United States as a consistent trout producer. Within a year, word of Ripley's skills had spread. He began marketing his wares not only through local fly shops but also the tourism capitol of Dollywood, giving visitors a chance to take home an authentic expression of mountain art.

Poor Uncle Bill. "I still owe him a lot of crappie jigs," Ripley chuckled.

Oddly enough, the sport of fishing itself is not one of Ripley's highest priorities. Although he does enjoy taking an occasional morning off to, as he puts it, "splash around in a stream or river in rubber pants," Ripley is much more comfortable sitting at his tying vise or talking to the anglers who use his wares.

"I probably spend 90 percent of my time tying flies and 10 percent fishing with them. I'd just as soon hear the stories from the people who are using my flies."

There's no shortage on that account, for Ripley's designs are proven fish catchers.

"We always hear good comments from our customers about Ed's flies," said Don Blevins of The Creel, a fly fishing shop in Knoxville. "He ties some doggone good ones. He's quite skilled."

Even with high-quality equipment, fooling a trout

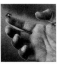

Feathered Treasures

can be an exasperating experience. The key is selecting a fly that mimics a natural insect living in the stream and delivering it with a light touch. Yet the challenge to commercial fly tiers comes long before that. They must catch the angler and convince him or her to buy their products. This can call for some deft footwork. Or handwork, as the case may be.

"A fisherman is looking for the perfect fly, an exact imitation of an insect," said Ripley. "Some of the time, though, that's not what a trout wants.

"You see, a trout pretty much feeds constantly. It'll hang low in the current and rise to meet something floating into its territory. What it's looking for is something out of the ordinary, a reason *not* to strike. The artificial fly on the end of your leader may look great to the human eye, but there could be something just a little bit off from the trout's perspective, so he'll ignore it. You want the fly to appear just 'buggy enough' to trigger a strike. And think about it—by the time a real insect has floated downstream, it's usually not in pristine condition itself."

Ripley dismisses the notion that fly tying is difficult. For him, the process is "the ultimate in simplicity."

That's easy for him to say, with untold hundreds of dozens of finished products to his credit. For the novice, however, it can be an intimidating procedure. To tie a common mountain pattern like the blue-wing olive, Ripley uses the following steps: The hook, in this instance a tiny number sixteen, is locked in the vise. Sorting through the stacks of dried rooster hackles (the skinned neck portion of the bird), he produces a couple of dun-colored feathers.

Many of these neck hackles are from birds raised specifically for tying flies. They can run as high as $125 each, although the average price is less than half that amount. Other feathers come from a variety of sources: wood duck, ring-necked pheasant, wild turkey, and teal from hunting friends; occasional songbirds, like the flicker, from road kills.

One supplier of vivid red, orange, and yellow shafts happens to be an exotic-bird fancier who collects shed feathers from the bottom on his cages.

Back at the vise, a small length of the feather, perhaps one-quarter inch, is secured onto the hook shank with a few wraps of thread. This will serve as the fly's tail. To form the body of this faux insect, he takes a pinch of "dubbing" (squirrel or rabbit fur) and spins it onto the thread with his fingertips. This "fat thread" is then wrapped around the hook.

Next Ripley moves toward the front of the hook, up near the eye. He wraps one end of the hackle with thread and, using a device called a hackle plier, slowly winds the piece around the shank, exposing each barb of the feather at a ninety-degree angle. These will serve as legs to keep the fly riding on the surface of the water. A couple of final wraps and knots with a whip-finishing tool, a few snips with tiny scissors, a dab of head cement (replete with a clean-out of the hook eye to remove excess cement), one squirt of silicone dressing to help keep the fly afloat and—presto!—the finished product emerges.

Elapsed time for these competent hands: five minutes if they're in a relaxed mood, a little less if a must-do order is waiting to be filled. Either way, quality is the first priority.

"I have a standing guarantee with any of my flies," he said. "If anything is defective, I'll retie it. The last thing I want is an inferior product."

A flippant goodwill statement, perhaps? One of those chamber of commerce buzz phrases?

Not coming from Ed Ripley. He wasn't raised that way.

"This may sound corny, but in Virginia when I was growing up, people really did look after each other. If somebody got sick and couldn't work, other people pitched in and bought their groceries. If your hay was ready to cut and you got down in the back, somebody would see that it was baled. If I'm on, say, the Clinch River and run into somebody who's

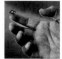

Feathered Treasures

not catching any trout, I give them some midges and tell them how to fish 'em. It's neat to catch trout on your own fly, but it's a lot more fun when somebody else does."

Trout aren't the only fish fooled by Ripley's creations. He also ties a series of streamers designed specifically for black bass. Comprised of angora fur, grizzly hackle, partridge feather, a couple of pieces of colorful, synthetic "flashabou," plus a set of plastic eyes, they become lifelike replicas of young bluegill and threadfin shad—two of the top forage species for largemouth and smallmouth bass.

And then there is what Ripley describes as his "goofy collection." Such as a lightning bug, its tail section dabbed with fluorescent paint to glow in the dark when activated by flashlight. Also a "disco cricket," aglitter with chenille and flashabou. Not to mention a pint-sized crawfish crafted from closed-cell foam and rabbit fur. Says the craftsman with a grin, "I never sell these to the public, although they will catch fish."

Conversely, some of the flies Ripley puts on the market will never see duty in the water. Among them are presentation models of stoneflies, craneflies, and dragonflies that are the piscatorial equivalent of a duck hunter's decorative decoys. Painstakingly tied to be anatomically correct down to the last antenna, they can retail up to fifty dollars each.

Also in the decorative department are colorful salmon flies he fashions into Christmas tree ornaments and jewelry.

The ornament is an angling version of the old ship-in-a-bottle idea. As Ripley ties the lure, he attaches it to a fine, stiff wire. Then he carefully folds his creation and inserts it into the neck of a clear glass ornament. With gentle prodding and grooming by another wire, the fly pops back into shape inside the dome, seemingly suspended in midair, ready for a lifetime of yuletide duty.

The large flies also have found themselves rendered into tie tacks and brooch pins, with one decided difference from the real McCoys: "Since these need to be flat on one side, I only use half the materials as a conventional fishing fly."

The most innovative project, however, blends Ripley's love of tying flies, his art background, and his deep sense of patriotism. He is creating commemorative salmon flies tied with the colors of military campaign ribbons—everything from the blue and gray of the Civil War to the olive, red, and yellow of Vietnam—that are then numbered, matted, and framed. Strictly limited edition.

"All of my fly-tying activities are an extension of my love of art," he says. "I don't ever want to be bogged down by trying to produce too much volume. I'd get burned out."

174

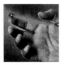

Feathered Treasures

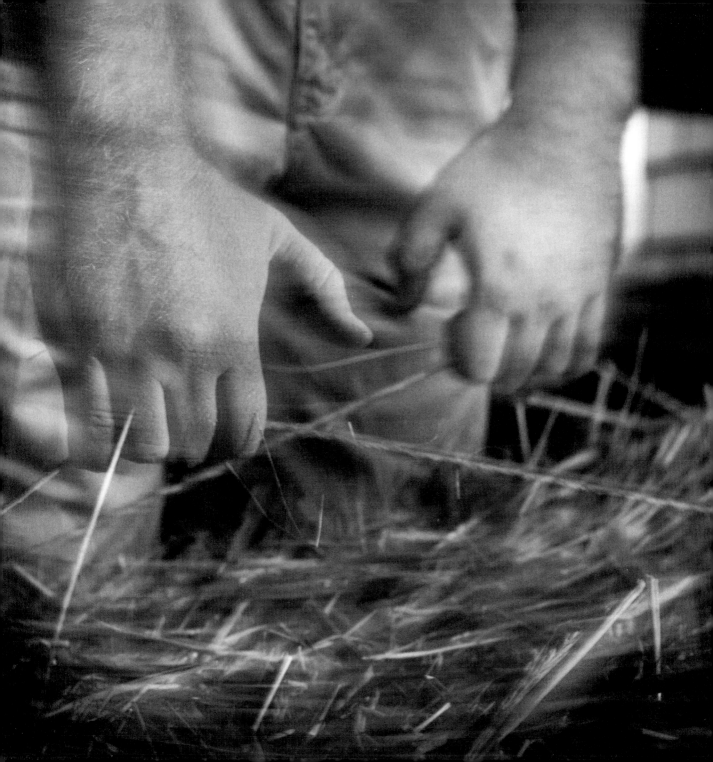

It's Always Milking Time

John Peace

The day starts early on a dairy farm. The hours are long. The work is hard. That's the way it's always been. That's the way it'll always be.

"A good dairyman never gets in any kind of trouble," Jim Galloway quips as he attaches the four suction cups of an automatic milking machine to the teats of a thirteen-hundred-pound Holstein standing above him. "He can't. He never has the time or the money to get away from the farm long enough!"

Galloway should know. For half a century, he has started nearly every working day at Clinch Haven Farms, long before the sun peeks across the mountains overlooking this 338-acre, picture-pretty spread.

"You can count on one hand the number of times I haven't been here at 4:30 in the morning," he says. "That's just the way it is. If you don't like to get up early, you've got no business on a dairy farm."

Galloway nods toward the other end of the milking parlor, down to where his grandson, John Peace, has just closed the gate on a stall behind yet another in a seemingly endless line of Holsteins. "Once when John was little, he wanted me to take him somewhere—to town or to a ball game or something—but I said, 'We can't go John. It's milking time.' He got all upset and started cryin'. He hollered out at me, 'Papaw, it's *always* milking time!'"

Actually, it's not. Milking time "only" rolls around twice a day at Clinch Haven, once at 4:30 A.M., again at 3:30 P.M. In between, there's plenty of time to relax—after all the equipment in the milking parlor has been cleaned and disinfected, of course; and all the cows have been fed and returned to pasture, of course; and the crops have been tended, of course; and the bookkeeping has been completed, of course.

Not to mention the "occasional" duties—like mending fences, spreading manure on the fields, treating various cattle injuries and ailments, and repairing equipment.

Why, sometimes, a fellow might even have a full

five minutes to kick back with a cup of coffee and take a load of his mind and body. And if he's *real* good at the job, he gets to do it all over again the next day. And the next. And the next. And the next.

Fortunately, there's a plus side to this rigorous agrarian pace. As far as Jim Galloway is concerned, it's the best youth tonic ever brewed.

"Somebody asked me once if I was ever going to join the AARP," he says with a delightful cackle. "I told 'em, yeah, when I get old enough."

Galloway arches a stream of tobacco juice and continues: "I was down at the grocery store one day, and this tour bus full of retirees from up north drove in. When it stopped and they opened the door, I climbed up the stairs and took a long look around. One of the folks asked me what I was doing. I told 'em I wanted to see what old folks looked like."

Clinch Haven Farms has been a Wise County, Virginia, institution almost as long as Galloway himself. It was founded in 1922 by Douglas Terpstra, a mining engineer who came to the United States from Holland. Terpstra supervised the installation of several electrical substations for coal companies in the area and then expanded his own business interests to include dairying. Thanks to his engineering background and an interest in science and technology, Terpstra quickly shaped Clinch Haven into a state-of-the-art dairy farm and milk-bottling operation. This was one of the initial Virginia farms enrolled in the Tennessee Valley Authority's demonstration program, serving as a model of innovative management for other farmers in the region.

"Whenever anything new came on the market," Galloway recalls, "Terpstra was the first to have it."

Galloway became acquainted with the Dutchman when, shortly after he returned to Virginia from service in the army air corps during World War II, he took a job at a dairy processing plant in Big Stone Gap. It wasn't long before Terpstra hired Galloway to run the milk-bottling plant at Clinch Haven. In 1952, Terpstra offered Galloway an option to buy the farm outright. Galloway took the plunge.

"I figured if I never made any money, I wouldn't be any worse off than I was at the time," he recalled. "Looking back, I can't complain. This farm has provided a good living for me. I've had to work hard, for sure, but I've never gone hungry."

In 1968, Galloway's son-in-law, Bill Peace, came on board. No stranger to agriculture himself, Peace was raised on a 550-acre farm in Hanover County, Virginia, just outside Richmond. He met Brenda Galloway when she was a student at Radford College and he was studying agronomy at nearby Virginia Tech. Today, Bill and Brenda's son, John, officially heads up the operation.

Much to his own surprise.

"I'd always worked around this farm when I was growin' up," says John, "but like most farm kids, I hated it. I wanted to get away."

He did, at least for awhile. After earning a degree in agricultural economics at Virginia Tech, John worked in the landscape business and then operated a Southern States farm store franchise in North Carolina. But the call of the land could not be denied. John and his wife, Kristie, knew there was only one place to put down roots and raise a family. Home they came.

"You don't know how good you've got it on a farm until you get out and see what the rest of the world is doing for a living," he noted. "Dairy farming is fulfilling work. There's something good about being your own boss, although you'll work harder for yourself than for anybody else. You can't dread the hours. Fortunately, I'm a morning person. When I was in college, I'd get up at 4:30 or 5:00 in the morning and do my homework before class. I never was good at staying up at night."

Down through these three generations at Clinch Haven, some things have stayed the same; some things have changed.

The high-butterfat Guernseys of the Terpstra era have been replaced with lower-fat, more-productive Holsteins. The milking must still be done twice a day, although John admits now to using horsepower (of the internal combustion variety) instead of foot power to round up the cattle each time. The bottling operation was phased out in the late 1970s, but in its place has come a Southern States farm store franchise offering a full line of feed, seed, fertilizer, and other agricultural supplies—including Bag Balm, a decades-old standby on dairy farms everywhere.

"Best stuff in the world for udders and hands alike," John noted, rubbing a dollop of the waxy, lanolin-based antiseptic ointment across his weather-worn palms. "Ain't nothing better."

And even though the feet of three generations are still planted firmly on the rich, green, rolling hills of this farm, much of the day-to-day business takes place in cyberspace.

"Getting a grip on the business end of a farm is one of the first lessons I learned in ag economics," says John. "A professor told me that an average farmer who's a good businessman will make more money than a great farmer who's a poor businessman. That's truer today than ever before. I use a computer every day to check grain prices and look at futures. I've heard it said that by the year 2010, most farmers will have a masters or Ph.D. They'll have to. Farming has gotten so complicated and the profit margins are so thin, you've got to keep finding a way to stay competitive."

A glance at the history of dairying in southwest Virginia—or anywhere else in America, for that matter—corroborates Peace's comments. Thirty years ago, small dairy farms dotted the landscape. Wise County alone had twelve full-time operations. Today, there are two. Neighboring Lee County used to boast sixty dairies. Three have survived.

"Little bottlers like us were everywhere," says John. "The backbone in each county was the school lunch program. It paid most of your bills. What you wound up selling to the grocery store was mostly profit. But the picture of agriculture has changed dramatically in the last couple of decades. Once the big agribusiness folks got involved, the little people started getting squeezed out.

"We're milking around one hundred head here at Clinch Haven. That was a large dairy in the 1950s and 1960s, even up into the 1970s. These days, though, it's small. The average herd in Virginia is around three hundred head. Some are already over five hundred.

"But that's nothing. Not long ago, I read about a dairy farm in Oklahoma that's milking twelve thousand cows three times a day. They've got one barn that covers forty acres, all under one roof. With that kind of volume, they can keep their unit production cost a lot lower than ours. It's mighty hard to compete with something like that. No way a small farmer can do it. My Dad's generation was the last that could go out and get a bank loan and buy a farm and expect to pay it off. If you're not born into a farm family these days, there's no way you can get into it."

"In our case, there's one more problem," added Bill. "We're boxed in. We've got nowhere to expand. Wise County is very mountainous. There are five coal companies than own 86 percent of the land. Most of it's to the north of us. The Jefferson National Forest is to the south. All the population is crowded down in what little low-lying, flat country is left."

Clearly then, John, his father and his grandfather all know the end will inevitably come to Clinch Haven Farms as a dairy. The pressure from land developers is simply too intense. As John puts it, "Somebody's always driving up and wanting to know what we'd take for the place."

But they're not ready to call it quits just yet. Indeed, they can't think about much of anything right now. It's milking time—again—and there's plenty of

It's Always Milking Time

work to go around. Not the least of which is getting the cows in line to move through the six-stall milking parlor.

"Every one of these ol' gals is a unique individual," John yells above the clanging of gates, the hum of machinery, and the lowing of cattle. "They've got their own personality and disposition. Some of 'em are easy to handle. Others are just downright hateful. We used to have this one ol' biddy who'd go out of her way every day to kick me. But she never would raise a foot at Papaw."

Why the difference?

"Beats me," John replies with a shrug and a dose of his grandfather's humor, "except for the fact that you're dealin' with a hundred women."

"John said that, not me!" shouts Paul McMahan, one of Clinch Haven's two milking assistants. Paul's part of the family here, too. His wife, Mary, works at the farm store.

As each Holstein moves into a stall in the milking parlor, a disinfectant-cleaning dip is applied to her teats. The cow munches on grain from a feed box as the suction hoses are attached and the milk begins to flow. Her udder will be emptied in three to five minutes. In the course of two daily milkings, each cow will produce approximately fifty pounds of raw milk. After milking, a brown iodine solution is applied to each teat. This dries into a barrier against mud, manure, and other foreign matter. Next customer, please. The cows move into a feed lot, where they are treated to silage and grain, then it's back to pasture for grazing and rest until the next milk cycle rolls around.

The milk travels through a matrix of stainless steel pipes into a refrigerated holding tank. It is emptied every other day by a truck from the cooperative to which Clinch Haven belongs. Approximately 120,000 pounds of raw milk flow out of Clinch Haven each month and are sold to processors in Virginia and Tennessee. Every batch is government-tested for quality, with a zero tolerance for even trace amounts of bacteria, antibiotics, or other impurities.

The milking may be over for a few hours, but the work continues unabated.

The stalls must be hosed down—"Manure, always manure," John groans; "if we could get a good price for cow manure, we'd be rich!"—and all those pipes hooked up to an automatic cleaning and sanitizing machine. Depending on the time of year, there's plenty to do out in the fields, as well—either preparing the soil for seed sowing, cutting and baling hay, harvesting corn, spreading manure, or tending the tobacco crop. There's never a break, regardless of the weather.

"Hot, I can take," says Bill. "But cold? Brrr! I hate that the worst. I'll never forget the winter of 1976–77. The cold never let up. We had snow on the ground all winter long. I was digging holes for fence posts the next spring, and there was still a frost line twenty inches down. Brother, that's when you know it's been *cold!*"

Herd maintenance is another ongoing project on any dairy farm. Not all the cows are being milked at any given time. Some are "drying out" in preparation for breeding, or else they are pregnant or calving.

Bull calves are sold soon after birth. The heifers are bottle-fed until they are weaned at six weeks and turned to pasture at ten to fourteen weeks. At twenty to twenty-four months, they will be artificially inseminated. After calving, their milk production now at its peak, they will join the rest of the herd back in the milking parlor.

Each cow has a productive life span of eight to ten years. Then they sold on the beef market—a quirk that isn't lost on Jim Galloway. He ponders the thought of "revisiting" his cows whenever he stops by a local fast food joint for a hamburger and milk shake.

Given the inevitable future of small-farm dairy-

ing, John's infant son—John III, or "Trey"—will probably not have a herd to manage. But John thinks there's a good chance he'll still be attached to the land in one form or another.

"We've got to stay flexible," he said. "That's the nature of any business these days. For example, there's good water around here. I've been talking to some fish producers who are seeing about the possibility of going into trout production. We're looking at getting into the greenhouse business or maybe growing vegetables for retail sale, although I'm not sure we're close enough to a large population base for that.

"Whatever we do, I hope we can either stay in farming or else get out at the right time. When I worked at the store in North Carolina, I saw a lot of farmers who knew they weren't going to make it, but they either couldn't, or wouldn't, change. They just kept accumulating debt until it got to the point they *had* to sell.

"Man, that's a slow death. A slow death is terrible. I don't want that to happen to us."

It's Always Milking Time

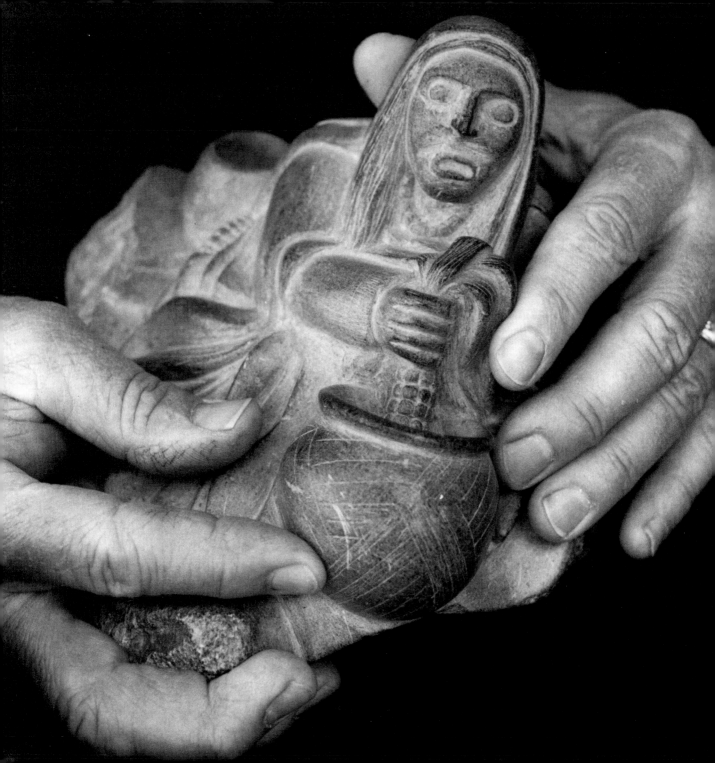

A Proud Heritage Carved in Stone
Lloyd Carl Owle

The genealogical trees of southern Appalachia are supported by a vast network of roots that spread throughout the world. Although predominantly of English and Scots-Irish descent, the European settlers who funneled into this mountainous region throughout the eighteenth and nineteenth centuries hailed from a broad lineage that also included French, German, Dutch, Italian, and Scandinavian connections.

Yet the roots of human occupation in this part of North America penetrate far deeper into native soil. Indeed, they were flourishing long before travelers from across the Atlantic happened upon the "new" world.

Conventional archeological wisdom places the earliest nomadic visitors to the southern highlands around thirteen thousand years ago, shortly after the end of the Ice Age. Some seven thousand years later, the first permanent villages of hunter-gatherers began to appear along rivers and streams. By approximately one thousand years before the birth of Christ, civilizations of crop-cultivating people populated this land. And although there are legends of encounters with light-skinned explorers to these mountains as early as the twelfth century, it wasn't until 1540, when Hernando de Soto arrived from Spain by way of what is now Florida, Georgia, and South Carolina, that native southern Appalachians had their first recorded contact with Europeans.

That's how deeply the tap root of Lloyd Carl Owle's family tree runs into the ground. It is virtually impossible to be any more homegrown than this.

Owle is part Cherokee, part Creek. He is descended from Yonaguska, the legendary Cherokee chief also known as Drowning Bear.

Yonaguska was one of the few natives permitted to remain in the eastern mountains during the forced removal of Cherokees to the Oklahoma territory in 1838–39. This inhumane eviction, sponsored

by the United States government, is memorialized by the plaintive name "Trail of Tears." It is the subject of a heart-rending outdoor drama, "Unto These Hills," which has been in continual seasonal performance in Cherokee, North Carolina, since 1949.

Owle was born, and has spent most of his life, on the Qualla Boundary of the Eastern Band of the Cherokee Nation. He studied social work and political science at Western Carolina University in nearby Cullowhee. He has devoted nearly all of his professional life to serving his people—first as a member of the tribal council, then for eighteen years as Cherokee field coordinator for Save the Children Foundation, and most recently as a cultural and intervention specialist with the Indian Health Service, working with alcohol- and drug-addicted teenagers at the Unity Regional Youth Treatment Center.

Yonaguska would be especially proud of Owle's latest mission, for it is a fitting tribute to his legacy. Cherokee history tells of a deep trance the chief fell into at age sixty. Many thought he had died. Instead, he traveled to the spirit world and had a vision about the ruinous effects of alcohol on his people. When he returned from his trance, he spoke eloquently to the tribe, warning them of the perils of strong drink.

"I've never had a drink of alcohol or taken any type of illegal drug," says Owle. "These things have almost destroyed our people."

With this deep love and respect for his heritage, Owle tries to help the troubled young people reconnect with their spiritual life. It is a daunting task, but one that he enjoys.

"It's one of the hardest things I've ever done," he says. "You really have to be dedicated. I feel fortunate to work with these kids. Most of them have gotten into trouble before they come here. They need love and understanding, but they also need to learn respect for themselves and for others."

This is more than simply an avocation for Lloyd Owle. It is a calling—a repayment, if you will, for

A Proud Heritage Carved in Stone

help he received as an academically challenged youngster growing up in the rural outback of Goose Creek in the Birdtown community.

"I didn't do very good in school," he recalls. "I spent a lot of time with my dad in the mountains, and I never could understand just memorizing a bunch of words or numbers. It took me quite awhile just to get to the sixth grade. Then one day one of my teachers, Mister Wilkinson, changed my life.

"Mister Wilkinson wasn't a Native American himself. He was from Texas. He's still alive today, must be in his eighties, and teaches at the Riverside Indian School. Anyway, he came all the way out to my house and sat down with me and told me if I didn't get an education, I could never amount to anything. I can't explain why, but that triggered something in me. I went from regularly skipping school to 100 percent attendance.

"All along, people had thought I was a problem child, but in the seventh grade they gave me a test that allowed me to skip up to the eighth. The teachers at Cherokee High School even began letting me help with their classes. I was pretty shy and didn't talk much, but I knew what was going on. Once, I remember another teacher saying, 'I know you understand every bit of this lesson, Lloyd. You might as well talk about it.'

"I guess," he says with a broad smile, "that's when I went from being backward to becoming an outstanding student."

Owle is the fourth of ten children. Economic times were exceedingly difficult for his family in the days before a booming tourism market, fueled in no small part by a gambling casino that draws throngs of visitors from throughout the East, began to attract outsiders to the Cherokee reservation.

"I doubt my dad ever made more than thirteen or fourteen hundred dollars a year when we were growing up," he said. "There weren't many tourists in Cherokee then, but he would dress up like a

chief and stand beside the road and pose for pictures. Some people used to complain that he and the other 'chiefs' who posed for pictures were wearing clothing from western tribes. Well, the Cherokee are known for their ability to improvise. My dad had a lot of mouths to feed.

"But even though we were poor in the economic sense, in a lot of ways we were rich. We learned to work hard. We also learned about survival. I don't have a lot of the fears that people do who were raised with everything materialistically."

Perhaps most important, however, Lloyd Solomon Owle passed on to his son an abiding appreciation for his native culture.

"He always hung around with Cherokee people," says the younger Owle. "He had great respect for the people who still spoke the Cherokee language. I was lucky to grow up in the company of elders who had respect for this heritage and who taught me our ways. I can speak Cherokee, but I wouldn't say I'm fluent in it. Then again, is anybody fluent in English? To be really fluent, you'd have to understand every word in the dictionary, and I don't know if anybody can do that.

"I was lucky to learn even the little things—like making rabbit traps, bows and arrows, water wheels, whistles, walking canes. The elders took the time to show me how. I got to where I could chip arrowheads, made beadwork, even weave baskets."

By the time Owle reached Cherokee High School, his talent with native crafts had begun to evolve at a geometric rate. He studied under artisans like Amanda Crowe, the gifted wood-carver whose skills have been praised nationwide, and John Wilnoty, a heralded stone carver. He also remembers, in vivid detail, watching as a cousin, Mose Owle, carved pipes from stone.

"I'll never forget the first time I saw him do that," Lloyd said. "To see him take something that was soft enough to carve with flint or a knife and then turn it into a object hard enough to smoke, well it just fascinated me. I thought to myself, 'Some day, I'm going to do that.'"

Suffice to say that day has arrived.

Stonecarvings by Lloyd Carl Owle are featured at both the Native American Craft Shop and the Qualla Arts and Crafts Mutual in Cherokee. Many of his pieces—from tiny pendants all the way up to 250-pound specimens—are on display in the Cherokee Heritage Museum. He has taught stonecarving classes at several elderhostels, as well as at Western Carolina University and Southwestern Technical College. His works have been exhibited at the Indian Arts Museum in New York City and the Smithsonian Institution in Washington, D.C. Through his craft, he has met any number of celebrities and dignitaries, including motion picture star Gloria Swanson, President John F. Kennedy, singer Johnny Cash, and Indian actor Iron Eyes Cody.

All of which he finds incredibly humbling.

"Arts and crafts are sacred to Native Americans," he says. "Whatever talent or creativity I have, I give the credit to God or the Creator, whichever you choose to call Him."

Much of Owle's life is centered around his spiritual convictions, a blend of ancient Cherokee custom and contemporary Christianity. He regularly practices the sweat ceremony, a Native American rite of purification and renewal, and encourages its use among the teenaged Indians he counsels.

As has been done for countless centuries, this ritual is carried out in a small, dome-shaped lodge covered with animal skins, blankets, or tarps. Ceremonial stones are heated and arranged in a particular pattern, based on Cherokee tradition. The participants, partly or completely disrobed, enter from the east and sit on the floor. Water is poured onto the hot stones, creating plumes of steam. A sacred pipe often is smoked, accompanied by song and prayer.

"The miracle of the sweat ceremony is in its

185

A Proud Heritage Carved in Stone

healing," he says. "It is wonderful to watch these kids discover the peace of mind it can bring. I feel fortunate the Creator has let me do this. Many times, these young people tell me they're confused about God. I tell them I don't understand Him completely myself. I've been on a spirit path all of my life, but I don't always understand why things are happening.

"All I know is that there is no Cherokee word for evil or devil. There's no way to curse God in Cherokee. We want the same thing as other people want: love, happiness, and joy. We want to be able to survive, to be good to other people as long as we live, and to live as long as we can. We want to think about the Earth and the universe and thank God for all that we have.

"I've heard it said we are a vanishing race," he added. "People say that in fifty years, the children won't be able to speak their native language, and a lot of the old ways will be gone. Maybe. But we may surprise some people, too."

This same gentle awareness of, and appreciation for, the world around him is evident in Owle's carvings. Many of the animals and objects he depicts in stone—lizards, grouse, turkeys, turtles, fish, feathers, as well as human hands and facial profiles—represent day-to-day encounters in the woods and waters of his homeland.

His medium is a native rock known by a variety of names, including "pipestone," "steatite," and "soapstone." This is a metamorphic rock, soft in comparison to other minerals, and is comprised mainly of tightly compressed talc. Because it can be machined with relative ease and is not affected by high temperatures, steatite has an abundance of commercial applications, particularly in the electrical and chemical industries. These same user-friendly characteristics have attracted artisans for countless centuries.

Owle collects chunks of steatite on his frequent journeys into the forests and fields of the reservation. Rarely does he know beforehand what each piece will produce. Rather, he lets the stone tell

him, based on its size, shape, and overall configuration. He may keep a piece of steatite for years before deciding its ultimate use, and then as much time may pass again before the project is completed.

"I can't work under the pressure of a deadline," he says. "I might have two or three pieces going at once. Sometimes it might take me five or six years to get one of them finished."

Part of the reason is the relative toughness of the material itself. Despite its common name, soapstone doesn't carve as easily as a bar of Ivory. This endeavor is a far cry from picking up a cedar stick and idly peeling off curls of shavings.

Owle begins by placing the stone atop a stump that has been cut into a V shape. He forms the outline of his design with a rasp and file. In the case of pipes, he hollows out the bowl using the time-honored Native American tool: a hand-operated pump drill he fashioned himself out of cherry wood. It is tipped with a flint arrowhead bit, secured in place by a thin strip of rawhide.

Now the work slows markedly. From this point on, every detail—every feather, every scale, every eye—must be painstaking cut with the blade of a knife.

"I believe in recycling," he chuckled, pointing to a small basket filled with old pocketknives. "Working in stone, I wear out dozens and dozens of knife blades every year. I wear them right down to nubs, either on the steatite or on the whetrock I use for sharpening."

Fortunately, there's a ready source of replacements. Visit a flea market anywhere in the vicinity of the Cherokee reservation, and you'll likely find Lloyd Owle picking and poking through the tool selections.

"A flea market's the best place in the world to find old files, rasps, and Case knives," he said. "There's no way I could afford to buy all these things new. I use too many of them."

Even after the details begin to take shape, much more handwork is required. Owle uses tiny chisels,

mostly homemade, and fine-grit sandpaper to make final cuts and smooth the rough edges. All the while, oil from his hands will have been polishing the surface of the piece to a brilliant luster, bringing out delicate traces of blue, green, gray, or black, depending on elements within the stone itself.

Owle estimates he has turned out "about a thousand" carvings over the years. But there is much more work to be done.

"Once when I was younger, I had a dream about everything I would do in my life," he said. "I know I'm not through yet."

*A
Proud
Heritage
Carved
in Stone*

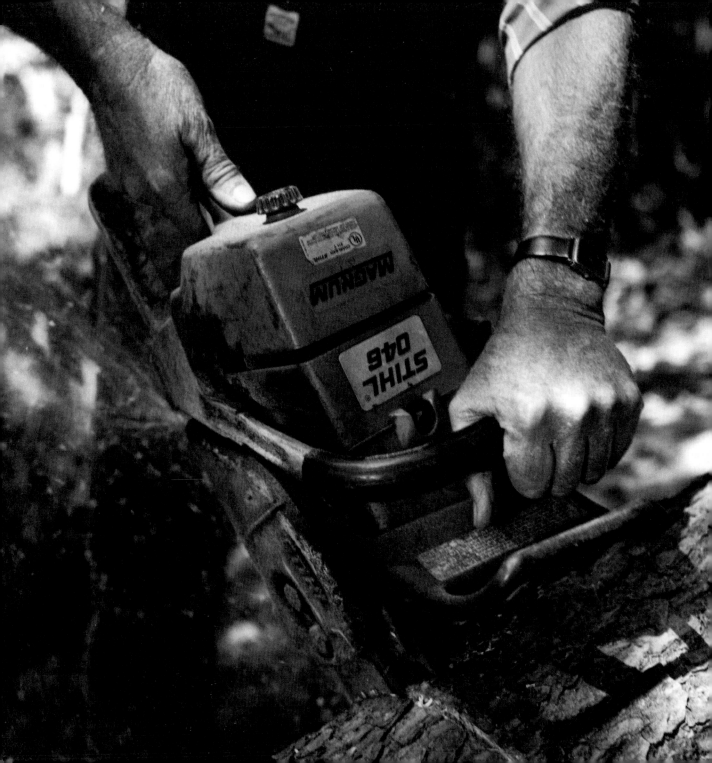

A Long, Lean Lumberjack

Bob Thomas

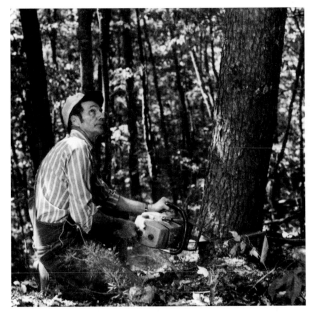

One of the living room walls of Bob Thomas's home in Fannin County, Georgia, is decorated with the six-foot-long, five-inch-tall blade from a Simon crosscut saw. An attractive farm scene has been painted along the length of its smooth face and jagged teeth. This is mountain motif at its traditional finest, just the sort of décor one might expect to find on the cover of *Southern Living* magazine or above the fireplace at a Cracker Barrel restaurant.

Be assured this blade did not come from an antique shop that deals in trendy trinkets, however. Long before it was retired to decorative status, this piece of steel pulled daily duty in the woods with a Thomas—Bob or his father, Elgin—at either end.

"I've cut many a tree with that blade," says Thomas. "A crosscut was all we had back in those days. It wasn't until, oh, 1956 or '57 that we got our first chain saw, a McCulloch from Mason's Tractor Company over in Blue Ridge. I'll never forget when we got that new thing. It was heavy, it was expensive, it was hard to start, and it'd break if you barely bumped it. But, Lord, we thought we'd moved up to a whole new world! Even with one of those early chain saws, a man could have a tree down and de-limbed in the time he'd just be gettin' started with a crosscut."

Yet there is more than occupational nostalgia tied to this piece of logging equipment.

"Whenever that blade'd get dull, Dad would give me a dollar and have me carry it down to Luther Bright's place to get it sharpened," Thomas continues. "I'd have to balance it up on my shoulder and then take off walkin' down the road. Luther had moved into this country after workin' for lumber camps over in Tennessee. He really knew how to sharpen a saw. He had all kinds of files and tools for the job."

Luther Bright also had a daughter that caught the young man's eye. Perhaps courting while your crosscut blade is being sharpened is not the most

romantic situation, but at least it got the job done. Bob and Billie Sue have been husband and wife since 1963.

Thomas was twenty-two years old back then. He was working in a sawmill. Whatever career goals he might have had, one thing was iron-clad certain: He wasn't ever going to leave his Georgia mountain homeland again.

"Right after I graduated from high school, I took off to Atlanta to make the big money," he recalled. "Took me eighteen months to find out that's not want I wanted to do. I had a job with Colonial Bakery, loadin' delivery trucks. I was workin' and livin' in downtown Atlanta. That was too much big city for me. I moved back home and meant to stay."

Thomas settled three miles southwest from where he was born on Mitchell Branch. He lives there to this day. After working a couple of years at the sawmill, he started his own logging operation. Over time, it has evolved into a business that is the epitome of the term "family affair."

Thomas's three sons—Russell, Roger, and Ricky—are members of the crew. So is Bryson, one of Thomas's brothers. Two cousins, Michael Thomas and Frank Painter, drive the trucks that haul logs to the mill.

"My boys just sorta grew into this job with me," he says. "When they were little, their mother would bring 'em to the loggin' site after school. They were always helpin' me on weekends. When they finished high school, they started to work for me."

Logging has deep roots in this family. When Bob himself was a boy—back when he was carrying that crosscut blade over to Luther Bright's—he helped his father cut oaks for railroad crossties and hauled them out with horses and mules. That gave him plenty of on-the-job training in selecting candidates to be cut.

"Dad hewed-out all those crossties with a double-bit ax," he said. "He wanted trees that were about

the same size as the tie. That way, it cut down on waste. I learned real quick how to size up a tree while it was still on the stump."

Thomas's keen eye for gauging the potential yield of a stand of trees is what keeps him in business today. Before he bids on any sale, he cruises the tract to take inventory. No simple task. Unlike stock on open display in a warehouse, this inventory is sealed behind bark and shrouded by time. Just because a section of land is covered with trees, that doesn't necessarily mean it will make good lumber.

"Let's say the tract is fifteen acres," he began. "The first thing I do is walk over it to see if the trees are about the same quality. That's somethin' you just can't tell until you get out there on the ground and start lookin'. There's a lotta difference between the good and the bad. There might not be more'n one or two good trees in an entire stand.

"You're lookin' for trees that are straight, with not a lotta limbs. I look close at the grooves in the bark, too. If they're still bustin' open and have a light brown color inside, that means the tree's still growin'. If the grooves are real tight, it means that tree has quit growin', or else it could be damaged in the heart.

"I also look for fire scars. If there's been a fire through several years earlier, it'll cause the butts of the trees to swell. They'll get sort of a funnel shape to them. Or else they might still have black streaks on 'em. You gotta keep an eye out for the hollow ones, too. I always look for woodpecker holes. It's hard to fool a woodpecker. He knows if that tree has bugs in it."

Once he gets a feel for the overall quality in the area, Thomas singles out one acre and counts the number of marketable trees, estimating the yield in board feet of lumber each will produce. Then he extrapolates for the entire stand, factors in a potential market price, and makes his bid.

"It's a guessin' game, just like playin' the stock

market," he noted. "Sometimes the trees won't turn out like I figured. Or else the market will change while I'm cuttin'. I might buy high and then have to sell low, which means that I'm lucky to just make expenses and break even. Or if I'm lucky, I'll hit it right and make a little money."

Three types of people never succeed in the logging business: fat ones, unimaginative ones, and careless ones.

This is among the most physically demanding jobs in all of southern Appalachia. The hours are long, the terrain steep. A logger's world is a rough and tumble one of dirt and rocks, chains and cable, backaches and callused hands. The sweat flows freely, summer or winter. True, a chain saw makes the chore decidedly easier than a crosscut and ax, but it takes plenty of labor to transform trees in the forest into logs at the sawmill. At six feet tall and 160 pounds, Thomas has the chiseled look a long-distance runner.

Before the first tree falls, however, there's prep work to be done. A road must be cut to make the site accessible for trucks that will haul the logs away. Thomas employs his own fleet of bulldozers to accomplish this mission. He also serves as his own mechanic during the occasional breakdown. In fact, he and the others in his crew are jacks-of-all-trades in matters of maintenance. Whether it's a chain saw that quits running or a truck engine on the fritz, repairs must be made quickly and usually on site.

"You can't afford to bring in a mechanic every time somethin' breaks," he said. "Besides, how you gonna get somebody to leave town and come out fifteen or twenty miles to the woods? You've just gotta learn to fix everythin' yourself. We even build our own engines back at the shop. You have to do stuff like that in order to survive in this business."

Although this line of work has few official divisions of labor, everyone more or less has his own task. Most of the time, Bob and Bryson will be jockeying the bulldozers. Russell fells the trees by cutting a notch on the downhill side, then sawing straight in from the opposite direction. After each tree crashes to the ground, Russell removes the limbs— *zip! zip! zip!*—with quick bursts from his chain saw. Meanwhile, Roger runs the skidder, fetching the logs to the landing. There, Ricky cuts each log to a prescribed length and stacks it onto the trucks using a boom-operated lift. Michael and Frank handle most of the truck driving responsibilities.

"Actually, Bryson can do just about anything," Thomas said. "It doesn't matter what the job is. If anybody's out, he can fill in for 'em."

Danger is ever-present. One mental lapse can result in crippling injury or death. In nearly every annual tabulation of hazardous occupations by the U.S. Bureau of Labor Statistics, logging ranks at or near the top. Yet fortune has been kind to Thomas and his workers. Bumps, scrapes, scratches, and the occasional falling limb are part of the daily fare, but they have mostly managed to avoid serious injury.

"Compared to the old days, loggin' is a lot safer," says Thomas. "The old-time chain saws didn't have any of the safety features that they do today. And back then, folks always used skid poles to roll logs up on a truck. That was nothin' but a cocked gun. A log could roll back'ards on you real quick. You don't have that kind of danger with a hydraulic loader. You still have to be real careful, of course. Especially on windy days, a tree can change directions on you as it's falling."

Wind or not, a tree doesn't even have to be sawed to create a hazard.

"The worst accident we ever had occurred about thirteen years ago," Thomas related. "We'd just eaten lunch and were walkin' back in to start work again when this tree just up and fell on Russell. It was a small maple, not much bigger than eight inches through. It hadn't been cut or nothin'. Strangest

A Long, Lean Lumberjack

thing you ever saw—it just took a notion to fall. It hit him in the back and cracked a couple of joints. He was in the hospital two or three days and out of work for about six weeks, but then he was right back on the job."

Nonetheless, Thomas fears for the future of his profession, a worry that has nothing to do with physical danger. In many areas, logging has fallen prey to political correctness. He and other timber cutters have seen their jobs dry up on many public lands, particularly the Chattahoochee National Forest.

A Long, Lean Lumberjack

"There's just not a lot of common sense out there any more," he laments. "People today use more wood they can possibly imagine—everythin' from houses and furniture and paper to by-products like toothpaste—but they don't want to see a tree cut down. Where do they think that wood's comin' from? It's kinda like people who eat beef but don't want to have an animal killed."

Thomas illustrated his point by recounting a confrontation that occurred at a public hearing on timber management: "This fellow was really givin' loggers the business, and I happened to notice he had a walkin' stick. I listened to him talk about how awful it was to cut trees, and I finally spoke up. I said, 'Mister, what's that walkin' stick made of?' He said, 'Wood.' I asked him, 'Well, didn't somebody have to cut that tree down to make a stick so you could get around?' You know somethin'? Before that meetin' was over with, he was wantin' to sell me some of his timber!

"I think a lot of the misunderstandin' is because folks don't connect with the land any more. They don't realize that timber is like a crop that keeps growin' and renewin' itself. I've been cuttin' in places where some folks say there's nothin' but old virgin timber, and you know what I've found in that 'old, virgin timber'? Rock walls and old chimneys, that's what. That ground was cleared at one time. Out on our old homeplace, there's thirty-inch pop-

lars growin' in the potato patch. Some folks will argue with you that those trees are three hundred years old!"

Forest regeneration and below-cost logging on national forests are two other concepts Thomas believes the public fails to grasp.

"Generally speakin', pine stands will grow on the south-facing slopes, and hardwoods will grow on the north," he said. "Hardwoods will come back from root stock. They don't have to be replanted. You can change a hardwood stand to pine, but you can't do it the other way. If you try to grow hardwoods in a pine stand, the pines will come back and out-grow 'em and shade 'em out. You can't grow hardwoods in a pine stand without just stayin' there continuously with a bushhog and clearing out around the little seedlings."

As for below-cost logging—timbering operations on public land that cost the government more dollars than they generate in sales—Thomas admits there's a discrepancy at first glance. But, he contends, one must look at the big picture: "Yes, a particular sale might cost a hundred thousand dollars because of the roads that were needed, and then only bring in thirty thousand or forty thousand dollars. However, there might be another thirty million board feet of lumber that will move out on that road in the years to come, plus the public will have the recreational use of the road. It's all part of the overall management of the forest.

"The sad thing is, our public forests are better managed today than they ever have been. Ever since, oh, around the end of World War II, the southern forests have gotten good timber management. But the whole thing has gotten into politics, and the people who don't want to see trees cut down know how to play the politicians."

Thomas is particularly incensed at some of the prohibitions within the Chattahoochee that were sparked by public outcries in Atlanta.

"I've made my livin' in the forest. I love to hunt and fish in the forest. I sure don't want to see the forest ruined. But to listen to the people at those public hearings, you'd think that loggers were the worst folks on earth."

It's a matter of perspective, he believes, and the balance has gotten knocked out of kilter: "The logger is an easy target to pick on. If I let one log get into a stream, the folks in Atlanta start hollerin' about water pollution. Then I can go down on Lake Lanier, where those same people get their drinkin' water, and watch boats churn the banks into solid mud. Another thing—you let a logger spill a drop of gasoline in the woods, and they start the same fuss. Go right back down there on the lake and look around all those thousands of docks, and you'll see oil and gas slicks all over the water."

Thomas has two grandsons, Tony and Tyler, whom he'd like to see follow in the family business. But he's not sure how much of a business will be around when they come of age.

"When my dad and I were loggin' and skiddin' out with a horse and mule, a man could select-cut and still make money," he says. "That was back when bread cost a nickel a loaf, too. You can't do that today. You can't turn the volume you need to stay in business. Nobody can.

"It's goin' to be a lot easier some day for people like my boys to get a factory job with good wages and benefits and regular hours. When that happens, the price of lumber is gonna skyrocket. But who's gonna be left to cut it? Nobody will be able to afford to start up. People like me, we growed into this business. It's like farmin'. There's no way I could go out today and buy the equipment I'd need and make a livin' cuttin' timber. Why, I couldn't even make the payments."

Enough sermonizing. The sun's up, and it's time to get moving. A typical day for Thomas and his crew starts around 7:00 A.M., when everyone gathers at the shop behind his house to prepare their gear. Each man sharpens his own saw—Stihls with twenty-inch bars—the way he likes it.

"Everybody's got their own style, their own technique," Thomas says. "The one thing we don't do is take our chains to a machine shop to be sharpened. That does the job too fast. It hardens the chain, and you can't file it later."

With the banter of brothers in the background, Thomas leads a mini-tour around the shop and launches into a few tales of his own.

"See those rafters up yonder?" he asks, pointing toward the ceiling. "Now, there's a story. We were addin' on to the shop a few years ago, and we run out of lumber right in the middle of the project. Well, I knew where there was some good, straight yellow pines, and I went out and cut 'em down the next mornin'. Took 'em straight to the sawmill and had 'em sawed into two-by-sixes. Then I brought 'em to this ol' boy I know, and he planed 'em that afternoon. We nailed 'em up by dark. In other words, they was standin' in the woods at dawn and covered with shingles that night. They won't warp out because they're tied in good with nails and decked with plywood."

The yellow pine story reminds him of another tree tale: "I been cuttin' timber all my life, and I thought I knew wood. But I sure got fooled one time. Happened several years ago when my wife got this sore in her mouth. My dad told her to make a mouthwash out of the inner bark from a red oak and rinse her mouth with it, and the sore would heal.

"Wel'sir, I went out and cut some red oak bark. Nope, my dad says, that's not red oak. He came up on the loggin' site, and I took him to another red oak. Nope, he says, that's not one, either! Finally, he pointed one out, and I said, 'Dad, that's not a red oak. That's a blackjack oak.'

"It didn't matter what the name was, because the inner bark was just like Dad said it would be—

red as a drop of blood. Billie Sue made a mouth-wash out of it, and sure enough, it healed the sore in a couple of days. Beat anything I ever saw!"

Then there's a favorite story from 1986, when drug runners dropped several loads of cocaine from a low-flying airplane. They intended it to be picked up by accomplices on the ground. Unfortunately, a bear found one of the packs first and literally ate itself to death.

A Long, Lean Lumberjack

"They found that dead bear and the cocaine within a quarter-mile of one of our loggin' jobs," Thomas recalled with a laugh. "Man! That place was crawlin' with law in no time! They brought in cameras and filmed us and asked all kinds of questions about whether we'd bought any new equipment lately. One of my boys said he thought some of those folks were with the *New York Times. New York Times* nothin'. That was the FBI!"

Which leads to yet another remembrance: "I used to smoke cigarettes, but I quit eighteen years ago. I'll tell you how it happened. I had this ol' friend who never did anythin' but make liquor and sit on his front porch. He smoked Prince Albert tobacco for fifty-five years. Well, one day he told me he'd quit.

"I said, 'I sure wish I could,' and he said, 'You gotta quit by the signs.'

"He went on and told me that when he was a boy on the farm and it come time to wean a calf, his momma and daddy'd always wait till the signs were in the knee. Then, by the time the signs would be back in the head, that calf would quit bawlin' and forget about wantin' milk. He said he figured if it'd work for weanin' a calf, it'd work for quittin' smokin'. So he waited until the signs were in the knee and laid down his cigarettes, and by the time the signs were back in the head, he never wanted another one.

"He told me that on Christmas Day. I checked, and on January ninth, the signs went to the knees. I put my cigarettes down that day, and I'm here to tell you I've never had another one and ain't never wanted one, either. I really believe in the signs. I plant my garden by the signs, and I kill hogs by the signs."

But the signs Bob Thomas is most interested in right now are the ones pointing toward the forest. He climbs into the cab of his pickup truck, fires the engine, and heads for his "office." There's work to be done, and he's the man for the job.

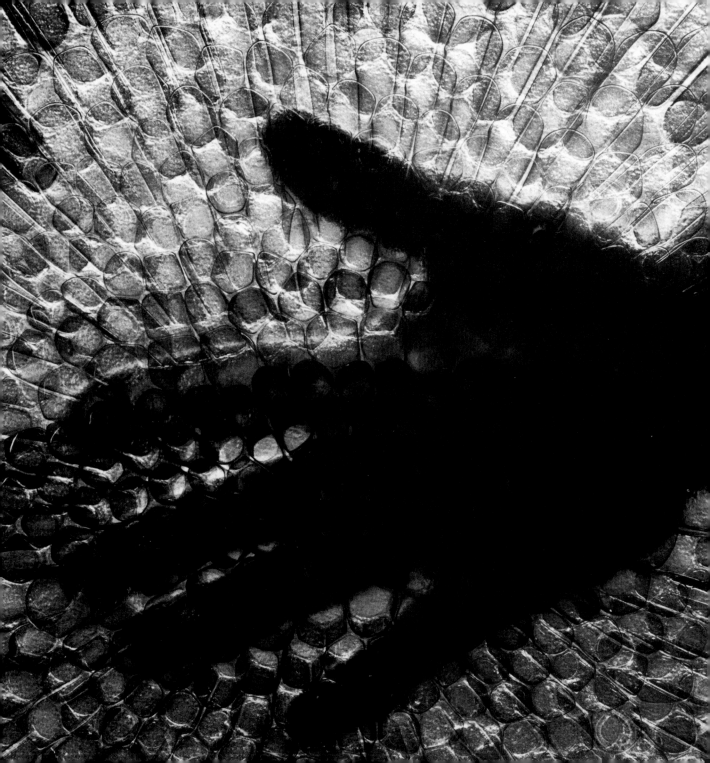

Clear as Glass

Gary Beecham

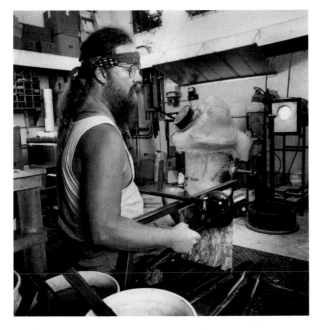

Preachers like to tell the joke about a wealthy businessman who, shortly before dying, has a talk with God about the hereafter.

"You know I'm a man of great faith," the man says.

"This is true," God replies.

"And you know I've spent much of my life here on Earth working on your behalf."

"So I'm told."

"Still, I am human," the businessman continues.

"I've managed to accumulate immense wealth by carefully planning for the future. I have left nothing to chance. Throughout my career, I've invested my holdings cautiously, always leaving myself an out in the event of sudden financial downturns."

"What are you getting at?" says God.

"I need a small favor," he answers. "Just this once, couldn't you make an exception to the can't-take-it-with-you rule? Although my faith about the glory of heaven is strong, I simply must allow myself a backup. You know—just in case things aren't quite as I expected."

"Hmmm, it is a rather unusual request," says the Lord, "but I suppose I could allow it if that's what you really want."

Sure enough, when the fellow arrives at the Pearly Gates, he's dragging a footlocker containing one million dollars' worth of pure gold. With great effort, he advances in line as each new resident is tallied. Finally he stands before Saint Peter.

"What's with the footlocker?" Saint Peter asks.

"God gave me permission to bring some of my earthly riches with me," replies the businessman. "It's all perfectly legal. Check your records."

Saint Peter adjusts his reading glasses, flips through several pages, and studies intently. Then he looks up with a start: "Well, bless my stars! You're right! So tell me—what sort of rare, exciting, valuable treasure did you bring?"

The newcomer clicks the latches on his footlocker, flips the cover open, and proudly displays row upon row of glistening gold bars.

"What?" Saint Peter shouts in disbelief. "You brought *pavement?*"

Okay, so it's a corny joke, perhaps best left to seminarians. But it does illustrate the relative nature of riches. As the old saying goes, "One man's trash is another man's treasure."

Gary Beecham offers yet another perspective about the matter. He holds up an empty, disposable, twenty-ounce cola bottle. It is a glass bottle, clear, with a screw-off cap—the very type of litter, unfortunately, that can be found along many ditches, roadways, and riverbanks throughout southern Appalachia.

"You can't even turn this thing in for a penny today," he says. "But can you possibly imagine what it would have been worth in an ancient culture? In Hellenistic times, glass was considered a precious material, valued just like gold and silver. To the ancient Egyptians, glass was treated as a precious stone."

That was an era of glassmaking infancy. Limited to clay pots for crucibles and wood fires for heating, early craftsmen produced some sophisticated glassware. But theirs was an expensive, labor-intensive operation that resulted in products available only to exceedingly wealthy customers. Centuries would pass before someone would discover the relative ease of shaping molten glass by blowing it with a hollow tube.

Glass would remain a precious commodity long after Europeans sailed across the Atlantic. Indeed, the first factory on American soil—built in 1608 in Jamestown, Virginia—was for glass production. Even as the fledgling United States began to expand westward, common glassware was a highly prized commodity. Amazingly, it wasn't until the development of automated machinery in early years of the twentieth century that glass, particularly in terms of vessels, finally became common and inexpensive enough that it could be taken for granted.

Gary Beecham has been fascinated by glass for nearly all of his forty-four years. As a child in rural Wisconsin, one of his hobbies was prowling around old homesteads and logging camps in search of vintage bottles.

"It got to be quite a source of recreation for my whole family," he recalls. "We'd try to figure out where the folks who lived in those places might have thrown their trash—and then we'd hope it hadn't all gotten smashed. We got a lease to dig around in the old city dump."

The fascination did not wane when Beecham entered the University of Wisconsin–Madison as a National Merit scholar. His intent was to study geology. But one day during his freshman year, he happened to visit the university's Fine Arts Department and watch a graduate student blow glass.

"I knew right then that's what I wanted to do," he said. "Geology was all right, but I could see the handwriting on the wall. I figured I'd have to at least get a master's degree, and then all I could do is either teach or work for an oil or mining company. I switched to art.

"I became a pest down in the glass lab," he chuckles. "I'd do anything they needed. I was willing to do all the dirty work. I helped as an apprentice. I didn't even care if I got a degree. I just wanted to learn the craft well enough to be a good glass technician—and to make a living."

One of Beecham's professors was Harvey K. Littleton, who fathered the concept of teaching glassmaking as an art form on the university level. After an educational career that lasted more than a quarter-century, Littleton left the academic world in 1978 and moved to the mountains of western North Carolina to concentrate on his art. Beecham graduated from the university in 1979 and worked for awhile at a glass factory in New York City. There, he further refined his skills as a technician.

But he wanted to explore his craft beyond the

realm of production paperweights and vases. He longed to create, to push the limits of his imagination. When his old professor telephoned one day and offered a job as his assistant, Beecham's only response was, "When can I start?" He moved to Spruce City and worked five years with Littleton. In 1985, he opened his own studio.

This region was the farthest south Beecham had ever ventured in his life. To borrow a phrase from country music, he literally was the "red-headed stranger" when he came to town. Between his clipped midwestern dialect and his auburn beard and ponytail, Beecham stood out like a pumpkin in a pea patch. More than one local was known to whisper to another, "What do you reckon he's a'growin' in that herb garden?"

But the unfamiliarity soon vanished. Beecham shared a common denominator with many of his neighbors: he loved to hunt and fish. That, plus his innate skills with tools, quickly made him one of the boys.

He even had a guardian angel.

"I didn't find this out till years later," Beecham says with a hearty laugh. "Apparently there was one fellow in the community who had built quite a reputation as a thief. I suppose I was next on his list. But I found out later that one of my friends took the guy aside and told him, 'That new fellow up there—the one with the red hair and beard? He's mean as a snake. He'd just as soon cut your throat as look at you.' You know what? I never had a lick of trouble!"

Within a few years, more glassblowers were flocking to western North Carolina. Many were attracted to Penland School, one of the largest and oldest crafts institutions in the nation. Penland was founded in the early part of the twentieth century by Father Rufus Morgan, an Episcopal priest, as a vocational education facility for mountain children. It is situated on a 470-acre campus, high on a ridge overlooking the Toe River, and was run for many years by Morgan's sister, Lucy. Still in operation today, Penland School draws students from throughout the United States and many foreign countries. It offers courses in pottery, woodworking, weaving, basket making, quilting, glassblowing, and other crafts.

"This area has become one of the centers for glass artistry in the country," said Beecham. "Right now, there are at least forty glass artists in and around Spruce Pine. About twenty of them have gained national and international standing.

"It just keeps building. None of us is in competition with the other. Just the opposite. We complement each other. In arts and crafts, it's hard to work in a vacuum. I know an artist who moved to the 'ideal' location in a remote part of Colorado to concentrate on his work. He couldn't get a darn thing done. You need to have other artists and other craftsmen around you to ask, 'Is this piece any good?'

"Also, it's very practical to have each other so close. We work with the type of tools and raw materials you don't typically find at the local hardware store. If you run out, there's a good chance one of your friends will have something you can borrow. Plus, we can order bulk supplies together and split the costs.

"The more artists that come to North Carolina, the more galleries and collectors that follow. If someone comes to see my work, they can just go down the road and see all the others. It works out best for everyone."

Even though Beecham lives and works on fourteen wooded acres on the outskirts of Spruce Pine, he knows his way around the globe.

He has traveled to Europe to work and exhibit his vessels. His pieces are represented by more than a dozen galleries in the United States, Germany, and France. He has participated in dozens of exhibitions, nationally and abroad. His glass is featured

Clear as Glass

in more than twenty permanent collections, including the Detroit Institute of the Arts, High Museum of Art in Atlanta, Capitol Bank Collection in Houston, North Carolina Governor's Western Residence Collection in Asheville, Mint Museum in Charlotte, as well as museums in Belgium, Germany, Austria, France, and Denmark.

But whether it's a utilitarian vase or a museum-quality piece of sculpture that will never come in contact with water and roses, every Beecham creation begins the same way.

By the scoopful.

Except for dense "color rods" of pigmentation imported from Germany, he makes everything from scratch. The main ingredient is a commercial pellet mixture comprised chiefly of sand, soda ash, and lime that gets fed, one scoop at a time, into the roaring maw of his furnace.

A glassblower's shop is laid out like an operating room. Every tool, every instrument, every component has its assigned place. Each must be within easy reach. It has to be this way. Smack in the midst of shaping a two-thousand-degree mass of molten material is not the time to discover you've misplaced a set of calipers.

This truism has special significance in Beecham's case. His wife, Mary Lynn White, also a noted glass artist, often assists him in the studio, particularly when stretching long glass rods or blowing heavy pieces of material. But most of the time, Beecham is a one-man show. He built his own studio, including the furnace and the annealing ovens into which finished glassware is placed to cool down. He even handcrafted the hinges that open and close the tall ceiling windows to help vent the heat.

Ah, yes, the heat. The ever-present heat. Temperatures often soar well above one hundred degrees inside this studio. But just as a farmer must make hay when the sun shines, Beecham must make glass when the propane burns. He usually

keeps his furnace fired from November through early summer, when searing outside temperatures simply demand a cessation of activity.

No time is lost when the furnace is running. Beecham often works eighty hours a week. There's plenty to be done—whether his schedule calls for functional drinking glasses and salad bowls; basketball-sized, colored garden balls; or more ornate pieces, like teardrop-shaped vases containing a rainbow of colors that flow through the center and radiate in all directions.

"I rarely do a drawing when I'm working on a new design," he explained. "Drawing is two-dimensional, and I've never been good at thinking in two dimensions. This is like playing with construction toys. Long before I actually begin a piece, I lay out all the individual components and arrange them. Then I rearrange them. Then I might pull everything apart and lay them out all over again.

"The physical making of a glass object has always come easy for me. It's always made sense. There's a game Harvey Littleton and I play. We'll look at a piece and say, 'How do you think that was made?' We'll keeping studying it until we figure it out."

The process doesn't always work to perfection, of course.

"Some days, everything you make gets thrown away," said Beecham, "and sometimes you'll go weeks without a screw-up. Then there are days when you walk into the studio and you simply don't have the touch. It's like being an athlete. Some days you hit every basket; some days you're throwing bricks. Even when everything is working well, you have to be careful. You can't let yourself get stale. You need to get away from a particular project every now and then, and then come back and look at it in a different manner."

This is a common, albeit maddening, theme in any type of creative art or craft. Trying to capture a new design or technique can be oh-so-elusive.

Clear as Glass

"Sometimes, I'll think about a piece over and over and over, and still the idea for the procedure, the technical aspects, won't come," Beecham noted. "Then I might be working on a completely different project, or maybe out mowing the lawn, or maybe I'll just wake up some morning and go, 'Yeah! That's how it's done!' That's how my mind works."

On this warm afternoon, Beecham needs to put the finishing touches on a sculpted piece of glass-work that will be shown in France later in the year. It must be transported to a gallery photographer the next day. But all that can wait, Beecham decrees. Let's make something a bit less complicated. Say, a drinking glass.

Beecham steps on a foot treadle that opens the door to his furnace. A menacing roar issues forth, accompanied by heat waves nearly thick enough to see. The white-hot core of the furnace, filled with molten glass, looks like hell itself.

"Burns?" Beecham responds to the question. "Naa. The only bad burns I've ever had are from welding or cooking food in the house. Glass will certainly burn you, but not as bad as hot metal or hot grease. You'll never see glassblowers just reach out and pick up anything. They'll always pause for a second just before touching it, to see if there's any heat coming off. It's a habit you learn real quick.

"Safety glasses are a must, however. You never know when a hot piece might snap off. I've had 'em fly up and bounce off the lens of the glasses. Better that than in my eye."

Beecham inserts one end of a five-foot stainless steel blowpipe into the furnace and twists it. A "gather" of glass forms at the tip.

"It's just like getting honey on a stick," he yells over the noise. "You gotta keep turning it to keep it from dropping off."

He attaches a small piece of ruby-red color rod to the molten ball. This will fuse with the original gather and give the drinking glass a pinkish tint when complete. In a moment he'll shape it further on a metal table or "marver." But already, the glass is starting to cool. It must be inserted into a smaller heating unit, the "glory hole," to bring it back up to working temperature.

Constantly turning the pipe, Beecham inserts the other end into his mouth and puffs, causing the glass to swell.

Back to the marver he goes, working, shaping, and snipping the glass ball as if it were taffy. Then he returns it to the glory hole for more heating. Next, he positions the swirling glass ball above a thick, heavy, metal mold that was made in Germany over a century ago. Blowing with greater power than before, he forces molten glass into the opening. Here, it will take shape. Patterned ridges inside the mold will impart a basket weave to the outside of the vessel.

Soon the glass comes out of the mold. It makes repeated trips to the glory hole and marver to be further shaped with both metal and wooden tools, the latter of which have been soaking in water. The vessel is then transferred to a "punty," a metal rod with a bit of hot glass on its end. This enables Beecham to continue working and forming the piece, opening it into a drinking glass.

Finally pleased with his product, Beecham breaks it free from the punty. With heavily gloved hands, he transfers it to an annealing oven where it will cool for four hours. This process relieves strain inside the glass and keeps it from shattering. Then Beecham will polish any rough edges and etch his initials into the base.

"Some studios have a three-person team, where each person can handle one particular step of the operation," he explained. "They can turn out a drinking glass like this every two minutes. Working by myself, it takes around fifteen minutes, just to get it to the annealing stage."

The impish interviewer cannot resist: What about

Clear as Glass

the drinking ware in Beecham's house? Surely he and his wife keep a few old jelly jars handy for juice and water, don't they?

"Actually, no," he answered with a grin. "Mary Lynn is always upgrading the glasses we use at home. I'll turn out a new set, and she'll say, 'Oh, those are nice! I think I'll just take them over to the house!'"

At least she doesn't have far to carry them. The Beecham-White house sits but a few dozen steps from his studio. The space between is a veritable paradise of growing things.

Bordered by a row of hemlocks, there's a series of herb gardens, thick with sage, thyme, and rosemary. Other raised beds have been assigned to asparagus, peppers, tomatoes, and squash. Apple and pear trees dot the hillside above. Further uphill is a tier of long oak logs on which Gary and Mary Lynn grow flavorful, flat-topped shitake mushrooms. And behind that sit four beehives, buzzing with activity.

"I sell just enough honey to afford to keep my bees," he joked.

Does he pack it in containers of his own design and creation?

"Oh, heavens no," Beecham replied. "I use Kerr canning jars from the store. Nobody could afford my honey if I had to make the jar."

Clear
as
Glass

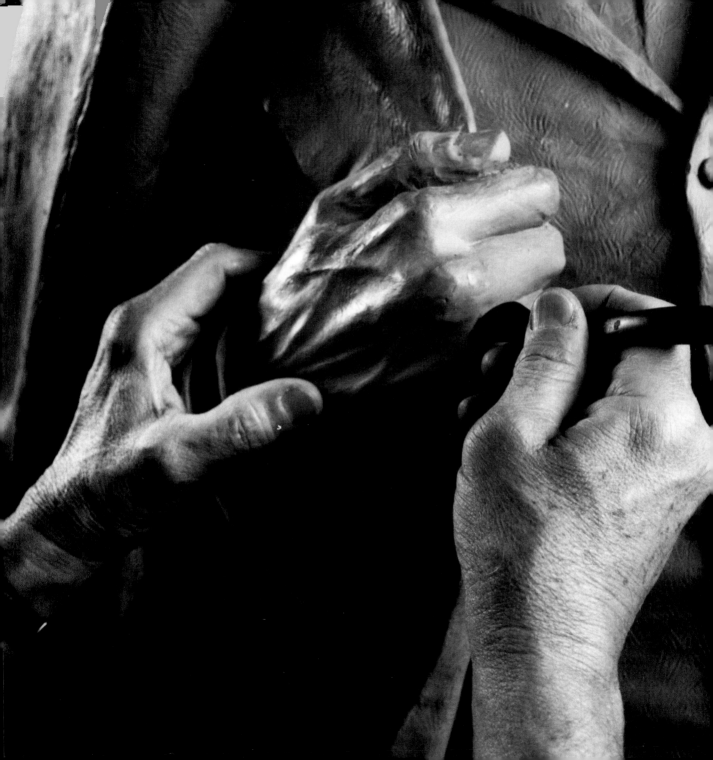

Bringing the Mountains to the Masses

Jim Gray

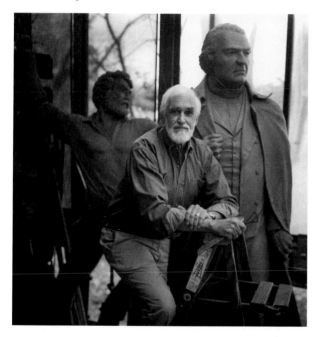

It was a warm day in the spring, and Fran Gray had just returned from the nursery with several flats and pots of plants. She removed them from her car and stacked each one carefully atop the old stone wall that borders the driveway. Then she went inside to change into work clothes.

Bad timing—at least as far as the flower garden was concerned.

Just as Fran entered the back door, her artist-sculptor husband Jim emerged from the garage. As soon as he spied those plants situated against the lichen-covered stones, he saw the making of a painting. It wasn't the first time, and it surely wouldn't be the last.

Gray set to work immediately. The flats and individual plants were positioned and repositioned until he was content with their placement. A quick trip to the shed produced a trowel and a pair of Fran's work gloves, which he tucked casually into the foreground. Satisfied, Gray grabbed his camera, shot the scene from a variety of angles and exposures, and made some sketches. Yes, the plants finally found their way into the garden, but not until Gray was fast at work on a painting titled *Promise,* later published as part of a long-running series of limited-edition prints from his lakeside home and studio.

Jim Gray can't help himself. As soon as his eyes lock on a promising scene, his mind and his hands begin working in tandem to reduce it to permanency.

"Oh, I'm sure there are some things that don't hold my attention for long once I look at them," says Gray, one of the most recognized names in southern art circles. "But it's difficult for me to look at anything and not at least subconsciously consider its painting potential. That's what I'm here for. That's what I do."

The moment you hear Jim Gray speak, you know

his roots run substantially farther to the south than southern Appalachia. His deep, creamy drawl has "antebellum" stamped all over it. Although Gray was born in Middleton, Tennessee, near Memphis, his family moved to Corinth, Mississippi, when he was two, then even deeper into Dixie to the Gulf shores of Mobile, Alabama, when he was nine. In fact, Gray was nearly thirty-five years old before he ever set foot in the misty highlands of the Smokies he depicts so beautifully in oils and watercolors.

If it hadn't been for an air force medical examiner, however, he might have wound up flying the friendly skies instead of painting them.

"When I joined the air force in 1951, the recruiter promised me I would become a pilot," Gray recalled. "That was before they gave me the eye exam. They had this test to check depth perception. I remember it well. I thought I had lined everything up perfectly. Apparently not. The examiner took one look and said, 'The first time you try to land a plane, you'll wreck!' I still think he was wrong."

That's how Uncle Sam gained an electronics instructor—who, coincidentally, also knew how to draw. Gray eventually was transferred to a training-aids branch where he helped produce some of the first technical drawings of the venerable B-52 bomber. Even then, the young airman had a pretty good idea of what he wanted to do with his future.

"Every person has that one special teacher who made an important impact on his or her life," said Gray. "Mine was Miss Clyde Kennedy, an art teacher at Murphy High School in Mobile. She must have seen something in me. She's the one who really sparked my interest in art and encouraged me to pursue it."

By the time he had graduated from Murphy High in 1949, Gray was already earning money by doing art work for a local loan company's advertising. He also worked as a Madri Gras float designer-builder and knew he could make a living with his art ability. The Korean conflict put those plans on hold temporarily, but when he left the air force in 1955, Gray knew where to start looking for work. Within a week after discharge, he had secured a job with a Mobile advertising agency.

By then, he had also acquired two other very important aspects of his life—a wife and a beard. Gray and his whiskers have only parted company one time, very briefly, since the 1950s. He and Fran haven't parted at all.

"I grew a beard before it was the cool thing to do," Gray says with a hearty laugh. "Back then, the only other people I knew who had a beard were a sculptor friend of mine, some weirdo out in California, and Fidel Castro!"

Thus began a career in advertising that spanned more than a decade, first at the Morris Timbes agency and later with his own partnership of Ditmars, Demeranville, and Gray. Here was a textbook picture of mid-American life, complete with three children, pets, a station wagon, and summer vacations. Indeed, it was one of those vacations that gave Gray the notion for a new career path.

"The entire time I was in advertising, I also maintained a painting studio," he said. "I worked there on weekends or whenever my partners and I would get at each other's throats. It was a good place to take a break. I'd also become a regular wharf rat by then, hanging out at the docks and painting seascapes, ships, watermen—whatever appealed to me. I was hungry. With every painting, I discovered something different. I started having one-man shows in and around the Mobile area, selling eight or ten paintings at a whack. I kept telling my partners, 'One of these days, when the time is right, I'm gone.'"

That time came in 1966, when the Grays visited the Great Smoky Mountains National Park. It was love at first sight. Soon after the vacation, Fran and the children returned to Gatlinburg to look, as

Gray remembers, "for a summer place, somewhere we could get away from the rigors of the advertising business."

She found it, all right: a house on three wooded acres with a spectacular, front-porch view of Mount Le Conte. If Gray was going to make the transition from advertising illustrator to full-time artist, the decision was nigh.

"I'll never forget the first time I saw that place," Gray mused. "Well, no, come to think of it, I did forget the *first* time!

"I'd worked all day at the office, then drove through the night to meet Frannie and the kids in Gatlinburg. I was dog-tired. Not only that, but for the entire drive, I kept thinking to myself, 'Man, are you ready to sell out your part of a thriving agency and move everything, lock, stock, and barrel, to the mountains?' By the time I arrived, I was a zombie. We drove out to see the house, and all I could do was walk around and stare and mumble. Frannie finally said, 'I think you need some sleep.' We drove back to the motel, and I crashed. When I woke up, we drove back out. I couldn't believe what I was seeing. I said, 'This is the place you showed me earlier? Where'd all those mountains come from?' It was marvelous. By September, we had moved."

Everywhere Gray turned in the new environs, he saw a painting. Reducing the scene to paper or canvas, however, was another matter.

"It was probably two weeks after we'd moved in and gotten everything out of the boxes. I kept telling Frannie, 'Boy, I saw a great scene today!' I'd go down to a stream in Greenbrier and sit there and look around and come home and tell her, 'What a great painting this will make!' Finally, she looked at me and said, 'So paint already!'"

He did.

These days, the Gray family operates four galleries—one in the Glades arts and crafts community east of Gatlinburg, one in downtown Gatlinburg, one in Pigeon Forge and one in Knoxville. They have published a series of more than 110 limited-edition prints featuring mountain vistas, streams, rocks, trees, wildflowers, and birds. Gray's originals and prints hang in homes, offices, and galleries throughout the United States, as well as Japan, Germany, France, and Italy. He has appeared in more than three dozen one-man shows at art museums and galleries across the country.

There's even a Gray image that has gone where no human has ever ventured. In a 1968 story about the Great Smokies, *National Geographic* magazine published a photograph of Jim and Fran, surrounded by his paintings, at their mountain home. A decade later, that picture was one of dozens selected by astronomer Carl Sagan to be included on NASA's historic *Voyager* mission. It's somewhere in outer space—"beelions and beelions of miles away"—along with recorded music, languages, and other messages from Earth.

"Every so often, I'll see something about *Voyager* in a newspaper or magazine article," said Gray. "To this day, it never fails to tingle the hairs on the back on my neck."

Surrounded by such artistic influence, the Grays' children evolved into the same line of work. Son Chris, a talented potter, has taken over the business side of the Gray galleries. Another son, Matt, is an artist, wood-carver, and sculptor who has opened his own studio and gallery at Perdido Key, near Pensacola, Florida. Their daughter, Laurie Gray Schmohl, is an artist, illustrator, and sculptor who lives in Fairhope, Alabama. Fran serves as CEO of Greenbrier, Inc., the publishing and framing arm of the galleries.

All of which frees Jim to do what he does best: bring his "friends" to life.

"A scene might be something I have contemplated for a long time or something I saw quickly, for just an instant. In either case, I have to analyze

Bringing the Mountains to the Masses

it in my mind for awhile, arrange it, put everything into perspective, take a few photographs if possible. I've got to like it. It has to please me. Any artist must do that. Otherwise, he's painting for the wrong audience. Then I'll start sketching. Once I've got a good sketch, I've got a friend.

"Here's when the professionalism takes over. You owe it to the subject to explore, polish it up a little bit, and give it an opportunity to really show forth. This is where the artist has such a great advantage over a photographer. I can add or subtract to enhance the scene. Maybe move a tree. Add a boulder. Remove a cloud that's in the way. Adjust the light to my liking. By the time I sit down with my photos and sketches and pick up my brushes, I've got an old friend. If nobody in the whole world likes it but me, that's okay. I've satisfied my soul."

He needn't worry.

Many of Gray's prints have been instant sellouts, not only offering mountain visitors a lasting image of the southern Appalachian landscape but also touching a resonant chord in their memories. Consider the development of *A Light in the Window,* a popular winter watercolor Gray painted in 1985.

"Frannie and I were driving back from New England. We were in Kentucky, right near the Tennessee border. A beautiful snow had fallen the day before, but by now the sky had cleared. It was getting toward evening. The sun was sinking low, casting all these wonderful shadows through the trees.

"There wasn't enough time to sketch. I stopped along the highway and started taking photographs. I kept driving and stopping and shooting—farms, fields, shadows, houses, anything. In all, I took enough photographs to do five or six paintings.

"Then I saw this wonderful little farmhouse with the warm glow of a light burning in one window, just as the sun was sinking out of sight. There was a guy walking down the road. I don't know if he belonged to that house or not. But in my mind's eye, it

was calling out to him, 'Welcome home.' It was perfect. No telling how many people have told me, 'I know *just* where that house is!' There are places like that all over the countryside. Maybe thousands. We all know them."

If pressed on the question of oils versus watercolors, Gray won't claim a favorite. He'd no more do that than pick a favorite child. Each medium has different qualities that separate it from the other. Oils, for example, are much more forgiving during the actual painting process. If he doesn't like what he sees, one swipe and it's gone, over and over as many times as it takes. With watercolors, the artist is allowed only one or two scrubs before the paper turns into a blotter. Conversely, oils are thicker, more dimensional. That tends to make them more difficult to reproduce in prints.

Then again, working in three dimensions comes natural for Jim Gray. It started during his childhood, back on his grandfather's farm, when he got his first pocketknife and discovered the joys of carving.

"My whole heritage is making things with my hands," he says. "Growing up, it never occurred to me that people would go out and buy things. They made them. My grandfather farmed. My father was a mechanic. They made a lot of their own tools and games. I started working with wood and native soapstone. I carved a little animal once—it was a squirrel or rabbit or something like that—and got several accolades for it. From then on, I was hooked."

Sculpting is a natural offshoot of painting. It starts with a sketch. But then, instead of being limited to the illusion of depth with a brush or pen, Gray can actually create it. He builds a clay model—"just like children do in kindergarten." Once he is satisfied with the initial result, he transfers it to a larger armature of steel and aluminum. Using his eyes and calipers to keep everything in scale, he applies and sculpts the clay.

Even then, that's just the beginning. Turning a

clay statue into a bronze figure via a process called lost-wax casting is a long, slow, demanding procedure that dates back more than four thousand years.

Says Gray, "The technology has certainly changed. Today, we even use it to make titanium parts for spaceships. But basically, we go about lost-wax casting the same way today as Bronze Age man did when he wanted to create a spear point."

It's a seemingly never-ending series of flip-flops with positive and negative images, starting with the finished clay product that has been divided into sections. A rubber mold is cast for each and backed by plaster. The rubber mold is then removed and melted wax is poured in to create a shell with the actual thickness of the finished product. This wax likeness is then dipped repeatedly into a slurry of plasterlike material that eventually hardens into a ceramic shell. While being fired in a kiln to temperatures of sixteen hundred degrees, the wax completely melts and burns off, leaving the empty shell into which the molten bronze is introduced.

After the bronze is cool, the ceramic material is broken away, the different sections are welded back together—"like a giant jigsaw puzzle," he says—and the seams are ground and finished to match the surface. Finally, a patina is created through a wash of chemicals, oxidizing the surface and becoming a permanent part of it. Then it's time to haul the creation to its permanent location, position it with a crane, cover with a silk shroud, and strike up the band for the grand unveiling.

Gray's major works of sculpture dot the landscape throughout southern Appalachia and beyond. A Dallas couple commissioned *The Strike,* which depicts a whaler about to throw his harpoon. A family of black bears graces the grounds of the Riverside Park Hotel in Gatlinburg. Church Street United Methodist Church in Knoxville is home of *The Teaching Christ,* arms outstretched, reaching for believers. There is a bust of the late, beloved author

Alex Haley in the Hodges Library at the University of Tennessee. Statues of former president Andrew Johnson stand in Nashville and Johnson's hometown of Greeneville. And in Sevierville, an over–life-sized bronze statue of singer, actress, and native daughter Dolly Parton sits proudly in the courthouse square.

Gray anticipates the interviewer's question even before it is asked. His eyes twinkle. A broad grin creases his face. "Yep, I had a lot of friends who wanted to help me on that one!"

The creativity of Jim Gray's hands even transcends the field of fine art. He holds three United States patents on orthopedic devices—two splints and a prototype exercise suit astronauts might someday use to maintain muscle mass during long periods of weightlessness in outer space. But whether his creations might wind up in some faraway galaxy, sitting on a mantle, or hanging from a office wall, Gray says the feeling of knowing someone likes and appreciates his works is wonderful.

"It's a rush. I hope I never get over it. What an ego trip it is to know that someone will pay their hard-earned money for something I have produced! Honest to gosh, my recreation is my work and vice versa. I cannot imagine going someplace without a sketch book. The most fun I can have is to find something I really want to draw or paint and sit down and do it."

What more can be expected from these hands? Gray slowly shakes his head at the question.

"Time is the great enemy. I wish I had three lifetimes to do everything I want. The days aren't long enough.

"Way back when I got out of the advertising business, I thought I could work and 'relax.' Don't get me wrong. I enjoy what I'm doing. I've had a lot of fun. But I wind up putting in more twelve-hour days than most folks ever think about.

"I used to teach art workshops but had to give it up because of time constraints. It was a wonderful

experience, and I miss it greatly. One of my students was Archie Campbell, the country comedian. He was a pretty good painter, but the best part was simply being in a workshop with him. We'd laugh all day long."

One thing Gray hasn't given up is his generosity to the Great Smokies. He has donated part of the proceeds of several paintings back to the national park, including a pledge of seventy-five thousand dollars from the sale of *Timeless,* a panoramic view of the Chimneys.

"I owe that park," says Gray. "I've taken a lot more paintings than trout out of there. I would not be living here except for the Smokies. I knew all that natural beauty would always be there, for me and my family. The park has allowed me a place to come and paint, to make a decent living, and have a good time doing it.

"Think about this: Almost all of my paintings have been either of the sea or the mountains, two of God's most beautiful and dynamic creations. I've never spent a day in those mountains that I didn't come out and have a feeling like I'd just been in church. I try not to ever forget to say, 'Thank you, Lord.'"

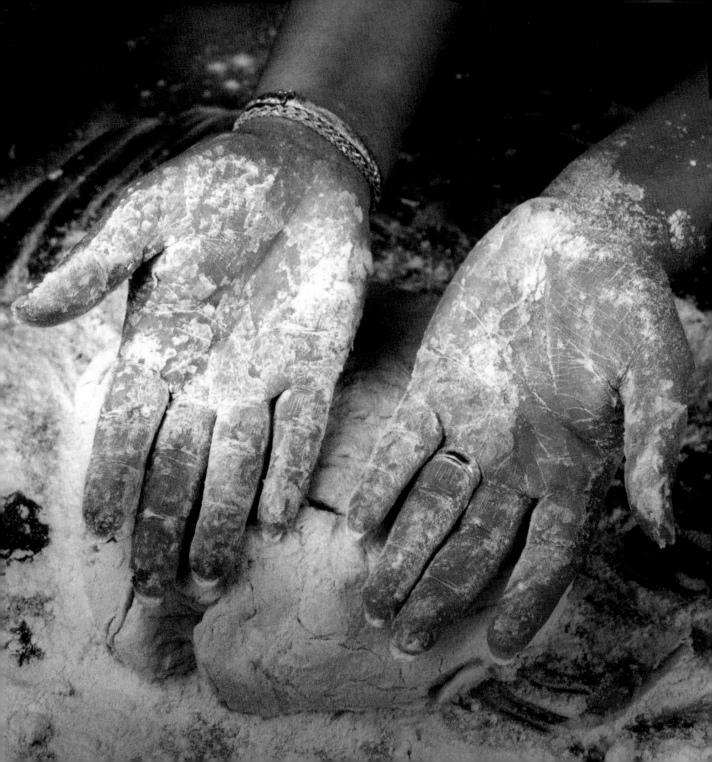

Born to Bake

Kathy Swanson

Hungry newcomers in Norton, Virginia, need not consult a street map to find Kathy's Korner. Nor should they bother thumbing through business listings in the telephone directory or asking directions from passersby.

Instead, all they have to do is turn their noses into the air and sniff. Unless their sense of smell happens to be dulled by allergies or a cold, one long, pleasant inhalation is all it takes to lead them to sweet-tooth nirvana at the intersection of Sixth and Alexander.

Chances are, they'll see Kathy Swanson even before they open the door. That's her at the window, standing behind a stainless steel table. She's up to her elbows in flour, sugar, eggs, cinnamon, nutmeg, and all the other ingredients of delightful concoctions that make mouths water and belts tighten.

"I love it when folks stand on the sidewalk outside my window," said Swanson. "Their eyes get big and they start licking their lips. Lot of times, they act like they're licking the bowl. A lot of 'em come on in."

Be forewarned. All diet plans, calorie counters, and fat gram charts should be checked at the door. You can pick them up as you leave. In the meantime, please direct your attention, not to mention your palate, to row after row of decorated sugar cookies, carrot cakes, fudge, brownies, white chocolate and macadamia nut cookies, pumpkin rolls, blueberry muffins, pecan tarts, and a to-die-for confection known as the Martha Washington peanut butter roll.

Yet Kathy's Korner is more than a bakery. It's also a restaurant—featuring a full breakfast and lunch menu, complete with sandwiches, salads, and a hot bar—and headquarters for a catering and specialty baking service.

And no one is more surprised than the owner herself.

"Back when I was a teenager, if someone had told me I'd be doing this for a living, I would have busted

out laughing," says Swanson. "I always pictured myself working in a dentist's office."

In truth, Swanson did serve as a dental assistant for a couple of years out of high school. She also briefly owned a children's clothing store. But genetics can't be denied. Way down there in the helix of Swanson's DNA was a command to blend generations-old skills of baking and entrepreneurship. It was only a matter of when.

214

*Born
to
Bake*

"I can't remember a time when my mother, Margaret Roberts, wasn't baking something good for us to eat," says Swanson. "She inherited it from her mother. My grandmother, Marie Dannimiller, lived in Akron, Ohio. When we'd go visit her on vacation, she'd always have these huge tins of cookies made up. Then all week long while we were there, she'd be baking some kind of cakes and pies."

The knack of running a business came from her father's side. Shortly after World War II, Percy Roberts and his six brothers founded what has become a chain of tire stores in Virginia, Kentucky, Tennessee, and North Carolina. Five of Swanson's eight brothers and sisters still work in the tire enterprise. One sister owns a cake-decorating service. Another has a hair-styling salon. A third sister, who died in 1996, owned a house- and office-cleaning operation.

Says Swanson, "I guess it's just in our blood to run a business."

Yet Swanson had no idea what she was starting in 1987 when she began decorating a few cakes for friends and neighbors. Before long the word spread. She began taking orders. In 1990, Swanson entered three baked goods in the Virginia-Kentucky District Fair and took a blue ribbon with each. Next thing she knew, she was making regular deliveries out of the family van.

"The timing was pretty good," she said. "My children were little then, and I wanted to stay closer to home."

The requests kept rolling in, and by 1992,

Swanson had developed a weekly regimen. On Mondays, Tuesdays, and Wednesdays she would take orders and buy supplies. Bright and early every Thursday, she tied on her apron and started baking. It went all day, sometimes far into the night.

"My poor husband and children had to fend for themselves on Thursdays," she recalls with a laugh.

On Fridays, Swanson would load up the van and make a sweep through neighboring towns and counties, often delivering up to five hundred dollars' worth of fresh pastries to the offices and homes of working women. In 1996, after completing a course at Mountain Empire Community College's Small Business Development Center, she took the plunge and opened Kathy's Korner in downtown Norton.

Which is not to suggest her pace has slowed. Just the opposite, in fact.

From Monday through Friday, 8:30 A.M. until 5:30 P.M., and 9:00 A.M. till 2:00 P.M. on Saturdays, she bakes and oversees the restaurant at Kathy's Korner. That is, if she's not catering a wedding, arranging a client's holiday party, hosting a business luncheon, or doing something *really* important, like turning out goodies for one of her five children's birthday parties or school bake sales.

"Yeah, the teachers are pretty happy to have my kids in their class," she quipped. "One of them threatened to hold 'em back another year, just to make sure the cookies kept coming."

Then again, familiarity can breed contempt: "Once when my daughters were young, they were going to have some friends over for the night. I offered to get up the next morning and bake fresh muffins. The girls wouldn't hear of it. They *knew* their friends wouldn't want anything like that! Even now, when we stop by a gas station or convenience store, they'll sometimes run in and buy a commercial snack cake. That's their only experience with that kind of stuff."

One key to Swanson's success is her adherence

to the principle of something old, something new. Many of her recipes are tried and true hand-me-downs from her mother and grandmother—like stackcake, pound cake, pecan tarts, banana nut bread, fried apple pies, and the peanut butter roll. But she's not hesitant to experiment.

"For one thing, I collect cookbooks," she said, "especially the ones from church groups. They're excellent sources of new material. I do a lot of sampling at other restaurants, too. If I taste something I like, or somebody brings in one of their favorites for me to try, I can usually work around and figure out how to make it on my own. Sometimes I can even improve on it by adding a spice or two. It's something you literally have to have a taste for."

Taste testing does have its limits, though. Swanson says she has no trouble resisting the delicious treats that line her shelves.

"After you've been around these smells all day long, the last thing you want to do is eat. You know what I do lots of times when I get home? Open a can of soup! One of my customers told me if he and I were married, he'd weigh four hundred pounds. I said, 'No you wouldn't, 'cause I don't cook that much at home anymore.'"

Funny thing about experiments, in or out of the kitchen. Some of the ones that prove most successful weren't planned at all. Ask any scientist.

"Once, I had just loaded the oven with twelve loaves of banana nut bread. They'd been in for, oh, about ten minutes, when I glanced at the table and saw a gallon jar of cooking oil, still unopened. I just knew the bread would be ruined. But when the loaves came out, they weren't bad at all. The oil in the bananas had worked just fine. These days, I still use cooking oil for that recipe, but not nearly as much as before."

Swanson adapts to other little disasters as they come. Like the day she was hurrying on a catering job and stopped too quickly at a red light. Ker-plunk. Two gallons of baked beans overturned in the back of the van, conveniently missing a sheet of plastic she had spread for such an event.

"There wasn't anything to do but scrape the mess out and keep driving," she sighed. "Fortunately, I had made more than I needed. There was still enough in the pot to handle the job."

But whether she's cooking for two or two hundred, Swanson says precision measuring is a rule that cannot be violated.

"You might get away with a pinch of this and a pinch of that in some dishes," she said. "But in baking, the ingredients have to be exact. Otherwise, the dough won't leaven properly. It'll either rise too quickly or not enough. It won't bake evenly. If it's not good, I'm not going to serve it."

Nor is this the time for trying to remember details off the top of one's head. Swanson keeps her recipes filed by batches produced. For example, if she needs sixteen loaves of banana nut bread, she flips to that particular page in her notebook and starts measuring.

Or counting and peeling, as the case may be.

Into a huge mixing bowl go twenty-four bananas, peeled and mashed. Plus twenty cups of flour, thirteen and one-half cups of sugar, three tablespoons and one teaspoon each of baking powder and baking soda, two tablespoons and two teaspoons of salt, five and one-half cups of oil, six and two-thirds cups of buttermilk, sixteen eggs, and five and one-third cups of chopped walnuts.

After thirty minutes in the mixer, the blend is poured into sixteen loaf pans, previously coated with a non-stick spray. No rising is required for this product. Just fifty minutes at 350 degrees and fresh, hot, banana nut bread is ready for the display case.

Nothing to it. Next recipe, please.

Despite what your mother may have permitted, Swanson shakes a disapproving finger at those who beg a lick from the mixing bowl.

Born to Bake

"Shortly before I opened the bakery, I attended a seminar the Scott County extension agent put on. A microbiologist was speaking. He asked how many of us ate raw eggs. Nobody raised their hand. Then he asked how many of us lick our spoons and bowls and let our children do the same thing. Nearly every hand went up. He waited a second and said, 'Didn't you just crack raw eggs into that bowl?' I got the message. Baking may not come with all the potential dangers of, say, working with fresh meat, but you've still got to be careful."

(C'mon. Does this mean she absolutely, positively, never, ever sneaks just an occasional itty-bitty taste of brownie mix or cookie dough? Swanson invoked the Fifth Amendment.)

She performs her magic in a double-wide, five-racked Blodgett convection oven that sees dawn-till-dark service most of the year and up to eighteen hours a day during the holiday crunch.

"The beauty of a convection oven, versus the conventional one people have in their homes, is that the heat is evenly distributed," she says. "There's not a hot spot on top or a cool spot at the corners. When I think back about how women years ago used to bake all those wonderful pies and cakes in an oven off to the side of a wood-burning stove, I'm absolutely amazed. I don't have any idea how they maintained the temperature."

When she does manage to squeeze time away from her business, Swanson enjoys camping with her husband, Dallas, and their five daughters, Autumn, Amanda, Amelia, Sarah, and Kathryn.

"Dallas always said he wanted to be surrounded by women," she chuckled. "I'm not sure this is what he had in mind."

Who does the cooking on these back-country excursions?

"Everybody pitches in," she replied. "That's the fun of camping. I believe we have as good a time cooking over an open fire as we do eating the meal."

Speaking of meals, there's always a gargantuan one every Christmas Eve at Swanson's parents' home. Counting all the brothers, sisters, cousins, nieces, nephews, aunts, and uncles, nearly fifty hungry diners usually attend. Naturally, everyone lends a hand—in the preparation and the feasting.

"You cannot possibly imagine what we put away," Swanson said. "Turkey, ham, dressing, gravy, two or three kinds of potatoes, green beans, corn, hot rolls, and a ton of desserts. I always have to fix a peanut butter roll for Daddy. That and maybe a pecan pie."

With one eye focused firmly on the past, Swanson directs the other toward the future. She's thinking of opening a second location in Big Stone Gap, Virginia. She's even flirting with the idea of franchising, knowing that such a step, however potentially profitable, will call for even more planning and commitment.

"When I took the small business course, they told me most restaurants never make it past their first year. I've come that far and more. I'm still flapping my wings and flying.

"I've got to keep trying. Things will work out. Just about every time I start out to cater a wedding, for instance, I get a little nervous. I'll never forget one wedding in particular. I had to bake nine cakes in all, including this huge, three-tiered one.

"When I head out to an event like that, the first thing I do is start worrying about all the things that could go wrong. I think, 'Why'd I get myself into this again? I've just got *one* chance at this thing today. I've got to do it right.'

"But then when the reception is in full swing and everybody is having a great time, I step back and smile and say to myself, 'All right! Good job!'"

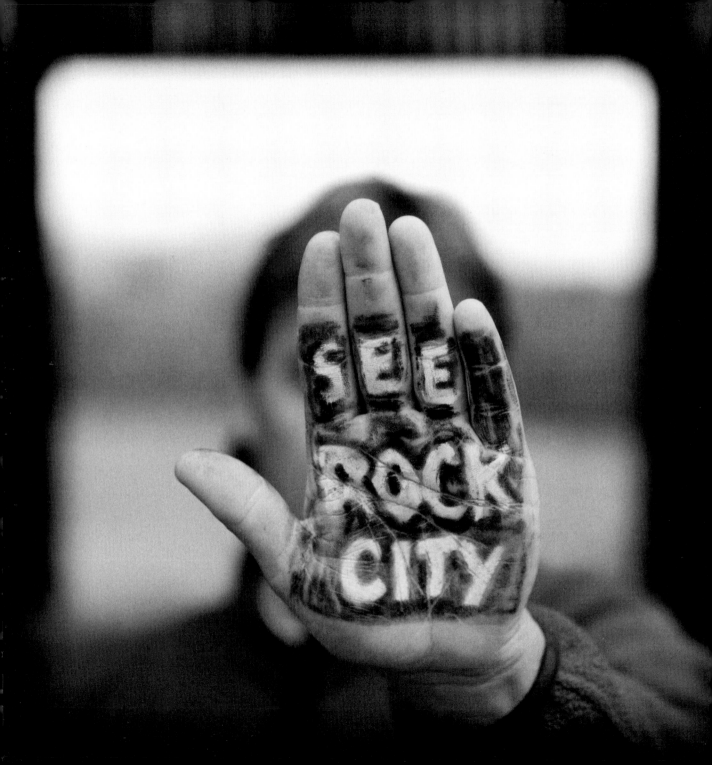

Seeing Rock City—Again

Jerry Cannon

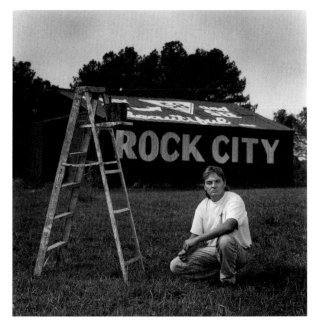

In 1937, a young sign painter named Clark Byers accepted an assignment that would ultimately become his life's calling, create a southern icon, and forever change the face of his rural homeland. Today, Jerry Cannon is keeping that mission alive.

"It's pretty easy if you know what you're doing," says Cannon, deftly turning the handle that controls a four-inch-wide roller. "See? I'm just gonna cut the letter in like this."

Cannon rotates his wrist, and a film of black paint flows smoothly inside the white letter *O* he previously had painted with a brush. Satisfied, Cannon moves further to the right and trims the remaining *C* and *K*. More letters wait on down the line—another *C,* then an *I,* a *T,* and a *Y*.

Cannon steps back to admire the beginning of yet another masterpiece. He's got several more hours of work ahead, this time with a nine-inch roller that will cover the wide spaces of rough-sided barn board above, below, and between the letters. But already, the message is clear to motorists lumbering along nearby Tennessee Highway 58:

"SEE ROCK CITY."

In a bygone era, Rock City barns were as much a part of the American highway scene as tail fins, gas wars, mom-and-pop tourist courts, Burma-Shave jingles, and "Jesus Saves" crosses. From the thirties until the late sixties, Clark Byers earned his living making sure travelers paid attention. He drove across nineteen states and painted slogans on nearly nine hundred barns, sheds, silos, and stores to advertise Rock City, a rock- and botanical-garden tourist attraction on Lookout Mountain near Chattanooga.

Byers's career came to a sudden halt in 1968 atop a barn near Murfreesboro, Tennessee. Reaching out with a putty knife to scrape a section of caked-up enamel, he brushed a dangling power line and was struck by seventy-two hundred volts of

electricity. Miraculously, the accident was not fatal. The painter remained hospitalized for some time and was out of work for a year. The pacemaker in his chest today is a constant reminder of that incident. Still active in his eighties, Byers lives on his one-hundred-acre farm near Rising Fawn, Georgia.

By the end of the sixties, travel routes, advertising tastes, and laws were changing. A straighter, faster interstate highway system began to absorb the traffic that had been creeping across the winding back roads. Television emerged as the preferred medium for polished commercial messages. As the number of farm families dwindled, so did the inventory of high-visibility barns. And even if officials of Rock City and other famous southern barn advertisers—like Jefferson Island Salt and Mail Pouch Chewing Tobacco—had wanted to broadcast their messages on the newer thoroughfares, they were restricted by provisions of the Highway Beautification Act of 1965. Thus Rock City curtailed its campaign for nearly two decades.

But good ideas refuse to die, despite the best intentions of Madison Avenue and Washington. Like Moon Pies, RC "dopes," bass fishing, and NASCAR, Rock City barns had become a permanent fixture in twentieth-century southern culture.

These byway treasures became the subject of an award-winning book, *Rock City Barns: A Passing Era,* by photographer David Jenkins. With a road map and Rock City's old file-card system as his guides, Jenkins traveled thirty-five thousand miles in fifteen states to track down the remaining 250 barns and capture them on film.

Enter Jerry Cannon.

A native Chattanoogan with a sense of history and a passion for painting—at the easel as well as barn siding—Cannon began to notice a few of the aging structures in his travels. In 1993, he approached Rock City's owners with the idea of keeping the signs alive. He showed them photographic evidence of his skills and received the same thumbs-up Clark Byers had received more than half a century earlier.

"The people at Rock City had tried a few sign painters, but they just hadn't panned out," he said. "I reckon the work was too hard, or maybe the barns were too scattered. They gave me a map, and I hit the road.

"I was a little hesitant at first. So were some of the barn owners. I mean, they didn't know me or anythin'. But then one day, I showed up at this house and knocked on the door and told the man I'd like to repaint his Rock City sign. He laughed real big and said, 'Where you been all these years?' I said, 'Well, I guess I'm the new man.' I knew right then it was gonna work out."

That was eight states and ninety barns ago.

"This isn't somethin' I can do full-time," says Cannon, who now makes his home in the Hamilton County, Tennessee, community of Georgetown. "I stay pretty busy around here paintin' barns, houses, churches, just about anything anybody wants me to paint."

But when he can spare the time, Cannon loads an extension ladder, rollers, brushes, paint, buckets, and rags into his aging Chevrolet pickup truck—there are 169,000 miles, and counting, on the odometer—and strikes out for the boonies.

"I travel pretty light," he said. "I really don't need much equipment. Once, this woman was writin' a magazine article about me, and she said somethin' like, 'Cannon keeps all his high-dollar gear in his basement.' Not really. 'Bout all I've got is a ladder, some rollers and brushes!"

Cannon remembers sketching as a child. True to his Dixie roots, hotrod cars were his specialty. He took art and mechanical drafting courses at Notre Dame High School, where he graduated in 1980, and briefly studied commercial art at the Univer-

220

Seeing Rock City— Again

sity of Tennessee–Chattanooga. But most of what he has learned has been by himself, on top of a barn with a brush or roller in hand.

A pretty decent education, it seems. Cannon has met Byers on a couple of occasions and received the "real good job" seal of approval.

"That was special, comin' from him," Cannon noted.

"I'm not on any kind of schedule from Rock City," he added. "They just give me a list of the barns, and I get to 'em as I can. I really don't have much contact with those folks except when I get my check. That sure helps pay the bills, all right. But you know, it's not so much the money as it is preservin' part of America."

This line of work doesn't come without its hazards. Cannon hasn't been hit by a power line—yet. He hasn't been struck by a snake—yet. And he hasn't fallen off a roof—yet. But there have been some close calls, one of which, to Cannon's chagrin, was caught on videotape.

"It was at this barn near Monteagle Mountain," he said with a sheepish grin. "They were tapin' a show about me for the *Tennessee Crossroads* program out of Nashville. The guy had just asked me about fallin', and I said somethin' like, 'You have to be real careful about steppin' in wet paint.' About that time, my feet flew out from under me, and down I went. I jumped up and said, 'Oops! Mistake number one!' They show it right on the program."

Another spill brought him perilously close to the brink. Working on the roof of a barn near Oak Ridge, Tennessee, Cannon hit a slick spot and shot down the hot tin on his belly.

"I was diggin' in with my nails and everything else!" he exclaimed. "I reckon the paint is what stopped me. It started lockin' to my skin as I slid. I managed to stop just as I got to the edge. I looked down, and about fifteen feet below were all these boulders. I started usin' a rope after that."

If you think Cannon was scared from that episode, imagine the hapless barn owner, who happened to be watching from her front porch.

"I didn't even realize she had seen me until a few years later when I came back to repaint her barn," Cannon said. "She looked at me and said, 'Ain't you the boy who was on that roof and like t'fell?' I said, 'Yes, ma'am,' and she hollered, 'Lord, son, you like t'give me a heart attack!'"

It all comes with the territory. Cannon can rattle off any number of bizarre encounters rarely faced by the nine-to-five crowd. Like the time in Alabama when a herd of captive bison decided to take on his vehicle. Or the day in Eagleville, Tennessee, when a vulture dive-bombed him. Or the morning in Georgia when a black bear cub forced him to stay on a roof a lot longer than planned.

"He just came walkin' out of the woods near the sign," Cannon said. "I drove a van back then, and I'd left the door open. He crawled up inside of it. I reckon he was sniffin' around for my food. I wasn't afraid of him. I was afraid of his momma. I didn't know if she was hangin' around out there where I couldn't see. So I just stayed where I was until he went away."

So much for extraordinary happenings. A typical day's regimen for a barn painter, particularly in the searing heat of July and August, would send most other folks hustling to the unemployment line.

"When it really gets t'cookin', that paint will actually smoke with fumes," he said. "Sometimes, I even have to wear a mask."

And then if Mother Nature decides to cool things off, he faces a different peril. "Soon as I hear thunder, I come down," said Cannon. "You don't want to be on a barn roof when there's lightning."

Most of the time, though, the task is routine. For a sign painter, that is.

"I try to take it like a puzzle," Cannon said. "Just

start at one corner and work toward the other. Yeah, I've boxed myself in a time or two, but there's always a way to work out of it. I feel real safe doin' this job. I always have that rope in one hand, and I keep it tied off at the ground or on my truck."

When Clark Byers was manning the brush, he mixed his own pigments with lamp black and linseed oil. Cannon opts for a more modern approach. He buys Kurfees commercial barn paint, semigloss black and stark white. The fact that Cannon uses a roller might evoke a stern "harrumph" from Byers, who remained steadfastly loyal to bristles throughout his career. But in one area they share common ground: No sprayers allowed.

Byers was famous for his ability to freehand the letters, often spelling out whimsical messages such as "To Miss Rock City Would Be a Pity!" and "Millions Have Seen Rock City—Have You?" Whatever the master wrote, the student duplicates.

"Clark did excellent work," he noted. "I try to keep it as original as possible. I don't want to change it."

Even if he could, time would ultimately betray him. Like ghostly roadside sentinels, the Rock City messages tend to bleed through any cover layers that would dare attempt to hide them. That's a phenomenon photographer Jenkins discovered as he researched his book. In Swain County, North Carolina, for example, Jenkins located a barn with white letters proclaiming, "See 7 States from Rock City Atop Lookout Mt., Chattanooga, Tenn." plainly leeching their way through a red paint-over.

Another Byers original was the Rock City birdhouse, a compartmentalized, red, white, and black condo favored by martins and swallows. Shortly before his accident, Byers even painted an entire barn near Dalton, Georgia, to look like a birdhouse.

Cannon has perfected a trick or two of his own. On the front of the Bettis-Allison barn in Tennessee, for instance, he used paint to create the illusion of a loft opening near the top.

"One fellow looked at that barn and told me, 'Painter, you're gonna cause some poor ol' bird to commit suicide!'"

Although some of the barns he has visited are in a sad condition, Cannon has been surprised to see many are still in good shape. He always makes a visual inspection of the beams and rafters before he climbs. Other than occasional board-rot on siding near the ground, many of them remain structurally sound.

"Barns were well built back then," he said. "A lot of them were made out of oak or cedar and have really been taken care of. Oh, they start to sag or tilt or squeak and maybe get a few yellow jackets in them. You just have to be careful."

But as much as he likes the old barns, Cannon is thrilled to meet the owners, many of whom are the very folks who dealt with Clark Byers a long, long time ago.

"Sometimes they'll invite me in for coffee and cake after I'm finished," he said. "You oughta hear their stories. Most of these places are way off the beaten path today, but they had a lot of traffic back then. I remember one woman named Jeanette. She lived on the road between Mobile and Montgomery in Alabama. She still talks about the time Hank Williams came by."

That's Hank *Senior,* you understand

Cannon knows his country music. When he's not on a ladder or swinging across the roof with a rope, he's often jamming on the guitar with his four brothers.

"We're a pretty musical family," he said. "We all play some sort of instrument. We like to get together every now and then and play and sing. In fact, one of these days I'd like to do a song about these barns. That'd be neat."

Cannon has other plans he'd like to incorporate with his Rock City work. In his studio at home, he has completed seven oil paintings of barns he has visited. One day, he'd like to compile a book of them. He also has plans to silkscreen the images

onto t-shirts. What's more, he'd like to film a documentary about his unique occupation and the interesting people he meets.

"Trouble is, plannin' is usually about as far as anythin' ever gets," he sighed. "I reckon I need a kick in the butt to get me goin'. This is really a good opportunity for me. A lot of artists never make it because they didn't come along at the right time. I've been lucky."

Lucky in his line of work, yes. But even luckier to be linked inseparably with the past. Jerry Cannon has been afforded the rare opportunity to bond with members from an earlier generation, a group of rural folks who ignore fat grams, maintain a wary distance from bankers and insurance salesmen, and still consider the Great Depression and World War II as current events.

"I'm tellin' you, the old folks I meet are somethin'," he says. "Some of 'em are way up in their eighties and nineties now. I've gotten to know a lot of 'em. They look forward to me comin' back and paintin' their barns again. Sometimes I do manage to get back. But then, some of 'em have died in between.

"Those old folks are special to me. A lot of 'em don't have any other family. Their kids have all grown up and moved on. Maybe they've just got a brother or sister livin' way off somewhere. All they've really got in this whole world is that ol' barn."

223

Seeing Rock City— Again

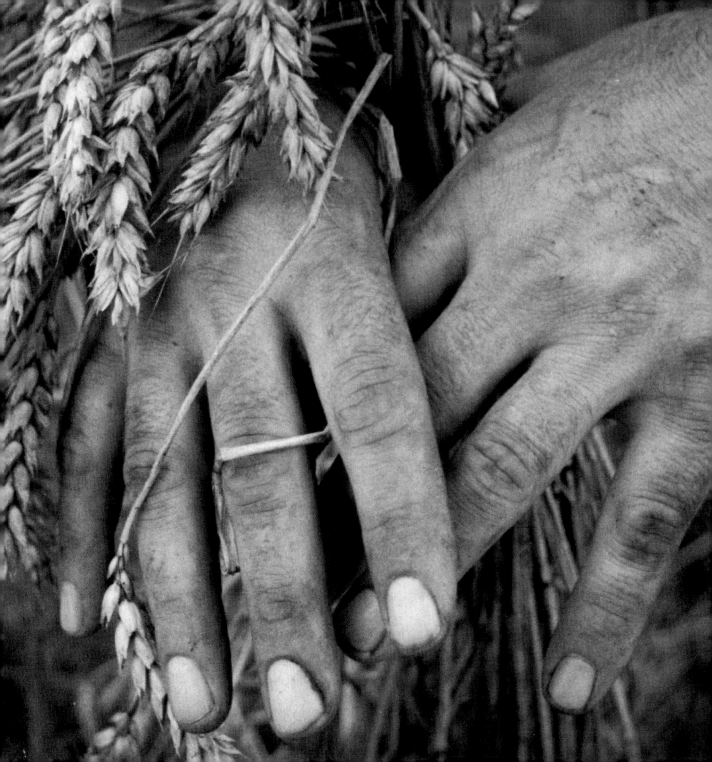

Grains from the Good Earth

Jay Graham

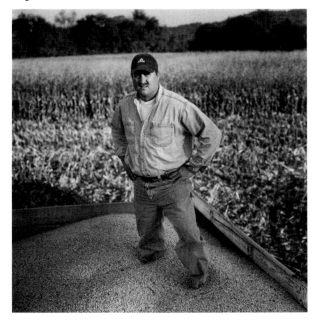

Six miles to the east, thunder rumbled intermittently off the steep slopes of English Mountain. An occasional bolt of lightning licked its way through the quickly darkening sky. The air, sticky as sourwood honey only moments before, now smelled cool and fresh.

"Don't let this fool you," Jay Graham cautioned. "We don't get a lot of rain from over yonder. It'll probably play itself out before it reaches here."

As if to mock Graham's admonition, the heavens opened up briefly. But the squall didn't last much longer than required to settle the dust. Within ten minutes, sunshine reappeared.

"See what I mean?" Graham remarked, satisfied his meteorological observations had once again proven correct. "But don't think I'm not grateful for a little shower like that. A farmer will take rain any way it comes."

Within reason, of course.

There's nothing like a pounding, relentless downpour to make a farmer pace the floor when it's time to plant or harvest. Graham never will forget waking one March morning in 1994, during some of the worst flooding in half a century, and seeing a veritable ocean of backwaters from the Pigeon River covering much of his farm.

"Man, I thought that was the end of the world!" he exclaimed. "I've never seen the water that high. Don't reckon many other people had, either. Fortunately, it went down pretty quick. It tore some ugly holes in the fields and rolled two-ton boulders around like they were toys, but then we were right back in business."

Farming has been *the* business for folks named Graham since the term "horsepower" had nothing to do with the internal combustion engine. Jay's great-grandfather, James Rufus Graham, served as sheriff of Jefferson County, Tennessee, between 1898 and 1902. Shortly thereafter, he broke ground

on a farm near Jefferson City. Some years later, he expanded his operation by leasing a second farm near the town of Dandridge.

After James Rufus Graham's death, his widow, Mary Carolyn, and two of their sons, John and Bill, moved to the Little Tennessee River bottoms near Loudon, Tennessee. This farm served them well for nearly thirty years. But then the Tennessee Valley Authority's Tellico project sent everyone packing. In 1970, Bill's son, James Graham, decided to take his wife and children back east. They settled on four hundred acres of fertile bottomland at the junction of the Pigeon and French Broad Rivers in Cocke County, just outside the city limits of Newport.

It was time for a change.

Until then, the Grahams had been dairy farmers. In fact, when James moved his family to Cocke County and established Grahaven Farms, he brought 250 head of Holstein cattle with him. Eventually he sold off the herd, much to the delight of one young James Graham Jr., a.k.a. Jay.

"The whole time I was growin' up, I never thought I'd follow my daddy into farming," he says. "But when somethin' like this is in your blood, you just can't deny it. I'll never forget one warm spring day, right about the time I was gettin' out of high school. I was drivin' along and lookin' out at the corn comin' up, and I knew this was where I needed to be."

On one condition.

"We had pretty much gotten out of the dairy business altogether by then," Jay recalls with a laugh. "I told Daddy we could get into raisin' chickens or hogs or anything else. But if any more cows came on the place, I was leavin'."

It was a deal. Today, Grahaven has grown into fifteen hundred acres on two tracts. It is headquarters for one of the largest corn-soybean-wheat operations in the entire state, let alone the mountainous regions of eastern Tennessee.

Families steeped in farming tradition don't

change overnight, and the Graham tribe is living proof. Although Jay is the only one of James and Yvonne Graham's five children who stayed in the fields at Grahaven, every member of the family shares a love of the land and remains linked in some way to agriculture.

Papa James himself now owns a John Deere dealership in Greeneville, Tennessee. Daughter Julie Walker, who earned a bachelor's degree in animal science, raises tobacco and beef cattle with her husband, Henry, on their farm in Washington County. Another daughter, Elizabeth Parker, whose college degree is in ornamental horticulture, is business manager at the Deere dealership. A son, John, who graduated in agriculture technology, was a ranger for the National Park Service; he was killed in 1994 while riding an all-terrain vehicle on the farm. Daughter Nancy Brawley, who earned a master's in agricultural economics, teaches high school math in Cocke County. An unofficial member of the family is Bill Ford, the only full-time hand on the place.

"Bill's been with us for over fifteen years," said Jay. "He's dedicated, and he works hard. I wouldn't take four other people for him.

"Oh, yes," he added with a grin. "And then there's Mother. She's the paste that holds all these pages together."

A fifth generation of farming Grahams is a definite possibility. Jay and his wife, Karen, have two young sons, Lucas and Austin, who are no strangers to the business of planting, cultivating, and harvesting grain. It's all around them, for this family lives in a two-story, six-columned, nineteenth-century plantation house overlooking a broad expanse of riverbottom.

This house, listed on the state historic registry, is called Beechwood Hall. The main section dates to 1803. An addition was built in 1878. But when the Grahams bought it in 1988 and started making re-

pairs, the first question a lot of their surprised friends asked was, "When did you build that place?"

They didn't. It's just that Beechwood Hall, which sits nine hundred feet off the road, had been camouflaged for decades by a jungle of brush. One of the first steps of reclamation was to invade the grounds with chain saw and bushhog and separate generations of honeysuckle, grapevines, and weeds from the stately pecan, walnut, and maple trees lining the driveway.

The years had taken their toll on the house, as well. "There's no telling how many nights we stayed up till midnight, scraping, painting, varnishing, sanding, and getting the place straightened back up," Graham recalls.

It was time well spent. Today, Beechwood Hall is a showplace, seemingly straight off the set from *Gone with the Wind*.

But down in the fields is where the real action is. Walking the long, flat fields of Congaree and sandy loam soils, their rows of corn stretching nearly as far as the eye can see, one gets the impression this is Iowa. Except for two distinct differences. Iowa doesn't (a) have the grandeur of the Great Smoky Mountains for a backdrop or (b) produce the quality of corn.

"It's my own opinion, but I suspect it has something to do with our heat and humidity, our longer growing period, our elevation, and the quality of our soil," says Graham. "Whatever the reason is, our corn's denser, thicker, and has more color than midwestern corn. The standard weight for a bushel of corn is fifty-six pounds. Ours can run as high as sixty-two."

So why isn't east Tennessee known as the nation's corn belt?

"A lack of farmable land," he replied. "The good soils here are concentrated in very small areas. Wherever you find good topsoil in east Tennessee, you'll find *great* topsoil. Otherwise, it's plain ol' red clay. That's why so many east Tennessee farmers work a few acres here and a few acres there. If we didn't have the hills and mountains and could concentrate our soil like they do in Iowa, three men could handle two thousand acres of corn, easy."

Stewardship of this valuable earthen resource is not a mission taken lightly at Grahaven. Says Graham, "It just makes common sense. The farmer is the ultimate conservationist. You know you're gonna go right back into the same place next year and plant a crop, so you'd better take care of your soil."

One way is by no-till farming, a concept that's been around for thirty years but only has come on the scene in these parts since the early 1980s. It is just what the name implies. Instead of being repeatedly prepared with plow and disc—subjecting the soil to wind and water erosion—the ground is cut with a slit in which the seed is planted and covered in one operation. Graham practices no-till exclusively for wheat and soybeans. With corn, it runs about half and half.

"There's a corn fungus called gray leaf spot that thrives in cool soil," he explained. "With no-till, you've gotta wait until the soil is fifty-five or sixty degrees before you can plant. Even then, the fungus can survive. The only way to stop it for awhile is to plow up the field every few years and expose the soil to the sunlight."

There's an environmental tradeoff for the newer approach. Because no-till crops aren't cultivated mechanically for weed control, judicious applications of herbicides are required—"judicious" being a key word. Gone are the days when weed killers are sprayed at random. The powerful, highly concentrated herbicides available to farmers today are costly and must be applied under government regulations.

Another marked difference from the old days is the wide variety of seed available.

"Twenty years ago, folks planted just a few varieties of corn, depending on whether they were growing

Grains from the Good Earth

for grain or silage," he said. "Today, I plant twelve varieties for grain alone, and they change every two or three years. I called 'em 'racehorse' varieties 'cause that's how they take off. They're bred strictly for production. Then in a couple of years, a hot new one will come out and I switch. We're fortunate to be a test farm for Pioneer corn. We have a forty-acre plot for experiments with new varieties. Any one time, we'll have upwards of twenty-four test varieties growing."

The result of this careful management has been an explosion in corn production, as attested by plaques from the National Corn Growers Association on Graham's wall. In 1994, his farm was best in the state for no-till, non-irrigated corn—a whopping 226.5 bushels per acre—and third in conventional or "minimum" till at 201 bushels. The honors stretch farther than state borders, too. In 1989, Grahaven's per-acre yield placed third in the nation.

Nice rewards. But there's only one way to achieve them. On fifteen acres or fifteen hundred, the term "sweat equity" applies to farming on a daily basis. Except for a brief period after the final fall harvest, there's no such thing as off hours.

"About the only thing that stays constant in farming," says Graham, "is you can always look back and see where you've been."

The grain farmer's year begins in March, when ground scheduled to be tilled conventionally must be plowed. By April, it's time to plant corn and early soybeans.

"The right soil conditions can happen in forty-eight hours," he observed. "When the time comes, you can't wait."

Corn and soybeans require attention right on through May and unto June. Then it's time for the harvest of winter wheat, which had been planted the previous fall. Or perhaps harvest(s) is more appropriate. In addition to the grain itself, wheat straw has become a valuable cash crop. An all-but-worthless by-product of the combining process fifteen years ago, the straw is now baled and sold to utility companies, landscape architects, and private homeowners.

As soon as the wheat is out, more soybeans, the late variety, go into the ground. The corn should be tasseling. "This," Graham pointed out, "is when you do a lot of prayin' for rain."

As August approaches, the last of the previous year's corn will have been sold, and the bins are prepared for a new load. Graham monitors the kernel moisture closely. When it drops from 28 to 25 percent, usually in September, the first combining of his crop begins.

"There's a real demand for corn that time of year," said Graham. "All of the last year's corn is gone, and the bulk of the current harvest won't have begun. You have to dry this corn—I use dryers fired by natural gas—but you can get a premium price for it because the demand is so great."

The pace quickens with each passing day. Now's the time for sowing next summer's crop of wheat. That duty typically concludes in early October, a season Graham describes as "the sweetest time of the year. Maybe people who don't farm can't understand it. But you give me a chilly October afternoon, out there in my combine, in a big field of corn. Whew! That's almost a religious experience!"

Bushel by multiplied bushel, the golden kernels pile up in Grahaven's elevators. There is capacity for seventy-five thousand bushels onsite. Space for another ten to fifteen thousand bushels is rented at bins and elevators in town.

Where does it go from there?

"Mostly, it winds up as stock feed," he replied. "I sell some to the local co-ops, where they still bag it in fifty-pound bags. We sell a lot to individuals too, whether they're driving an eighty-foot tractor-trailer

or a pickup truck. And I've sold a bunch in five-gallon buckets for people to feed their squirrels."

By that time, several frosts will have coated the land, and late soybeans will be brittle in their shells, ready for combining. With any luck, all the crops will be in by Thanksgiving.

Says Graham: "That's when we all sit down and break bread together and say a prayer of thanks."

This is the one time of year Graham can afford to sneak away long enough to indulge his passion for hunting. The mounted heads of heavily racked whitetail bucks on the walls of Beechwood Hall attest to his skills as an archer and rifleman. He also pursues migratory waterfowl during the snowy and rainy days of midwinter, decoying flocks of mallards, black ducks, widgeons, pintails, and teal that are attracted to potholes and sloughs on the farm.

Among the many "trophies" from these excursions is a most unusual memento—a shadow box filled with pieces of a Faulk's duck call.

"Any duck hunter can understand the significance of this thing," he said with a sigh. "This was my favorite duck call, the best one I'd ever had in my life. It had a perfect pitch to it and never failed me. It fell out of the truck one morning when I was gatherin' my gear to go hunting. Before I realized it was gone, I'd backed over it. I'm tellin' you, I almost cried."

No time for extensive mourning, however. Work is excellent therapy for any loss, and there's never a shortage of it on the farm. Implements must be repaired over the winter—assuming the repairs could wait until then, which is highly unlikely.

Graham rolled his eyes at the suggestion: "Nothing every breaks when you plan for it. These things happen like Murphy's Law. You want to know how it typically goes? Like this—the motor on top of a grain elevator quits working right about the time you get a flat tire on the combine and the clutch goes out on your grain truck."

His solution?

"Jump up and down and cuss for twenty minutes," he laughed. "Then shut up and start fixin' it."

All joking side, these are not tasks to be taken lightly. There's a sharp object or overhanging wire waiting at every turn in farming, making it a most dangerous profession. Graham thanks his lucky stars that, aside from his brother's tragic accident, Grahaven has largely been spared a disaster.

"You've got to be careful and stay on your guard. I had a friend electrocuted while he was putting up silage. Bang! He was dead before he knew it. There's always a skinned knuckle or a busted finger in farming, but other than that we've really been lucky."

This man of the earth hopes his luck holds out in more ways than one. He knows farmland is dwindling all across America, and that Tennessee is no exception. Just as his forefathers were forced to find new ground, Graham feels the crunch from expanding cities and towns. This disturbing pace has quickened in recent years, as eastern Tennessee's reputation for tourism and retirement opportunities gathers national attention. Already he has been approached by developers wanting to convert the productive fields into a golf course.

"It's a vicious cycle," says Graham. "The more popular this part of the country becomes, the tougher it is to farm. The more farms that close down, the fewer markets I have for my crops. The encroachment really scares me. I love this way of life. I hope my sons will, too. But some day I suppose a decision will have to be made about pullin' up and movin' on. If and when that happens, I reckon I'll go buy myself another farm."

Grains from the Good Earth

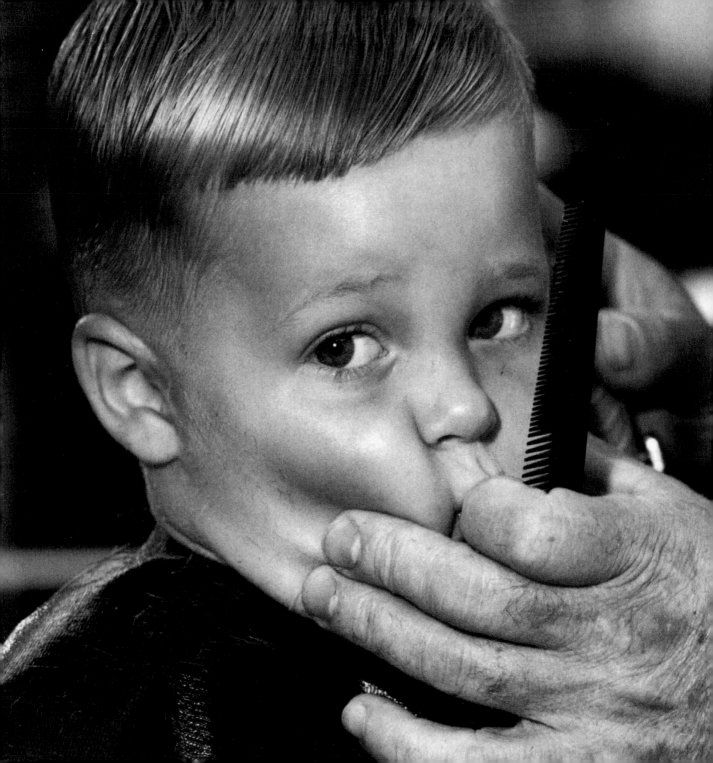

"Who's Next?"
Ronald and Bubby Turner

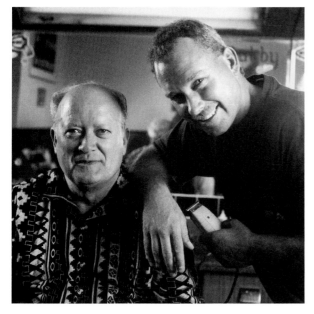

Midday Saturday in a small-town barber shop is neither the time nor the place to take a lunch break. Just ask Ronald Turner.

Even though his wife had dropped off a McBurger and fries at eleven-thirty that morning, and even though enticing aromas from the bag wafted throughout the room, and even though it was after one o'clock, and even though his belly was well into its rumbling stage, Turner knew the food would have to wait.

"It'll probably end up gettin' thrown away," he said, depositing six dollars from a customer into the drawer behind his chair. "Most of the time on Saturdays, it does. Too many folks need a hair-cuttin' for me to stop and eat."

Turner shook out the body drape he was holding, brushed a few tufts of hair off the seat cushion, and turned to the line of chairs facing him.

"Who's next?"

Turner has been saying that for nearly forty years. From 6:30 A.M. till 7:00 P.M., six days a week, fifty-two weeks a year, he cuts hair at a two-stool shop on Main Street in Wise, Virginia.

"Oh, I did take a vacation for one week a few years back," Turner recalls as his next client settles into position and makes the customary take-a-little-off-the-sides-and-top request. "Went on a cruise to the Bahamas. But other than that, I don't take off more'n a day or two a year. Can't afford to. Got too many customers."

Turner came by his trade naturally. His father, Clarence Turner, also was a barber. But cutting hair wasn't exactly what Ronald had in mind when, at age fourteen, he quit school. His sister, Ada, was married to a solider stationed at Fort Dix, New Jersey, back then. Ronald drifted north and worked a couple of years at the base commissary.

But the mountains kept calling the youngster back. By the time he was seventeen, an age when

most teenagers are barely thinking about what they "might" do for a living, Turner had graduated from the Fisherville Barber College in Staunton, Virginia, and returned to his hometown to hang out his shingle.

"A fellow named Mib Killen started this place in 1957," says Turner, hardly looking up as he sweeps with comb and clippers. "He had seen the name 'People's Styling Salon' on a shop up in Washington, D.C., and liked it. The name never has changed. I came in 1962 and then bought it in '67 when Mib decided to move.

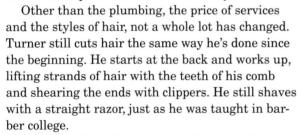

"Who's Next?"

"The goin' price for a haircut when I started was fifty cents. Back then, we also heated the hot water on a stove. A lot of the men in town would come by for a shave. Each man had his own shaving mug and brush. We kept 'em on the shelf till they'd come in."

Other than the plumbing, the price of services and the styles of hair, not a whole lot has changed. Turner still cuts hair the same way he's done since the beginning. He starts at the back and works up, lifting strands of hair with the teeth of his comb and shearing the ends with clippers. He still shaves with a straight razor, just as he was taught in barber college.

"Actually, the styles never do change a whole lot," Turner pointed out. "The same ones pretty much come and go. When I started, people got their hair cut real short or in flat tops. Then things went real long in the seventies. A lot of barbers even went out of business because of it. Now, the short styles are comin' back. I'm cutting hair today just like I did all those years ago. Same with sideburns. They keep goin' away and comin' back."

Turner has taken on a few partners through the years. But with the exception of Clifford Hampton, who worked for fifteen years, they never stay long. Most folks don't like the modest pay, let alone the fact they have to remain on their feet throughout the day. But in 1985, another barber joined the corps, and Turner couldn't have been more proud.

His own son, Ron Dewayne (everybody in town still calls him by his childhood nickname, "Bubby") set up shop in the chair beside him.

Actually, this was a complete family operation for awhile. Ronald's wife, Linda, got her license and styled women's hair for nearly a decade. She had to quit when all the standing damaged the nerves in her leg. And for two years, Bubby's wife, Melissa, also pitched in. She left to take a retail job when a Wal-Mart store opened nearby.

"Bubby still cuts women's hair, but I pretty much stick with the men," Ronald quipped. "I'm afraid of the women. They get too mad if you happen to do something they don't like with their hair. It's easier with the men. I can argue with them. Besides, you know what the men always say: The only difference between a good haircut and a bad haircut is about two weeks."

One-liners like that roll off of Ronald's and Bubby's tongues as the hair falls to the floor. It's part of the business. A barber who won't talk is a barber soon out of work. Bubby has mastered the art. He keeps the patter going all day long.

"Yes, sir!" he chuckled as a customer with receding hair settled into his chair. "I wouldn't miss this easy six dollars for nothin'!"

A few seconds later he holds out a jar of thick wax used to stiffen flat tops. "See this stuff here? The main ingredient is 'possum grease. That's what the state does with all those dead 'possums they find on the highway."

Ronald doesn't miss a lick, either, even at his own expense. "I'm not a very good advertisement for barbering," he chuckled, pointing his clippers toward the shiny, expansive real estate on top of his head. "Heck, I can't even advertise for hair tonic!"

Over at the next chair, Bubby laughed aloud.

"Don't laugh," Ronald shot back. "You're gonna be there some day, too."

"I know," Bubby replied, bending over to reveal a

bald spot at the back of his own head. "I reckon this is the only thing my daddy will ever leave me."

"You learn real quick not to take sides in anything—sports, politics, divorces, religion, what have you," Ronald noted. "You just listen and agree or disagree along with 'em. Lord knows, the customers have enough opinions on their own. Why, I've seen fights almost break out in here. It can get pretty hot around election time. And back when there'd be union troubles at the mines, you never knew what to expect. The union men would sit on one side of the room and the non-union men on the other, and they'd get t'sayin' stuff back and forth to each other."

Speaking of fights, ask about some of the less-than-enthusiastic toddlers they've worked on. Three-year-olds not accustomed to having a set of clippers whirring about their scalp have been known to punch, kick, bite, twist, squirm, and scream.

"It don't bother me one bit," says Bubby. "After all, my first customer cried. It was back when I was a kid, and I was 'practicing' on my sister, Janine. Cut all of her hair off. Man, she pitched a fit!"

Age limits do not apply in this business. Ronald remembers trimming the locks on a two-week-old baby. It was a particularly hot summer, and the child had been born with a full head of hair. Mama thought getting rid of the mat might keep her youngster cooler and make him less fussy. It worked.

There's also plenty of work on the other end of the age spectrum. Ronald's first customer back in 1962 was Dicky Prater. That's the same Dicky Prater who still comes in every couple of weeks. Indeed, many of the Ronald's customers are well into their nineties and have been using his services since he started the trade. One of them, ninety-six-year-old D. P. Davis, the first football coach at nearby J. J. Kelly High School, still drives himself to the shop for his every-other-week trim. The rich and famous have been among his clients, as well, including former Virginia congressman William Wampler, and Carroll Dale, former wide receiver for the Green Bay Packers.

The need for a haircut doesn't even stop at death. Ronald often visits local mortuaries to clip one of the dear-departed before the family receives friends.

"That's the kind of job you'd better not mess up," he says with a wink. "You don't get but one crack at it. There's not much of a chance their hair'll grow back."

Yes, the Turners admit, sometimes they do err. All barbers do on occasion. A gap here, a nick there. But that's where skill and experience come in to play. With a bit of deft trimming and clipper work, the mistake can be erased just as easily as an artist might eliminate an unwanted line in a sketch. As Bubby says with a laugh, "Most of the heads we see look so bad, you can't hurt 'em with scissors and clippers. It only helps!"

"But folks find out pretty quick it's not all that easy," Ronald added. "Plenty of times people come in here and admit they messed up tryin' to cut their own hair. They want me to fix it. They were figurin' to save money by cuttin' it at home. Doesn't take long to learn it's a lot easier just to pay somebody else to do the job."

With more than half a century of combined barbering experience, the Turners figure there's nothing they haven't seen. Like the time a tipsy customer threw off the drape and staggered from the chair just as Ronald began splashing bay rum tonic onto his head. "Don't waste that stuff on my hair!" he shouted, wrenching the bottle from Ronald's grip and chug-a-lugging the entire contents.

Or the time a customer with a well-appointed toupee plopped into the chair and admonished Bubby in a whisper, "Stick with the real hair. Watch out for the synthetic."

Or the backwoods characters who come to town for a haircut once every three or four years—whether they need it or not.

Or the two families with five boys each who used

233

"Who's Next?"

to invade the shop on alternate Saturdays. "We had people sittin' in each other's laps," Ronald sighed.

Sometimes, though, the sideshow takes place outside. The Turners' shop is just across Main Street from the Wise County Court House. It's not unusual to look out the front window and watch divorcing couples square off and take matters into their own hands. And once, a prisoner broke from custody and made his bid for freedom just as Bubby started to work on a customer. Bubby dropped his clippers, ran outside, tripped the convict, and held him until deputies arrived.

234

"Who's Next?"

"That's one thing I love about this business," Ronald said. "You never know what's going to happen. Every day's always different."

Well, almost. . . .

It was now quitting time. Ronald swept up the mounds of hair that had gathered at his feet througout the long day. He rotated the sign in the window from "Open" to "Closed." He flipped off the light, locked the door, and walked down Main Street toward his car.

Over on the counter, still sealed in the bag, his McBurger and fries remained uneaten.

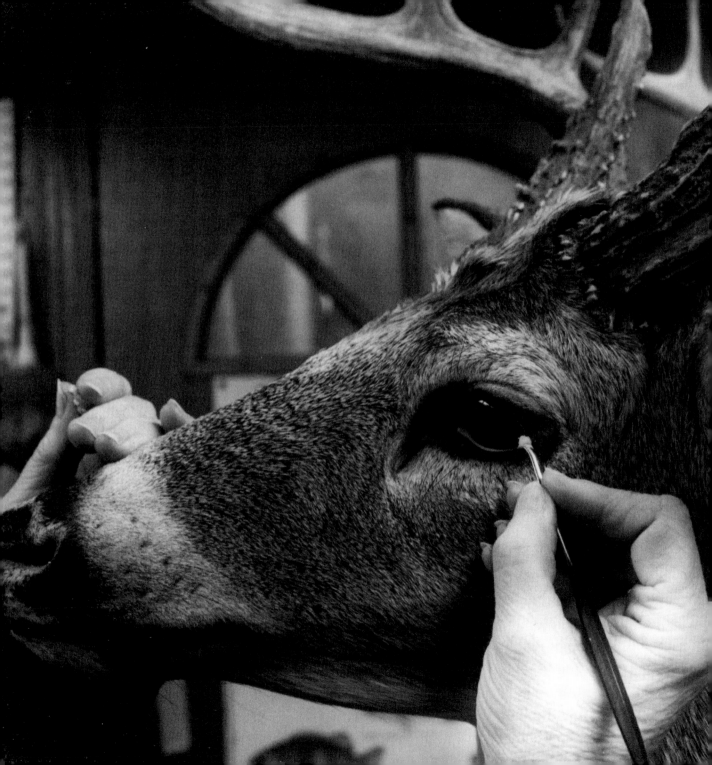

A Beauty Shop for Bucks, Ducks, and Bass

Sylvia Singleton

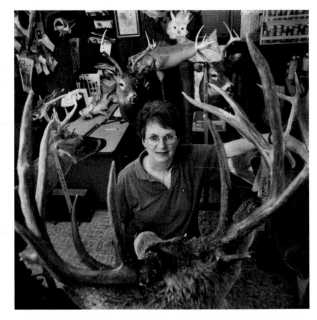

There are ancillary benefits and tradeoffs to every line of work.

A tailor, for example, has decided advantages over, say, a bricklayer, should either accidentally rip his pants on the job, whereas the bricklayer would probably be more skilled for a do-it-yourself home project like construction of a barbecue pit. A projectionist down at the local theater gets to see the latest hit movies without having to stand in line or sit in a chair laced with cola syrup and popcorn kernels; then again, after hundreds of performances, even one more episode of *Forrest Gump* may well be maddening. Airline pilots and flight attendants can while away their off hours—on expense accounts, no less—in tourist meccas that are to die for. And newspaper sportswriters, even though they won't admit it, have been known to thoroughly enjoy watching the home team perform from their bird's-eye vantage, high above a sold-out athletic event.

Sylvia Singleton understands this occupational concept completely. In her line of work, it's called having your bass and eating it, too.

"It was early one spring, and I hadn't had a chance to get to the lake," she explained. "My husband and I had just been talkin' about hankerin' for some fresh fish when the door opened up and in walked a customer carryin' a six-pound largemouth bass. Let me tell you, that thing was *fresh*. It was still floppin'. I wrote up the man's order and thanked him for the business. Soon as he left, I looked down at that bass and said, 'Supper!' I grabbed my skinnin' knife and peeled out the meat, stuck the skin in the freezer and headed to the house. It was delicious."

Singleton draws the line on questionable specimens, and she doesn't need a bar-coded supermarket expiration date for guidance: "I only eat what's fresh. I'm not takin' any chances on somethin' that's

been sittin' in somebody's freezer for twelve months. That's strictly workin' material."

Highly skilled work, for sure. In Singleton's hands, the trophies from southern Appalachian hunting and fishing trips all but spring back to life. She's a taxidermist, practicing her craft every day in a small shop in the rugged outback of Hawkins County, Tennessee. With the grandeur of Stone Mountain as a backdrop and babbling Poor Valley Creek in the foreground, this place is special to Singleton.

*A
Beauty
Shop for
Bucks,
Ducks,
and
Bass*

It's more than just a business location. It's home. Real home. The kind you are born to and never leave.

"This land looks a lot different than when I was growin' up," she says, nodding toward the lush pastures that climb toward the steep, forested ridges. "My daddy was a dirt farmer. He raised tobacco, along with a little corn and hay. I don't believe he ever had a public job in his entire life. But nobody did back then. They all just grew tobacco and tried to scratch out a livin' in these hills. It was a tough time. There was never much money. We were poor as Job's turkey."

A grin creased Singleton's face as the irony of the reflection evolved in her mind. "How 'bout that," she spoke. "Now, I could stuff Job's turkey!"

But taxidermy was the farthest thought from Sylvia Henard's mind in 1961, when, after two years and two days at Rogersville High School, she dropped out. She married Billy Singleton, a Missionary Baptist preacher, and they set to raising a family. Four sons—Reagan, Landon, Chris, and Jason—came along in stairstep fashion, initially neutering any plans she might have of work outside the home.

"I managed to take some cosmetology courses and started to work as a hairdresser," she said, "but with four youngin's, it was hard to work a steady job for any length of time. Mostly, I just filled in for other hairdressers when they went on vacation. I really didn't think about a full-time job till Jason got in school. Billy'd had a heart attack by then, and he wasn't preachin' full time. We decided to build a beauty shop here at the house. I still had my cosmetology license and started lookin' around for some more classes to take to bring myself up to date."

That's when she opened a catalog from Walters State Community College and saw taxidermy offered as a vocational course, taught by regional expert Alfred Goins. It triggered a response from long ago.

"I grew up hunting with Daddy," said Singleton. "There wasn't any deer or turkeys around back then, just rabbits and squirrels. Billy started huntin,' and then the boys did, too. So I joined in. We didn't do much good the first few years. Then Landon killed his first buck. We wanted to get it mounted for him, but it cost $125, and we simply couldn't afford it. We just cut off the antlers and put 'em on a board for him. I remember at the time how bad he wanted to get it done up right and how much I wished we could make it happen. Soon as I saw that course on taxidermy, I knew it was for me."

As it turned out, this woman's touch was perfect in a typically all-male world. Especially a woman already trained in the art of beauty culture.

"I took two years of instruction from Alfred Goins, a basic course and the advanced," said Singleton. "Later, he told me he could always pick out my stuff in class because there was such an attention to detail. It's not just me, though. 'Bout everybody I talk to in this business says they can tell a woman's work from a man's. Makes sense, I reckon; we know what it takes to make a face look pretty."

In 1985, the first year Singleton hung out her shingle, she took in the grand sum of seven deer. But word of her skills soon spread. By the next season, her workload had increased five-fold. Currently, she averages around 150 deer a year, plus 50 to 75 fish, a dozen wild turkeys, not to mention foxes, raccoons, squirrels, as well as elk, wolves,

and other animals from her customers' faraway ventures. And yet, the most she's ever done to advertise is print business cards and put up a sign in her front yard.

"Actually, I don't know if I could handle much more," she said. "It's all I can do right now to get the last of one season's deer finished before a new season begins. You oughta see this place on opening day, or else on Thanksgiving Day. Once, there was fourteen deer laid out by the shop. Billy and I laid into skinnin' and finally had 'em done by dark."

It's not so much the labor intensity of the situation that requires attention on crowded days, it's also the attendant stories. Everybody who walks into a taxidermy studio has a tale to tell, and in Sylvia Singleton they have an attentive audience.

"In this business, you don't hear so much about the big one that got away. Elsewise, they wouldn't be comin' in here with a deer or a fish for me to mount," she said. "What I hear are the success stories. I love 'em, and I love to swap tales, too. My brother kids me about it. He says I talk too much. Shucks, that's the fun of this type of work. A little kid's four-inch bluegill is just as important as somebody else's five-pound bass. I want 'em to tell me about it. If I ever had to give up hearin' and tellin' stories, I might as well give up taxidermy."

For instance: A hunter showed up one morning with a big buck, fresh from the woods. Well, *almost* from the woods.

"He'd just gotten out of his car and was unloading his gear. He hadn't even gotten started to his tree stand when this buck stepped out in front of him," said Singleton. "One shot, and he was headed to my place.

"Another fellow, who lives way out in the country, didn't even get that far. He was startin' to go huntin' one day, when he looked out the back window, and there stood a deer. You know, there's not too many people who can show you a deer head on a wall in a room in their house and honestly tell you that's where they shot it from!"

The history of taxidermy, in the crude forms of dried skins, horns, and bones, can be traced back for thousands of years. It didn't become a serious endeavor, however, until tanning methods were perfected in the eighteenth century, and then only as an exercise practiced for the nobility. Even well into the twentieth century it remained quite elementary—as witness the stiff, lifeless specimens displayed in many museums, homes, and sporting clubs through the 1950s. The craft has been refined in more recent years with the development of synthetic materials (flexible artificial fish fins, for example), but it basically remains a process of hide skinning and tanning, all orchestrated by an artist's touch.

On a deer, for example, Singleton measures the circumference of the neck and the distance from nose to eyes to find the proper size form to use as the basis for the mount. This form, constructed of dense plastic foam and ordered from a taxidermy supply house, will dictate the overall shape of the finished product.

Next, she makes a Y-shaped incision at the rear of the antlers and proceeds several inches down the back of the neck. Then she begins to separate the remainder of the skin from the skull and neck, paying particular attention to the ears, eyes, and nose. After that, the antlers are sawed off, along with a small piece of skull tissue, and attached to the form.

Next, the hide is scraped of all bits of flesh and salted to remove excess moisture. Then it goes into two solutions—first a pickling mixture to kill bacteria, later a tanning compound to preserve the skin. The hide is then fitted onto the form, much like stretching a wet sock across a darning egg, and the incision closed with stitching.

239

A Beauty Shop for Bucks, Ducks, and Bass

A finished product? Not by a long shot. This is where the close work begins.

The lips must be tucked back into a lifelike position. The area around the eyes and tear ducts is sealed with epoxy. Short, well-aimed bursts of paint from an air brush are directed to the nose and around the eyes. And the hair is brushed into place.

"Just like a woman in a beauty shop," Singleton deadpanned as she stepped back to look at her latest creation. "Except these customers never have much to say."

Although she can rush an order if a birthday gift is pending, Singleton prefers to allow several months, start to finish, on any project. If not, it might not dry properly between stages, an error that can spell ruination later on.

"Sometimes people get anxious and want to see what their deer or fish looks like as it's being worked on. I really don't mind, but I do discourage them from coming because it's never goin' to look like much until it's done. That's especially true with a fish. After it dries and before I paint it back to the original colors, it'll be all washed out and faded—sorta like we women look when we first get out of bed in the morning!"

When the job is done, however, the result is a colorful, lifelike representation of the original subject.

"If an animal is mounted properly and cared for, it'll last forever," she said. "All it needs is occasional dusting and maybe a light coat of baby oil every now and then to add shine to the hair or fur. It shouldn't be kept in a place that's damp, of course, because it can mildew. And never, ever hang it over a fireplace! I know that's supposed to be a traditional place to put a deer head or a fish, but it's wrong. Too hot and dry. It'll crack all to pieces."

Even if that happens, all is not lost. Given her years of experience, plus annual refresher courses at Piedmont Community College in Roxboro, North Carolina, Singleton has become quite proficient in restorations. One example is a seven-pound walleye mounted by another taxidermist more than twenty years earlier. It had belonged to the father of one of her regular customers. When the man died, his son brought the dust-covered, cracked, broken-fin fish in for review. It went back to him as fresh and colorful as the day it came from the water.

"You learn all kinds of little tricks along the way," Singleton noted. "On that walleye, I used pieces of round toothpicks to recreate spines in the dorsal fin. They worked perfect."

Don't get the idea she stays cooped up in the shop *all* the time. Singleton and her entire family spend a good portion of every fall in the woods themselves. They usually account for around a dozen deer, which, as Billy notes, "sure does keep our meat bill low. We cook it all kinds of ways. The first one of the year, we try to barbecue whole. But Sylvia's real specialty with deer meat is fryin' it with onions."

Once again, those ancillary benefits and tradeoffs arise.

Being in the woods affords this artisan an opportunity to find stumps, odd-shaped pieces of wood, rocks, and other materials to include with her mounts. Unfortunately, such a discovery usually signals the end of the hunt.

"When I find a piece of wood I like, I know I'd better take it in right then," she said. "Otherwise, I'll forget where it was. You can't ever go back and find it once you walk away."

Singleton acknowledges that her line of work might not appeal to all people. Some folks simply don't care for dead animals hanging in their house. Others take it further. She recalled one taxidermy show that was picketed by animal rights demonstrators.

"It may get worse in the future," she said. "You

never know about these things. But I reckon it depends on how you were raised. I always looked at animals as a gift from God for us to use. When I mount a deer or a duck or a fish, I think about it as using the animal thoroughly, like folks did in the old days. It has provided food and then stays on as a beautiful, permanent reminder of the trip. I don't have a problem with that."

241

A Beauty Shop for Bucks, Ducks, and Bass

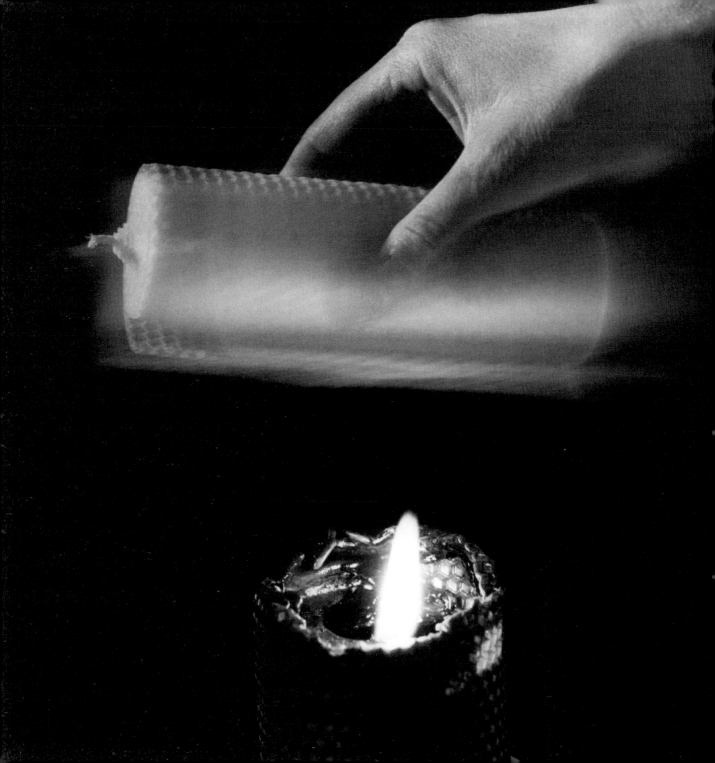

The Simple Life

Kim Corbett

I f everyone lit just one little candle, the world would definitely be a brighter place. But that sure would throw a wrench in Kim Corbett's plans.

A madhouse run on candles at this stage of the game would mean more nights at the workbench, more sales calls, more miles on the road, more time away from her son, and more stress. Thanks, but no thanks.

The only "more" she wants right now is "more simple."

Corbett has seen her share of bright lights, big city. She's quite content to leave them both behind.

These days, her idea of utopia is a small house, nestled in the woods, on a dead-end road just outside of tiny Burnsville, North Carolina.

"If I put more effort into my business, I could be making a lot more money," says Corbett. "But it's not all about money any more."

The barons of Wall Street may recoil at such heresy, but Corbett couldn't care less. She makes no apology for her decision to adopt a Waldenesque life-style. Nor does she need to, for she has paid her dues in the hostile badlands of steel and concrete. Out here in the country is where she wants to be, along with her toddler son, Ryan.

Why did she make the switch?

"None of Your Beeswax!"

Please don't take offense. That's not a clipped reply to the question. It's simply the name of Corbett's business. As far as she's concerned, there couldn't be a better place in all of southern Appalachia to make and sell old-time beeswax candles .

There couldn't be a better name, either.

None of Your Beeswax! is cute, catchy, rolls easily off the tongue, is simple to remember, and wraps up the story of this enterprise in four short words. So forgive her this one throwback to the world of traditional commerce. Corbett just couldn't help herself. It was her marketing mind at work. Some things can't be denied.

Even though she is now firmly entrenched in the

heartland of the Blue Ridge, Corbett grew up far away from the mountains. She was raised near Milwaukee. What's more, her early life was a rifle-shot removed from the highlands.

Shortly after she graduated from high school in 1987, Corbett left Wisconsin and moved to Savannah, Georgia, where she found a job as buyer for a hospital. It wasn't long before she had worked herself into a highly specialized field as inventory buyer for the operating room.

"I worked closely with the head nurse and the surgeons," she recalled. "If they needed a certain instrument or piece of equipment, I'd do all the research and buy it for them. A lot of this was capital equipment—lasers and anesthesia machines costing thousands and thousands of dollars."

That experience led to a move to Orlando, Florida, where she worked for a pharmaceutical company, selling home health services to physicians' groups and large managed-care companies. Her success took her deeper into corporate circles. She wound up in Hickory, North Carolina, in advertising sales.

"It was a full range of advertising," she said. "Newspapers, radio, television, billboards, whatever the client needed.

"I was in the typical rat race. I was making a lot of money and spending it foolishly. It's a rut. The more you make, the more you spend. I wanted something different. I wanted to go back in time, toward self-sufficiency."

The first order of business was economic detoxification, a process the originator of the Walden mentality understood quite well. "Our life is frittered away by detail," Henry David Thoreau wrote in 1854. "Simplify. Simplify."

"It's amazing what you can do without once you give it a try," says Corbett. "I went from a brand-new Saab to an eight-hundred-dollar 1988 Ford with no air conditioning. It can get a little uncom-

fortable when the summer weather really turns nasty, but it's nothing I can't handle."

Quite a relative term, that word "uncomfortable."

When Corbett thinks back to her years in business, "uncomfortable" conjures up memories of stylish suits, high heels, makeup, and panty hose. None of that for her now. Shorts, an old shirt, and a pair of sandals will do just fine.

As for those other items of feminine necessity in the city?

"Strictly for weddings and funerals," Corbett laughed. "That's about the only time you'll catch me in panty hose and makeup anymore.

"Seriously, you don't know the times, back when I was in sales, that I'd be driving around town, going from one appointment to another, and I'd pass a construction site and see a bunch of guys working. I'd say to myself, 'Now, *that's* what I wish I could be doing!'"

The bills still have to be paid these days, of course. It's just that there aren't near as many of them as there used to be. To augment her candle-making operation, Corbett dabbles in marketing and sales on a freelance basis. This time, however, she does it on her terms, from her house.

"Ten years ago, I could never have imagined myself as a single mom," she says. "But I like it. It's actually less stressful now than before. I'm fortunate to live in an area with like-minded people. Our children are certainly the focal point of our lives, but the women here are still individuals, too. We're finding something within ourselves that we like to do. There's a lot of home schooling in this area. There are a lot of people interested in eating organic foods. That's why I picked this area to raise my son."

Corbett can set her own production pace for much of the year, but between late September and Christmas, it's crunch time. This is when she's most likely to be found in the back room of her house,

patiently turning sheets of beeswax into decorative yet practical candles.

She learned the craft from Brenda Furnell, a nurse with the Mitchell County Health Department. Furnell had been making candles for years but decided to close her operation. Corbett bought her inventory of raw stock and started her own production.

"All of these are pure beeswax," she noted. "That's important to know. If people look closely on the label of some 'beeswax' candles, they'll find they might be as much as 75 percent paraffin, which is a petroleum by-product.

"I like pure beeswax because it's not toxic. It creates a superior candle that burns with almost no smoke and doesn't have an offensive odor. There's a faint honey aroma to beeswax candles, but they aren't artificially scented like some commercial candles. A lot of people are allergic to that."

The use of candles for illumination is virtually as old as humanity itself. In pioneer America, candle production was just another household chore, usually practiced by the women. Often they were made from tallow rendered from the fat of cattle or sheep, with the wicks fashioned from strands of yarn or cloth. Beeswax also served as a favorite medium, thanks in no small part to the popularity of beekeeping.

The wax itself oozes from tiny glands on the undersides of worker bees. It's the building material for honeycomb, in which eggs are laid, young bees are raised, and honey is stored. The wax is commercially extracted by boiling honeycomb in water and skimming the residue from the surface. It is then filtered, colored with organic dyes, and pressed into thin sheets, mottled with the traditional honeycomb design. Corbett buys her wax sheets from two supply houses, one in New York, the other in Minnesota.

"I can get deliveries right here to the house, but there's only a certain time for it," Corbett said. "If the weather's too cold, the wax gets brittle and breaks. If it's too hot, it'll melt like butter."

Her candles are rolled, not hot-dipped in molten wax. It's a process better watched than practiced. Especially by those with shaky hands.

Working on a Formica-surfaced table, Corbett lays a precut wick along the edge of a wax sheet that has been warmed with a blow dryer or a candle to make it more pliable. Then slowly, carefully, she rolls it, tighter and tighter, larger and larger, until the trailing edge is securely pressed in place with her fingertips. A square sheet of wax will suffice for a flat-topped candle. For a taper, however, she must begin with a sheet that has been sliced at an angle.

Be not fooled by the apparent ease of this exercise.

"I had to make several hundred before I finally got the knack," she said. "You have to keep them wound tightly or else they won't burn evenly. You also have to keep the edges in perfect alignment."

Corbett makes twelve styles, from stubby votives barely two inches tall all the way up to traditional dinner tapers and pillars that can range as long as twelve inches. Some have individual wicks; other remain joined with a common, decorative wick. The colors span a broad rainbow, from green to blue to rose, purple, red, teal, natural—even black.

Although the practical need for candles virtually ceased with the spread of electricity, the demand for them remains high. Soft, warm candlelight is still the mainstay for festive occasions ranging from romantic dinners to holiday celebrations. And it doesn't hurt to keep a few handy in case the power goes off.

"I've also found a lot of people are using candles these days as a host gift or house-warming present," said Corbett. "Instead of buying wine or flowers, they bring candles. It's a nice gesture of friendship."

Corbett does some direct retailing at craft shows and festivals, but the bulk of her sales are through galleries and a network of potters who include her candles with their works. Mail order is available,

subject to temperature. The one avenue she hasn't tried, however, is the Internet.

"One of my old friends at the ad agency wants to create a web site for me, but thus far I have resisted," she said. "I can barely keep up with the orders I have now. Maybe that's something to think about later on."

High-tech possibilities notwithstanding, Corbett has discovered a distinct bonus about her craft.

"My hands can get very rough out here in the country," she says. "Dirt has a way of doing that. But then I sit down and start handling this beeswax, and it's like I'm working in hand lotion. By the end of the day, they're soft and smooth once again."

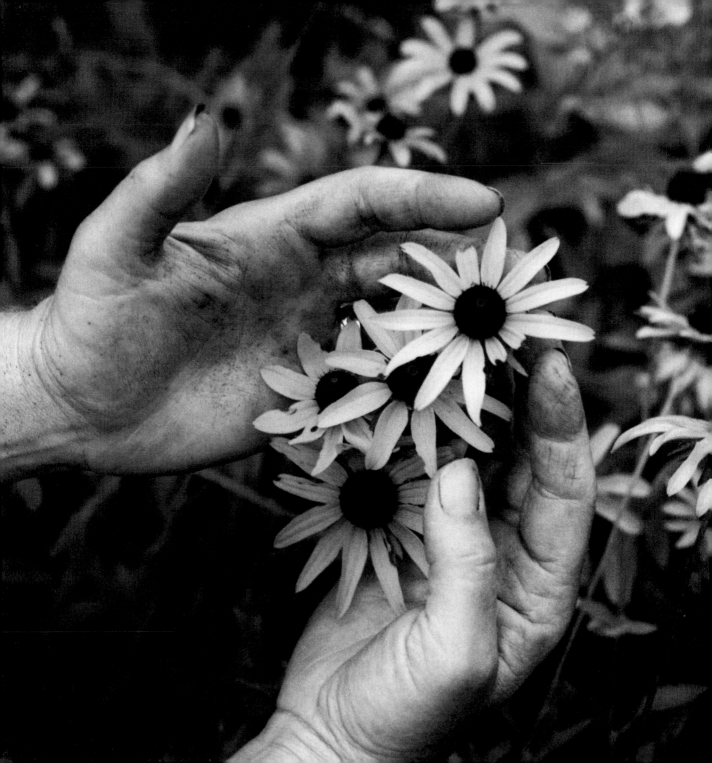

The Seeds of Success
Meredith and Ed Clebsch

Meredith Clebsch held the seed pod of a wild bleeding heart plant between the thumb and forefinger of her left hand. Using the edge of her right thumbnail like a knife, she deftly cut a slit down the center of the sac. A gentle squeeze later, out popped twenty to thirty round, black seeds, not much larger than the dot over lowercase i's in this text.

Clebsch cupped the tiny spheres in the palm of one hand. "Notice the thin white tissue on each seed," she said. "That's called an aril. It's a fatty substance that protects the seed. If it dries out, the seed goes dormant. If it stays moist, the seed 'knows' all is well for germination. In the wild, ants and other insects eat the aril, but they also carry the seeds into the leaf litter on the forest floor where they can germinate."

The seeds Clebsch was holding will eventually find their way into leaf litter, too. But instead of being scattered on the forest floor at the whim of Mother Nature, these will be planted in one of the wood-frame nursery beds lying nearby under a canopy of oaks and pines. Eventually, they will be producing seeds of their own.

"This process is not quite like growing a crop of corn," Clebsch said with a smile. "It takes a little longer."

True. But as fanciers of wild flowers all over the United States will attest, the wait is worth it. They know the end result will be healthy stock, ready for replanting, that was raised in a nursery environment, not snatched from the wild. Which is precisely the reason why Meredith and Ed Clebsch founded Native Gardens on fifteen acres of rolling, partially wooded farmland near Greenback, Tennessee.

A widely respected professor of botany at the University of Tennessee, Ed Clebsch knew all too well that many commercial wild flowers—whether purchased through a mail-order house or from a

kindly grandmother-type at a roadside plant sale—had been dug from the soil on some remote mountain or valley and brought to market.

"We wanted to change that concept," he said.

This truly was an idea whose time had come. For years, Clebsch had been dreaming about starting a commercial operation to propagate wild flowers. Little did he realize that a student in one of his classes shared the same goal. Their friendship and mutual interests blossomed. In 1984, Ed and Meredith married.

Their search for a suitable location carried them to the site of a one-time sweet potato farm well on its way to being reclaimed by nature. The house on the property was one hundred years old and showed it. The real estate agent hadn't even listed the tract in nearly a year.

Perfect. They bought it immediately.

Not much about the house has changed in the ensuing years. The front porch, shaded by several large sugar maples, is still the perfect place to sit and talk, meditate, read, or snooze in the cool of a summer evening. As Ed noted, comfortably rocking with his feet on the weathered railing, "The thirty-two-mile commute to UT doesn't mean a thing when I'm out here on this porch."

The grounds themselves have been turned into a living tribute to the concept of landscaping with wild flowers. The front yard is lush with river oats, wild ginger, lady fern, celandine poppy, jack-in-the-pulpit, and Virginia bluebells, to name but a few. To the side are more sun-tolerant varieties like garden phlox, Carolina bush pea, thin-leafed coneflower, Indian pinks, climbing aster, black-eyed Susan, sweet pepper bush, and winterberry, plus Dutchman's pipe vine climbing along the porch. Bordering the house, the trained eye can spot favorites such as columbine, royal fern, sweet shrub, green dragon, touch-me-not, lizard tail, and Alabama snow wreath.

Clearly, this is not a typical yard from suburban America, where petunias prevail and a green carpet of Kentucky 31 is clipped like a GI haircut. The Clebsches wouldn't have it any other way. Neither would a growing number of homeowners throughout the United States who are returning to native plants for their natural beauty and the habitat they provide for birds and butterflies.

"At one time, wild flowers had somewhat of a cult following, mainly of older women," Meredith explained. "They always had a wild-flower bed with some unique specimens they or their husbands had dug from the wild. But the idea of actively landscaping with native plants was new."

One challenge, obviously, was to educate the public. Ever the teacher, Ed still leads wild-flower tours and other botanical field trips throughout the region, including the long-running Gatlinburg Wildflower Pilgrimage and the Smoky Mountain Field School's winter field botany course. Three to four times a year, he and Meredith sponsor wild-flower propagation workshops.

Regulators have required some education, as well. Only in 1995 did the Federal Trade Commission finally recommend that plants collected in the wild be identified as such before they can be sold. According to the new proposal, the words "nursery grown" can apply only to plants that were propagated under nursery conditions, not dug from the wild and held in a bed for one season.

Another dose of education was required for the Clebsches themselves.

"We just pretty much 'went into business,'" Ed says with a laugh. "I remember the dean of our business school asked me what sort of market research I had done. I said, 'Excuse me?'"

But even if the dollars-and-cents aspects of this operation would have to be learned on the run, the botanical side was well-rooted. Armed with their own technical expertise, plus valuable tips from friends in the New England Wildflower Society and

the North Carolina Botanical Garden, the two leaped into their new venture—though "leap" in terms of wild-flower propagation is more than a bit too strong.

"It took us three years to produce even a few salable-sized plants from seed," Meredith said.

But just as the mighty oak grows from a tiny acorn, so has their business flourished in the oft-treacherous jungle of commerce. Today, Native Gardens offers more than two hundred varieties of native wild flowers, grasses, shrubs, and trees. A mail order list goes to ten thousand customers each year. There is an active wholesale market. Retail shoppers may purchase plants at various sales and exhibitions the Clebsches attend each spring, and also at selected open house dates. As they say in the South, this enterprise is growing like kudzu.

"I want to stay relatively small and concentrate on the harder-to-grow plants," Meredith said. "Wild flowers have grown so popular, there are some spring perennials that you can now buy at the larger commercial greenhouses. That's not our niche. We won't ever be mass-producing."

This is a slow, labor-intensive operation, sometimes demanding fifteen hours at a stretch. With the help of three assistants (and Ed, now that he has "officially" retired from the university), Meredith still gathers seed, divides existing plants, or makes cuttings to root new growth. Sometimes, it truly is a sit-and-wait proposition—or, as Ed describes it: "By gosh and by golly."

"You've got to be there every day and know what to look for," Meredith explained, holding a fire pink seed pod. "When this thing is mature, it will begin to droop. The color changes from green to tan, brown, or black."

The pods are emptied, one at a time, and the process of mimicking nature begins in earnest. With some species, such as fire pink, the seeds need to dry. Meredith accomplishes this feat in special cellulose-based dehydration units, otherwise known as brown grocery bags. On the other hand, seeds from, say, bleeding heart and trillium must remain moist. They are sealed in plastic. To "overwinter" they spend time in the refrigerator.

"When I'm gathering seed from the wild, I never take more than a third," she stressed. "I always want to leave plenty to assure natural propagation onsite."

Even an exercise so innocent as seed gathering has its risks. Meredith can laugh now about the time an irate neighbor wanted to know what the blue blazes she was doing in a patch of bluebells on his property.

"He thought he'd caught a poacher," she said. "He thought I was digging them up. I finally got him to understand all I wanted was some seed. Then he invited me back!"

The seeds are scattered in nursery beds, covered with leaves (just as would occur naturally), and left on their own. This can prove hazardous—like the time voles burrowed beneath one of her woodland nursery beds and devoured two thousand tender young bluebells, wiping out three years' worth of effort.

"That taught us to line the bottom of the beds with hardware cloth," she noted.

As the plants grow, they are individually potted and set out in cold frames to mature to market size. Their schedules vary immensely. Quick growers, such as columbine and celandine poppy, can be planted in January and be in full bloom by spring. More often, though, the clock ticks slowly. Maple-leaf viburnum, ginseng, jack-in-the-pulpit, and blood-root will call Native Gardens their home for as long as three to seven years before they are developed enough to withstand the rigors of transplanting.

"Fortunately, our well is on a good aquifer," said Ed. "We've never had a shortage of water. If we had to rely on city water for this operation, we'd go broke."

Propagation by cutting can be equally tedious. Tiny pieces must be scissored from existing plants,

dipped into a hormone solution to spark root growth, and potted. When Meredith started this phase of the venture, she discovered there was precious little reference material on the process as far as herbaceous plants were concerned. Once again, "by gosh and by golly," she discovered the key was to use a water-based solution, not the alcohol-based substance advised for woody plants.

Division is just what the name implies: One large, mature plant with a full crown and well-developed root system is gently split into two or more smaller units. This process works particularly well for native grasses. The basic rule of thumb here, Meredith claims, is to divide spring bloomers in the fall and vice versa.

Propagation by seed and cuttings has given Native Gardens its first unique variety of wild flower, the "Tellico fire pink." It began quite by accident more than ten years earlier when Meredith, inspecting a bed of fire pinks that had been started from wild seed, spotted a truly pink flower among the stems. This was a stark contrast to the cardinal red hue that characterizes the species. She isolated the plant. Its seeds were sown in a separate area, and the resulting flowers were further isolated from other fire pinks to avoid cross-pollination.

"The first year, I got one pink plant," she said.

Again, she concentrated the genes, using only the seeds from that particular flower. In addition to many red plants, these produced a trio of pinks. Through painstaking seed collection and judicious cutting, she perfected the new line and named it Tellico after a nearby mountain river.

Despite an ever-building inventory of species, year in and year out the spring wild flowers (columbine, bleeding heart, and bloodroot chief among them) have proven most popular with customers. Two requests the Clebsches haven't yet satisfied, however, are for trillium and lady's slipper. Beds of trillium are in the works—it's a seven-year process—but lovers of lady's slipper will have to wait longer.

"We simply haven't had luck in propagating them," said Meredith.

"It's purely speculation on my part, but I believe it has something to do with local strains of fungus that are associated with the roots," added Ed. "If you move the plant from its original site, it just doesn't seem to flourish, no matter how much soil you take with it."

Did he say "move" a plant?

Yes, the Clebsches do extract some plants from nature, but with clear consciences and official permission. They participate in the rescue opportunities that come up when a stand of a wild flowers finds itself in the path of construction, or destruction, as the case may be. Their most recent recovery work took place on the site of Interstate 181 between Asheville, North Carolina, and Johnson City, Tennessee. Many of the plants for the Tennessee Aquarium in Chattanooga were procured this way.

"I'm optimistic this process can be used more and more in the future," said Ed. "Many state highway departments now have a botanist or biologist on staff. If this person can let others know when an area is going to be disturbed, a lot of native plants can be saved."

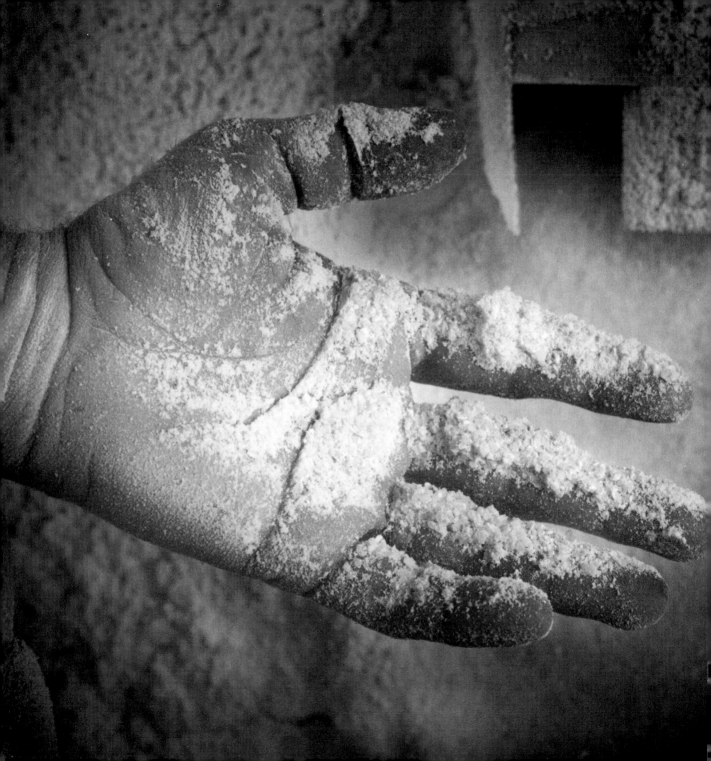

True Grits

George and Cecilia Holland

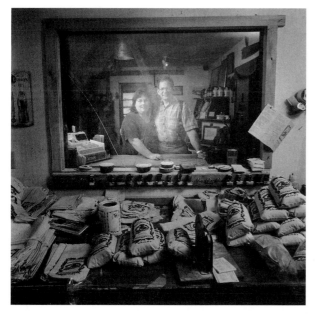

George Holland has been on the job for less than half an hour, but already he has aged a good twenty years. One glance at his face tells the story: His sideburns and eyebrows, dark and shiny only moments before, are now frosted thicker than cornstalks on Thanksgiving morning. Indeed, his entire body is powdered white.

But this rapid aging process can be reversed just as quickly. All Holland has to do is flip the off-switch on the Meadows grain mill that is rumbling beside him. As its twenty-inch grinding stone rotates slower and slower, he gently shakes his head, pats his cheeks, and wipes his hands on the front of his pants.

Well, whadaya know—it's the original George Holland again.

"You learn to wear a lot of beige colors in this business," he says, gesturing toward his clothing. "You don't find too many millers dressed in brown and black."

Nor miller's wives, either. At the counter up front, Cecilia Holland also is clad in light tones. It's strictly a matter of practicality, she points out. In a place like this, flour has a way of jumping out at you from every direction.

Welcome to Logan Turnpike Mill, headquarters in this section of north Georgia for grits, cornmeal, wheat flour, pancake mixes, waffle mixes, muffin mixes, and other makin's of good things to eat. This place is as authentic and old-time as it gets. Other than the merchandise on the shelves and an occasional cat on mouse patrol, the forty-something Hollands are the youngest things you'll find under the tin roof.

That Meadows mill George was just running? It's from 1952. Nearby sits another Meadows mill, this one with thirty-inch stones, that dates to the 1920s. Over to the left is a Gump bagging machine, still sporting its 1910 patent plate. Also a balance scale, circa 1930. As well as an 1898 sausage machine for

churning flour mixes. Not to mention a 1917 Williams mill, powered by a six-horse, Fairbanks-Morse engine—a "one-lunger" in millerspeak—that sees regular duty at county fairs. There's also a Perkerson mill out back that George hopes to have up and running some day soon. It's a Civil War–era mill that, with a bit of dressing, could be grinding meal just as effectively for Yankee tourists today as it did back when folks clad in blue weren't the least bit welcome around these parts.

"I did go modern a couple of years ago and buy a tipper-tie machine," George admits. "It runs off an air compressor and wraps wire around the top of each bag. Twisting them by hand was giving me carpal tunnel syndrome somethin' awful."

North Georgia is about as much "home" as George Holland can claim. His father was an air force chaplain, hop-scotching his family from Guam, Germany, and Korea to Georgia, Colorado, and New York.

"My last three years in high school were in three different states," he recalled.

Yet his roots are deeply planted in Georgia clay. Both of his grandfathers, Harvey Holland and Claude Haynes, were circuit-riding Methodist ministers in these highlands not long after automobiles had made their debut. In retrospect, horses may have been more practical.

"I can still hear one of my Grandmothers talk about how she'd drive the car up some old muddy road while Granddad would get out and push," he says.

In 1977, George earned a zoology degree from the University of Arkansas. Then he promptly set his diploma aside. Instead of pursuing a career in that field, he returned to Georgia, drawn by a love of hiking, rock climbing, and canoeing, as well as summer experiences as a church camp counselor. He took a job teaching outdoor education at the Wolf Creek Wilderness School near Blairsville.

In May 1980, Holland fell during a rock-climbing trip near the Hiwassee River in Tennessee. His back was broken. After surgery, he spent a year in rehabilitation, then returned to Wolf Creek. There, he met Cecilia Guettler, a Florida native who was working as the lodge manager. They married in 1984.

George's experiences in rehab led the couple to the Shepherd Center in Atlanta, where he spent five years working as an outdoor recreation therapist for individuals with spinal injuries. It was during this time that he and Cecilia began dabbling in the grain-milling trade.

"We had some good friends, George and Becky Rogers, who were our neighbors in north Georgia," Cecilia explained. "George was working with the U.S. Forest Service, and they had started a little milling operation. I began helping Becky with some of the flour mixes. One day, Becky called and said her husband was being transferred to Arkansas, and they didn't plan on taking the milling equipment with them. I said, 'Well, we've been looking for something to get us out of Atlanta.'"

They didn't exit immediately. For the next two years, the Hollands became nomads—Monday through Friday in the big city, weekends at the mill in the mountains, one hundred miles to the north.

"It was all pretty new to me," said George. "Up till that time, it was a big deal for me to change the oil in my car. I had to rely heavily on Cecilia's father, Norbert. He loves to tinker around with machinery.

"But the beauty of some of the older equipment is that it was designed for people just like me. Think about it: These old engines were sold to farmers who were still working with horses and mules. It had to be pretty simple for them to understand. I'm the same way. I've got a little common sense, plus a lot of endurance and stubbornness. I can figure out how to take something apart and put it back together. As time went on, we were having a lot of fun at the mill, but driving back and forth

was getting to be pretty hectic. Finally, in 1988, I said, 'Enough! We've either got to go for broke with the milling business or give it up.'"

To the mountains they came. For keeps.

Their mill house at that time was on a remote highway that once had been known as the Logan Turnpike. Working there, and touring county and state fairs, the Hollands quickly developed a base of loyal customers. A flourishing mail-order business developed. But if their out-of-town clients tried to come calling, they usually wound up spending most of their time getting "unlost."

"They'd drive up and yell, 'We finally found you!'" said George. "It was not the ideal location."

Thus, when a man named J. R. Rich decided to close his old country store on Gainesville Highway in Blairsville, the Hollands switched locations but kept the Logan Turnpike name. They moved their milling equipment inside the former retail section of the store and converted Rich's old living quarters into their office.

This place is light-years removed from the hustle and bustle of Atlanta. It's a quiet, peaceful setting, interrupted only by the sound of passing cars and the crowing of a neighbor's rooster. Just coming to work here can be fun. Where else but at Logan Turnpike Mill can a fellow paddle to the office in a canoe?

Truthfully, Holland arrives most mornings in his pickup truck. But the Nottely River does flow alongside the couple's home at Hogpen Gap. If water conditions are right, Holland can—and does, on occasion—shove his aged Blue Hole canoe right out of his yard and paddle three miles downstream to the mill. Not a bad way to start the day.

Although the Hollands' machines are powered by electricity, it's only natural that their mill would be situated beside running water. That was the prime source of energy in the old days.

"In this part of the country, you could count on finding a mill about every five miles," says George. "That was in the days before preservatives and refrigeration, and meal would go bad pretty quickly, especially in summer. Five miles was about as far as anybody wanted to travel to get their corn ground."

Artificial cooling is perfectly acceptable these days. In fact, the Hollands recommend their products be stored in either a refrigerator or freezer. But preservatives are a no-no. When you open a bag of their meal, what you see is what you get. For palates numbed by years of agribusiness chemicals, one taste of bread made from fresh, plain flour is a celebration. It's like growing up on hothouse tomatoes from Florida and suddenly discovering the delights of a homegrown ruby beauty, sliced and served three minutes from the vine.

Fresh, speckled, coarse-ground grits are another pleasant surprise. This stuff is not your standard store-bought grits—hydrogenated, sulfated, mutilated wallpaper paste that was pulverized into dust six months earlier, hermetically sealed in foil, and delivered to a chain grocery store. Not by a long shot. It has character and texture as well as taste.

"Grits are simply a by-product of corn milling," said George. "For that matter, the terms 'grits,' 'meal,' and 'flour' refer more to texture than the grain they came from. Sure, you can make wheat grits; it's just cracked wheat. Or you can make corn flour, which we do; it's the central ingredient in our three-grain pancake mix. It's just ground finer than traditional cornmeal."

What makes all the difference is knowing how to calibrate the distance between the grinding stones—and the only way a miller can learn this skill is by making adjustments and feeling the meal as it emerges.

"A lot of times people will come up to me at fairs and tell me about going to the mill when they were

True Grits

a kid," George commented. "They almost always want a taste of fresh meal. A lot of times, they'll also talk about how hot the meal was when it came out—sometimes so hot they couldn't hold it. The sad thing is, if the meal was that hot, something was wrong. Either the stones needed dressing or else the corn was too wet. There shouldn't be that much friction.

"Ideally, what you've got in a mill are these two huge, heavy stones that are perfectly balanced and positioned so that they're almost floating. You want the grain to be cut, not rubbed. The meal should come out around seventy or eighty degrees. The hotter it gets, the more nutrients it's going to lose."

Historically, millstones were made from just about any local rock. After all, they only had to be harder than the grain they were going to grind. The ones at Logan Turnpike are made from blue granite.

A series of grooves and ridges—"furrows" and "lands," respectively—radiate from the center or "eye" of the stones. Grain is ground on the flat-faced lands. As one stone moves over the other, meal dribbles into the furrows, where it is carried out. From there, it moves to a series of sifters which separate the coarser and finer particles.

Occasionally, the furrows or lands become irregular. When that happens, they must be meticulously chipped or "dressed" with a metal pick.

"In the old days, there were a lot of traveling stone millers who'd come around and perform the job," George says. "Those old timers were pretty clever. They'd keep a straight stick and coat it with kerosene and lampblack. They'd rub this across the rock to find the high spots. Then they'd pick 'em down."

In that era of barter, the miller rarely charged money for grinding grain. Instead, his fee came in the form of a percentage of meal called a "toll." Usually it was one-eighth. He packaged this product and sold it to other customers.

The Hollands still do a bit of custom grinding for their neighbors. On this particular day, for instance, two pillow cases full of white corn lay on the floor, waiting to be processed.

"This man's an old friend," Holland said. "He comes by about once a month. Fixes cornbread every day. What he doesn't eat for supper, he eats the next morning for breakfast."

They've even had some rather bizarre requests, like the woman who showed up one day with a bag of dried beans. She wanted them ground up for a facial powder—and into the hopper they went.

But by far, most of their milling produces meal, flour, and grits for retail and wholesale markets. They buy bulk grain from local growers, grind it, and sell to restaurants and farmers markets. Mail order sales to individuals have gone to such far-away outposts as Hawaii, Alaska, and England.

"It costs those folks more for the shipping than for the grits," George quipped, "but if that's what they want, I'm happy to supply it."

They also do a steady business in related products, like small, hand-cranked grain mills for home kitchen use, as well as locally produced jam, jelly, preserves, salsa, and honey.

Still, the daily pace at Logan Turnpike Mill is laid back. No need around here for nerve pills or courses in stress management.

"There are more efficient mills than ours, with bigger motors and larger grinding capacities," said George. "But I prefer to go slower. It's all I can do to stay up with two hundred pounds an hour."

Production is even slower at the dozen or so fairs the Hollands visit every fall. But the chance to interact with visitors—young and old, mill veterans and mill newcomers—is an equitable exchange. With the ancient, one-lung Williams mill *ffffth-ffffthing* in the background, they have a chance to swap stories with guests and invite them to sample Cecilia's grits and three-grain pancakes.

"The grits are really a lot of fun," says Cecilia.

"People will come up and want to know how to say the word correctly. Should it be 'grits is' or 'grits are'? Sometimes, they'll even ask for 'a' grit. And always, folks are wanting to know how do we get grits in the first place? One of our miller friends down in Tifton, Georgia, carries a small tree around with him. He smiles real big and points to it and tells 'em that every morning, he goes out and picks a big mess of grits off his grits tree."

(What? You mean that's not where they come from?)

True
Grits

Index of Subjects